NEW
FEMINIST
CRITICISM

ART • IDENTITY • ACTION

NEW FEMINIST CRITICISM
ART • IDENTITY • ACTION

Edited by
Joanna Frueh,
Cassandra L. Langer
& Arlene Raven

IconEditions
An Imprint of HarperCollins*Publishers*

Also by the same editors:
Feminist Art Criticism: An Anthology.
First IconEdition published in 1991.

HarperCollins books may be purchased for educational, business, or sales
promotional use. For information please write: Special Markets Department,
HarperCollins Publishers, Inc., 10 East 53rd Street, New York, NY 10022.

FIRST EDITION

Designed by Abigail Sturges

Library of Congress Cataloging-in-Publication Data

New feminist criticism : art, identity, action / edited by Joanna
 Frueh, Cassandra L. Langer, and Arlene Raven.—1st ed.
 p. cm.
 Includes bibliographical references and index.
 ISBN 0-06-430909-6
 1. Feminism and art—United States. 2. Feminist art criticism—United
States. I. Frueh, Joanna. II. Langer, Cassandra L. III. Raven, Arlene.
N72.F45N48 1993
704′.042—dc20 92-56247

94 95 96 97 98 CC/CW 10 9 8 7 6 5 4 3 2 1

CONTENTS

ACKNOWLEDGMENTS

We are grateful to Cass Canfield, Jr., and to Bronwen Crothers, his assistant, for their invaluable contributions to *New Feminist Criticism* from its beginning. Thanks are due as well to Kate Scott for her competent copy editing and to Nancy Sabato for her thoughtful jacket design.

INTRODUCTION

New *Feminist Criticism: Art, Identity, Action* offers a wide range of feminist criticism sparked by ideas and events of the 1980s and early 1990s when presidential and administrative conservatism and social protest emphasized issues of art censorship, abortion rights, racial injustices, AIDS activism, ecology, homelessness, and unemployment. Some authors explore what female artists and critics want, their reasons for valuing feminism as an arena of stimulation, as a place of promise that still offers freedom from familial demands and imposed gender roles, and as an environment that is constantly schooling people in the challenge of differences in race, class, age, ethnicity, and gender. In some respects this new collection follows our previous anthology, *Feminist Art Criticism,* and it supplements considerations and critiques in the summer '91 *Art Journal,* guest-edited by Joanna Frueh and Arlene Raven.[1]

Culture, language, identity, and ethics are themes that recur throughout the articles, and a common interest in feminism as a vehicle for intellectual investigation and adventure unites the writings, which differ in methodology. Some essays deliberately combine narrative forms, thereby offering fresh possibilities for writing criticism. Authors honor racial and social identities that characterize them and their experience as "other"—excluded in America—and they often present soul-searching encounters with self and others. In their revisionary approaches, writers

offer exciting new insights into the complex interaction between women and cultures, and many question inclusion as well as exclusion.

Twenty years ago feminist critics as varied as Kate Millett, Cindy Nemser, and Lucy Lippard challenged the art establishment. One way was to critique the "phallic criticism" contained in male writings on women artists and to demonstrate how phallic criticism typecast women according to clichés associated with female biology.[2] This work initiated new directions for writing criticism and making art. Artists Judy Chicago and Miriam Schapiro and artist-art historian Pat Mainardi believed that men's and women's different social and biological experiences offered clues to women's different sensibilities. White middle-class feminists, determined to understand how men's treatment of gender difference contributed to the oppression of women, pioneered the reexamination of human identities, women's lives, and sexual politics. Noticing how privilege, deprivation, language, and gender intersect, feminist theorists of different ethnicities, colors, and sexual orientations began to analyze problems of race and class.

Women artists used traditional and avant-garde media to focus on subject matter and content the art world ignored and avoided. Hannah Wilke, Carolee Schneemann, and Joan Semmel used the female body as a site and vehicle of sexual and aesthetic pleasure and power for women, May Stevens and Nancy Spero put political and social consciences to work against war and patriarchy, and Mary Beth Edelson, Ana Mendieta, and Betye Saar summoned the love and force associated with the Great Goddess archetype. The above artists' works, which do not deal exclusively with either body, politics, or spirituality, are a tiny sample of the energies and images that women asserted in an attempt to repossess and empower women's minds, souls, and bodies, to transform a patriarchal and paternalistic art world and culture at large, and to eradicate the stigma of female worthlessness they produced.

Women, who once hesitated to use their sexual and gendered identities in their art, fearing to be shamed and branded inferior by art world "authorities," began to affirm and inspire one another and to make changes within and among themselves that also altered art world institutions and practices. Essays in *New Feminist Criticism* and *Feminist Art Criticism* address these changes and the necessity of yet greater change. Overall, women began to listen to women and to learn from their art, scholarship, and conversation in what has come to be a continuing phenomenon that provides an increasingly complex discourse.

Arlene Raven's memoir, "The Archaic Smile," a twenty-year chronicle including selected historical highlights, tells how thousands of women

throughout the United States joined and were trained in the boot camp of feminism at alternative institutions such as the Woman's Building in Los Angeles, where they faced problems such as separatism, the family, mixed loyalties, domestic environments, and autonomy. The history and values embodied in the radically new feminist art and design programs at the California Institute of the Arts, Valencia, organized by art historians Raven and Paula Harper, artists Chicago and Schapiro, and designer Sheila de Bretteville, still reverberate throughout feminist art criticism in the United States.

Lippard's widely read *From the Center* (1976) expanded the audience and dialogue of feminist criticism. The A.I.R. and SoHo 20 galleries in New York, Artemisia in Chicago, and Grandview galleries I and II in Los Angeles proved the availability of serious female art. Mainstream trade journals, including *Art in America* and *Arts Magazine,* felt obliged to include articles on women. Alternative magazines founded by women, such as the *Feminist Art Journal* (1972–77), *Womanspace Journal* (1973), *Womanart* (1976–78), *Chrysalis* (1977–80), *Women Artists News* (1975–91), and *Heresies* (1977–), created common ground from which to struggle with the complicated issues feminism raised.

In 1980 *New York* magazine critic Kay Larson examined the "shock tactics" used by feminist artists to pave the way for a new era in which women artists themselves began to define what art should be. Larson thought that far from displacing men, female leadership in the arts had opened new avenues of exploration for all artists. She discussed works she considered generative by both male and female artists.[3]

In the early 1980s feminists' interest in postmodern theories based in linguistic, philosophical, and psychoanalytical studies enriched feminist aesthetics, but also clouded issues and generated conflicts among feminists in the art world as well as other professional arenas.[4] In a 1984 *Artforum* article Kate Linker considered this shift from feminist aesthetics' grounding in the personal to its deconstructionist-based critique of male dominant social and cultural systems and structures. Referring particularly to psychoanalyst-theorist Jacques Lacan's writings, Linker discussed artists Mary Kelly and Annette Lemieux and also considered Louise Lawler's work, which challenged the modernist "purity" of art—or the artistic text—by noting its dependence on the outside world through titles, labels, and segments of language.[5] Linker represents a transitional Zeitgeist—she agreed with and challenged aspects of contemporary feminism—that was to revolutionize feminist criticism during the 1980s.

Psychoanalytical examinations of phallocentrism based on the work

of Lacan and Sigmund Freud proliferated, especially in film criticism, and have greatly influenced art criticism during the past decade. Feminists brilliantly critiqued misogynist and sexist seeing and thinking while simultaneously reinforcing cultural stereotypes, such as theorizing women as bearers of meaning rather than makers of meaning. A prime example is English critic Laura Mulvey, who in "Visual Pleasure and Narrative Cinema" used Freud to analyze desire and scopophilia, divided into active/male and passive/female looking, and claimed that the image of the castrated woman orders "the gaze" and gives it meaning.[6]

Critics such as Craig Owens, Hal Foster, and Brian Wallis believed postmodernism to be a crisis of Western European cultural and institutional authority.[7] Artists Mary Kelly, Sherrie Levine, Cindy Sherman, Barbara Kruger, Jenny Holzer, and Louise Lawler figured prominently in art criticism whose postmodernist position the art and academic press privileged and whose writers extensively cited European intellectuals such as Jean Baudrillard, Jacques Derrida, Michel Foucault, Paul Ricoeur, Theodor Adorno, Walter Benjamin, Julia Kristeva, and Roland Barthes. Mainstream critics with access to New York or international art world publications spoke as though American feminist art critics couldn't be trusted to voice their own insights about masculine authority and the discourse of "others"—especially women.

Distrust of "the father's word" is a feminist tradition. As black lesbian feminist Audre Lorde said in 1975, *"The master's tools will never dismantle the master's house.* They may allow us temporarily to beat him at his own game, but they will never enable us to bring about genuine change."[8] Some feminists have viewed postmodernism as a conflicted concept that may be the index of a new episteme and a discursive formation distinct from modernism, but these same feminists are also wary, for postmodernism has continued the preeminence of male art and critics and has ignored and even attacked the validity of a personalist and experiential theory and practice of feminist representation. Political scientist and psychotherapist Jane Flax discussed the problem in 1987: "Postmodern discourses are all 'deconstructive' in that they seek to distance us from and make us skeptical about beliefs concerning truth, power, the self, and language that are often taken for granted within and serve as legitimation for contemporary Western culture. . . . The relation of feminist theorizing to the postmodern project of deconstruction is necessarily ambivalent. . . . Any episteme requires the suppression of discourses that threaten to differ with or undermine the authority of the dominant one."[9]

Afro-American Studies scholar Barbara Christian critiqued postmodernist critical theory, speaking as one who has "been intimidated,

devalued by what I call the race for theory. . . . I see the language [critical theory] creates as one which mystifies rather than clarifies our condition, making it possible for a few people who know that particular language to control the critical scene—that language surfaced, interestingly enough, just when the literatures of peoples of color, of black women, of Latin Americans, of Africans began to move to 'the center.' "[10] Linda Klinger discussed similar problems in the art world in 1991. She said, "I'd like to consider in what ways recent critical theory cannot accommodate—literally 'writes out'—feminist artistic practice."[11]

All in all, the 1980s saw feminist critics working on—and sometimes arguing with each other about—interrelated issues from a panoply of perspectives and methodologies. The point always was to destabilize the powers that be, even feminist "truths" and epistemes, and the differing directions taken by writers during the 1980s provide practical paths for feminist theorists.

In "Debunking the 'Post' in 'Postfeminism': Feminist Pleasures and Embodied Feminist Theories of Art," Amelia Jones discusses some of the consequences entailed in the narrowing of feminist theories of representation in the 1980s. Critiquing their tendency to suppress or ignore feminist practices that engage the female body directly and raise questions of pleasure and desire, she presents a provisional model for a new approach to art history and cultural criticism, one that loosens the prescriptiveness of these theories by reevaluating the work of feminist body artists from the 1960s and 1970s.

Continuing the feminist practice of reclaiming women's art and criticism means asking: What constitutes masculinity and femininity in painting, sculpture, and performance? How does art criticism situate artists in gender terms? How is femininity articulated by art criticism's language? What larger cultural purpose does femininity serve in art critical discourse? One may infer from these questions that the power of gender as a rhetorical strategy is its paradoxical ability to make and yet mask the connections it establishes between sexual difference and institutional or economic power.

The questions remain: Why would anyone want to assign gender to artists or images? Who would benefit? Mira Schor's "Patrilineage" addresses these issues and asks how the building blocks of career construction and ultimately of art historical reputation, from exhibition reviews to essays, catalogues, and anthologies, are at basis gendered. Schor treats the problem of legitimation through the father alone, showing how art critics validate women artists by assimilating them into a lineage of male forebears. She also points out the necessity of reading critical texts care-

fully to see how they endorse male or female artists and authors. Her consideration of this daunting project stresses the need to refer to matrilineage—women's culture and female-centered social arrangements—within contemporary art practice, critical discourse, and teaching in order to reveal privilege. Activist critiques, such as Schor's, of the stereotyped relations that exist between the sexes have brought about a crisis within the American educational system, particularly at universities in which academicism reduces women's oppression to "the woman question" and "gender studies."

In "There's No Place Like Home" Phyllis Rosser chronicles ways in which feminist art and thought have challenged domestic myths. Beginning with the 1970s, she describes how women were liberated from their glorified but imprisoning roles as fulltime mothers and creators of a haven from the outside world. She shows how second-wave feminists began the painful process of revealing the truth about patriarchal violence in the home through consciousness-raising and how the media and government responded in the 1980s by undermining women's emerging power. Inspired by seventies feminists, a new surge of activist art is developing in the 1990s that deals with the politics of domesticity and brings consciousness-raising about family abuse into the public realm.

Using autobiography and psychoanalytical theory, Andrea Liss's "The Body in Question: Rethinking Motherhood, Alterity, and Desire" delves into her own motherhood and the fashioning of maternity, offering the mother-child relation as a possible model for a feminist ethics based on loving recognition of the other. "At stake" in a feminist understanding, she says, is "strategically negotiating between engrained codes of maternity and embracing the lived complexities of chosen motherhood." Writing in the spaces where representation and experience sometimes touch, Liss challenges notions of women's work and art as devalued labor and provokes us to breach the debilitating taboos dividing the public and private realms.

Since the mid-1980s gays and lesbian feminists have contested taboos, for example, pointing out verbal and visual complexities of our understanding of AIDS. Flavia Rando, Jan Zita Grover, and Martha Gever are among those who have examined the illness, comparing and contrasting the development of its meaning within a contemporary and historical context in which the gay male/female is perceived or "pariahed" as the source of infection.[12] Their writings have helped expose how cultural representations connect a discourse of vice and disease to women's and homosexual males' sexual freedom.

Lesbian feminists have consistently been in the vanguard. They have

struggled to advance their own agenda, and they have been critical in focusing on the questions: What is a woman? What is feminine? What is female? But in the early days of the second wave, heterosexual feminists treated lesbians as "the Lavendar Menace," and Betty Friedan and members of her circle within NOW (National Organization for Women) discriminated against lesbians because she felt their sexual orientation was a liability to the women's movement.

Neemah Shabazz's "Homophobia: Myths and Realities," published in *Heresies* in 1979, attacked sexual discrimination within the feminist movement and dealt with the truths and consequences of identifying with lesbianism. Shabazz underscored how homophobia is one of the major causes of division within women's liberation and how oppressors often use lesbianism as a "discipline" or threat to heterosexual women to keep them "in line" and "under control." She saw the home as the foundation of such socialization, which is reasserted in primary, secondary, and high schools. Churches and colleges also participate in this tyrannization. Myths about lesbians, she noted, include the noxious notion that "a woman is that way because she has a 'natural defect.' "[13] Debates over the question What is a woman? have provided a deeply political and richly symbolic understanding of women's experiences in a patriarchal society.

Harmony Hammond's "A Space of Infinite and Pleasurable Possibilities: Lesbian Self-Representation in Visual Art" gives an overview and analysis of emerging lesbian images and problems of representation. She documents the history of lesbian self-representation in visual art, exploring it in relationship to the creation of lesbian identities. Hammond finds lesbian art to be as varied as lesbians. She describes how self-defined lesbians have expressed themselves, how that expression has changed since the early 1970s, and how, given today's theoretical and actual destabilization of gender and sexuality and given the sociopolitical climate around art, censorship, and antidiscrimination legislation, self-definition continues to develop and change.

In "The Masculine Imperative: High Modern, Postmodern," Laura Cottingham examines the assertion of male value and female dis-value by some of postmodernism's most celebrated practitioners. Arguing for the priority of social determinants in considering the impetus for and reception of the art product, Cottingham suggests that the practices of successful contemporary white male artists such as Jeff Koons, Richard Prince, and Matthew Barney are attempts by these artists and the larger culture to resituate the heterosexual white male at the center of power just as he's experiencing some meaningful tugs from the margins. In proposing an antiformalist continuum between the Abstract Expressionism of the

1950s and the "new masculinity" of the 1980s, Cottingham shows how postmodernism, when viewed as a patrilinear development, not only is *compatible* with high modernism, but is an obvious extension of it.

In a world troubled by negations of people different from oneself, women's identities are the foundation for feminist inquiry and feminist political action. Various critical positions regarding identity, racism, anti-Semitism, essentialism, and class have been part of a feminist process of analysis and activism. Lippard asserted in 1989 that sometimes only idealism can reclaim the positive and disclaim the negative, and she called for experimentation with alternatives to operative systems by examining the multiple identities of feminists to see how we as people create priorities.[14] To honestly answer, What do I and can I know about women from whom I differ in race, class, age, ethnicity, and culture? leads to real knowledge, and real knowledge can begin to shape shared values.

But the white middle-class feminist movement had forgotten and silenced the voices of women of color, and redress is currently nowhere near completion. Gloria Anzaldua, a Chicana tejana lesbian-feminist poet and fiction writer, said in 1990, "Many whitewomen did not acknowledge that they were agents of repression. . . . Whites not naming themselves white presume their universality; an unmarked race is a sign of Racism unaware of itself, a 'blanked-out' Racism."[15] Black intellectual bell hooks exposed feminist racism in a 1984 essay, "Black Women: Shaping Feminist Theory," in which she wrote, "Often the white women who are busy publishing papers and books on 'unlearning racism' remain patronizing and condescending when they relate to black women."[16] Artist Howardena Pindell documented art world racism in a 1989 article, and in the 1970s Faith Ringgold asked the mainly white middle-class Women's Caucus for Art, Where are the women of color?[17] What do you mean? WCA members defensively responded. Ringgold insisted that the WCA needed "other" women discussing differences, actively participating, and building its policies.

Lorraine O'Grady's "Olympia's Maid: Reclaiming Black Female Subjectivity" argues that the black female's erasure in white media and fine arts is a lingering inheritance of slavery and the 19th-century cult of "true womanhood." When she is not totally absent, the black female continues to be represented in the contradictory asexual and hypersexual stereotypes of Mammy and Jezebel. In the course of becoming the symbolic negative whose purpose is to affirm "normal," i.e., white female sexuality, her true subjectivity disappears. The contemporary artist concerned with reclaiming her finds that she must shoulder both an accumulated symbolic absence and the dead weight of history's events. But

even having done so, the artist is faced with yet another hurdle: the black female's continued absence from white poststructural and feminist theory, including its offshoot in psychoanalytic film criticsm, all of which are still mired in a Western binarism whose tendency is invariably to place black bodies at the "other" extreme. For the artist confronted by a theoretical absence reflecting a symbolic one, there is both fearful responsibility and wary pleasure in making an uncharted path through the minefield of black female subjectivity and the limits placed on it by culture.

Margo Machida's "(re)-Orienting," like Hammond's "A Space of Infinite and Pleasurable Possibilities," ventures into the conflicted territory of self-representation. "Race, not gender," says Machida, "is often seen as the primary marker that distinguishes Asian women in a predominantly white society." Because there is no *single*, all-encompassing Asian American women's experience, Machida juxtaposes multiple realities and considers issues raised in a series of panels and discussions that she set up to focus on social, political, and artistic issues. The points of view reflected in her essay represent a rich spectrum of opinion. Artists Yong Soon Min, Tomie Arai, and Hung Liu make art that combines image-making with political and personal concerns—gender, race, feminism, tradition, family, sexuality, and concepts of self. "Given the complex mix of social and personal factors in which Asian women artists' lives are embedded," Machida explains, "it is essential that their art and ideas be investigated on an individual basis. Only by making these artists primary sources can their work be fully understood and related to a larger framework that speaks to the Asian American community, multicultural America, and Asia."

In her revision of art, education, and history, "Multicultural Strategies for Aesthetic Revolution in the Twenty-First Century," Charleen Touchette considers her personal history as a fractional Native American in relationship to the kaleidoscope of identity politics. She appeals, in a voice reminiscent of a speaker in a talking circle, for a wider use of analytical and critical methods gleaned from feminist communities. Touchette proposes strategies for change that mirror the idea of "world" traveling suggested by feminist philosopher Maria Lugones as a way of experiencing difference by shifting into a different space of being. She believes that "we learn to love each other by learning to travel to each other's 'worlds.' "[18]

Clarity about one's own maneuvers requires constant awareness of the nature of prejudice. Exploring restrictive relations between race and class, Adrian Piper's "Passing for White, Passing for Black" directly

addresses identity crisis, racism, sexism, and responsibility. Piper asserts that white Americans have a difficult time acknowledging the fact that almost all of them have significant African ancestry, which makes them black according to this country's conventions of racial classification. Focusing on her own experiences and those of other people of color, she draws ironic parallels between the politics and practice of equality. Her pointed analysis examines the role of institutions and individuals in orchestrating racial antagonism, and challenges readers to make a deliberate commitment to resisting injustice.

Feminist art's and criticism's long-standing concern with the relationship between reality and female archetypes appears in writings by Gloria Orenstein, Andree Collard, Starhawk, and Susan Griffin. They have contributed to a growing body of thought by feminists who strongly identify with nature and are concerned for threatened ecologies.[19] When a popular television commercial cautioned, "You can't fool Mother Nature," it played to people's belief in the almighty mystery and powers of nature and of woman-as-nature. Feminist theorists question the mystique that makes Earth emblematic of the natural female. Yet myths of femininity that connect ancient matriarchal forces—the material body and the earth—with motherhood dominate social attitudes: Christians believed that the merely human (female) must be transformed into the divine (the living spirit, which is male) in order to ascend to the kingdom of heaven, and central to discussions of "ecofeminism" (ecological feminism) is the close identification between women and their bodies, an identification that has been developed by misogynists and that entails a nature/culture split which links woman with nature and man with culture.[20] Radical and conservative feminist philosophies alike have appealed for man to renegotiate his denial of the feminine, which he projects on nature. The idea of transcending matter—earth—resides in a worldview that requires an obsessive will to control women in order to supersede the female (material) and ascend to the divine.

In 1989 Karen Hust discussed photographer Laura Gilpin's renegotiation of Mother Nature.[21] Hust set Gilpin in the context of a mainstream photographic tradition and explained that she recast the nature/culture divide by refeminizing the Western landscape, thus imaginatively handing the Great Mother's ancient power back to her. Similarly, Suzaan Boettger's "In the Missionary Position: Recent Feminist Ecological Art" looks at ecofeminism as a source of women artists' increasing involvement with reparative environmental works and with reclaiming nature and the concept of femininity from degraded status. The large public projects of women such as Patricia Johanson and Harriet

Feigenbaum, which revitalize wildlife habitats and restore ecological systems, "are not only predominant in the [environmental] genre, but have been instrumental in making the genre prominent," notes Boettger.

Joanna Frueh's "Visible Difference: Women Artists and Aging" treats aging and ageism between women as critical to feminist thought and action. Interweaving scholarly, mythopoetic, and autobiographical narratives, Frueh presents the liberties and difficulties of being an old(er) woman artist. Beneath the text's surface layered meanings give voice to old(er) women's bodies, minds, and souls. Using material from questionnaires and interviews with menopausal and postmenopausal artists and discussing works by Rachel Rosenthal, May Stevens, Anne Noggle, Claire Prussian, Vera Klement, and others, Frueh demystifies and frustrates assumptions that women who are beyond childbearing age are no longer productive, creative, or worthy of serious attention. She shows that many women, rather than being oppressed by their experience as old(er), find freedom in exploring culturally disruptive self-presentations, sensual pleasures, and a libidinal intellect. Characteristically, Frueh theorizes woman's body from the subject's vantage point.

In "The Hair of the Dog That Bit Us: Theory in Recent Feminist Art," Christine Tamblyn uses a metaphor from homeopathic medicine to explain how theory informs the work of several feminist artists. Turning theoretical concepts back upon systems of patriarchal oppression to analyze and subvert them becomes an effective strategy for countering these oppressive hierarchies. Rather than constructing utopian alternatives to patriarchal culture, the artists Tamblyn mentions satirize or appropriate its tactics with the intention of symbolically undermining them. The films, videos, performances, and installations these women create thereby "cure" the rampant academicization of art.

Cassandra L. Langer's "Transgressing *Le Droit du Seigneur:* The Lesbian Feminist Defining Herself in Art History" critiques literary semiotics, the rhetorical structures of art history, and feminist criticism itself by analyzing the theory of the gaze from the vantage point of a lesbian feminist ethics. Her extended query for deciphering some lesbian codes offers a nonessentialist theory of what the cryptogram "otherness" embodies in the works of Romaine Brooks. Langer is concerned with creating alternatives and resisting both dominant heterosexist interpretations and new politically correct representations that undermine lesbian individuality.[22] She probes the obliteration of various gazes by asking, Who looks, what do they see, and what does that do? Langer's re-vision replies within a framework of same-sex desire that extends the accepted borders of sexuality, methodology, art history, and feminist criticism.

The strides taken by revisionist art history, art education, art, and art criticism suggest strategies for the future that focus on infinite realities and possibilities. *New Feminist Criticism: Art, Identity, Action* does not present a unified theory or practice of feminism, art, or criticism. The essays do, however, affirm that mothers matter in the birth and nurturing of art, art history, and criticism, and to some extent this book prophesies events that have yet to come into being. Today women in art are still kept in place by acquired attitudes that cultural institutions promote and reinforce through gender politics that teach us (1) that art has been associated with elite groups rather than the community at large, (2) that art has been assigned a peripheral rather than a core role in people's lives, and (3) that art, although traditionally male-oriented and reflecting male values, has been deemed effeminate.

Like St. Joan's crusade, the agenda that feminists forged during the 1970s and 1980s was original and presumptuous. Early leaders had the courage to be outspoken before the F-word—feminism—was rehabilitated by fashionable postmodernism and at the same time declared passé. Feminists exhibited a radical and mighty skepticism regarding official systems of authority, and it shows in every probing piece of art and art criticism created. Visual and written records demonstrate that to change perceptions women must provide alternatives in multiple concepts and in diverse avenues of resistance and power. *New Feminist Criticism: Art, Identity, Action* presents the unfinished, unfolding business of feminism in art, which ultimately wants the humanizing of humanity.

Joanna Frueh,
Cassandra L. Langer
& Arlene Raven

Notes

1. Joanna Frueh and Arlene Raven, guest editors, *Art Journal,* 50, 2 (Summer 1991).
2. Cindy Nemser, "Stereotypes and Women Artists," *The Feminist Art Journal* 1, 1 (April 1972): 1, 22–23.
3. Kay Larson, "For the First Time Women Are Leading Not Following," *ArtNews* 79, 8 (October 1980): 64–72.
4. One perspective on the conflict that arose between poststructuralist and essentialist feminism is found in Linda Alcoff, "Cultural Feminism Versus Post-Structuralism: The Identity Crisis in Feminist Theory," in Micheline R. Malson, Jean F. O'Barr, Sarah Westphal-Wihl, and Mary Wyer, eds., *Feminist Theory in Practice and Process* (Chicago and London: The University of Chicago Press, 1989), pp. 295–326. The article originally appeared in *Signs* 13, 3 (Spring 1988). For discussions about 1980s feminist conflicts in the art world, see Joanna Frueh, "Has

the Body Lost Its Mind?" *High Performance* 12, 2 (Summer 1989): 44–47, Arlene Raven, "Cinderella's Sister's Feet," *The Village Voice Art Special* 3, 2 (October 6, 1987): 6, 8–9, and Cassandra L. Langer, "Feminist Art Criticism: Turning Points and Sticking Places," *Art Journal* 50, 2 (Summer 1991): 21–28. See, too, three articles in *Heresies: A Feminist Publication on Art and Politics* 6, 4 (1989): Mira Schor, "From Liberation to Lack," 15–21; Whitney Chadwick, "Negotiating the Feminist Divide," 23–25; and Lucy Lippard, "Both Sides Now," 29–34.

5. Kate Linker, "Eluding Definition," *Artforum* 23, 4 (December 1984): 61–67.

6. Laura Mulvey, "Visual Pleasure and Narrative Cinema," *Screen* 16, 3 (Autumn 1975): 6–18. A reprint in Brian Wallis, ed., *Art after Modernism: Rethinking Representation* (New York and Boston: The New Museum of Contemporary Art and David R. Godine, 1984, pp. 361–74) had significant impact on 1980s art criticism.

7. See Brian Wallis, "What's Wrong with This Picture? An Introduction," in Wallis, ed., *Art after Modernism: Rethinking Representation,* pp. xi–xviii; Hal Foster, "Postmodernism: A Preface," in Hal Foster, ed., *The Anti-Aesthetic: Essays on Postmodern Culture* (Port Townsend, Washington: Bay Press, 1983), pp. ix–xvi; and Craig Owens, "The Discourse of Others," in Foster, *The Anti-Aesthetic,* pp. 57–82.

8. Audre Lorde, "The Master's Tools Will Never Dismantle the Master's House," in Audre Lorde, *Sister Outsider: Essays and Speeches* (Trumansburg, New York: Crossing Press, 1984), p. 112.

9. Jane Flax, "Postmodernism and Gender Theory," in Malson et al., *Feminist Theory in Practice and Process,* pp. 54–55, 63. The article first appeared in *Signs* 12, 4 (Summer 1987).

10. Barbara Christian, "The Race for Theory," in Gloria Anzaldua, ed., *Making Face, Making Soul: Haciendo Caras; Creative and Critical Perspectives by Feminists of Color* (San Francisco: Aunt Lute Books, 1990), pp. 335, 338. Christian's article originally appeared in *Cultural Critique* 6 (1989). Also see Anzaldua's "Haciendo caras, una entrada," in *Making Face, Making Soul,* pp. xxv–xxvi.

11. Linda Klinger's "Where's the Artist? Feminist Practice and Poststructural Theories of Authorship," *Art Journal* 50, 2 (Summer 1991): 39–47, is a critique of the death of the author. All articles in Note 4, except Alcoff's, also address art world feminists' problems with postmodernism.

12. Two examples of such criticism are Jan Zita Grover's "Introduction to *AIDS: The Artists' Response* (Columbus, Ohio: Hoyt L. Sherman Gallery, The Ohio State University, 1989), pp. 2–7, and Douglas Crimp's "How to Have Promiscuity in an Epidemic," in Douglas Crimp, ed., *AIDS: Cultural Analysis/Cultural Activism* (Cambridge: MIT and *October,* 1987), pp. 237–70.

13. Neemah Shabazz, "Homophobia: Myths and Realities," *Heresies: A Feminist Publication on Art and Politics* 2, 3 (1979): 34–36.

14. Lucy Lippard, "Both Sides Now," 33–34.

15. Gloria Anzaldua, "Haciendo caras, una entrada," pp. xx–xxi. Anzaldua's *This Bridge Called My Back: Writings by Radical Women of Color,* co-edited with Cherrie Moraga (Watertown, Massachusetts: Persephone Press, 1981), is a feminist classic.

16. bell hooks, "Black Women: Shaping Feminist Theory," in bell hooks, *Feminist Theory: From Margin to Center* (Boston: South End Press, 1984), pp. 1–15.

17. Howardena Pindell, "Art World Racism: A Documentation," *New Art Examiner* 16 (March 1989): 32–36.

18. Maria Lugones, "Playfulness, 'World'-travelling, and Loving Perception," *Hypatia: A Journal of Feminist Philosophy* 2, 2 (1987): 3–9.

19. See Irene Diamond and Gloria Feman Orenstein, eds., *Reweaving the World: The Emergence of Ecofeminism* (San Francisco: Sierra Club Books, 1990), Andree Collard with Joyce Contrucci, *Rape of the Wild: Men's Violence against Animals and the Earth* (Bloomington and

Indianapolis: Indiana University Press, 1989), Starhawk (Miriam Simos), *The Spiral Dance: A Rebirth of the Ancient Religion of the Great Goddess* (San Francisco: Harper & Row, 1979), Susan Griffin, *Woman and Nature: The Roaring Inside Her* (New York: Harper Colophon Books, 1978), and Carolyn Merchant, *The Death of Nature: Women, Ecology, and the Scientific Revolution* (San Francisco: Harper & Row, 1980).

20. The classic study of this phenomenon is Sherry Ortner, "Is Female to Male as Nature Is to Culture?" in Michele Zimbalist Rosaldo and Louise Lamphere, eds., *Woman, Culture, and Society* (Stanford, California: Stanford University Press, 1974), pp. 67–87.

21. Karen Hust, "The Landscape Chosen by Desire: Laura Gilpin Renegotiates Mother Nature," *Genders* 6 (Fall 1989): 20–48.

22. Sarah Lucia Hoagland, "Why Lesbian Ethics?" *Hypatia: A Journal of Feminist Philosophy*, guest ed. Claudia Card, 7, 4 (Fall 1992): 195–206, defines heterosexism as "a particular economic, political and emotional relationship between men and women: men must dominate and women must subordinate themselves to men in a number of ways. As a result men presume access to women while women remain riveted on men and are unable to sustain a community of women. This undermines women's community."

THE ARCHAIC SMILE

Arlene Raven

Spring 1972

No teenage flirt photo fills the cover of *Ms.*'s premier issue in December of 1971. Instead, artist Miriam Wosk paints a handmade picture of a contemporary housewife.

A slim twenty- or thirty-something, our cover "girl" has eight arms. But metaphorically, her physiology seems familiar. Eight may be the number required to cook, iron, drive her children and husband to their appointed tasks, clean her house, groom herself and the dog, schedule her family's activities, and see to whatever else might fall into her marital lap along with the unborn baby in her womb.

Although engaged in eight strenuous undertakings at the same time, our housewoman wears high-heeled shoes and stands on one foot. She can do it all. Companioned only by a cat, this wife whirls among simultaneous activities in a still, barren landscape where she is entirely alone.

Gigantic tears form under each eye, yet they do not fall. Her lips are fixed in an upward turn.

Five hundred years before Christ cried on the cross, the lips of all wide-eyed idols of ancient Athens were sealed in identical smiles. A snaky-haired gorgon might commemorate a bloody battle, or a vigorous youth mark a grave. But whatever the occasion, their smiles remain interchangeable and unchanged.

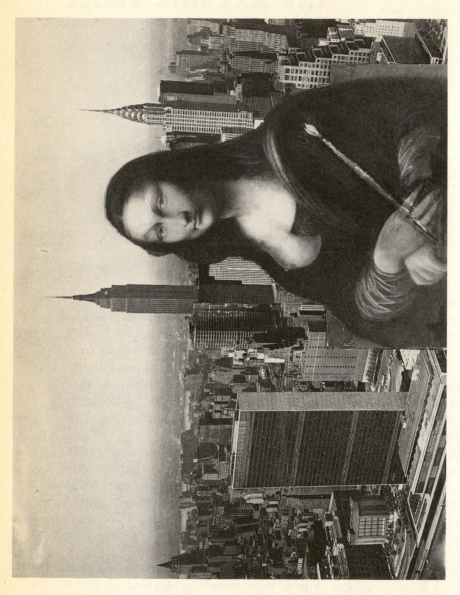

Anita Steckel, *Mona Lisa*, 1973. Mixed media

There is a special name for this early smiley-face, located somewhere between a simper and a snicker—the "archaic smile." But the archaic smile is not actually a smile at all. An expression merely *resembling* a smile, it cannot be counted on to convey the pleasures generally signaled by upturned lips.

The archaic smile is peculiar to all Greek sculpture of the historical period ending at about 500 B.C. "Archaic" also denotes any time perceived as earlier or more "primitive" than another. Archaic time, moreover, is nonlinear; thus an "archaic" physiognomy can emerge at any time.

The sixteenth-century face of the *Mona Lisa* demonstrates the persistence of a family resemblance over a number of generations. Her lips are singled out from those of all of Leonardo da Vinci's other figures and all other smiles of the time as representing an extreme of indecipherability. Mona's smile shows no teeth or tongue, and nothing moves. She is static and mute. These features pleased Leonardo so much that he revered Mona Lisa as the essence of womanhood—mysterious and unknowable.

Betty Friedan, in her pioneering 1963 book *The Feminine Mystique,* recognized archaic smiles on the artfully painted faces of certain mid-twentieth-century American women. Wives and mothers living in single-family dwellings in U.S. suburbs, these mostly white middle-class housewives surrendered to severe social pressure (becoming psychological and exerted even by women on themselves) to manifest only the sunniest satisfaction with their designated arena and assigned role within home and family.

But Friedan's book was about their actual dissatisfaction and suffering. A chapter titled "The Happy Housewife Heroine," when juxtaposed with its frustrating and decidedly unhappy content, paralleled the irony of her readers' own lives—the forced split between what women felt pressed to profess, and what they actually felt. What they actually felt, consequently, was believed by each to be a solely personal problem so mysterious that Friedan called it "the problem that has no name."

In the arts, as elsewhere, female facades were not routinely examined for what might lurk behind, nor even reflected upon as authentic human appearances. Consider Marcel Duchamp's defacement of an image of Leonardo's Mona Lisa when Duchamp added a mustache to her upper lip *(L.H.O.O.Q.)* in 1919. His deliberate affront to female beauty is not usually seen as central to his gesture. The younger artist is perceived, rather, as actively responding to the universal aesthetic "problem" of twentieth-century male artists—primal jealousy that great art of the past

The American Feminist Art Movement
A Random Sampler

This small historical sampling is compiled with appreciation for all of the efforts made by and on behalf of women in the arts during the past two decades. May our work not be forgotten or erased.

1972
Following the example of a landmark protest at the Los Angeles County Museum of Art (LACMA) in 1971, local women picket the Corcoran Gallery of Art in Washington, D.C., for excluding women from its 1971 biennial. The protesters later hold the first National Conference for Women in the Visual Arts at the Corcoran.

A.I.R. (Artists in Residence) Gallery is founded in New York City. First cooperative of women artists in the United States.

The Feminist Art Studio is established in Ithaca, New York.

Midmarch Arts, a nonprofit arts service group, is created to organize women's exhibitions and conferences.

West Coast Women Artists' Conference, the first feminist art conference on the West Coast, is sponsored by the Feminist Art Program (Cal Arts).

Women's Caucus for Art (WCA) forms to address concerns of art professionals within the College Art Association (CAA). In 1974, WCA breaks from CAA. Local chapters are created throughout the United States.

"Womanhouse," a multimedia collaborative environment, is created by the Feminist Art Program. Organized by Judy Chicago and Miriam Schapiro.

The first all-women shows in the United States open: "Invisible/Visible" (Long Beach Museum of Art, California), "Old Mistresses" (The Walters Art Gallery, Baltimore, Maryland).

Fight Censorship group of artists founded in New York City by Anita Steckel to protest the prohibition of sexually explicit imagery from the art arena.

"The Feminist Art Journal" is established by Cindy Nemser and publishes quarterly until the summer of 1977.

1973
The Woman's Building opens in Los Angeles as a center for women's culture. Its public space closes in 1991.

Galleries are founded across the United States: ARC, Artemisia (Chicago), Chrysalis (Bellingham, Washington), Hera (Wakefield, Rhode Island), SOHO 20 (New York City).

continued on page 6

such as that of Leonardo exists. Duchamp saved face, but Mona Lisa lost it. And nobody noticed.

Duchamp's guerrilla operation on the famous looker is homosocial iconoclasm of the oedipal variety. Female beauty, he also demonstrated, is a commodity that depends on absolute passivity and the absence of character or human persona.

No action was taken before the 1970s to tear away at the vulnerable relationship between art, artist, and female beauty, and to build a new alliance between feminine comeliness and female liberation. The hairy-lipped Mona Lisa remained the sole twentieth-century representation of this woman until New York artist Anita Steckel presented a monumental mixed-media *Mona Lisa* (1973) as an American artist, placing an empowering brush in her hand and positioning her smack up against the Manhattan skyline.

In plain sight of the White House and the Washington Monument, "Women in the Visual Arts," the first such conference on the East Coast, was held in the auditorium of the Corcoran Gallery of Art in Washington, D.C., April 20–22, 1972. Originated by a small group of Washington artists, art historians, and museum professionals who had recently picketed the Corcoran's biennial exhibition for its lack of female representation, the conference was (according to organizer Mary Beth Edelson) seen as a follow-up effort.

I was there and am also here now to tell you that what transpired during those three days was unexpected in its impact and was truly revolutionary for those present. This event was to generate alliances and work that would change individual lives and the course of contemporary art in the United States fundamentally over the next twenty years.

Part of this change in contemporary art resulted from the phenomenon of men looking on and borrowing heavily from the artistic discoveries of feminists, then receiving more art-world recognition during the 1980s for adopting, for example, soft materials, writing on their pictures, or exploring their sexual bodies, than the feminist inventors of these innovations.

How did change occur? From the inside out. From passing information and insights from one woman to another. From actions and efforts that seemed imperceptible, or slight, but ran deep into the creative souls of what became in twenty years a nationwide art community. Today, this feminist art community at its best still embraces consensus and difference

The Social and Public Arts Resource Center (SPARC) opens in Venice, California, as a multicultural arts organization dedicated to producing and exhibiting public art.

Women Artists It's Time is founded in Miami; *Midwest Women Artists Conference* forms in Saugatuck, Michigan; and *Feminist Art Workers* organizes in Los Angeles.

Womanspace Gallery hosts "Female Sexuality/Female Identity," the first women's invitational exhibit in the United States.

1974

Mother Art collective formed to create performances and installations concerned with mothering and women's changing roles.

Women's Studio Workshop printmaking studio opens in Rosendale, New York.

Women graduate students at the University of Colorado organize *Front Range Women in the Visual Arts* in Boulder.

1975

Double X forms as a Los Angeles coalition of women artists who sponsor exhibitions. Their 1978 "Working Together" includes the collaboratives *Ariadne: A Social Art Network, Mother Art,* and *The Waitresses.*

Women Exhibiting in Boston (WEB) is founded and sponsors exhibitions until 1983.

The Feminist School is founded in Syracuse, New York, offering art history and studio art classes.

1976

Ariadne: A Social Art Network forms in Los Angeles to present performances and dialogues on violence against women.

Atlanta Women's Art Collective organizes in Georgia with twenty-three members.

"Chrysalis," a magazine of women's culture, is founded in Los Angeles.

The Waitresses, a performance group, is formed by Jerri Allyn and Anne Gauldin in Los Angeles.

WARM (Women's Art Registry of Minnesota), a Minneapolis women's collective, opens WARM Gallery in 1976, which remains open until 1990. Today, the collective runs a mentor program and organizes an annual show.

Women's Video Center (L.A.) provides instruction, hosts video screenings and festivals.

The show *"Women Artists 1550–1950,"* curated by Linda Nochlin and Ann Sutherland Harris, opens at the Brooklyn Museum in

continued on page 8

in art, politics, and daily life, and strives for authenticity and inclusiveness.

That is not to say that involvement in the women's movement in art has not been without formidable tribulation. Differing organizing strategies, struggles over the race, class, affectional preference or abilities composing groups, and the individual needs of artists vs. the enormous amount of time movement work requires were merely a few of a great many rocks in the road.

Changes in the United States and the microcosm of the art world had the same negative, crushing financial and moral impact on women and their art that they have had generally. Nevertheless, my assessment that a national women's art community has grown in twenty years is not an overoptimistic view. We have experienced heartbreaking losses. But women have both amazing staying power and the will to keep on keeping on. It has been a movement of small, moving moves ever in motion.

Tenuous contact and a turn of consciousness are always the first exchanges. At the 1972 conference, speakers showed their visual art shyly, sheepishly—then, emboldened by the enthusiastic applause, ever more forcefully. Eventually, some got to the same hard facts about their lives as women/artists that Friedan had so plainly stated about housewives, and they shared stories along the hair-raising journey of the Mona Lisa.

I met an artist sitting in my section of the auditorium behind a gigantic column (the better to hide) who had been working for thirty years but had never shown her paintings to another soul. In the front row, a particularly well-dressed matron not allowed by her family to have a studio in her own home made collages from the trunk of her car.

The common conflict of sparring and scraping with a shifting self in which artist and woman never completely merged was newly acknowledged in the darkened, round room. The astonishment and empathy of recognitions came in "oh's" and "m-m-m-m's" and small cries of solidarity that unified presenters and audience in an equal exchange.

Alice Neel, then sixty-something and wearing a housedress, was speaking for the first time in public about her work. So deprived had she been, during a life dedicated to her art without recognition or a critical context, that when her allotted time came to an end she could not give up the podium. Encouraging Neel to allow herself to disrupt the conference schedule, her ardent audience understood the profundity of her long wait for the platform and her need to fully experience it.

Ms.'s multiarmed Mrs. illustrated Jane O'Reilly's landmark article, "The Housewife's Moment of Truth." "We are all housewives," she

New York City. The historical traveling exhibition contains the work of eighty-three artists.

1977

"Heresies," a feminist magazine on art and politics, is founded in New York.

MUSE Gallery, women's cooperative and alternative exhibition space, opens in Philadelphia.

The exhibition *"Women in American Architecture: A Historic and Contemporary Perspective"* is held at the Brooklyn Museum.

Women in the Arts, a nonprofit organization with a membership of fifty women, organizes an annual conference celebrating Pennsylvania artists. The conference takes place each year until 1981.

Womanswork, a private gallery outside Tempe, Arizona, is founded and serves as an exhibition space for women in the Southwest until 1979.

1978

Hestia Art Collective formed in Northampton, Massachusetts, to offer support to women and discuss the roles of artist and citizen.

Women and Their Work, a multicultural arts group, opens exhibition and performance space in Austin, Texas.

1979

New York Feminist Art Institute opens as an alternative school for women artists. Closes in 1990. Today, NYFAI is the umbrella organization for the Ceres Gallery, which opened in 1985.

The Women's Building opens in San Francisco as a cultural and community center.

"The Dinner Party," a sculptural installation by Judy Chicago and hundreds of art workers, opens at the San Francisco Museum of Art.

The Incest Awareness Project, cosponsored by Ariadne and the Gay and Lesbian Community Services Center, opens at the Woman's Building Los Angeles as a public media campaign and exhibition called "Bedtime Stories: Women Speak Out About Incest" by adult female survivors.

"Cross Pollination" opens at the Woman's Building, Los Angeles, showing traditional and contemporary art by Asian, black, and Chicana women.

The Women's Caucus for Art's "Outstanding Achievement in the Visual Arts" awards, organized by Charlotte Robinson, are read out by U.S. President Jimmy Carter for the first time. Recipients

continued on page 10

wrote, "the people to turn to when there is something unpleasant to be done." For me, O'Reilly's sweeping and disturbing statement in retrospect set the content of this momentous conference into the context of the longer-term battle for an unqualified and inspirited female self-identification in a society appropriate to it. And it gave an inkling of the bloody battles that would and still do mark its progress.

No "woman in the arts" at the Corcoran wanted to be viewed as a "housewife," even if everyone else was so designated. Even if her work employed household metaphors such as sweeping a room or ironing clothes—in fact, especially not in that case.

Wanting in on centuries-old artistic traditions and opportunities previously open only to men, the majority of women gathering together in the early 1970s sought to create professional work and to distinguish themselves individually as artists. Most participants then saw the organizing of exhibitions, collectives, and co-op galleries as being of potential assistance in women's becoming visible independent artists succeeding within the existing art world.

There had been almost no opportunity for these female artists to show their work in public. But, curiously, a kind of "secret" work being made by a number of the women present was not meant for galleries or museums—it was more open art, less concerned with official male styles of the day, closer to the maker—and had its premiere showing in this all-female context.

Women's common oppression and degradation in the home and in American society, as O'Reilly put it, was approached in pieces and parts through the physical evidence of women's artworks. Work that was self- and female-referential, though, sometimes qualified itself by glorifying the unique uncommon. It was only possible, at first, to address these issues central to the female body and psyche in the safer public territory of an all-female professional setting and the private all-woman consciousness-raising circle.

But in the half-said words, sighs, changes in positions in the chairs, and sidewise looks, there was a sense of unanimity in understanding that something germinal and kindred in those pieces and parts, uncomfortable truths about how we had all learned to be that idealized and degraded woman, was taking shape. Longing and shame mingled with distaste and security in following our mother's feminine models (and her mother's, and hers) haunted everyone.

Can I be a woman and an artist? Mothers mostly said no. Each artist could reflect on how she had attempted to follow her mother to appease the household gods, while at the same time devaluing and rejecting her

are Isabel Bishop, Selma Burke, Alice Neel, Louise Nevelson, and Georgia O'Keeffe.

1980

"Extended Sensibilities," art by lesbians and gays, opens at the New Museum, New York City.

"The Great American Lesbian Art Show," a national network of lesbian art events, opens an invitational exhibition at the L.A. Woman's Building.

The Birth Project, needlework designed by Judy Chicago about the birth experience, commences in Benicia, California.

The Women's Caucus of the Society for Photographic Education is founded at the society's seventeenth annual conference.

1981

espace dbd, a performance art space, is founded by Rachel Rosenthal in Los Angeles. In 1992 Rosenthal forms the Rachel Rosenthal Company ensemble, The Actual Company of Players.

The Los Angeles County Museum of Art is picketed by women and men of color for lack of diversity in its bicentennial exhibition. Identical masks worn by protesters depict curator Maurice Tuchman's face.

The Women's Graphic Center (L.A.) presents a series of lectures by its members that include Miriam Wosk's discussion of her illustrations for the first *Ms.* cover.

Vida Gallery, a nonprofit women's art exhibition space, is founded at the Bay Area Women's Building. In four years, the gallery provides over four hundred artists with a place to show their work.

1982

Los Angeles Artists for Survival creates an event called "Target L.A.," the first antinuclear music and arts festival organized by Cheri Gaulke and Ed Pearl.

Jenny Holzer's "What Urge Will Save Us Now That Sex Won't" appears on the electronic spectracolor board at New York City's Times Square.

1983

National Museum of Women in the Arts is established in Washington, D.C. Opens to public in 1987. Its permanent collection, drawn mostly from the holdings of the founders, Wilhelmina and Wallace Holladay, has five hundred works by women from the sixteenth century to the present. A library and research center housed at the museum promote the study of women in the arts.

continued on page 12

mother if she had been primarily a "housewife." A surprisingly large number of art works were on this theme, and the process of the construction of woman through generational family learning proved to be central and especially graphic for younger artists.

At the Corcoran, Miriam Schapiro and Judy Chicago showed slides of *Womanhouse,* an environment created in six weeks by their Feminist Art Program at the California Institute of the Arts in a condemned house in downtown Los Angeles and then opened to the public from January 30 to February 28, 1972. Rooms were transformed into a fear bathroom, a menstruation bathroom, a lipstick bathroom, a giant-sized nursery, a woven womb room, and a "nurturant kitchen" of fried-egg "breasts" and innumerable plates of prepared food.

In *Womanhouse,* a bride (her gown's train leads right to the kitchen) and a mannequin with a Mona Lisa smile literally embedded among the sheets of her linen closet are the only two figures presented. Together they portray the post–World War II wife and mother. By creating the environment of the homemaker, the young women in the Feminist Art Program addressed their mothers' lives directly. Acting as artists, their serious play took place in archaic time that allowed the universally most important relationship between mother and daughter to be excavated in new forms.

Discarded from conventional parlance as obsolete, archaic time is a marker uncommonly full of first meanings in the nonordinary world of the arts. *Womanhouse* was archaic territory. When the closed-mouth smile appears in archaic time and territory, it sparks curiosity to search beneath the surface of the skin for its authentic local significance.

Of the performances (an art form that proved especially suited to feminist work) that were presented at *Womanhouse* during its six-week tenure, one in particular forespoke the essential future character of the women's art movement. *Birth Trilogy* is a ritual of rebirth and new identity symbolizing the coming together of women to attend their own and one another's birth.

These daughter/artists were determined to break out of the home and into the world by confronting the most troublesome of female stereotypes and, instead of living them, living through them and thus strengthening themselves in their work. And they were doing that complicated work together. The birth dance is not only a symbol but a true reflection of the relationships among a couple of dozen women in California who set off on an odyssey.

Birth Trilogy connected. One by one the tears began. All around the amphitheater, tears streamed as a form of cheering too, until anger, grief,

"At Home," a Long Beach Museum of Art exhibition, celebrating the tenth anniversary of the L.A. Woman's Building, brings together environments, performances, artists' books, video events, poetry readings.

1984

Let MOMA Know: Women Artists Visibility Event (WAVE) is organized in New York City to protest the inclusion of only 14 women (from a total of 165 artists) in "An International Survey of Recent Painting and Sculpture," an exhibition celebrating the Museum of Modern Art's reopening after being closed for one year. The demonstration, attended by four hundred protesters wearing buttons reading THE MUSEUM OF MODERN ART OPENS BUT NOT TO WOMEN, is sponsored by the New York City chapter of the Women's Caucus for Art, the New York Feminist Art Institute, the Heresies Collective, and the Women's Interart Center.

"Judy Chicago—The Second Decade, 1973–1983" at ACA Galleries is Chicago's first one-woman show in New York.

1985

Guerrilla Girls established in New York City to combat sexism, racism, and arts censorship. These anonymous female activists don gorilla masks, adopt names of deceased women artists, and distribute posters of art world statistics. In 1991 and 1992, they expand their poster campaign to include other issues, including the Persian Gulf War, national health care, the AIDS and homelessness crises, and the Clarence Thomas hearings.

"Rape" exhibition and tour opens at Ohio State University Gallery of Fine Art.

1986

The first conference organized by *Women in Photography,* "Making Connections," is held at Syracuse University. A second conference, "Expanding Connections," is held at Bryn Mawr College in 1989.

The *"Seventy-Fifth American Exhibition,"* is presented at the Art Institute of Chicago. According to the catalogue, its purpose is "to inform the public about some of the best work done by Americans." The twenty artists shown include four women: Jennifer Bartlet, Sue Coe, Susan Rothenberg, and Cindy Sherman.

1987

The exhibition *"The Graphic Muse: Prints by Contemporary American Women"* is put on at Mount Holyoke College, Massachusetts.

continued on page 14

and relief flowed everywhere, cracking the self-treasonous, simulated, synthetic Stepford Wives–style smiles.

For me, a life of commitment to the values and the work of the feminist art movement was determined in a split second of archaic time, right then and there. Although twenty years have passed, I am still in that moment.

Spring 1992

On Sunday, April 12, some women who had attended the first conference at the Corcoran and others who had not reassembled in Washington, D.C., to "remember, to celebrate, to look ahead."

Many stories about the women's movement in art are recalled and retold, new tales spinning as we spoke. And each, like that of every feminist predecessor, presents the picture according to its eye witness.

Although the initial Corcoran conference was the first organizing enclave on the East Coast for artists, similar efforts caught fire after 1972. There was a sharp rise in the number of women's institutions—galleries, bookstores, schools, work collectives, and printing and publishing centers—all during the 1970s.

The rightness of the self-segregation of women for support and self-knowledge was debated then, but did not turn as punitive as it did in the next decade, when feminism was declared either dead or victorious and thus obsolete, and when funding of any all-female institution was routinely turned down by state and national art councils.

Some of these original coalitions remain viable today. But the backlash against women, fueled not only by woman-hating but also by worsening economic and political conditions in the 1980s, caused the physical space available for feminist activities to shrink. Changes in critical language toward a less populist or journalistic vocabulary countered and may have confused the academic status of women's studies and in particular access to the study of art and art history. Nevertheless, this last decade contributed insights into the representation of femininity that have broadened the foundation of feminist knowledge in the 1990s and generated the addition of large and remarkable bodies of work by women.

It is true that more women are showing in galleries and museums than ever before. It is also true that more men are showing, and that there are more galleries to show in. Furthermore, a "ceiling" of recognition is still entirely in place above which many mid-career and older female artists cannot rise. And statistics distributed on posters in New York by

The Corcoran Gallery's *"Fortieth Biennial Exhibition of Contemporary Art"* shows four women among thirteen exhibiting.

1988
At the First Cleveland Performance Art Festival (held at the Public Theater), performance artist/ex–porn star Annie Sprinkle creates a stir. On hand to arrest organizer Tom Mulready and Sprinkle, should she insert a speculum into her vagina, are two police officers and an Ohio judge.

1989
"Making Their Mark: Women Artists Move into the Mainstream, 1970–85." Exhibition opens at the Cincinnati Art Museum.
"American Women Artists: The 20th Century," featuring forty-eight artists, opens at the Knoxville Museum of Art, Candy Factory, and Bennett Galleries in Knoxville, Tennessee.
The Fantastic Coalition of Women in the Arts, a multicultural group of artists, writers, and museum curators, forms to ensure that women of color are included in the art world.

1990
Jenny Holzer becomes the first woman ever selected to represent the United States at the Venice Biennale.
Karen Finley and Holly Hughes, performance artists, file suit against the National Endowment for the Arts over an obscenity clause that artists are required to sign in order to receive grant money.

1991
ARTnews selects fourteen artists from around the world as those "to watch in the 1990s." Only four women are included in the list.

1992
The twentieth-anniversary exhibition of the *National Conference for Women in the Visual Arts,* "Then and Now," is held at the Corcoran Gallery of Art, Washington, D.C.
Women's Action Coalition (WAC) organizes in January, committed to taking direct action on issues affecting all women's rights. Its motto is "WAC Is Watching. We Will Take Action."

Research assistance: Heide Lang

the Guerrilla Girls group since 1985 paint a dismal picture of resistance to change in behalf of women within the art world.

Backlash has a particular relevance to the feminist art movement. As women have been driven back to home and hearth (childlessness means depression) and away from full careers (so as to avoid hair loss and heart attacks), and when even Betty Friedan has warned that women have "new 'problems without a name,' " many female artists have made backlash their subject. They image, mirror, and confront the realities behind the "trends" of the past decade that have insinuated that the independence needed to accomplish creative work is "female trouble."

Jane O'Reilly's claim in her *Ms.* story that all of us are housewives called upon when something unpleasant is to be done has proved to be tough truth. One cannot view the progress or state of the women's art movement without keeping this general truism in mind. While it is true that some feminist institutions have closed their doors or reorganized, it is possible that this decline parallels that of banks, businesses, and government agencies during the Reagan and Bush administrations. But if there is something unpleasant, like the crumbling of an entire country, to be assessed, women will bear the blame and burden.

As I took a break from my computer screen today, April 29, I turned to the *Oprah Winfrey Show,* where the guest was a doctor who himself had surgically turned up his wife's lips into a perpetually pleasant smile. Women's bodies more than ever form the battleground between old men of the U.S. Congress and Supreme Court, and women themselves. The strong and varied body of women's art work today stands directly in this territory—affirming ownership of oneself, opposing censorship of the contemporary physical facts of life, and claiming control of women's wombs.

Just this year, the feisty Women's Action Coalition began to meet at a gallery in New York's SoHo to plan political actions. At two galleries in downtown New York, two art shows—"Where are the Women-After the Rage, Part II" at ABC No Rio Gallery and "The Fate of the Earth," an installation of art works by women artists from around the world at the Ceres Gallery—present concerns and an agenda for the empowerment, health, and well-being of the planet.

Today the silhouette delineating a recognizable movement may not be as clear. In fact, these days seem like the incipient archaic time of two decades ago, when feeling was just about to take form. Besides, women's stories in the art of art and the war of art are never cast in single dimensions, nor have they come to an end.

POSTFEMINISM, FEMINIST PLEASURES, AND EMBODIED THEORIES OF ART[1]

Amelia Jones

Dedicated to Hannah Wilke, 1940–1993

We live in a particular moment of highly charged sexual politics. Within the last year, supporters of women's rights have seen a number of disturbing public displays of these politics: the ridicule of a well-educated African-American female lawyer by an all-white, all-male Senate commission for her exposure of sexual harassment by an African-American male candidate for the Supreme Court; the media-fed rise of Camille Paglia, whose self-serving, pseudo-intellectual, and antifeminist pronouncements have established her as the Phyllis Schlafly of gender studies. And we have seen women professionals, both fictional and actual, become targets for reactionary rhetoric about "family values" and the "cultural elite," as men debate the vicissitudes of feminine behavior and attempt to pass legislation on a woman's right to choose. Intimately related to these epochal events in the history of American sexual politics is the development of antifeminist cultural discourses that veil their hostility to feminism through the spuriously historicizing term "postfeminism." In the last decade, as Susan Faludi points out in her book on the antifeminist "backlash," feminism has become a dirty word.[2]

I will explore here the discursive means by which the death of feminism (its status as "post") has been promoted through photographic and written texts, examining what is at stake—politically, culturally, and economically—in this promotion. Tracing various constructions of post-

feminism, I will analyze it on several different levels, each of which corresponds to a sociocultural configuration of oppression against women that must be excavated in order for an effective understanding of postfeminist politics to take place. I will begin by introducing some examples of how feminism has been reduced to a unitary construct, then discursively and photographically executed (in both senses of the word) as postfeminism in the popular press in the last few years, and will follow this with an examination of some of the ways in which postfeminism has permeated art discourse.

As a coda to this critique I will suggest ways of rethinking the dilemma posed by the mobilization of the term postfeminism by returning to a previous moment of feminist art history, reintegrating into the so-called postfeminist debate the feminist body artists from the explosive early years of the second wave women's movement, the 1960s and 1970s. Looking again at these artists, who began to produce their work before postfeminism (or feminist postmodernism) began to be defined in art discourse, will be useful in exposing the negative effects of postfeminism. Through this recourse to feminists' articulations of the physical body I hope to suggest a way to revive positive and empowering meanings in relation to feminism in Western culture. The point of looking back to practices that have been for the most part ignored since the 1970s is definitively *not* to reject 1980s feminist art practices and theories in all of their complex and variously enabling effects, but, rather, to think a way out of a critical definition of feminist art that, from the point of view of the 1990s, is beginning to appear dangerously prescriptive. In this essay, then, I will suggest a way of rethinking the relatively limited notions of sexual critique that I believe have accompanied the incorporation of feminism into postmodernism (as postfeminism) in art discourse by theorizing the particular feminist interpretive pleasures that these embodied works evoke as they activate the feminist subjects of art and art history.

POSTFEMINISM IN POPULAR CULTURE

The enemies of the postfeminist backlash in the popular press are professional women in general, and feminism and its avatars in particular—especially those self-defined feminists who confuse and transgress previously accepted codes of domesticated femininity. The fantasized feminist enemy is a homogeneous figure: visually and textually coded as a professionally powerful and often excessively sexual woman, she is also severely limited in terms of race and class, not to mention sexual orientation.

Within the representational politics of popular culture, any identity formation deviating from the upper-class, anglo, straight imaginary of the American subconscious must be transformed or homogenized to comply with the normative American subject.

The demographically limited yet still highly threatening feminist enemy to the status quo has been epitomized recently by the fictional character Murphy Brown, whose repeated invocation and excoriation by the conservative right has signaled the strength of the threat posed by the figure of the self-sufficient woman. By naming Murphy Brown the enemy of "family values" because of her independence from men, the namer both denies the existence of those other, actual single mothers who aren't as picturesque for the dominant myths of femininity as Brown, and hopes to negate the dramatic social and political shifts in American culture that undermine the paternalist ideology of the ideal family. The recent resuscitation of this patriarchal fantasy by the right under the guise of "family values" is a symptom of the massive anxiety of the patriarchal system, signaling a reaction formation against the threatening incursion of women into the work force and, more recently, the political arena.[3]

As innocuous (and fictional) as she may seem to those of us on the "radical" feminist edge (and/or from Dan Quayle's "cultural elite"), Murphy Brown, then, functions as a powerful discursive category for the right, which has explicitly identified her as feminist and so antithetical to their antifeminist agendas. In contrast, in the advertisements and news magazines I want to discuss here the contemporary female subject is produced as unequivocally postfeminist—still safely subordinate to the commodity system and to the circulation of normative, heterosexual male desires. The photographic images of postfeminist women perform an ideological function. With the cultural authority of Anglo masculinity increasingly thrown into question as gay, feminist, and nonwhite cultures insistently articulate counter-identities to this imaginary norm, it has become all the more urgent for the patriarchally driven commodity system to reinforce predictable stereotypes of femininity. The upper-middle-class, white, postfeminist woman is produced to bolster a masculinist economy of social relations.

Exemplifying the explosion of media interest in the volatile and changing nature of contemporary feminine identities are the five issues of *Time* magazine that have been devoted to the "woman question" in the last three years.[4] Articles in each issue fabricate models of gender relations based on the kind of statistical information that Susan Faludi's *Backlash* exposes as inaccurate and deceptively applied; they manipulate

popular conceptions of feminism through these spurious statistics, defining it as "post" in advance.

Two advertisements for the Fall 1990 special issue entitled "Women: The Road Ahead," for example, set the stage for this issue's overall antifeminist orientation, juxtaposing cartoon images of women with the texts "You've Come the Wrong Way, Maybe," and "Who says you *can* have it all?" Not surprisingly, the title page of the issue itself labels our current period unequivocally as "the postfeminist era." While containing diverse articles, some of which are clearly feminist[5], the special issue is sprinkled with postfeminist ads for its sponsor Sears; these work blatantly to reinforce profit-driven notions of "proper" femininity. With photographs of glamorous, predominantly white women absorbed in frivolous, consumerist activities, the advertisements rely on texts to finalize their constructions of contemporary femininity: "I don't like to go shopping, I like to go buying," and "I'm a senior partner in a very successful enterprise, my family" are two examples. The economic stakes and class implications subtending postfeminist ideologies are evident in these advertisements: it is clearly the independently wealthy, stay-at-home postfeminist who makes the better consumer than the working feminist. The advertisements construct unequivocal images of contemporary women as Anglo, rich, nonprofessional, narcissistic, and profoundly materialist— determining a unified postfeminist subject.

The cover story of *Time* from December 4, 1989 is unabashedly antifeminist in tone and content. In bold yellow letters, the cover text reads, "Women Face the '90s," continuing, less favorably: "In the '80s they tried to have it all. Now they've just plain had it. Is there a future for feminism?"[6] Inside the magazine, the cover article—which is illustrated by a range of images of protesting feminists and feminist symbols on a time line (including a cartoon of a woman, labeled a postfeminist, saying "I can't believe it. I forgot to have children")—employs the term postfeminist in describing the rejection of feminism by younger generations of women.[7] Attributing this rejection to the "fact" of their realization that women can't have it all (as if "having it all" were necessarily the primary goal of the women's movement in the first place), the author, Claudia Wallis, attempts to make younger women's putative disillusionment appear inevitable. She asserts that "motherhood is back" and feminism is outmoded because, after all, "hairy legs haunt the feminist movement, as do images of being *strident and lesbian.* Feminine clothing is back; breasts are back . . . [and] the movement that loudly rejected female stereotypes seems hopelessly dated" (p. 81; my emphasis). While the article appears to ask innocently if there is "a future for feminism," it

precludes such a future by linking feminism inexorably to the highly charged and implicitly devalued image of "being strident and lesbian."

The *Time* article is one among innumerable examples of the popular construction of feminism as a unified attack on the mythologized American family. Calling for a return to the ostensibly simpler family values of yore, this view of feminism in turn legitimates and in fact necessitates its obliteration. The image of the woman's responsibility to the family is most blatantly reinforced in antagonism to feminism in the *Good Housekeeping* "New Traditionalist" advertisements that have been displayed prominently at bus stops and in upscale magazines such as the *New York Times Magazine* in the last few years. In these ads, bold texts such as "She started a revolution—with some not-so revolutionary ideals" and "More and more women have come to realize that having a contemporary lifestyle doesn't mean that you have to abandon the things that make life worthwhile—family, home, community, the timeless, enduring values," are accompanied by images of beaming, yuppie mothers in sparkling domestic settings with one or two cherubic children.

The politics of postfeminism takes a violent and explicit turn in the recent spate of films exploring the deviance and ultimate expendability of women who are sexually and/or professionally powerful; examples here include the notorious *Fatal Attraction* (1987), as well as *Presumed Innocent* (1990), *The Hand That Rocks the Cradle* (1991), *Poison Ivy* (1992), *Single White Female* (1992), and the virulently misogynist and homophobic *Basic Instinct* (1992), where the "strident lesbian" becomes a man-killing bisexual with an ice pick/phallus.[8] These narratives produce the necessity of annihilating the nondomesticated contemporary woman in bloody orgies of human destruction, or at least of reinscribing her into the family structure. With the termination of this woman (who is always, needless to say, pretty and anglo) comes the termination of feminism and its threatening antipatriarchal goals.

Notable, too, the other side of the postfeminist coin is the emergence of the so-called "men's movement" in the popular media. Its popularity confirmed by the phenomenal success of Robert Bly's recent book *Iron John,* the men's movement appropriates and perverts the rhetoric of feminism to urge the contemporary American male to "find a voice of [his] own" as a "Wild Man."[9] Bly laments the feminization of the American male at the hands of his female caretakers, and calls for the extirpation of this spineless femininity through primitivist histrionics and rituals of male bonding. The "Wild Man" immerses himself in mother nature and beats the appropriated drums of his "primitive" brothers with big

sticks to prove to himself that, even as he becomes outnumbered in the job market, his ability to dominate is intact.[10]

These photographic images and their accompanying texts encourage men to reconstruct a primitivistic masculine self through the appropriation of elements from non-Western cultures, a gesture of self-renewal that is hardly innovative, having a long and nefarious tradition within Western practices of cultural and military conquest. Just as discourses of postfeminism attest to the power of feminist and working women in contemporary culture, the fact that masculinity needs to be shored up proves the intensity of the threat that the vast numbers of working women of all sexual, racial, and class identities pose to the patriarchal system (not to mention the threat posed by the increasingly powerful identity politics of the nonheterosexual male).[11]

THE POSTFEMINIST SUBJECTS/ OBJECTS OF CONTEMPORARY ART

The popular deployment of the term postfeminism thus involves invidiously redefining femininity, feminism, and even masculinity in relation to racist, class-bound, and patriarchal models of gender and sexual identity. While the use of the term postfeminism in discourses on contemporary art appears, in constant, to involve a significantly different purpose, in my view it has had primarily negative effects for feminism here as well. I want to argue, in fact, that it has tended to be played out in dominant discourses of postmodernism in the 1980s into the 1990s through appropriative techniques that ultimately generalize and defuse the politics of feminism.

While I do not have the space to describe at length the parameters of what I am identifying as dominant discourses of postmodernism in the visual arts, it is important to give a very general definition to clarify this descriptive, and thus inevitably narrowing, label.[12] The discourses of postmodernism I am calling "dominant" are those texts, generated primarily within New York City–based institutions in the last ten years or so, that tend to work from models of radicality derived from avant-garde theories of culture to privilege contemporary art practices defined as undermining, deconstructing, or otherwise subverting earlier claims of purity and transcendence made in the name of modernist art (particularly by art critic Clement Greenberg). Within this logic, a specific type of feminist practice (whose effects are determined to be compatible with avant-gardist strategies of subversion) is incorporated into postmodern-

ism and the particular politics of feminism are defused; feminism is gener-
alized as one radical strategy among many available to disrupt modern-
ism's purities and exclusionary ideologies.[13] The label postfeminism,
which signals a moment "beyond" feminism, is symptomatic of the effects
of this incorporation.

Postfeminism, however, is by no means always mobilized in a con-
sciously antifeminist way. Artists who speak and work from explicitly
feminist perspectives—Mary Kelly and Barbara Kruger, for example—
have been labeled postfeminist by feminist art historians and critics in an
attempt to distinguish their work from earlier, supposedly essentialist
feminist art practices.[14] But, I am arguing, the end result of the applica-
tion of this term, with all of the historical implications of its "post" prefix,
is to promote antifeminist ends. Although far more subtle and certainly
more thoughtful than the popular media's blatant attempts to dismiss
feminism *in toto,* discourses of postmodernism tend to address the rela-
tionship between feminism and postmodernism through modernist and
ultimately masculinist models of interpretation—models that work to
empower the postmodern critic through "aesthetic terrorism," hierarch-
izing art practices on the basis of avant-gardist categories of value and
excluding work not deemed to be "radical" or anti-modern enough.[15] The
incorporation of one particular kind of feminism into a broadly con-
ceived, even universalizing, project of postmodernist cultural critique
tends to entail the suppression of other kinds of feminist practices and
theories. It encourages the collapse of the specific claims of feminism into
postmodernism, allowing the postmodern theorist to claim postmodern-
ism as an antimasculinist (if not explicitly feminist) alternative to an
authoritative and phallocentric modernism. The strategic appropriation
of feminism both radicalizes postmodernism and simultaneously facili-
tates the silencing of the confrontational voices of feminism—the end
result being the replacement of feminism by a less threatening, postfemi-
nism of (non)difference.

Ironically, the strategic construction of a radical, antimasculinist
postmodernism relies on the very type of oppositional logic constitutive
of modernist art discourse that postmodernism is defined as rejecting (the
logic in the texts of Clement Greenberg, for example, that affords him the
power to differentiate "high" art from "low," "good" art from "bad").
In discourses of postmodernism, "progressive" artistic practices are privi-
leged through their alignment with a narrow, avant-gardist feminism, and
opposed to "regressive" artistic practices. Still working to hierarchize
artistic practices and, by extension, to promote the judgments of the critic
as correct and to confirm her or his authority, these discourses serve

masculinist critical ends. Thus, even Craig Owens's sophisticated and important article, "The Discourse of Others: Feminists and Postmodernism," which begins seemingly innocently by placing feminism and postmodernism in the same space (he describes "women's insistence on incommensurability" as "not only compatible with, but also an instance of postmodern thought"), ends up collapsing feminism into the "postmodernist critique of representation": "th[e] feminist position is also a postmodern condition."[16]

As Tania Modleski points out in her new book, *Feminism Without Women: Culture and Criticism in a "Postfeminist" Age,* the effects of this discursive dynamic within postmodern discourses, in which "feminist criticism [is] . . . becoming absorbed into the academy," are facilitated by the confusion of feminism with feminization, a confusion that serves masculinist critics who wish to benefit from the radicalizing force of the feminist label.[17] Interestingly, then, while the postfeminism of popular culture works to deny the continuing empowerment of feminist discourse and the sexually and professionally active feminist subject, the postfeminism of academic criticism works simultaneously to celebrate and absorb feminism and feminist theory. Postfeminism in art discourse is precisely this absorptive operation: the incorporation of feminism into postmodernism as "post".

Exemplifying the effects of this incorporation, Dan Cameron employs postfeminism as the title of a recent article on postmodern art, using the term broadly to encompass all art by women in the 1980s that, in his terms, uses "structuralism to critique social patterns in terms of social domination."[18] Under the broad rubric of postfeminism, Cameron discusses women artists as diverse as Barbara Kruger and Susan Rothenberg, lumping together an artist well known for her feminist polemic (Kruger) and one who is not concerned in any direct way with feminist issues in her approach to object making (Rothenberg). In fact, Cameron's argument becomes increasingly muddled as the article progresses. Cameron implies that any female can be (and, perhaps, necessarily is) postfeminist just by virtue of her sex; but he also claims that "there is by no means a dearth of male artists working from [the] identical premises" of the female postfeminists (80). According to Cameron, men are able to appropriate feminist radicality by simply acknowledging the contingency of art as language; feminism becomes useful to nonfeminist male artists and critics as postfeminism.

Cameron also discounts the explicitly feminist agendas of artists such as Kruger and Laurie Simmons by placing these artists in a masculinist genealogy of avant-garde critique: "following on the heels of Pop,"

they then become the "sources" for male artists Jeff Koons, Peter Halley, and Philip Taaffe, whose works, Cameron admits, are "more vociferously" collected than those of their supposed (maternal?) mentors, the postfeminists (80, 82). We can hardly be surprised at this last discovery, given the modernist value systems and hierarchies still maintained even in Cameron's own ostensibly pro- but effectively antifeminist argument.

It has become quite common in art criticism to subsume feminist work under a broad framework of postmodernism. Barbara Kruger and Sherrie Levine, for example, are described by *New York Times Magazine* writer Richard Woodward in universalizing terms as simply using "photography conceptually to ask questions about the source and presentation of images in our culture."[19] Even the most explicitly feminist projects, such as Cindy Sherman's incisive critiques of the visual construction of the feminine, are submitted to this absorptive strategy. Sherman has posed herself as embodied object, frozen into gendered positions of vulnerability in her *Untitled Film Stills* in the late 1970s and, in work from the 1980s, as monstrously overblown in the very clichéd "darkness" of her sexual unknown; in recent photographs, she poses and photographs grotesque plastic female sex dolls, aggressively displaying their rigid genitalia, dildos, and artificial limbs. Yet Sherman has been construed by Donald Kuspit as expressing a "universal" message lamenting the general condition of humanity:

> Sherman's work has been interpreted as a feminist deconstruction of the variety of female roles—the lack of fixity of female, or for that matter any, identity, although instability seems to have been forced more on women than men. . . . But this interpretation is a very partial truth. Sherman shows the disintegrative condition of the self as such, the self before it is firmly identified as male or female. This is suggested by the indeterminate gender of many of the faces and figures that appear in these pictures, and the presence of male or would-be male figures in some of them. Female attributes—for example, the woman's clothes in one untitled work— . . . are just that, dispensable attributes, clothes that can be worn by anyone. The question is what the condition of the self is that will put them on. . . .[20]

In this article—entitled, with disturbing and certainly unintentional irony, "Inside Cindy Sherman"—the stakes of postfeminist rhetoric are clear. Being "inside" Cindy Sherman, Kuspit constructs himself as knowing the artist better than she does herself. (How else could Kuspit "know" that what certainly do appear to be "female attributes"—women's clothing, a female authorial name, and even bloody women's underpants—are really things "that can be worn by anyone"?) Kuspit's fantasized *penetration* into this interior takes place via a probing set of metaphysical art

historical tools such that Sherman's insistence on her otherness, as a "symptom" of masculinity's uncertainties about itself, is folded back into a narrative of (masculine) universality.

Kuspit concludes with the following argument: "It is . . . her wish to excel with a certain aesthetic purity as well as to represent inventively . . . that reveals her wish to heal a more fundamental wound of selfhood than that which is inflicted on her by being a woman" (396). For Kuspit, the "true" meaning of this art is not feminist but moves into the wide yet phallocentrically organized expanse of the universal, with its "fundamental wounds" and intrinsic "aesthetic purity." Familiarly enough it is masculinity and, in this case, critical and political authority that are at stake in Kuspit's argument: to sustain the privilege of masculinity, a pre- or antifeminist system of gender relations must be maintained, with Sherman's feminism effectively eradicated through its incorporation into the "universal" concerns of humanism. Crucial to this maintenance is the recuperation of female subjectivity within the pre-/postfeminist terms of sexual difference whereby, as French feminist Luce Irigaray points out, even while the difference of a unified category "woman" is established, it is always already incorporated into a masculinist economy of the same.[21] For Kuspit this economy takes place as a "new subjectivism" (the title of the book that includes the Sherman essay).

THE STAKES OF POSTFEMINISM

As I have suggested, these incorporative disempowerments of feminism in art discourse require and rely on the maintenance of certain modernist and ultimately authoritative and masculinist models of artistic value. These are models that draw from avant-gardist ideologies to construct oppositional categories of "progressive" versus "regressive" postmodern art practices.[22] Underlying this dominant postmodern value system is the stipulation that the progressive art practice must follow avant-gardist strategies of "distanciation" as developed in the aesthetic theories of Bertolt Brecht—must aim to displace and provoke the spectator, making her/him aware of the process of experiencing the text and precluding her/his identification with the illusionary and ideological functions of representation.

As appropriated by postmodern art theory, Brechtian distanciation requires, above all, a resistance to pleasure—a prohibition of the object's seduction of the spectator as an embodied and desiring subject.[23] In dominant conceptions of postmodernism, which tend to perpetuate

Greenbergian modernism's hierarchies of taste disguised under avant-gardist terms of political rather than formal radicality, art that refuses visual pleasure is valued over more overtly seductive, sensual, or "decorative" work. As feminist art historian Griselda Pollock argues, distanciation is a crucial strategy for feminist artists because of its "erosion of the dominant structures of cultural consumption which . . . are classically fetishistic. . . . Brechtian distanciation aims to make the spectator an agent in cultural production and activate him or her as an agent in the world."[24] This is a feminist strategy for Pollock because the fetishistic, objectifying regime of consumerist capitalism is consummately patriarchal.

The desire to maintain critical and artistic authority, an authority that demands the illusion of control over chaotic pleasures of the flesh, paradoxically has its feminist parallel in Laura Mulvey's feminist call for a destruction of visual pleasure in her ubiquitous and formulative 1975 article, "Visual Pleasure and Narrative Cinema." Mulvey states her well-known polemic as follows: "It is said that analyzing pleasure, or beauty, destroys it. That is the intention of this essay."[25] According to Mulvey's argument, because the construction of woman as objectified other through visual representation is inevitable, feminists must necessarily work to refuse this objectification. Woman, Mulvey argues, stands "in patriarchal culture . . . as bearer . . . not maker of meaning," becoming an object of scopophilic, fetishizing, and inexorably *male* desire—an object of the "male gaze"; her disempowerment serves to palliate the male viewer's fear of lack (15).

Mulvey's call to refuse male visual pleasure has been an organizing force in the development of feminist art and theory for the last two decades, particularly those very same art practices from New York now canonically inscribed in much contemporary criticism as feminist post-modernism or postfeminism (from the works of Kruger and Sherman to those of Mary Kelly). The so-called postfeminists have operated consistently within the Freudian terms of Mulvey's paradigm, working explicitly through psychoanalytic models of sexual difference to deconstruct the modernist conception of subjectivity as masculine and empowered through vision (through the "male gaze"). In working to deconstruct modernism's reliance on the subject/object dichotomy, manipulating photographic imagery of the female body (or, in Kelly's case, scrupulously avoiding it) in order to intervene in its psychically objectifying effects, these artists work polemically within oppositional models of sexual difference to break them apart.

While Mulvey's polemic has provided a space for the development

and definition of a feminist postmodernist practice in the last decade, in view of its insistence on the refusal of pleasure (a pleasure that she defines as exclusively male and exclusively visual), it can also be seen to be aligned with a particularly masculinist emphasis in modernist art criticism on bodily control. Mulvey's call to distance the (male) spectator exemplifies the turn to avant-gardist theories of representation in 1980s discourses on contemporary art and the consequent devaluing of art practices that elicit bodily desires. In view of the pervasiveness of Mulvey's model—and its role in reinforcing what Mulvey herself has recently called the "1970s paranoia about visual pleasure"[26]—it is clear why feminist artists whose works evoke visual and other bodily pleasures have been excluded from histories and theories of contemporary art.

How is the refusal of pleasure a masculinist project? The maintenance of critical authority in art discourse demands the rigorous separation of embodied pleasure from so-called theory; within this cultural policing, the possibility of a work of art that is both sensual and conceptual, both corporeal and theoretical, both eroticized and politically critical is disallowed. As sociologist Pierre Bourdieu has written of the psychic motivations encouraging this refusal of pleasure in discourses of "high" culture, "the object which 'insists on being enjoyed' . . . neutralizes both ethical resistance and aesthetic neutralization; it annihilates the distanciating power of representation, the essentially human power of suspending immediate, animal attachment to the sensible and refusing submission to the pure affect. . . . [Only] pure pleasure—ascetic, empty pleasure which implies the renunciation of pleasure— . . . is predisposed to become a symbol of moral excellence and the work of art a test of ethical superiority. . . ."[27]

According to Bourdieu, the aesthete's "disgust" toward the impure pleasures of the flesh is the means by which he or she ensures "ethical superiority," performing his or her distance from the chaos of human corporeality and the stench of fully embodied desire (489). The resistance to pleasure is above all a resistance to corporeal engagement motivated by a desire to control the chaotic and unpredictable pleasure of the erotically engaged body. Only a cerebral pleasure purified of eroticism can elevate the aesthete or critic above the masses (which, as a number of cultural theorists have noted, are inexorably identified with the threat of femininity[28]). Within the eminently masculinist logic of criticism, the critic fears a collapse of the very hierarchizing boundaries of difference that enable the "male gaze."

The exclusion of 1960s and 1970s feminist body art from histories of contemporary art is deeply informed by mutually implicated fears of

femininity, physical seduction, and the dangerously chaotic pleasures of the flesh. Seduction, sexuality, and corporeality, as male philosophers from Nietzsche to Baudrillard have consistently argued, are intimately connected to the threateningly sexualized feminine body (the seducer's "domain approaches that of the feminine and sexuality"[29]). Because the feminist body artists of the 1960s and 1970s aimed to revalorize these cultural codings of femininity by performing the very bodies so threatening to patriarchal culture, the turn to conceptions of radical practice as necessarily distancing or antipleasurable in effect has enabled the suppression of their works. Explicitly playing out highly charged scenarios through the performance of female (though not "essentially" determined) bodies, the feminist body artists break down the masculinist critical prohibition of pleasure. As authors of and objects within their own works, they perform female artistic agency. Encompassing both the sensual and conceptual, they trouble the exclusionary value systems of art history and criticism by refusing the prohibition of pleasure.

As French feminist Luce Irigaray has pointed out, the refusal of pleasure intersects with the denial of female agency and thus has ideological, and explicitly antifeminist, effects. Within the psychoanalytic map of bourgeois Western subjectivity, "woman has to remain a body without organs. . . . The geography of feminine pleasure is not worth listening to. Women are not worth listening to, especially when they try to speak of their pleasure."[30] While it is the female body that elicits most directly the "disgusting" (lower class, but also clearly heterosexual and male) pleasure of which Bourdieu writes, and thus requires objectification as a means of controlling its potential threat, this very same body is conventionally refused to the female viewer as a locus of pleasure. As Emily Apter has written of this dynamic, "The fetishized feminine Imago, conforming to a commercialized ideal of what seduces the eye, is thus barred to the female spectator." In the Mulveyan "feminist anti-fetishism" or "puritanism of the eye," where Freud's models of subjectivity prevail and visual seduction is seen to be necessarily complicitous with male fetishism, female pleasure is simply ignored.[31] The negation of female pleasure is potentially complicitous with its denial by patriarchy, the disempowering effects of which are described so vividly by Irigaray. In overlooking the question of female pleasure, critical texts that privilege so-called postfeminist art for its refusal of the desiring "male gaze" have maintained both modernism's general refusal of pleasure and the Mulveyan focus on male pleasure (and its prohibition) at the expense of accounting for the possibility of desiring female viewers and makers of art.

In the last part of this essay, I want to reinscribe into this debate my

particular anti-postfeminist interpretations of several examples of femi-
nist body art, which I read as activating rather than negating relations of
pleasure in experiencing the work of art. In offering these readings, argu-
ing that the works articulate multiple feminist identities that transgress
the psychoanalytic determination of the woman as objectified other and
refuse the oppositional critical logic subtending postfeminism, I am spe-
cifically *not* claiming feminist body art as "inherently" working against
the effects of postfeminism. Rather, I argue this while acknowledging the
contingency of my claims on my own feminist desires, which I self-
consciously attempt to implicate in the interpretive exchange through
which I designate the works as anti-postfeminist. In my view, acknowl-
edging the productive and desiring role of interpretation itself is a neces-
sary component of strategically challenging the masculinist logic of post-
modernist and postfeminist interpretative models, which confirm their
own authority by denying the highly motivated nature of their resistance
to and fear of pleasure.

My central argument is that at this particular moment the most
radical rethinking of feminism can take place through the articulation of
re-embodied theories of female artistic subjectivity, feminist agency, and
representation in the broadest sense. Ideally, by re-embodying the sub-
jects of feminism—by saturating theory in and with the desiring making,
viewing, and interpretive bodies of art theory and practice—the notion of
a unified feminist subject (a notion that we saw was integral to this
subject's termination in the popular press accounts of postfeminism) can
be rejected. And, by acknowledging multiple feminist subjects of infinitely
variable identities, we can perform reinvigorated feminist art histories
and practices that are radically empowered through the newly recognized
diversity of feminisms.

PERFORMING FEMINIST BODIES

The performative body has generally been marginalized and avoided in
the construction of histories of contemporary art, presumably because, in
the terms of modernist art historian and critic Michael Fried, it *theatrical-
izes* artistic production, activating the viewer/viewed relationship in a
manner highly threatening to the authority of aesthetic judgment.[32] The
resistance to corporeal engagement is motivated, at least in part, by the
need to substitute "visual pleasure" for that less predictable ("disgust-
ing") pleasure of the ontologically engaged body. When the body of
performance is female, the threat to the masculinist critic is doubled. A

female body in performance elicits the corporeal desires of the viewer, potentially escaping the "male gaze," and authorizes the female as subject of action.

With feminist body art, in fact, women artists appropriate and flamboyantly perform the very activity of artistic production. Driven by a compulsion to fuse the outer body, which for women in patriarchy is objectified into a "picture" through male desire, with the inner self (the acting *cogito*—the intellect, the psyche), they enable themselves by enacting the feminist axiom "the personal is political." As body artist Eleanor Antin has mused, "The notion of the body is itself an alienation of the physical aspect of the self. . . . But what if the artist makes the leap from 'the body' to 'my body'? 'My body' is, after all, an aspect of 'my self' and one of the means by which my self projects itself into the physical world."[33]

In performances such as Robert Morris's *Site* of 1965, Carolee Schneemann offered her body up as living "representation" or masculine *imago* of a historicized conception of the prostitute's body. Acting as "cunt mascot" (her own words), she was "PERMITTED TO BE AN IMAGE, BUT NOT AN IMAGE-MAKER CREATING HER OWN SELF IMAGE."[34] While Schneemann has often been reduced in art historical accounts to this passive role in Morris's artistic investigation, she was, during this early period, a painter and object-maker, and an active figure in the Judson Dance Theater. Schneemann also performed her eroticized body in her own projects, such as her 1963 piece *Eye Body,* in which, she has written, "covered in paint, grease, chalk, ropes, plastic, I establish[ed] my body as visual territory, . . ." marking it as "an integral material" within a dramatic environmental construction of mirrors, painted panels, moving umbrellas, and motorized parts.[35] As early as 1963, then, almost ten years before the development of a cohesive feminist movement in the visual arts, Schneemann deployed her sexualized body in/as her work. Describing this piece in her book *More Than Meat Joy,* Schneemann is clear about her motivations: "In 1963 to use my body as an extension of my painting-constructions was to challenge and threaten the psychic territorial power lines by which women were admitted to the Art Stud Club. . . ." (52).

By the early to mid 1970s, Schneemann's performances, which continued to entail the imposition of her own naked body, became measured, precise, and even more explicitly feminist in tone. In *Interior Scroll,* originally staged in 1975, Schneemann performed herself in an erotically charged narrative of pleasure that worked against the grain of the fetishistic and scopophilic "male gaze." Her face and body covered in strokes of

paint (or, in its second performance, mud), Schneemann pulled a long
and thin coil of paper from her vagina ("like a ticker tape . . . plumb
line . . . the umbilicus and tongue"[36]), unrolling it to read a narrative text
to the audience. Part of this text read as follows: "I met a happy man, /
a structuralist filmmaker . . . he said we are fond of you / you are charm-
ing / but don't ask us / to look at your films / . . . we cannot look
at / *the personal clutter / the persistence of feelings / the hand-touch sensi-
bility.* . . . "[37] Through this action, which extends "exquisite sensation in
motion" and "originates with . . . the fragile persistence of line moving
into space," Schneemann integrated the occluded *interior* of the female
body (with the vagina as "a translucent chamber") with its *mobile* exte-
rior, refusing the fetishizing process, which requires that the woman not
expose the fact that she is not lacking but possesses genitals, and they are
nonmale.[38]

Furthermore, the performative body, as Schneemann argues, "has a
value that static depiction . . . representation won't carry." She is con-
cerned, she said in a recent interview, with breaking down the distancing
effect of modernist practice: "My work has to do with cutting through the
idealized (mostly male) mythology of the 'abstracted self' or the 'invented
self'—i.e., work [where the male artist] retain[s] power and distancing
over the situation."[39] Through *Interior Scroll,* Schneemann gave herself
over not, I would argue, only as a "subject of identification" for the
female viewer, but also as subject/object of female desire. "In some
sense," Schneemann has stated, in this work "I made a gift of my body
to other women: *giving our bodies back to ourselves.* "[40] The female subject
is not simply a "picture" in Schneemann's scenario, but a deeply con-
stituted (and never fully coherent) subjectivity in the phenomenological
sense, dialectically articulated in relation to others in a continually nego-
tiated exchange of desire and identification.

Unlike a male body artist such as Chris Burden, who could play at
relinquishing responsibility only to reaffirm his authority (directing oth-
ers to martyr him as subject/object of artistic production), Schneemann
seems to recognize the importance for women artists of maintaining what
Parveen Adams has called the "interchangeability of positions within . . .
fantasy."[41] Thus, Schneemann plays out the inexorable oscillatory ex-
change between subjectivity and objectivity, between the masculine posi-
tion of speaking discourse (which no man can have any more securely
than a woman can, though he has a definitive advantage under patriarchy
in pretending to possess it) and the feminine position of being spoken. By
"speaking" her "spokenness" already and integrating the image of her
body (as object) with the action of making itself, Schneemann plays out

the ambivalence of gendered identity—the fluidity of the positions of male and female, subject and object in fantasy and in gendered identity as we live it in post-Freudian culture.

Hannah Wilke has performed both her conventionally determined gender (her "femininity") and her artistic authority (her "masculinity") in deliberately outrageous and, for me, highly pleasurable ways. For example, in a poster that Wilke plastered in multiple outside Leo Castelli Gallery in 1977, she poses topless captioned with the text "Marxism and Art: Beware of Fascist Feminism." Wearing only a wide tie that hangs flaccidly between her obviously female breasts, she masquerades as a man with a deliberate lack of success, warning of the dangers of an institutionalized model of "proper" feminist practice.[42]

The photographic image, one of her "performalist self-portraits," is from Wilke's "Starification Object Series," a group of elaborate performances in which she flirted, shirtless, with the audience while they chewed pieces of bubblegum she had handed out at the door. At one point in these performances, Wilke would take the gum, form it into tiny loops, and stick these masticated labial-shaped lumps in patterns on her nude body.[43] In the performance itself, the labial wads would integrate the bodily fluids of the audience with Wilke's own body surfaces and externalize the "scars" of femininity on her naked flesh. The female genitals become marks of a woman's lack of lack, themselves things to be seen; through them, Wilke gave herself over to female, and particularly feminist, desire. And yet, as Wilke has argued, each "bubblegum cunt" also, "from a woman's point of view," looks like "the head of a cock."[44] Far from essentializing the genital aspect of the female body, these androgynous shapes oscillate between male and female objects of sexual desire, according to the spectator's point of view.

In the 1970s Wilke presumptuously performed herself to intervene in the construction of a highly invested "father" figure of postmodern practice. In a performance staged at the Philadelphia Museum of Art in 1976 called *Hannah Wilke Through the Large Glass,* Wilke performed a slow-motion striptease, literalizing the "stripping of the bride" enacted diagrammatically in the upper half of Marcel Duchamp's *Large Glass* by peeling off her man's suit and fedora behind the "masterpiece" itself.[45] Like Cindy Sherman, her better-known "postfeminist" follower, Wilke deliberately took on the objectified "mask" of sexuality thrust upon the female subject under patriarchy. And yet it is crucial that Wilke performed and had filmed her erotic and specifically bi-gendered relationship to the Duchampian "gaze," for it is through this act that Wilke flamboyantly asserted the female body itself as the active producer of its own

objectification (as seen through the work of the male master), a subject of its objectivity.

In the late 1960s and early 1970s, a number of artists began to produce images of themselves, often for gallery advertisements, that are highly performative in effect. For example, in photographs advertising exhibitions at their respective galleries in New York City, Wilke and Lynda Benglis make a singular point of refuting the male gaze altogether, deliberately playing pin-ups in order to play out their subjectivities, thumbing their asses, as it were, at the male-dominated art world.[46] In her 1974 advertisement for Paula Cooper Gallery (a photograph taken by Annie Leibovitz), Benglis appropriates a classic cheesecake pose, but subverts it through her not quite total nudity, jeans bagged indecorously at her high-heeled feet. Wilke's advertisement for Ronald Feldman Gallery from 1970 includes a photograph taken by Claes Oldenburg, her lover at the time; here, Wilke integrates her sexed-up body, rear-cleavage coyly displayed through a veil of hosiery, into the process of artistic production itself: she is turned away from the "male gaze" because she is self-absorbed, presumably in the creative act.

As Sue-Ellen Case has argued in a recent article disputing the heterosexism implicit in psychoanalytic models of sexual difference, the ass confronts the male or female viewer as a site of desire that refuses the phallic economy of heterosexual patriarchy: "The relation of the camera to the ass certainly refigures forms of desire untouched by the Lacanian relation to the penis. The anus is not itself a signifier of lack, and only comes to represent lack when tropes of sexual difference are reinserted into the discourse, feminizing it, while the penis is retained as signifier of the 'masculine.' " Case's analysis bolsters my argument that these two brazenly sexual performative acts dislocate what she calls the "gaze/look compound" of heterosexual feminist theories of representation, theories whose "pleasure in theorizing the look . . . appears dependent on disavowing or displacing what *should not be seen*"—that is female desire, particularly of a not firmly heterosexual sort.[47]

In Benglis's infamous self-produced spread from the November 1974 issue of *Artforum,* she poses only in sunglasses, her naked body greased and one hand holding a huge dildo.[48] With Benglis's greased body and extended dildo as a visual reference, we can begin to think ourselves away from the machinations of the "gaze/look compound" to a more unruly notion of artistic subjectivity and interpretive desire. Here, Benglis subverts the psychic symbology of the penis itself; literalizing the insistence of psychoanalytic models on the woman's ultimate desire to have a penis, she performs a violently threatening female subjectivity. The nature of

this threat is made more clear by comparing Benglis's piece with the self-portrait poster Robert Morris made in dialogue with Benglis's advertisement that same year. (The two artists were lovers at the time.) While Morris safely—if certainly ironically—reconstructs the male artist as penis, garnishing his taut, muscular torso with leather and chains and topping his head with a hard cap, he continues to veil the organ itself (the elastic band of his underwear is visible at the edge of the frame).[49] Conversely, Benglis's display of the obviously fake penis refuses this organ alignment with the mythical "phallus." (Yet, ironically, it is Benglis's deflation of the pretensions of the male organ that empowers her, endowing her provisionally with phallic power.)

The scandal Benglis's advertisement provoked at the time provides further proof of the threatening nature of her appropriation of power. In the following issue of the magazine, a group of *Artforum* editors—Lawrence Alloway, Max Kozloff, Rosalind Krauss, Joseph Masheck, and Annette Michelson—published an absurdly intolerant letter, part of which reads as follows: "For the first time . . . a group of associate editors feel compelled to dissociate themselves publicly from a portion of the magazine's content, specifically the copyrighted advertisement of Lynda Benglis. . . . In the specific context of this journal it exists as an object of *extreme vulgarity.* . . . [It] reads as a shabby mockery of the aims of . . . [the women's] movement. . . ."[50] (my emphasis).

Benglis's "extreme vulgarity" is that which punctures the masculinist authority of these critics. Displaying the sexual excess of the threateningly active female subject in wild abandon, she becomes that which *should not be seen:* woman as desirable body, woman with penis, woman with phallus, woman as self-producer, woman in control of the critical gaze. As is clear from the response it engendered, with this performative act Benglis successfully inverted the oppositional politics of the gaze. Appropriating the penis to act out its mobility as a sign of gender, in the meanwhile Benglis elicits uncontrollable critical desires that must be rechanneled into critical opprobrium.

Benglis experimented with other personae in gallery flyers, such as her appearance in another ad in *Artforum* earlier that same year, where, leaning coolly against the roof of a car in sunglasses, with closely cropped hair and wearing a man's-style blazer, she takes on a "butch" persona. Again, Benglis's gesture must be seen as part of a project of continual performative self-construction that elicits male fear (or the *masculine* fear of the authoritatively invested critic) and not only female identification, but female desire. Because these ambivalently gendered bodies constructed by Benglis seem to me to be radically empowering in their

Lynda Benglis ad, *Artforum,* November 1974

conflation of subject and object of desire, I both identify with the project they represent and *desire* the highly sexed bodies themselves. I want to see these bodies as neither simply male (with penis) or female (the anatomically sexed Benglis) *nor* simply hetero- or homosexual objects of the viewer's (simply "masculine") gaze.

To wrap up this discussion of the potentially dislocating effects of feminist body art on postfeminist politics, I turn now to an artist who breaks apart the closed system of sexual difference and the "male gaze" by activating the long-suppressed relationships between race and gender, refusing the totalizing conception of difference that freezes heterosexual gender, in Michael Warner's words, as "our only access to alterity in modern thought."[51]

In her *Catalysis* series (1970), Adrian Piper aggressively exacerbated the effects of her racial and sexual difference by imposing herself on the social environment. Carrying tape-recorded burps with her to the library, blowing gum bubbles and leaving the gum stuck to her face, wearing clothing smeared with rancid butter, dried food, or wet paint in stores, subways, and other public places, Piper enacted the fear and repulsion her blackness engenders in Anglo culture, particularly because it is hardly visible (she could "pass" as white): "I am the racist's nightmare, the obscenity of miscegenation. I am . . . a living embodiment of sexual desire that penetrates racial barriers and reproduces itself. . . ."[52]

In *Some Reflective Surfaces,* first performed in 1975, Piper confused her identity through a performative construction of herself in whiteface with a debonair moustache penciled onto her upper lip. In one part of this performance, Piper's "white man," marked out through the title as a "reflection" of what the gaze desires her to be rather than an actual "self," sat in front of a film showing the black female Piper dancing with friends to the tune of Aretha Franklin's "Respect." A male voice-over gave commands to "trim the legwork," "loosen up," and so on.[53] Piper's assumption of a body alternatively sexed and gendered forced her audience to experience her simultaneously as a white man, "present" to them through "his" body, and a black woman, "present" only in representation and directed by the voice of a male authority. It is both her invocation of racial and sexual identities and her physical participation in this self-construction, where she splits apart the ontological subject (supposedly fully "present") and the subject in representation, that serve to trouble Mulveyan models of sexual difference. Not only a "female man," in this piece she also insisted on being an Anglo African-American.

In a series of posters produced in 1975, Piper poses as what she calls the "Mythic Being," a black man with afro and penciled-on moustache.

In these images she insists on embodying the mythologized figure most feared by mainstream Anglo society. In one poster, in which Piper depicts herself as the "Mythic Being" next to the caption "I EMBODY EVERYTHING YOU MOST HATE AND FEAR," Piper again aggressively asserts an identity that is not simply articulated along the poles of male/female through the agency of the gaze, but is articulated against the grain of this gender- and vision-bound model—hence its threatening mode. Piper insists on bringing out into the open what is "hated and feared" through her own body—female and, in visual terms, ambiguously raced.

Piper's project, in its complication of the politics of postfeminist theory, enables me to formulate some closing remarks. I have argued that feminist body art dislocates the "gaze/look compound" of Mulvey's model through its performative and highly sexualized formulations. In its encouragement of spectatorial pleasures and re-embodiment of female subjectivity, feminism, and feminist art and theory, feminist body art exposes the falsely unifying claims of postfeminist discourses, with their exclusionary construction of a straight, white, upper-middle-class, contemporary postfeminist subject. The dissolution of this mythically unified postfeminist, with multifariously raced, sexed, and classed female subjects articulated in her place, radically confuses the postfeminist system, allowing for the production of a new stage for feminism and feminist theory that is empowered if self-critical, rather than "post."[54] Feminist body art, with its embodiment of artistic production and its complex intersubjective and erotic effects, encourages feminist art discourse to open itself in an empowering way to multiplicities of feminist desire and authorial subjectivity.

Notes

1. This essay is a revised version of a lecture given for the Foundation for Art Resources, Los Angeles, in April 1992. Earlier versions of the first portion of this essay appeared in the following forms: "PostFeminism—A Remasculinization of Culture?" *M/E/A/N/I/N/G* 7 (1990), 29–40; "Feminism, Incorporated: Reading 'Postfeminism' in an Anti-Feminist Age," *Afterimage* 20, n. 5 (December 1992), 10–15.
2. Susan Faludi, *Backlash: The Undeclared War Against Women* (New York: Crown Publishers, 1991).
3. See Ruth Rosen's "Column left/'Family Values' Is a GOP Code for Meanness," *Los Angeles Times,* April 21, 1992, B7.
4. This includes the following issues of *Time* magazine: "Women: The Road Ahead," *Time* special issue, Fall 1990; " 'Women Face the '90s,' In the '80s they tried to have it all. Now they've just plain had it. Is there a future for feminism?," *Time* December 4, 1989; "Why Are Men and Women Different? If it isn't just upbringing. New studies show they are born that way," *Time* January 20, 1992; "Why Roe v. Wade Is Already Moot," *Time,* May 4, 1992. For

a slightly more profeminist note, see "Fighting the Backlash Against Feminism: Susan Faludi and Gloria Steinem Sound the Call to Arms," *Time,* March 9, 1992. See also Sally Quinn's strikingly antifeminist editorial, "Feminists Have Killed Feminism," *Los Angeles Times,* January 23, 1992, B7.

5. The issue includes a critical examination of 1980s antifeminism by Barbara Ehrenreich, "Sorry, Sisters, This Is Not the Revolution," *Time,* "Women: The Road Ahead," special issue, Fall 1990, 15.

6. The cover image, which features a crudely carved wooden sculpture of a woman in a business suit clutching a baby and a briefcase, was created for *Time* by the feminist artist Marisol. Purchasing the skills of an artist whose work is usually identified as exemplary of 1960s and early 1970s feminist art, the magazine recontextualizes her piece into an icon of postfeminism.

7. Claudia Wallis, "Onward, Women," *Time,* December 4, 1989, 80–82, 85–86, 89.

8. I discuss the remasculinizing operations of recent Hollywood films in my article " 'She Was Bad News': Male Paranoia and the Contemporary New Woman," *Camera Obscura* 25–26 (January–May 1991), 297–320.

9. Robert Bly, *Iron John: A Book About Men* (Reading, Mass.: Addison-Wesley, 1990). These phrases come from the titles of popular-press essays on the "postfeminist male"; see the issue "Drums, Sweat and Tears: What Do Men Really Want? Now They Have a Movement of Their Own," *Newsweek,* June 24, 1991, including the article "Heeding the Call of the Drums: All over America, the ancient, primal art of drumming is helping men find a voice of their own" (52–53); and the special issue of *Esquire* entitled "Wild Men and Wimps," October 1991.

10. See Janice Castro, "Get Set: Here They Come! The 21st century work force is taking shape now. And guess what? White, U.S.-born men are a minority. . . . ," *Time,* "Women: The Road Ahead," special issue, Fall 1990, 50–51.

11. As Russell Ferguson has argued, the "need to enforce values which are at the same time alleged to be 'natural' demonstrates the insecurity of a center which could at one time take its own power much more for granted"; in "Introduction: Invisible Center," *Out There: Marginalization and Contemporary Cultures,* ed. Russell Ferguson, Martha Gever, Trinh T. Minh-ha, Cornel West (New York: New Museum of Contemporary Art and Cambridge & London: MIT Press, 1990), 10.

12. I discuss this hegemonic postmodernism and its attendant modes of exclusionism at length in my book, *Postmodernism and the En-Gendering of Marcel Duchamp,* forthcoming from Cambridge University Press.

13. Thus Fredric Jameson conflates feminism with minority civil rights movements and other specific protests as merely a "jargon" or pose taken up as a means of empowerment. Per Jameson, feminism is an example of the "stupendous proliferation of social codes today into professional and disciplinary jargons, but also into the badges of ethnic, race, religious, and class-refraction adhesion." In "Postmodernism or the Cultural Logic of Late Capitalism," *New Left Review* 46 (July–August 1984), 65.

14. As in Laura Mulvey's article, "Dialogue with Spectatorship: Barbara Kruger and Victor Burgin" (1983), in her book *Visual and Other Pleasures* (Bloomington and Indianapolis: Indiana University Press, 1989); see 134.

15. Mira Schor introduces this notion of "aesthetic terrorism" in "Figure/Ground," *M/E/A/N/I/N/G* 6 (1989), 18.

16. Craig Owens, "The Discourse of Others: Feminists and Postmodernism," *The Anti-Aesthetic: Essays on Postmodern Culture,* ed. Hal Foster (Port Townsend, Wash.: Bay Press, 1983), 62, 59, 64. There are many feminist cultural theorists who have examined the feminism/postmodernism intersection in ways that are more sensitive to the specificities of feminist theory. See, for example, Janet Lee, "Care to Join Me in an Upwardly Mobile

Tango? Postmodernism and the 'New Woman,' " and Shelagh Young, "Feminism and the Politics of Power: Whose Gaze Is It Anyway," in *The Female Gaze: Women as Viewers of Popular Culture,* ed. Lorraine Gamman and Margaret Marshment (Seattle: Real Comet Press, 1989), 166–72, 173–88; Susan Suleiman, "Feminism and Postmodernism: In Lieu of an Ending," *Subversive Intent: Gender, Politics, and the Avant-Garde* (Cambridge, Mass.: Harvard University Press, 1990), 181–205; and the essays collected in *Feminism/Postmodernism,* ed. Linda Nicholson (New York: Routledge, 1990).

17. Tania Modleski, *Feminism without Women: Culture and Criticism in a "Postfeminist" Age* (New York and London: Routledge, 1991), 3. This confusion, as I have argued in my book *Postmodernism and the En-Gendering of Marcel Duchamp* (see 21–28), takes place in discourses of postmodernism through the appropriation of the notion of the disruptive feminine developed by French feminists such as Julia Kristeva and Hélène Cixous. Conflating the disruptive feminine with femin*ism,* postmodern theorists then radicalize particular art practices as undermining the phallocentric subject perceived as central to modernist ideologies of artistic genius; by extension, they also radicalize themselves, confirming their critical authority.

18. Dan Cameron, "Post-feminism," *Flashart,* no. 132 (February/March 1987): 80–83.

19. Richard Woodward, "It's Art, but Is It Photography?" *New York Times Magazine,* October 9, 1988, 31.

20. Donald Kuspit, "Inside Cindy Sherman," *The New Subjectivism: Art in the 1980s* (Ann Arbor: University of Michigan Press, 1988), 395.

21. Luce Irigaray, "The Blind Spot of an Old Dream of Symmetry," *Speculum of the Other Woman,* trans. Gillian C. Gill (Ithaca, N.Y.: Cornell University Press, 1985), 21, 22.

22. As in Hal Foster's argument opposing "neoconservative" postmodernism to a radically avant-garde "poststructuralist" postmodernism; Hal Foster, "(Post)Modern Polemics," *Recodings: Art, Spectacle, Cultural Politics* (Seattle: Bay Press, 1985), 121–38.

23. Isaac Julien, a filmmaker best known for his experimental films on black identities and homosexual pleasure, discusses the politics of the prohibition of pleasure in avant-gardist theory: "On the left of avant-gardism is pleasure, which the avant-garde itself denies, clinging to the purism of its constructed ethics, measuring itself against a refusal to indulge in narrative or emotions and, indeed, in some cases, refusing representation itself, because all these systems of signs are fixed, entrenched in the 'sin or evil' of representation. The high moral tone of this discourse is based on a kind of masochistic self-censorship." Isaac Julien quoted in Manthia Diawara, "Black Studies, Cultural Studies: Performative Acts," *Afterimage* 20, no. 3 (October 1992): 6. See also Roland Barthes' discussion of the effects of this disdain of pleasure by the left, in *The Pleasure of the Text* (1973), trans. Richard Miller (New York: Hill & Wang, 1975), 22–23.

24. Griselda Pollock, "Screening the Seventies: Sexuality and Representation in Feminist Practice—a Brechtian Perspective," *Vision and Difference: Femininity, Feminism and the Histories of Art* (London and New York: Routledge, 1988), 163.

25. Laura Mulvey, "Visual Pleasure and Narrative Cinema," in *Visual and Other Pleasures,* 16.

26. Laura Mulvey, "Impending Time: Mary Kelly's *Corpus,"* in *Visual and Other Pleasures,* 149.

27. Pierre Bourdieu, *Distinction: A Social Critique of the Judgement of Taste,* trans. Richard Nice (Cambridge, Mass.: Harvard University Press, 1984), 489, 490, 491.

28. See, for example, Klaus Theweleit's brilliant study of the texts of male fascist writers, in which, he argues, women are conflated with the masses as threatening to masculinity: *Male Fantasies,* 2 vols., trans. Stephen Conway, Erica Carter, Chris Turner (Minneapolis: University of Minnesota Press, 1987, 1989).

29. Jean Baudrillard, *Seduction,* trans. Brian Singer (New York: St. Martin's Press, 1990), 180. Andreas Huyssen discusses at length this link between mass culture and femininity in modern Western culture, citing several examples from Nietzsche's work, in "Mass Culture as

Woman: Modernism's Other," *After the Great Divide: Modernism, Mass Culture, Postmodernism* (Bloomington: Indiana University Press, 1986), 44–62.

30. Luce Irigaray, "Così Fan Tutte," *This Sex Which is Not One,* trans. Catherine Porter with Carolyn Burke (Ithaca, N.Y.: Cornell University Press, 1985), 90. See also Johanna Drucker's article "Visual Pleasure: A Feminist Perspective," *M/E/A/N/I/N/G* 11 (May 1992), 3–11.

31. Emily Apter, "Fetishism and Visual Seduction in Mary Kelly's *Interim,"* *October* 58 (Fall 1991): 97, 101.

32. Michael Fried's well-known polemic against minimalism makes evident that artistic performativity itself epitomizes a shift in modes of production and reception that is highly threatening to the masculinist critic; see his "Art and Objecthood" (1967), in *Minimal Art: A Critical Anthology,* ed. Gregory Battcock (New York: E.P. Dutton, 1968), 116–47.

33. Eleanor Antin, "An Autobiography of the Artist as Autobiographer," *The LAICA* [*Los Angeles Institute of Contemporary Art*] *Journal,* no. 2 (October 1974): 18. Antin, like artists Martha Wilson, Linda Montano, and those discussed below, focuses on self-reconstruction in her performative work, taking on various masks and alternative personae to perform her authorial subjectivity as multiply identified. See Lucy Lippard's discussion of this self-performative orientation in "The Pains and Pleasures of Rebirth: European and American Women's Body Art," *From the Center: Feminist Essays on Women's Art* (New York: E.P. Dutton, 1976), 121–38.

34. Carolee Schneemann, *More Than Meat Joy: Complete Performance Works and Selected Writings,* ed. Bruce McPherson (New Paltz, N.Y.: Documentext, 1979), 194; this book includes illustrations of the performances I discuss here.

35. *Ibid.,* 52; see also her description of the piece and its relationship to "shamanic ritual" in her interview with Andrea Juno, in *Angry Women,* ed. Andrea Juno and V. Vale (San Francisco: Re/Search Publications, 1991), 68; and Henry Sayre's analysis in *The Object of Performance: The American Avant-Garde since 1970* (Chicago: University of Chicago Press, 1989), 74.

36. Schneemann, *More Than Meat Joy,* 234. Here Schneemann describes the two versions: the first took place in 1975 at "Women Here and Now" in East Hampton, Long Island, New York; the second, in 1977 at the Telluride Film Festival in Colorado. The mud employed in the second version was taken from a stream near Telluride.

37. *Ibid.,* 238. The audience for its original performance was almost all female; see Moira Roth, "The Amazing Decade," *The Amazing Decade: Women and Performance Art in America, 1970–1980,* ed. Moira Roth (Los Angeles: Astro Artz, 1983), 14.

38. The first poetic descriptions in this sentence are from a letter sent to me by Schneemann, dated November 22, 1992, encouraging me to revise my earlier, more blunt readings of her work; swayed by her powerful self-readings, I have done this in places. The term "translucent chamber" appears in *More Than Meat Joy,* 234.

39. Schneemann, *Angry Women,* 72, 69.

40. Schneemann, *More Than Meat Joy,* 194.

41. Parveen Adams, "Per Os," *Camera Obscura* 17 (May 1988): 17, 18.

42. For illustrations of this and other images by Wilke, see Joanna Frueh, *Hannah Wilke: A Retrospective,* ed. Thomas Kochheiser (Columbia, Mo.: University of Missouri Press, 1989). Wilke has said that she made this poster—after a group of women asked her to produce a statement related to the question "What is feminism and what can it become?"—because "I felt feminism could easily become fascistic if people believe that feminism is only *their* kind of feminism, and not my kind of feminism . . . real feminism does not judge. . . ." From the interview, "Artist Hannah Wilke talks with ernst," *Oasis de Neon* 1, no. 1 (1978): n.p.

43. Wilke has stated, "I choose gum because it's the perfect metaphor for the American woman—chew her up, get what you want out of her, throw her out and pop in a new piece." Quoted in Avis Berman, "A Decade of Progress, But Could a Female Chardin Make a

Living?" *ArtNews* 79, no. 8 (October 1980): 77, cited by Frueh, *Hannah Wilke*, 73. The labial lumps have become signature forms for Wilke, who has produced numerous pieces with gum or kneaded eraser wads on paper and larger clay versions of these suggestive folded shapes.

44. "Artist Hannah Wilke talks with ernst," n.p.
45. Wilke had a short film (with the same title) and a video documentary, *Philly,* made of this performance; Hans-Christof Stenzel also filmed it for a fictionalized movie on Duchamp *(C'est la Vie Rrose)* shown on German television in 1976. See Frueh, *Hannah Wilke,* 35, 170.
46. For illustrations of Benglis's various performative photographs see Susan Krane, *Lynda Benglis: Dual Natures* (Atlanta: High Museum, 1991).
47. Sue Ellen Case, "Tracking the Vampire," *Differences* 3, no. 2 (Summer 1991): 12, 13. While Case's argument aims at replacing the "perturbations in this discourse" put into play by the specifically lesbian subject, it is extremely useful for my argument here because it takes issue with the now canonical models of feminist theory adopted to discuss representations of and by women. Because I interpret feminist body art as troubling conventional notions of sexual difference, Case's antiheterosexist model is valuable in understanding these works' polymorphous sexual effects. My appropriation of her model is motivated by a conviction that queer theory, along with third world feminism, are currently the most active agents in breaking down the binary models of subjectivity informing postfeminist constructions of feminism, where difference is determined to be purely heterosexual and ostensibly nonraced and nonclassed.
48. According to Susan Krane, this spread was entirely Benglis's idea—she rejected the magazine's offer to include it as part of an article on her work and paid for the advertisement herself; Krane, *Lynda Benglis,* 41.
49. As Mira Schor describes Morris's gesture, "decorously, he is shot from the waist up and for good measure you can spot his BVDs waistband at the bottom edge of the photograph." Mira Schor, "Representations of the Penis," *M/E/A/N/I/N/G* 4 (November 1988), 9. According to Susan Krane, Morris accompanied Benglis to buy the dildo Benglis used in her piece and the two artists posed with it in a group of staged Polaroids. Krane, *Lynda Benglis,* 42; Morris's poster, which advertises an exhibition at Castelli-Sonnabend Gallery in April 1974, is reproduced on page 40.
50. *Artforum,* 13, no. 4 (December 1974): 9. Of the editors, only Peter Plagens, from the West Coast, got the joke, publishing a facetious letter in the same issue calling Benglis a "shameless hussy."
51. Michael Warner, "Homo-Narcissism," *Engendering Men: The Question of Male Feminist Criticism,* ed. Joseph Boone and Michael Cadden (New York and London: Routledge, 1990), 200.
52. Adrian Piper, "Flying," in *Adrian Piper: Reflections 1967–1987,* catalogue of exhibition curated by Jan Farver (New York: Alternative Museum, 1987), 23.
53. See the description of this performance in Moira Roth, ed., *The Amazing Decade,* 122.
54. For a provocative discussion of how this might take place, see Chela Sandoval, "U.S. Third World Feminism: The Theory and Method of Oppositional Consciousness," *Genders* 10 (Spring 1991), 10–24.

PATRILINEAGE

Mira Schor

Artists working today, particularly those who have come of age since 1970, belong to the first generation that can claim artistic matrilineage, in addition to the patrilineage that must be understood as a given in a patriarchal culture.

The past two decades have seen systematic research and critical analysis of work by women artists, beginning with the goal of recalling them from obscurity and misattribution, inserting such artists into an already constituted, "universal"—white male—art history, and, more recently, focusing on a critique of the discipline of art history itself. A second historical and critical system has grown in critical relation to the first, as well as a substantial body of significant work by women artists contemporaneous with this rethinking of the gender of art discourse. Even if insertion into a predetermined system is no longer an unqualified goal, communication between systems remains unsatisfactory, incomplete.

One indicator of this separate but unequal system and the lack of communication between systems of discourse and art practice is the degree to which, despite the historical, critical, and creative practice of women artists, art historians, and cultural critics, current canon formation is still based on male forebears, even when contemporary women artists—even contemporary feminist artists—are involved. Works by

women whose paternity can be established and whose work can safely be assimilated into art discourse are privileged, and every effort is made to assure this patrilineage.

In a sense it is simply stating the obvious that legitimation is through the father. It must be noted that in this historical moment, some fathers are better than others. Optimal patrilineage is a perceived relationship to such mega-fathers as Marcel Duchamp, Andy Warhol, Joseph Beuys, and mega-sons such as Jasper Johns and Robert Rauschenberg. Irony, coolness, detachment, and criticality are favored genetic markers. Picasso is not a favored father in our time, and no one attempting to establish patrilineage would claim more "feminine" fathers—Bonnard or even Matisse fall into this gendered category. The mega-fathers for the 1960s, 1970s, and 1980s have tended not to be painters; Johns is the exception to this, but his insertion of found objects into his paintings and his iconography of cultural emblems assures his patrilineage to Duchamp.

Legitimation is also found through the invocation of the names of a particular group of authors: six Bs spring to mind—Baudelaire, Benjamin, Brecht, Beckett, Barthes, and Baudrillard. Jacques Derrida, Sigmund Freud, Michel Foucault, and Jacques Lacan are other frequent sires for the purposes of art historical legitimation. The preponderance of thin lips and aquiline profiles among these gentlemen suggests a holdover of Victorian ideas about phrenology. The game is still afoot for Sherlock Holmes, apparently the prototypical mega-father.

To fully analyze the persistence of patrilineage, one would have to develop a methodology to study a vast number of contemporary artists, male and female, white and nonwhite, straight and gay, exhibiting and being written about, to trace their artistic family trees, and then read through critical texts to see how their work is referenced to male or female artists and authors. Further controls would establish how various male and female authors undertake this process of legitimation via referencing.

This is a daunting project and not one that I can at present undertake. This essay can only offer a scattershot of incidences of patrilineal legitimation, and raise questions about matrilineage within contemporary art practice, critical discourse, and teaching. I will examine texts from several stages of career construction: the exhibition review, the art magazine feature article, the catalogue essay, and the essay anthology. The scope of my examples is by necessity limited, considering the seemingly infinite applicability of the system of patrilineal validation at issue.

The exhibition review is one of the most basic, routine, preliminary elements in canon formation. Reviews at the back of the major, mainstream, international art magazines are generally short texts that usually

refer to at least one other artist or author to offer context and validation to the artist being considered. Almost without exception men are always referenced to men; with few exceptions, women artists are also referenced to men. Such references do not usually involve serious efforts at comparison and analysis but rather function as subliminal mentions. Just the appearance of the name of the sire on the same page as that of the artist under discussion serves the purpose of legitimation, even if it is in a sentence that begins "Unlike . . ." Examples proliferate. One can start and end anywhere, anytime. An *Artscribe* review by Claudia Hart of Louise Lawler's work notes the number of "refined colour photographs of culturally mythological paintings—a Jasper Johns flag, drips by Pollock, a Miro. . . . Her mock displays nevertheless set up a mannered Borgesian labyrinth." Her work is then related to that of Dan Graham, and of course, Duchamp.[1] An *Artforum* review by Charles Hagen of Rebecca Purdum's work references her to J. M. W. Turner, Claude Monet, and Henry Moore, while one by Lois E. Nesbitt of the painter Judy Ledgerwood's work references her to Mark Rothko, Johns, Peter Halley, and, finally, to April Gornik, although a reference to Purdum seems called for by Ledgerwood's hazy, painterly surface.[2]

Women artists are rarely legitimating references for male artists—or should one say that women artists are rarely legitimated by the mention of their work in the contextualization of a male artist, even when significant visual and iconographic elements link a male artist's work to that of a female forebear or contemporary. For example, an *Artforum* review of a Robert Morris exhibition, written by Donald Kuspit, discusses the eroticism and spirituality of a work such as *House of the Vetti* (1983), described by the curator Pepe Karmel as "a central slit enclosed by narrow labial folds of pink felt."[3] Kuspit fails to note the obvious reference by both Morris and Karmel to the multitude of "labial" works done by women artists in the 1970s that preceded and informed this work by Morris. The description of the work and the work itself, reproduced with the review, particularly recall the work of Hannah Wilke.

Feature articles in the major art publications also yield a preponderance of references to fathers. A February 1990 *Artforum* feature article by Christopher Lyons on Kiki Smith is a case in point. Smith's work, as Lyons immediately notes, is very much about the body, representing inner organs, "humors," egg and sperm, flayed skin, tongues, and hands. It is often made out of materials such as rice paper or glass, whose delicacy is a metaphor for the fragility of the living body. Smith is of the first generation of artists whose education could have included an awareness of art by women and of issues of gender and the role of the body in

gender discussion. Her works on rice paper particularly recall the work of Nancy Spero, while certain other works recall Eva Hesse. Lyons seems aware of the problematics of tradition. He begins his article by stating that "much celebrated art comes at the end of a tradition, and is recognized in terms defined by it. But certain artists appear to rediscover, under the pressure of new conditions, a lost or buried concern. . . . Smith's is a timely subject—the body has become a political battleground, as the various organs of social control figure over it." He does not, however, define what these "new conditions" are or what the nature of the "political battleground" might be, although the feminist component of these questions appears obvious.

Instead, Smith is almost instantly given a mega-patrilineage: "The concept of self-empowerment, *Selbstverwaltung,* at the heart of Joseph Beuys' political activity is also, in a quieter way, a goal of Smith's emblematic employment of the body's elements." Note that Smith's way is "quieter," i.e., more feminine. This daughterhood (the term implies both relationship to a parent and good, filial behavior) is reinforced three paragraphs later when Smith's actual patrilineage is invoked; her father, the sculptor Tony Smith, is mentioned. Once Smith's patrilineage is safely (and doubly) established, Lyons briefly mentions that Smith follows "the path of Nancy Spero rather than Andy Warhol."

Catalogues by curators deeply involved with trend setting and career production also reveal a view of art history and lineage remarkably untouched by developments in feminist art and analysis. *Pre/Pop Post/Appropriation* is the exhibition catalogue by Tricia Collins and Richard Milazzo for a show they curated at the Stux Gallery in New York in November 1989.[4] In this exhibition the younger artists showcased by Collins and Milazzo and Stux—Annette Lemieux, the Starn Twins, and Nancy Shaver, among others—are given historical context and legitimacy by the inclusion in the show of works by Rauschenberg and Johns. The catalogue goes further, listing, in elegant boldface italic headings, Cézanne, Duchamp ("and the Meta-Game of Desire"), Rauschenberg, and Johns. Despite frequent references to the "Body," and "Desire" (as in "The 'Body,' 'originally' coded for desire, is frozen in Cézanne, and meta-conceptualized and meta-eroticized in Duchamp"[5]), the catalogue essay betrays no awareness of the vast amount of available materials on sophisticated theorization of the body in works by artists such as Mary Kelly or philosophers such as Luce Irigaray. The contextualization system of legitimation is extended to the statements on each individual artist. The men are of course referenced to men (the Starn Twins to "Rembrandt, Picasso and the Mona Lisa"). And so are the women. "The

'Body' has always figured prominently in Suzan Etkin's work." In her early work, a "process of objectification had to do with reclaiming her own body as a woman, and historically, repossessing the body of the Woman as an object of desire, on a symbolic level, not only from the male artist in general, but specifically, from an artist whose work she, in fact, still very much admired: Yves Klein."[6] Does one need to be reminded at this juncture of Klein's piece in which naked women, covered in pigment, rolled around a piece of paper on the floor in front of bemused onlookers?

Holt Quentel's "world literally sewn, patched together, willfully, intentionally; torn and then stitched back together; then worn away" is the world of the other male artists in the exhibition. But what of quilts by women, which gained legitimacy as aesthetic artifacts through the agency of the feminist art movement? What of Sonia Delaunay? What of Lee Bontecou? Betsy Ross does get a mention in the section on Lemieux, but Lemieux's use of autobiography, female anonymous biography, receives no other historical context than that of modernism and postmodernism.

Meg Webster's "concrete effort to reassert immediacy in the work of art, to bring (back) to consciousness the radical content and process of Nature, and to reassign Value to the element itself" is referenced in this catalogue and in an individual show catalogue by Collins and Milazzo (Scott Hanson Gallery, January 1990) to Rauschenberg, Ross Bleckner, and Robert Gober. Ana Mendieta, Michelle Stuart, Nancy Holt, Alice Aycock, and the many women artists represented in Lucy Lippard's *Overlay* who use earth to work on the concept of Nature have been occulted by the exclusivity of Collins and Milazzo's use of patrilineage to further their system of art-star production.

Critics and dealers may prefer to legitimate women artists whose very real self-referencing to male artists make it possible for them to be inserted and then re-subsumed to patriarchy. Clearly, all women are inculcated with patriarchal values and all women artists are taught about a male art history. Clearly, many women artists participate in the perpetuation of patrilineage by consciously associating their work with that of male forbears. Why link one's work and career to a weaker, less prestigious line? It seems likely that male critics in particular choose to write about women artists who conform best to this system. But this generation of artists, critics, and curators cannot pretend that there have been no women artists or writers. And yet, the elision of women is so seamless that, reading through a Collins and Milazzo catalogue essay or an *Artforum* review, one forgets that there *are* women.

This seamless persistence of patrilineage is most frustrating at the intersection of postmodernist and feminist discourse. *Art After Modern-*

ism: Rethinking Representation, edited by Brian Wallis, is an anthology positioned at just this intersection.[7] In the front of the book, the contents lists essays by Rosalind Krauss, Abigail Solomon-Godeau, Mary Kelly, Lucy Lippard, Laura Mulvey, Constance Penley, Kate Linker, and Kathy Acker (nine out of the twenty-four authors). But in the back of the book, the index reveals a pattern of referencing consistent with patrilineage. The index references at least eighty-three male visual artists, writers, and critics, with multiple page references to Duchamp, Warhol, Adorno, Baudelaire, Benjamin, and Brecht. Twenty-seven women are referenced; of these, fewer are writers and theorists, and the overall number of page references is smaller. This survey is unscientific but reveals something of the underlying persistence of male referencing in the process of art historical construction.

Perhaps most disturbing is the use of patrilineal legitimation in noteworthy feminist texts, such as Griselda Pollock's *Vision and Difference,* one of the most substantial exercises in feminist revision of art historical practice. Her essay "Screening the Seventies: Sexuality and Representation in Feminist Practice—A Brechtian Perspective" reveals its basic reliance on patrilineage in its title. Pollock charmingly begins one early section of the essay by saying, "I want to start with boys,"[8] but in fact she never ends her use of the "boys." In order to position artists such as Silvia Kolbowski, Barbara Kruger, Sherrie Levine, Yve Lomax, Marie Yates, and, principally, Mary Kelly at the forefront of a critical avant-garde, Pollock rates their success in effectively intervening in patriarchal systems of representation by the degree of their adherence to Brechtian principles of "distanciation," as formulated by Brecht and promoted by Peter Wollen and Stephen Heath (the latter two in essays in *Screen* magazine).

Pollock first outlines the Brechtian program and its scripto-visual practices and techniques, then repeatedly inscribes Kelly's work into this context:

> While the major but not exclusive theoretical framework of the *PPD* [*Post Partum Document*] was a revision of the psychoanalytical schemata of Lacan, the representational strategies were informed by the Brechtian uses of montage, texts, objects in a sequence of sections. . . .
> Although the *PPD* was produced within the spaces and discourses of the visual arts, its procedures echo Brecht's almost cinematic conception of the interplay of text, image, object. . . . The *PPD* fulfills Wollen's projection of a complex work of art confronting not Woman or women but the underlying mechanisms which produce the sexual discourses within which women are positioned in contemporary western patriarchal societies. . . . But in terms of artistic

practice the questions of subjectivity and sexual difference need to be developed in relation to Brechtian strategies and their political priorities.[9]

The usefulness of Brechtian strategies to intervene in patriarchal representation should not, however, vitiate at least some discussion on the ambiguities and ironies of relying so heavily on a male system to validate a feminist practice. In this significant example of feminist avant-garde canon formation, the woman artist is still subsumed to her mega-father.

These samplings from the published material of mainstream art culture turn one into a de factor Guerrilla Girl: there are so few features on women artists, so few reviews—and those are so often placed farther back in the review sections—so few references to women artists, writers, and theorists. Hence the significance of a 1989 Guerrilla Girls poster listing all the works by women artists that could be purchased for the price of one Jasper Johns. There *are* mothers. Matrilineage and sorority, though constantly re-occulted by patriarchy, exist now as systems of influence and ideology. In addition to the wealth of fathers, which no sane woman could deny, as a painter and a critic I place myself in a matrilineage and a sisterhood: Frida Kahlo, Charlotte Salomon, Florine Stettheimer, Miriam Schapiro, Pat Steir, Ida Applebroog, Elizabeth Murray, Ana Mendieta, Louise Bourgeois, Charlotte Brontë, Jane Austen, Louisa May Alcott, Emily Carr, Luce Irigaray, Griselda Pollock, Mary Kelly, Simone de Beauvoir, Simone Weil—all artists and writers whose works have influenced, informed, and, perhaps most important, challenged my visual and critical practice.[10] That my resistance is the male art system is by now a vestigial cliché; I am most challenged by resistance within the present of feminist thought. To hone one's critical understanding by a vigorous debate with other women offers more hope for a revitalized art discourse than does the endless reinscription of a stale patrilineal system.

All studio-art and art-history students should know the names listed on the Guerrilla Girls poster. They should be aware of the multiplicity of feminist art history, practice, and theory. If there is a resolution or a solution to the persistence of patrilineage, it must be at the level of education. At the end of a semester survey course on the history of women artists one student, an art history major, asked, "Why do we have to have this course? Why didn't we learn about these artists and these issues before?"

Why indeed? Feminist art programs and women's art history courses had barely developed and been reinforced with a minimum of slides when the rightist backlash of the Reagan years intervened, cutting funds, at-

WHEN RACISM & SEXISM ARE NO LONGER FASHIONABLE, WHAT WILL YOUR ART COLLECTION BE WORTH?

The art market won't bestow mega-buck prices on the work of a few white males forever. For the 17.7 million you just spent on a single Jasper Johns painting, you could have bought at least one work by all of these women and artists of color:

Bernice Abbott	Elaine de Kooning	Dorothea Lange	Sarah Peale
Anni Albers	Lavinia Fontana	Marie Laurencin	Ljubova Popova
Sofonisba Anguisolla	Meta Warwick Fuller	Edmonia Lewis	Olga Rosanova
Diane Arbus	Artemisia Gentileschi	Judith Leyster	Nellie Mae Rowe
Vanessa Bell	Marguérite Gérard	Barbara Longhi	Rachel Ruysch
Isabel Bishop	Natalia Goncharova	Dora Maar	Kay Sage
Rosa Bonheur	Kate Greenaway	Lee Miller	Augusta Savage
Elizabeth Bougereau	Barbara Hepworth	Lisette Model	Vavara Stepanova
Margaret Bourke-White	Eva Hesse	Paula Modersohn-Becker	Florine Stettheimer
Romaine Brooks	Hannah Hoch	Tina Modotti	Sophie Taeuber-Arp
Julia Margaret Cameron	Anna Huntingoon	Berthe Morisot	Alma Thomas
Emily Carr	May Howard Jackson	Grandma Moses	Marietta Robusti Tintoretto
Rosalba Carriera	Frida Kahlo	Gabriele Münter	Suzanne Valadon
Mary Cassatt	Angelica Kauffmann	Alice Neel	Remedios Varo
Constance Marie Charpentier	Hilma af Klimt	Louise Nevelson	Elizabeth Vigée Le Brun
Imogen Cunningham	Kathe Kollwitz	Georgia O'Keeffe	Laura Wheeling Waring
Sonia Delaunay	Lee Krasner	Meret Oppenheim	

Information courtesy of Christie's, Sotheby's, Mayer's International Auction Records and Leonard's Annual Price Index of Auctions.

Please send $ and comments to: **GUERRILLA GIRLS** CONSCIENCE OF THE ART WORLD
Box 1056 Cooper Sta. NY, NY 10276

Guerrilla Girls untitled poster, 1989, 17" × 22"

tacking the ideal of affirmative action. In the art world, movements based on process, concept, and performance—not linked to the market—were replaced by art movements based on critiques, often collaborationist, of capitalism. Schools followed, or rather slipped back. Curricula lost courses on women; women faculty lost energy for teaching such courses. Slides of works by women artists were lost. Most art schools do not provide enough information on women artists, and what little material they do offer is often without a pedagogic and theoretical framework. Combined with the patrilineal tendencies of art writing and canon formation noted in this essay, the art student, female or male, has few tools for disrupting patrilineage.

To cause such a disruption is not a question of creating a Marceline Duchamp: it is exactly the opposite. The end-game of postmodernism turns on the eternal ritual killing and resurrection of a limited type of father. Other models might provide a path to a new art history and a different system of validation and legitimation. And maybe some bastards and orphaned daughters (and the entire third world) could find homes and genetic placement.

Postscript: Summer 1992

In researching and writing "Patrilineage" in the winter of 1990, I noted that "the scope of my examples" was "by necessity limited, given the seemingly infinite applicability of the system of patrilineal validation." I did not anticipate that this applicability was not only lateral in terms of the examples available to me at that particular moment, but also vertical in terms of consistent applicability into the future. Rather than radically interfere with the original text of the essay for the purposes of republication, I offer some afterthoughts and consider some more recent instances of patrilineage. Selecting a few examples among many candidates, I perversely feel a scientist's delight that my thesis still holds true, yet profound frustration that naming the syndrome has not effected a cure for it.

In writing this postscript, I benefit from criticism leveled at the original essay, particularly that I did not offer enough of an alternative to what seems like such an insidiously persistent art historical mechanism. The instances of patrilineal validation addressed here in examples of the critical reception of works by Karen Finley, Janine Antoni, and Sue Williams articulate the absurdity and pathos of this mechanism when it is applied to clearly gender-oriented, feminist works. Also, precisely by pointing to the, at the very least, unconscious complicity of some women artists, these examples raise the possibility of methods for averting it.

Looking back on the eighties, some women artists used assaultive or flamboyant behavior or "transgressed" via their appropriation of pornography, often by the exploitation of their own bodies, in works that claimed or were claimed to occupy an ideologically oppositional position to works by artists such as Eric Fischl or David Salle, thereby achieving a similar, although not quite so lucrative, notoriety. Were these "bad girls" rewriting patriarchal representations of women and recuperating them with subversive feminist intent, or were they just "bad boys" with estrogen, replicating age-old exploitation of the female body? Works such as Cindy Sherman's self-portrait in a clinging T-shirt (*Untitled #86, 1981*) or low-cut camisole (*Untitled #103, 1982*) certainly strained acceptance of the supposedly ironic, critical stance her work was credited with. Some women have also felt ambivalent about performance works by Karen Finley. The frightening conviction she brought to her invocation of a rapist hinted at a genuine—albeit unintentional—rather than simulated hatred of women.

Regardless of what one thinks about these artists' works, it is an art-historical fact that this type of controversy over the problematic of self-exploitation by a woman artist has occurred before. In the 1970s, women argued and *worried about* the political wisdom and the potentially negative repercussions of Lynda Benglis's 1974 *Artforum* exhibition ad in which she presented herself naked, wearing only sunglasses, and holding in her crotch a double dildo as if it were a huge phallus of her own; Hannah Wilke's photographs of her body as an installation site for her little vaginal sculpted forms; or Carolee Schneemann's performances involving the active use of her naked body and sexual orifices. It is also a fact that these women artists and others are not referenced in discussions of Sherman or Finley. Peter Schjeldahl's introduction to *Cindy Sherman,* a 1984 Pantheon book, enacts the type of eroticized response that, if not downright objectionable, is certainly problematic for work that is said to critique the eroticism of the traditional representations it appropriates. Schjeldahl writes:

> I am interested to note that I automatically assume, without knowing, that the photographer of the "film-frames" was always male. As a male, I also find these pictures sentimentally, charmingly, and sometimes pretty fiercely erotic: I'm in love again with every look at the insecure blonde in the nighttime city.[11]

He then provides a patrilineal cohort for the artist:

> The difference [from earlier artists' responses to received images] in the case of Sherman's generation—a farflung, international cadre, to which must be associated even the great German, Anselm Kiefer—is the steely concentration, the

self-abnegating discipline, which they got from these avant-garde elders and
with which they have solicited the oracles of images.[12]

The mention of Kiefer is clearly superfluous, belonging to the subliminal
type of patrilineal validation I noted in my essay. On the same page,
Jean-Luc Godard, Rainer Fassbinder, Andy Warhol, and David Salle are
summoned to buttress Sherman's admissibility into the pantheon. Or is
it that her work provides an opportunity for this critic to buttress *his own
position in the patrilineage* by naming the powerful male artists he so
admires?

A Woman's Life Isn't Worth Much, Finley's 1990 installation of wall
drawings and writings at Franklin Furnace, included a text written on the
walls in simple, deliberately clumsy print, which was composed of fiery
but somewhat flat-footed, statements of feminist wishes and simple howls
of female rage. These words were accompanied by drawings illustrating
patriarchy's dos and don'ts for women's appearance. They were "primi-
tive" in style and stereotypical of what people may think early-1970s
feminist art looked like: see Jane with a bra—see Jane without a bra—see
Jane burn a bra.

Yet it must first be said that while this work *seemed* to have the feel
of early feminist art, a cursory look at documentation from the period
between 1970 and 1973 reveals a much more varied and sophisticated
assault on patriarchy, from raw and bloody performances by women in
the Feminist Art Program at CalArts in 1973 to Suzanne Lacy's chillingly
economical *Rape Is . . . ,* 1972, in which the reader must break the seal
of a coolly corporate-looking book and rape the art object in order to
read its contents. Many of the art objects and performances produced
by women artists in New York in the late 1960s and early 1970s and by
women involved with the Feminist Art Program at CalArts and later the
Women's Building in Los Angeles in the early and mid-1970s would seem
like obvious referents for Finley's work. She certainly owes a debt to
Carolee Schneemann's 1975 performance, *Interior Scroll,* in which
Schneemann pulled a scrolled text from her vagina and "read a text on
'vulvic space'—about the abstraction of the female body and its loss of
meanings"[13] or to *Up to And Including Her Limits* (1973), in which,
tethered to a rope for eight hours a day, Schneemann would move her
body so as to write on the wall and floor around her. In Faith Wilding's
1972 performance work, *Waiting,* the artist, dressed as an old woman
keening in a rocking chair, relived her life as an endlessly passive process
of waiting for things to happen to her body and for others to live her life
for her, of waiting for life. The monotonous, eerily anxiety-producing

aural tone of Wilding's incantation prefigures the tonality employed by Finley in many of her performances. Yet Finley's work has received critical validation via association with important male figures, which other feminist artists, themselves more relevant to Finley's work, are often denied. A review of the Franklin Furnace exhibition immediately links her to the proper fathers:

> Mixing futurist aggression, Brechtian political performance strategies, Artaud's sensualism, and Allen Ginsburg's hypnotic zeitgeist-attuned chanting, Karen Finley's work has always elicited impassioned response.[14]

Performances are notoriously ephemeral from the point of view of written history, but *Waiting* is to be seen in Johanna Demetrakas' 1973 documentary *Womanhouse,* was discussed in *Ms.,* and the full script is reprinted in the appendix of Judy Chicago's *Through the Flower: My Struggle as a Woman Artist.*[15] Schneemann's work is widely documented. It would stand to reason that a woman coming of age in this time and committed to a feminist and aesthetic edge would seek out such empowering works. Interesting in this regard is a comparison of interviews with both Schneemann and Finley in *Angry Women,* the title of a recent issue of *Re/Search.* While Schneemann mentions several important women in her personal history and many "favorite female predecessors"[16]—Virginia Woolf, Marie Bashkirtseff, Paula Modersohn-Becker, Margaret Fuller, Simone de Beauvoir—Finley engages in the type of patrilineal self-validation I have described as referencing via the negative. She speaks about how she tried to live out Jack Kerouac's *On the Road* but ended up getting "picked up and at gunpoint [having] to give someone a hand job."[17] Immersed in its dark side, Finley seems nevertheless still enthralled by the masculine mystique. She "felt resentful of what was going on in the '60s and '70s with the cutting edge male Body Artists (Chris Burden, Vito Acconci, the Kipper Kids and Bruce Nauman) who did use their bodies— well, as soon as *I* (a woman) tried to do that, the situation changed, because the female body is *objectified.*"[18] Yet, almost incredibly, she never mentions any of the women performance artists using their bodies in those years who struggled with the same critical inequity.

Another example of the elision of matrilineal influence is to be found in reviews of a recent exhibition at the Sandra Gering Gallery of an emerging young artist, Janine Antoni. The exhibition, entitled *Gnaw,* consisted of two installations. In one room, resting on marble set on pallets low to the ground, were two 600-pound blocks of hard dark-brown chocolate and soft white lard, respectively, sculpted slightly by what appeared to be chisel marks but in fact were the artist's bite marks.

In an alcove, heart-shaped chocolate boxes made of molded chocolate and red lipsticks in fancy black and gold casings were displayed in glass cases. Despite the work's formal impact, statements by the artist were necessary to make the connection of process between all the elements, and in order to clarify the intended signification of bulimia. In an *Artforum* review, Lois E. Nesbitt writes about bulimia (a disorder primarily affecting women) and yet provides art-historical validation via allusions to "Joseph Beuys' lard works and Dieter Roth's chocolate sculptures."[19] A *New York* magazine piece accomplishes the same patrilineal objective, albeit by what amounts to a double negative: "A German woman hissed, 'This isn't art, this is lipstick. I hate Joseph Beuys.' "[20]

Beuys is demonstrably a much favored mega-father and certainly a presence in Antoni's work. Yet recent works by two women artists of much more immediate relevance to Antoni are not mentioned, either in reviews or in statements by the artist, despite the fact that both had exhibited work in New York shortly before or immediately after her exhibition. In a performance-installation at LA Louver Gallery earlier the same season, Ann Hamilton sat at a table, surrounded by white cloths impregnated with wine, biting into lumps of dough which she then spit out and placed in a basket for them to rise and decay. This work spoke of bulimia and waste, with undertones of Christian iconography.

Works done over the last few years by Maureen Connor, exhibited frequently in the year preceding Antoni's exhibition and collected in an exhibition that opened the day Antoni's closed, were indisputable influences on Antoni, her former student. For example, twice, in 1991 and 1992, Connor had exhibited *Ensemble for Three Female Voices* (1990), in which she expressively integrates the contingency of the female body, the cultural construction of femininity, and the silencing of women. These linked meanings are economically encapsulated in human larynxes, cast in red lipstick, stuck on microphone stands, within an installation which included the taped sounds of a baby girl, a middle-aged woman, and an old woman laughing and crying. *Ensemble for Three Female Voices* has been a truly *germinal* art work—to change patrilineage, the word *seminal* must only be used when appropriate, but even some feminist art historians and critics find it difficult to wean themselves from the old language of influence. Not only Antoni, but also Rachel Lachowicz have used this novel, ingeniously gendered material, following in Connor's footsteps. Equally relevant to Antoni's work are Connor's many works that examine bulimia and anorexia as feminist tropes.[21]

Antoni, in personal conversation, has noted Connor's work as an important *competitive* context for her own. Although feminist artists and

theorists have critiqued the usefulness of the Oedipal narrative for women, it constructs male artists' relation to their aesthetic and ideological fathers and, as such, is a constitutive and privileged element of patriarchal and patrilineal discourse. In addition to the perceived benefits to women of patrilineage, it may well be that many women shy away from openly admitting to conflict or competition with other women—with mothers, for instance—no matter how productive those relationships may be, both because these relations are less privileged in mainstream discourse, and because women have been traditionally trained to avoid conflict. If it is an egregious example of patrilineage to elide Connor and Hamilton from any contextualization of Antoni—given that these influences are so obvious, close, and privately acknowledged—one must wonder at the degree of complicity of the artist herself. Matrilineage can only begin when a woman artist risks forgoing validation via mega-fathers in favor of her own female teachers and contemporaries, or at least enriches the public's understanding of her work by a more balanced self-contextualization.

Another recent example of patrilineal unwriting of feminist history is particularly distressing because it is done in the service of a new breed of "angry" young women artists. After a divisive decade in which women artists were urged to steer clear of essentialist positions and nonappropriative methods, the anti-essentialist discourse as a critical system seems to have collapsed altogether, as women working in sculpture and painting, depicting women in a very essentialized victim position, are receiving a great deal of attention. Many women were struck by the simultaneity of Kiki Smith's prone, featureless, female creature dragging feces across one gallery floor with Sue Williams's abused, beaten, and branded female figure lain out on another (Smith's *Tale,* at Fawbush Gallery, and Williams's *Irresistible,* at 303 Gallery, both in May 1992). These works are not analyzed for what they naturalize about women, nor in the context of the ideological battles that were so central to feminist discourse in the past decade. One even suspects that their popularity is partly based on the attractiveness to the mainstream of the female victim position. My comments, I must add, are not meant as criticism of the works, which I feel are strong, but as analysis of the relationship among the work, its critical reception, and the manner in which certain ideas about women get produced and perpetuated.

The production of Williams's career is unfortunately built on an erasure of the history of two preceding decades of work by women, doubly unfortunate for the role that Williams herself may play in the process. Roberta Smith's *New York Times* feature on Williams ("An

Angry Young Woman Draws a Bead on Men," May 24, 1992) provides an interesting example of such an erasure. Smith places Williams at CalArts at the same time as male art stars such as David Salle, Eric Fischl, Ross Bleckner. Neither Smith nor Williams mentions that there was a ground-breaking and influential Feminist Art Program at CalArts at that time. Not all women in the art school joined that program by any means, and there were certainly tensions about being in or out, but the program provoked great curiosity among nonparticipating students, male and female, since it operated behind closed doors. Its presence constituted an unprecedented conscience check on rampant machoism. It makes me sad, as a member of that program and as a feminist educator, that Williams wasn't able to avail herself of the personal support and empowering influence of this important educational experience but instead remembers CalArts as a " 'man's world then.' " This omission is galling to women who find Williams's work reminiscent of early Feminist Art Program class assignments emerging out of consciousness-raising, and to gay male artists who feel that the program gave them permission to deal with sexuality in new, non-Greenbergian, forms.[22]

It should be noted that Smith and Williams were following a well-established path. The erasure of the CalArts Feminist Program was well under way as early as 1981, when a ten-year alumni show, curated by Helene Winer, included only two women artists and no one from the program but many of the aforementioned male art stars in whom the art world was building an investment. Thus, one artist's or one critic's work is not at fault or at issue here, rather a particular process of career construction and its effect.[23] But the persistence of the patrilineal validation system and the participation in this process by women who do not wish to be associated with feminism does not serve the textual and formal development of art by women.

If women are denied access to their own past they always occur in history as exceptions, that is to say as freaks (Sue Williams's "self-destructive" personal history is useful to this type of myth-making) and they are forced to rediscover the same wheel over and over, always already losing their place in the growth of culture. They are denied the critical mass of a history, with ancestors and even with Oedipal battles between generational rivals. If women themselves deny association with feminism, they are likely to be subsumed to male history no matter how exceptional they are. Women may feel they risk a lot by linking themselves to women progenitors as well as to men, but while magazine review saying "Unlike . . ." or, even, "Like . . ." may bring short-term

career benefits, in the long term, experience shows that the art history textbook will name only the mega-father, and "like" will become simply "and followers," among which women will be the last to be named.

It is a commonplace of history that it is written by the victors. Western civilization is so much a male "hommologue"[24] that it will always privilege a man's failure over a woman's success. It can barely consider accomplishments of women. They don't compute. To undo that process requires constant vigilance. Women must reexamine the very notions of success and failure in the light of their basis in a patriarchal value system. Yet women's fear of association with a "weaker" position remains a powerful force in the maintenance of patrilineage *by* women. Comments by individual women working in the new abstract painting suggest a distrust of any word beginning with *fem-*, rejecting the marginalization *fem-* might entail but, by the same token, rejecting the specificity of political/personal experience that might enliven their work and prevent its absorption into yet another "universalist," that is to say male, movement.

In "Patrilineage" I insisted on the importance of a new, more gender-conscious form of studio-art and art-historical education. Patrilineage can only be dismantled by the conscious will to do so on the part of women and men involved in the process of art production, criticism, and history. Women artists must identify women artists whom they admire, were influenced by, or even those they dislike or feel competitive with, revealing the *woman's world* many women artists now occupy in their daily aesthetic lives. An effort must be made by critics not only to be aware of those influences, but even to search for them, and to place the issue of gendered influence as a problematic of art. What does it mean for a woman to claim to be doing "universalist" work? Or to be clearly influenced by male artists, including, in some cases, misogynist ones? These questions must be critically addressed.

Patriarchy has a lot invested in the notion of universality and in the process of patrilineage. Property is what is inherited through legitimate lineage, and the possession of property—be it culture, history, philosophy—is ultimately what is at the core of this art-historical mechanism. Artists and art writers, women in particular, have a stake in undermining traditional notions of property, value, and lineage. The method is really very simple: it will always be a man's world unless one seeks out and values the women in it.

Notes

1. Claudia Hart, *Artscribe,* no. 67 (January–February 1988): 70–71.
2. Charles Hagen, *Artforum,* January 1990, 134; Lois Nesbitt, *Artforum,* November 1989, 151.
3. Quoted by Donald Kuspit, *Artforum,* September 1989, 140.
4. Tricia Collins and Richard Milazzo, *Pre/Pop/Post/Appropriation,* exhibition catalogue (New York: Stux Gallery, 1989).
5. Ibid.
6. Ibid.
7. *Art After Modernism: Rethinking Representation,* ed. Brian Wallis (New York: New Museum of Contemporary Art; Boston: David R. Godine, 1984).
8. Griselda Pollock, *Vision & Difference: Femininity, Feminism and the Histories of Art* (London: Routledge, 1988), 157.
9. Ibid., 169, 170, 199.
10. When I first wrote this essay, my wish was to choose names of women that were very well known, in order to establish their seemingly obvious availability as spiritual mothers to a woman artist, indeed to any artist. In order to be dispassionate, I did not place myself in the most relevant matrilineage and sorority: my mother, Resia Schor, is an artist whose answer to widowhood was to further develop her own art and her capacity to support herself and her family rather than seek the help of a man; my sister, Naomi Schor, a distinguished feminist scholar, laid a path for me to follow, through "women's lib" and French feminist theory. Beyond these two most important female models, I live in a sisterhood of artists, former students, colleagues, friends all, whose work is of primary concern to me: Maureen Connor, Nancy Bowen, Susanna Heller, Susan Bee, Robin Mitchell, Faith Wilding, Portia Munson, Rona Pondick, Jeanne Silverthorne, among too many others to list.
11. Peter Schjeldahl, Introduction ("The Oracle of Images") *Cindy Sherman* (New York: Pantheon Books, 1984), 9.
12. Ibid., 8.
13. Carolee Schneemann, in an interview with Andrea Juno, published in *Angry Women, Re/Search #13* (San Francisco: Re/Search Publications, 1991), 72.
14. Melissa Harris, "Karen Finley at the Kitchen and Franklin Furnace," *Artforum* (September 1990), 159.
15. Faith Wilding, *By Our Own Hands* (Santa Monica: Double X, 1977), 106, n. 12.
16. Ibid., 68.
17. Karen Finley, in an interview with Andrea Juno, op. cit, 48.
18. Ibid.
19. Lois E. Nesbitt, "Janine Antoni at Sandra Gering Gallery," *Artforum* (Summer 1992), 112.
20. Rowan Gaither, "A Sculptor's Gnawing Suspicions," *New York,* March 9, 1992, 24.
21. These include several sculptures from 1991 in which Connor created impossibly skinny figures out of black stretch lingerie material, and *Taste 2,* 1992, exhibited a couple of months before Antoni's *Gnaw.* In *Taste 2* a bathroom scale rests on a low platform that has been covered with a white bath mat. Inside the scale a tiny monitor has replaced the numbers that usually reveal one's weight. It plays a tape loop of the artist stuffing herself with various foods in a random order. Suddenly her bulimic ritual of frantic bingeing ends as the monitor plays, in reverse, the images we have just seen so that the foods fall out of her mouth and become reconstituted. By the end of the tape they magically reappear on their plates completely intact and ready to be consumed and purged again in an endless cycle.
22. Tom Knechtel, a student at CalArts in the early 1970s, at the same time as Sue Williams, took Roberta Smith to task for her "reimagining the history of Cal Arts," including the occulting of painting from its history, including such significant women painting teachers as Elizabeth Murray, Pat Steir, and Vija Celmins, and the elision of the Feminist Art Program. As

Knechtel significantly notes, "Even those women and men who didn't participate in the program could not escape its influence." Tom Knechtel, "The Total Picture at Cal Arts," letter to the editor, *New York Times,* Sunday, June 21, 1992.

23. While Smith's ignorance of the history of early feminist art may be understandable in this instance, given the way the culture as a whole has dealt with that history, her recent choices for inclusion and exclusion in a new category of "angry" (young) women is less so. In "Women Artists Engage the 'Enemy'" (*New York Times,* Sunday, August 16, 1992, section 2, p. 1), Smith is more obviously market-driven, even as her choices help shape that market, and as such her choices, her premise, and even her conclusions are more open to question.

 She points to and helps establish a new mini-movement of women involved with appropriation of male artists such as Richard Serra, Andy Warhol, and David Salle. In that effort, she names Rachel Lachowicz and Janine Antoni. Lachowitz's use of lipstick as an art material is, like Antoni's, a direct appropriation of Maureen Connor's work: Lachowicz was in an exhibition which included Connor's *Ensemble for Three Female Voices,* and her first lipstick sculptures surfaced a few months later. Smith does not consider other appropriations of male artists, for example, Connor's subversive riffs on Marcel Duchamp's bottle-racks.

 Consideration of appropriations among women artists would deepen Smith's argument for this group of artists as a new feminist movement. Further, the conclusion of her article undermines the status of the works Smith has presumably set out to boost when she states that "imitation is the highest form of flattery. Except for Sue Williams and Janine Antoni, these women have not yet achieved the originality of the feminist photographers of the early 80's, or of the male artists they parody. Kass's work wouldn't be nearly as engaging if it didn't incorporate the visual inventiveness of Salle or Warhol." If that is the case, then why does Smith consistently, in what appears to be a series of articles on these "angry" women, ignore women artists who *are* working originally: Ida Applebroog might be a more outstanding example of an angry (older) woman who appropriates, subverts, and invents imagery far more critical of cultural iconography and modernist syntax.

24. Luce Irigaray, *Speculum of the Other Woman* (New York: Cornell University Press, 1985), 240. Irigaray speaks of the "phallosensical hommologue" of Western civilization.

THERE'S NO PLACE LIKE HOME

Phyllis Rosser

> *Dorothy clicked the heels of her shoes together three times as she said "There's No Place Like Home, There's No Place Like Home, There's No Place Like Home." When she woke up she was lying in her bed in Kansas, surrounded by all her relatives.*
>
> The Wizard of Oz (MGM, 1939)

Raising three small children in suburbia was the most depressing work I've ever done. Painter Tomar Levine captured my anguish in a portrait of me for *Ms.* magazine, illustrating my article in the March 1976 issue entitled "A Housewife's Log: What She *Really* Does All Day."[1] I sat at a littered breakfast table in my nightgown holding a newspaper as I stared hopelessly into space, surrounded and entrapped by the mundane objects of my daily life—a baby bottle, a milk carton, cereal boxes, dirty dishes. I had kept a journal of what I was doing on a moment-by-moment basis to show how child rearing was consuming nearly every minute of my day:

10:26 Started writing again. Sam (my daughter) requested a cookie and a drink.

10:28 Sat down again. Sam asked me to watch her turn somersaults.

10:30 Tried to write while ignoring Sam's interruptions.

10:40 Talked to Bill (my husband) before he left to see some customers in Princeton.

11:00 Finished yesterday's journal. Went downstairs to see who was crying in the boys' room . . .

11:03 Made the boys' beds. Cleaned up the children's bathroom where somebody had just missed the toilet bowl.

11:25 Prepared a snack for Sam.
11:30 Put on a Bette Midler record for Brandy (my son). Changed Sam's diaper.[2]

As a white middle-class suburban mother I was supposed to be living "the American Dream" but my portrait showed a woman staring into a nightmare.[3]

THE FEMINIST LIBERATION OF HOUSEWIVES

Friedan's comparison of housewives' lives to the conditions in Nazi concentration camps in *The Feminine Mystique,* her landmark book of 1963, comforted me then. Friedan said, "The prisoners' ability to predict the future and prepare for it was systematically destroyed . . . a gradual process which ended with the destruction of adult self-respect."[4] This nightmare continued when the New Right and the Bush Administration tried to turn the clock back to 1954 and return women to their submissive status in the home.

Friedan's book chronicled the rise of "a mystique of feminine fulfillment" after World War II, when the suburban housewife became the "dream image of the young American women and the envy . . . of women all over the world."[5] But behind this image of perfect happiness lay anger and even insanity (mental breakdowns) brought on by the loss of identity that came from being relegated to and isolated in the home. Louise Bourgeois captured my feeling of entrapment in her *"Femme-Maison"* series (1948)—drawings and engravings in which a nude woman's head and upper torso are replaced by a house, symbolizing the postwar condition of women who both created and were confined to the household.

Contributing to my anger and depression was the fact that women's role in the home was not held in high esteem because most housework can be "capably handled by an eight-year-old child" and child rearing is not considered intellectually challenging.[6] Not only was women's work in the home not valued, but housewives themselves were treated like children. Friedan incited women to leave the "comfortable concentration camp" of the American home that "denies women's adult human identity."[7]

Ironically, the home was not even a "comfortable" concentration camp. Inspired by *The Feminine Mystique,* feminist consciousness-raising and performance art in the seventies revealed that for many women home had become a war zone of violence and abuse. Male violence was creating psychological trauma in its victims that was identical to the "shellshock"

experienced by soldiers in war, says Harvard psychiatric professor Judith Lewis Herman.[8] She credits feminists with being the first to break the conspiracy of silence and bring to public awareness the dark side of the patriarchal family myth: alcoholism, drug abuse, battering, child abuse, incest, rape, and murder.[9]

My sanity was also challenged during my early child-rearing years by the pressure to conform to the bland, nonthreatening ideal of wife/ motherhood that pervaded suburbia, where all discussion of major social issues had been banned but housewives were expected to spend volunteer time in the community managing social problems and maintaining the myth of paradise. Marisol's sculpted wood-block figures, such as *Women and Dogs* (1964)—two women carved from life-sized blocks of wood with multiple heads facing many directions—embodied suburbia's zombielike conformity and conservative values and, for me, my trapped energy trying to break free.[10] Happily, feminism liberated women from the volunteer world in the seventies, but they were asked to return again in the eighties as President Reagan called on the private sector to handle social problems the government refused to fund and President Bush challenged people to become one of "a thousand points of light"!

I thought I was crazy to have moved to suburbia, but it wasn't until I saw Sandy Skoglund's 1991 installation, *Gathering Paradise,* that I understood why I was so unhappy.[11] A 1950s vision of domestic bliss was turned on its head in her life-sized re-creation of the kitchen, dining room, family room, and patio of a typical fifties ranch house. The rooms that filled a New York Gallery were sparsely furnished with the bland icons of that era, including a Colonial hutch in the dining room and a metal umbrella table with wooden slat chairs on the flagstone patio. All surfaces and furnishings were painted either powder blue or salmon—popular fifties colors used to convey tranquillity. But Skoglund uses them to make the viewer feel slightly nauseated, off-balance. The surfaces were cracked, suggesting that dreams of paradise don't always stand the test of time.

Ninety lifelike squirrels (made of cast polyester) leaped on the furniture, sniffed the air, and searched for food in a playful but menacing way as they invaded the house, making the human-made environment seem unnatural. Skoglund says, "American suburban society takes it for granted that everyone would want to live like this, that it's 'normal.' But I grew up in a suburban home and never felt it was normal or comfortable. It was claustrophobic."[12]

For Skoglund, the fifties concern with color coordination, tranquillity, and orderliness signified an obsession with control. I finally understood what this meant—that suburbia is a place of repression and retreat

from reality, where both sexes but particularly women, who spend entire days there, are kept out of contact with the real world. They not only feel isolated, they feel invisible. British social studies professor Elizabeth Wilson says women experience a sensual enjoyment in displaying themselves in city stores or restaurants, a pleasure they are deprived of in suburbia, which ensures that there will be no "dangerous outbreak of female sexuality."[13]

Women in suburbia were also deprived of realizing their potential. Friedan had found that educated women who were removed from cities where they could pursue professional careers, take university courses, or have access to day care were taking tranquilizers to keep themselves from feeling that their lives were pointless.[14] So many women went to doctors in the fifties complaining of a "terrible tiredness" that one physician who decided to investigate "housewife's fatigue" found, not surprisingly, that women were bored by the "repetition of their jobs, the monotony of the setting, the isolation, and the lack of stimulation."[15]

Skoglund's rooms, which are devoid of people except for a Cibachrome photograph near the entrance, indicate another serious environmental problem. Can she be reminding us that while the New Right attempts to "turn the clock back to 1954," the nuclear family has already left the home? The suburban home, itself, may be viewed as an artifact of the past. But "blaming women for the breakdown of the family," says Skoglund, "assumes that women have been responsible for it. What about men?"

During the 1970s I escaped "annihilation," as many women like me did, by juggling child rearing and housework with a part-time job at *Ms.* magazine. Others returned to college or graduate school and entered the professions in large numbers. We were aided in our quest by the first issue of *Ms.* in spring 1972 featuring Miriam Wosk's eight-armed Goddess of Housework on the cover and Jane O'Reilly's classic essay, "The Housewife's Moment of Truth," and by *Womanhouse,* a landmark feminist installation in Los Angeles created by members of the Feminist Art Program at the California Institute of the Arts under the direction of Judy Chicago and Miriam Shapiro.[16] *Womanhouse* (January 30–February 28, 1972) allowed viewers to visualize for the first time the subjugation of women in their homes.[17] Inhabiting the house were a naked mannequin embedded in the shelves of a linen closet and another mannequin in a wedding dress who stood on "The Bridal Staircase" where her white train turned gray as it flowed into a breast-walled "nurturing kitchen."

"*Womanhouse* turned the house inside out," says Arlene Raven, art historian of the Feminist Art Project at CalArts. "The isolation and anger

that many women felt in the single-nuclear-family dwelling in every sub-urb of America were flung out at the public who came to see the environ-ment and performances."[18] Its startling effect has lingered long afterward in photographs, articles, and films.

Feminist artists of the '70s also celebrated the homemaking and creativity of housewives by incorporating into their art, women's crafts (quilting, needlepoint, embroidery) which were considered inferior be-cause they were done by women in the home. Miriam Schapiro created a technique she called "femmage" in which she mixed beads, buttons, needlework, fabric, and lace to make painted collages of roses, samplers, fans, and hearts—subject matter also associated with domesticity. Schapiro described the collage elements in her paintings as the needle-work of departed and forgotten women.[19] Arlene Raven saw her work as a healing metaphor for women—developing wholeness from a fragmen-tary sense of self and the world.[20]

Mierle Laderman Ukeles' conceptual artwork/exhibitions in the '70s called "Maintenance Art," or "Care," saw the housewife's role in a larger perspective. In *Washing, Tracks, Maintenance: Maintenance Art Activity III* (July 22, 1973) Ukeles washed the most heavily trafficked floor areas of the Wadsworth Atheneum in Hartford, Connecticut, waited for people to track them up and rewashed them until the museum closed, accumulat-ing the rags in a pile.[21] She wanted to show that women's role ("unifica-tion . . . the perpetuation and maintenance of the species, survival sys-tems, equilibrium") represented the life instinct in art as opposed to the death instinct, the reigning principal of the avant-garde.[22] The real prob-lem after every revolution, she said, was who's going to pick up the garbage on Monday morning?

But feminist consciousness-raising was attacked by a backlash in the '80s that championed home and hearth. Women like me who had chosen to move out of the housewife role found their efforts distorted in women's magazines, which encouraged us to be "Superwomen" and "have it all": high-powered careers, perfect children, beautiful homes, and elegant par-ties. Those of us who had fought society, our families, and our own conditioning to work outside the home were appalled to hear during the '80s that women were suffering from "superwoman burnout" and fleeing the work force to devote themselves to "better" motherhood.[23]

A tidal wave of backlash articles washed over us. Media-created "trend" stories based on questionable statistics announced that women who pursued their careers at the expense of marriage and/or family were suffering from record levels of depression; women who delayed marriage were experiencing "a man shortage"; and women who delayed childbear-

ing were suffering from infertility (their biological clock was running out of time).[24] Mothers' worst nightmares about day care were fueled by frightening headlines: "When care becomes child molesting: It happens more often than parents like to think."[25] In 1988, *Good Housekeeping* launched its "New Traditionalist" ad campaign, featuring former career women in their Cape Cod homes surrounded by adoring children. The ad copy told us they were finding their identity by serving home, husband, and kids.[26]

Emissaries of the New Right were among feminism's most vicious attackers. Moral Majority leader Reverend Jerry Falwell declared that feminists had launched a "satanic attack on the home" and Heritage Foundation founder Paul Weyrich warned that the women's liberation movement was trying to restructure the family, "particularly in the downgrading of the male or father role in the traditional family."[27] Fundamentalist ministers and the Reagan-Bush Administrations created an antifeminist agenda aimed at dismantling nearly every legal achievement of the women's movement, particularly the Supreme Court's legalization of abortion in 1973.

THE DOMESTIC MYTH IN POPULAR CULTURE

During the past three decades, movies have encouraged both the changes in women's lives and the backlash against their independence. Lunacy became a form of feminist resistance in the '70s, as suburban housewives were driven crazy by subordination, repression, drudgery, and neglect.[28] In *The Stepford Wives,* the most extreme statement of this theme, housewives were literally turned into robots created by their husbands. In *Diary of a Mad Housewife* and *A Woman Under the Influence,* pill-popping and nervous breakdowns appeared to be reasonable responses by wives to their domestic lives.[29]

Housewives also left home to find their own voice, in movies like *Private Benjamin, Up the Sandbox,* and *The Turning Point.* They turned to other women for advice and were told to lead their own lives and enjoy their freedom in *An Unmarried Woman* and *Alice Doesn't Live Here Anymore.* In *My Brilliant Career,* the heroine turns down a marriage proposal, saying, "I can't lose myself in somebody else's life when I haven't lived my own yet."[30]

But during the '80s, the backlash shaped Hollywood's portrayal of women, rewarding the "good mother" and punishing the independent

career women.[31] *Fatal Attraction* carried hatred of the single woman to psychotic extremes, suggesting that women go crazy without a husband and family. In the final scene, the "good wife" kills the deranged "other woman" who is chasing her husband, in the "sanctuary" of the home—which preserves the family but gives no consideration to the pregnancy of the single woman. In the early nineties, *The Hand That Rocks the Cradle* played on women's paranoia about another type of woman destroying the family—the lethal baby-sitter. A woman who blames another woman for the deaths of her husband and unborn child becomes the other woman's baby-sitter and violently tries to replace her as mother of the family. Moral: Mothers, you'd better stay home.

Baby Boom, a prototypical '80s movie, warned women that motherhood and high-powered careers don't mix. When a fast-track female executive who finds a baby someone has *left* to her so irresistible that she quits her job, moves to a farm, and successfully markets her homemade baby applesauce, she isn't allowed to cash in on a $3 million deal to sell the business to a baby-food company. Successful career women, on the other hand, were depicted as aggressive and loveless in *Broadcast News* and *Working Girl.*

Television has played a more persistent role in promoting the traditional family because advertisers, who still view the housewife as the ideal shopper, demand it, says journalist Susan Faludi. The glorification of the American housewife's role in the nuclear family began in the '50s with shows like "Ozzie and Harriet," "Leave It to Beaver," "The Donna Reed Show," and "Father Knows Best." Mothers in these shows were "domestic princesses" who wore shirtwaist dresses, aprons, and high heels.

Women were finally given a model of a career woman in the highly successful mid-'70s situation comedy, "The Mary Tyler Moore Show" (although Mary was chaste and deferential to her boss). The role of housewife was also satirized in "Mary Hartman, Mary Hartman," a blue-collar parody of soap operas in which Mary tried to live by *Family Circle* magazine's rules, keep her floor properly waxed, and deal with a mass murderer who held her hostage in a Chinese laundry.[32]

But TV during the '80s reflected and promoted the backlash. "Nesting" became a crucial theme with dozens of female characters giving birth, sometimes on the air, and "Thirtysomething," a nighttime soap opera about yuppies agonizing over the details of their lives, had an impact on white middle-class viewers far beyond its ratings. Introduced in the fall of 1987, it glorified homemaking and embraced all the backlash issues: cocooning (retreating to the home), mommy tracking (putting child rearing ahead of career), the man shortage, and the biological

clock.[33] The featured backlash women were the blissful homebound mother, the neurotic spinster, and the aggressive career woman. The most unsympathetic character was a feminist. Therapists and clergymen used the show for counseling purposes and my twentysomething son, who felt it modeled adult life, often discussed its parables with me.

By 1988, only two strong female leads were allowed in prime time, "Roseanne" and "Murphy Brown."[34] "Roseanne," played by the feminist comedian Roseanne Arnold, has remained the highest-rated TV show since it was introduced in the mid-'80s. A blue-collar housewife in control of her life and everyone around her, she works outside the home to support her family and has no illusions about either job. "I clean everything and everything's my fault," she says.[35] The show satirizes the role of housewife as "Mary Hartman, Mary Hartman" did, but Roseanne's vulgar wisecracking and fat body are a far cry from Mary's childlike confusion and Barbie Doll looks.

Roseanne allows me and many others to exorcise both our housewife rage and nurturing anger as she speaks emotional truths to her children we wouldn't dare utter even with her loving candor. Arnold is also one of several famous performers who have discussed their abusive childhoods publicly, hoping to encourage new openness about this issue.

FEMINISTS EXPOSE DOMESTIC VIOLENCE

Since the 1920s the home has been idealized as a refuge from the outside world, which has led to an increasing emphasis on family privacy and isolation from the community.[36] This isolation has in turn permitted an astonishing rise in family violence and abuse, causing women victims to exhibit responses that are characteristic of Vietnam war veterans' post-traumatic stress disorder: "intense fear, helplessness, loss of control, and threat of annihilation."[37] The terror and madness of domestic violence were first brought to light by 1970s feminist speakouts, performances, and exhibitions where individual experiences of wife battering and rape, child abuse and incest were presented. These personal stories raised public consciousness, examined the politics of the experiences, and began the healing process for victims who were finally allowed to break their silence. Art historian–critic Arlene Raven says, "This is the process of feminist art . . . uncovering, speaking, expressing, making public the experience of women."[38]

One of the primary issues feminists explored was rape, which of course goes beyond the domestic sphere. Susan Brownmiller, in her land-

mark book *Men, Women and Rape* (1975), called rape "a deliberate, hostile, violent act of degradation and possession on the part of a would-be conqueror, designed to intimate and inspire fear." Rape was redefined in the '80s as a crime of sexual assault rather than sexual passion, so the victim no longer had to prove that she'd struggled to get away.[39] But in thirty states it is still legal for men to rape their wives.[40]

Performers Cheri Gaulke and Tyaga related the hidden violence against women in fairy tales to the battering of women in the home by becoming embedded in bedroom furnishings until one woman was buried alive under a mound of mattresses in *The Mattress on the Pea* (1977). Gaulke's performance of *Broken Shoes* (1980) exposed another form of physical and psychological violence against women in the home, the repression of female sexuality in the ancient Chinese practice of foot binding.[41]

Men's rage at women's newly won independence contributed to an escalation of violence against women during the '80s. Domestic-violence shelters experienced more than a 100 percent increase in the numbers of women seeking refuge.[42] Reported rapes more than doubled and sex-related murders rose 160 percent, with at least one third of these murders committed by husbands or boyfriends.[43] Most women were murdered after filing for divorce and leaving home. During the '90s we've become aware that women are even killed by their husbands in courthouses while filing for divorce.

In June 1992, the American Medical Association published a report calling domestic violence "a public health problem that has reached epidemic proportions."[44] Three out of four women killed in America last year were victims of domestic violence and nearly one quarter of the women in this country will be abused by a current or former partner sometime during their lives.[45] Children who witness domestic violence are five times more likely to become batterers or victims in adulthood, but only ten states have laws mandating arrest for this crime.[46]

The prevalence of incest has long been a matter of feminist concern. In 1979, the Incest Awareness Project presented a year-long public information project in the Woman's Building in Los Angeles. The project's logo featured a young middle-class girl carrying "the world" on her shoulders with a photographic negative of a happy family inset above her head. Designer Bia Lowe hoped this image of a young women about to throw off the weight of keeping the family together would give incest survivors a sense of direction and community rather than the feelings of defeat and isolation that come from the family's conspiracy of silence.[47]

The silence had been shattered in print in 1978 by *Kiss Daddy Good-*

night, Louise Armstrong's description of her incest experiences as a young girl along with the stories of many other sexually abused women. But, despite the growing awareness and sympathy for victims, Armstrong reports in her afterword to the 1987 reprint of the book that a backlash developed during the '80s. When she appeared on call-in shows, most callers were males who were "annoyed, even vituperative, sometimes apoplectic," and saw her book as "a manifestation of a sinister feminist plot." *Psychology Today* reported that a "pro-incest lobby" had been formed by researchers and academics heralding "positive incest" as a way to foster affection in the American family.[48]

Several well-known feminist artists have made abuse of women and children the subject matter for much of their work over the past twenty-five years. Ida Applebroog paints a world suffused with irrational violence, particularly toward children. In *Boboli Gardens* (1987), an older woman plays an oboe as a prepubescent, nude, young woman stands awkwardly beside her, staring vacantly into space.[49] They are painted in bright yellow and surrounded by areas of blood red, orange, and dark brown. In a side panel an ominous-looking, fat, nude male wearing a gas mask rides a large sea turtle. "You dumb bitch" is written above, under three small cartoon images of a young boy and girl who appear to be watching the scene with trusting innocence. Applebroog tells us that men commit unspeakable sexual acts against vulnerable children who are ignored or left unprotected by women.

Sculptor Nancy Grossman creates images of women and children triumphing over abusive patriarchal power. The eloquent, leather-covered wooden heads that she has been making since 1969 show the child who is never allowed to speak, standing up to her humiliation with dignity and power. But they also embody the tyrannical male power of the abuser and are self-portraits of the artist. As an adult, Grossman sees herself and everyone else as potentially both abuser and abused and acknowledges the dark side in all of us.[50]

During the '80s, the growing concern with domestic violence, child abuse, and drug addiction became a psychotherapeutic phenomenon. Information ranged from psychoanalyst Alice Miller's books on the psychic damage of traditional child-rearing practices, to counselor John Bradshaw's well-known TV series chronicling the way families have created our addicted society, to the work of psychiatric professor Judith Lewis Herman on the physical and emotional damage of childhood sexual abuse.[51] For me and many women who have been victims of psychological abuse, it has been therapeutic to see the truth behind the domestic

paradise myth revealed, but our rage and frustration continue as we try to comprehend the widespread nature of family violence.

<div align="right">

CONTEMPORARY ARTISTS RESPOND
TO DOMESTIC TERRORS

</div>

A new wave of consciousness-raising about home and family arose in the late '80s and early '90s, when artists began to compare the realities of housekeeping and the devastation of domestic violence to the well-publicized "family values" of the New Right. These artists made it clear that the home had become a battleground on two fronts—ideological and physical—and that the New Right's idealization of the nuclear family is far from the truth.

Building on the consciousness-raising and psychological truth-telling of seventies feminists, these artists are creating an exciting new political movement with art that graphically depicts the effects of physical and psychological violence and advocates change to alleviate the suffering. Abuse victims who are not artists are also exhibiting paintings and sculpture describing their experiences and a number of artists are involved in community projects to heighten public awareness. At issue is not only the battle of how to define "the family" but the question of how to restructure it for survival in the twenty-first century.

The Museum of Modern Art's photography show "The Pleasures and Terrors of Domestic Comfort" (September 26–December 31, 1991) showed the home under ideological siege. Missing altogether were any references to the important domestic issues of violence and child abuse. But, while a range of white middle-class affluence was shown in the photographs (hardly any nonwhites were pictured), many of the people looked unhappy and estranged from their own lives. Photography curator Peter Galassi says, "In the 1980's the political right and left rediscovered the bitterness of their mutual antipathy, nowhere more deeply than in their shared conviction that the home is a major battleground of social struggle."[52]

Many of the photographers depicting this struggle were born in the early years of postwar affluence and must have compared their family lives unfavorably to those in *The Brady Bunch,* a '70s TV model of American family life (two single parents with three children apiece created a combined family of eight—all the children were blond; we were never told what happened to the parents' former mates). The housewife-mother had a maid. This paean to affluence showed a life where no work

was done, not even by the maid. Everything happened in a big, isolated suburban home where the parents were mostly pals, money flowed in, and food appeared.[53]

In the Museum of Modern Art's show, the home as battleground is amusingly and chillingly presented in Ken Botto's photograph, *Fort Winnebago* (1986), where a doll house with a plastic figure of a girl skipping rope and a toy Winnebago parked in front are protectively flanked by a toy tank. Lorie Novak's *Fragments* (1987) shows a shattered dream of family togetherness.

Mary Frey harks back to *The Feminine Mystique* with her ironic comments on the banality and mindlessness of housework in her *Untitled* photograph from her "Real Life Dramas" Series (1984–87) in which a middle-aged woman wearing a cleaning smock kneels with dustpan and broom in hand, lost in thought. The romance-novel caption says, "She quickened with the realization that things would never be the same."

"Dirt and Domesticity: Constructions of the Feminine" (June 12– August 14, 1992) at the Whitney Museum of American Art at the Equitable Center, New York City, explored the historical definition of femininity as the way in which women manage dirt. Cleanliness became a way of dividing women along class and racial lines as well as enforcing second-class citizenship because of their sexual "lack of cleanliness." In *Accept This Fact* (1987), Toby Lee Greenberg shows a woman from the fifties saying bitterly, "What's the use" as her husband walks out the door. Romance has fled from her life because she is not as good a housekeeper as her neighbor. Greenberg's work makes it clear that dirt never goes away; it just has to be hidden from men.[54]

In *She Was, She Wasn't* (1991), Myrel Chernick explores the relationship between the messages of motherhood and the messages of femininity with slide-projected texts on pink or blue backgrounds (for the genders of her children). In one set of slides she describes her infant daughter's preoccupation with napkins and dishtowels which the one-year-old child arranges around the house. Chernick wants to show there's a 'messiness' between motherhood and femininity: To be feminine you must have a neat house; to be a mother you must tolerate a messy one. Their messages self-destruct each other.

Ann Hamilton's *Still Life* (1988) of 800 men's white shirts which are folded, starched, singed, gilded and piled on a table, suggest the hours of tedious labor involved and recall the performance of *Ironing* at *Womanhouse,* in which one sheet after another was ironed (causing some audience members to run out, angry that they had to watch such boring, repetitive work).[55] Carrie Mae Weems' photograph of a *Bride* (1989)

showing her in her wedding portrait with her mouth taped shut, reminds us that marriage silences the bride. Funereal-looking artificial flowers in tall wicker baskets are placed in front of the photograph, recalling the bride on the staircase at *Womanhouse* whose train grows gray as it descends to the kitchen. Exhibitions examining this form of female oppression are an optimistic and cautionary sign that younger women (and men) understand what the domestic world that they're being encouraged to reenter involves. This renewed concern with housework may also have prompted *Ms.* magazine to reprint Patricia Mainardi's classic essay, "The Politics of Housework," in its May–June 1992 issue.[56]

Installation artist Sherry Millner considers the modern family a kind of training unit that is being used by the New Right to promote the ideology of war. *Protective Coloration,* her 1991 installation at Artists Space in New York City, is a humorous but message-filled presentation of the modern nuclear family in a setting that looks like a Natural History diorama.[57] The Mercs, as Millner calls them, are dressed in combat camouflage and stand in a living room full of camouflage-patterned furniture and artifacts identified with aggressive military action. A photograph of Rambo hangs next to a painting of Christ and scenes from Vietnam alternate on the TV with a sales video for submachine guns featuring wholesome college girls in bikinis and high heels, who demonstrate the guns as they talk about how "sexy" the guns feel. Sex and violence are tied together in the patriarchal love of war, she says.[58]

Millner, who participated in the CalArts Feminist Art Program in 1974, recalls the powerful imagery and anger of *Womanhouse* in *Protective Coloration.* She sees the "home front as the last battlefield, as under siege" with the New Right trying to make us "comfortable with the images of death" in this life-and-death struggle for control of the nuclear family as a training ground for future wars. Camouflage, she says, not only indicates the warlike nature of the struggle but also the need to "deceive the observer" by hiding the true identity of an object. "No detail is too small" to be overlooked by the New Right, she says. Even toys are used to reproduce social relationships and promote the siege mentality.

Although the image of the nuclear family has become more important as we have fewer of them, it is no longer possible economically or psychologically for women to return to the home, even though they're forced to take the blame for the family's disintegration, says Millner. She thinks that images of the family should move into community models, recalling architect Dolores Hayden's models for collective living during the thirties that included a common kitchen and laundry room and child

care on the premises—a form of communal labor that capitalism has never allowed.

Domestic violence and abuse was the subject of a number of exhibitions during 1992. In "Songs of Innocence, Songs of Experience" (March 27–June 3, 1992) at the Whitney Museum of American Art at Equitable Center, Meg Cranston's work reminded us of the psychological violence still experienced by young girls. *Play Dumb* (1988), written in bright blue letters on a broken antique drum, speaks to the ancient, repressive but still treasured tenets of traditional female socialization—be subservient, act stupid, keep quiet.

Mike Kelley uses well-loved, oft-played-with stuffed animals to represent sexually abused children. In *Fruit of Thy Loins* (1990), his worn toy animals issue forth from the body of a large rabbit, implying that they will produce more of the same, while the rabbit stands with outstretched arms seemingly indifferent to his much-handled brood.

Collier Schorr combines words and childhood images to convey the fear and craziness of both psychological and physical abuse. In *The Cat and the Cow* (1967–91) a small, plaster-covered baby's dress symbolizing feminine socialization seems mute, but the lining is full of phrases that define ("Sweet as Sugar"), taunt ("Come closer I won't hurt you"), and indicate abuse ("Uncle Rick was here '71"), revealing childhood as sexual and violent. In her *Housetrap* series (1970s–1990s) doll houses become traps that snare innocent children with betrayal and abuse instead of providing safety and love.

Cindy Sherman presented a shocking, dehumanized, and traumatic view of sex that could be seen as representing childhood sexual abuse in her 1992 New York exhibition.[59] She photographed dolls and prosthetic devices that were combined to create grotesque versions of pornographic poses and fetishistic sex. *New York Times* critic Charles Hagen said Sherman "seems to be exploring a child's view of sex and sexuality in which sex is both monstrous and mechanical."[60] In one untitled work a green mannequin has a chest that looks like a monster mask and a penis that seems to unwrap, dripping semen at its tip. Photographs of enlarged genitals and a forced sexual act equate sex with brutality.

Peggy Diggs's concern with the devastating effects of physical and sexual violence *and* with the ways artists can reach out to help the victims was seen in her mixed-media show, "The Domestic Violence Project" (February 8–April 18, 1992) at the Alternative Museum in New York. Strongly influenced by Angela Browne's book, *When Battered Women Kill,* Diggs has conducted extensive research among women who have been jailed for killing abusive husbands to identify images that would

convey the fear and terror of violent abuse in a new way. Although it seemed a cliché, she found the most potent image for abused women to be a hand coming toward them. In her sculpture *The Position,* a room-sized hand covered with burned matches descends ominously on the figure of a victim made of wire screening covered with a suit of copper nails (for survival) who is caught between the impending violence and a child lying nearby.

One of the women Diggs interviewed was imprisoned in her home except for grocery shopping. This women said, "I didn't know I wasn't alone in this. . . . I didn't know I was a battered wife. . . . If I had only known there was a battered woman's shelter two blocks from my house I would have been able to get help." She said art about physical violence had to reach women who may not be looking for help but happen to see it on a bread wrapper or a milk carton. Diggs created a message that Tuscan Dairy in Union, New Jersey, ran on its milk cartons in January 1992: huge fingers curled into a snarling mask framed the sentence "When you argue at home, does it always get out of hand?" Underneath it said, "If you or someone you know is a victim of domestic violence, call: National Domestic Violence Hotline" followed by an 800 number. Many calls were received, says Diggs, and they are still coming in.[61]

Y Core, a Chicago art consulting firm that organized "Women's Work," a community-based arts project aimed at raising consciousness and promoting social change on women's issues nationwide, has launched the Domestic Violence Awareness Campaign for San Francisco. Barbara Kruger, Carrie Mae Weems, Susan Meiselas and other artists are working with social service agencies to create billboards and transit-stop images that will encourage victims to seek help.[62]

Interest in domestic violence has swept across the country, becoming the subject of a number of art shows. "House on Fire," an exhibition on child abuse, was held at the Howard Yezerski Gallery in Boston in July 1992, in memory of a man who had been severely sexually abused by his father.[63] "The Home Show" (June 5 – July 17, 1992) at the Center for Creative Studies, Detroit, featured sixty works on the emotional toxicity of the home.[64]

"Goodbye to Apple Pie: Contemporary Artists View the Family in Crisis" at the DeCordova Museum and Sculpture Park in Lincoln, Massachusetts (September 19–November 29, 1992), was the first museum exhibition to survey what assistant curator Nick Capasso calls "the growing trend in contemporary American art: the impassioned involvement of artists with themes centered on the acute internal and external stresses

experienced by families today." Thousands of artists, says Capasso, have turned to the family as their primary subject matter.

This show of seventy works by eighteen artists focused primarily on personal experiences of domestic violence and abuse, the societal factors that contribute to it, and the facades families erect to hide the truth. Many of these artists operate in the public realm, creating art that advocates change and attempts to solve family crises. Many of their works have also been excluded from exhibits because of their disturbing content and confrontational approaches.[65]

Capasso has found that art by incest and child abuse survivors is a grass roots phenomenon going well beyond the art world. The "most disturbing show I've ever seen," he says, "was 'The Art of Healing,' " a nonjuried show of 400 art works by incest survivors, organized by psychotherapist Judy Wilbur-Albertson and exhibited in May 1992 at Lake Shore Hospital in Manchester, New Hampshire.[66] Wilbur-Albertson, a sexual assault survivor and painter as well as a therapist, has been dealing with women's issues for the past twenty years. Currently, she works with women who are sexual assault survivors. She has found art is a safe way of describing one's trauma, particularly for members of abusive families who have not been allowed "to speak or seek the truth."[67]

Although much of the work in "The Art of Healing" is not of gallery quality, it helps both survivor and viewer exorcise their pain and no longer see themselves as crazy. Exhibitors become different people, she says, because they finally feel they have value. They can speak of what has happened to them with no stigma and be understood by others who share their experience. Her show, which is becoming an annual event, is the largest in the country, but others have been held in Texas, Maine, Rhode Island, Washington, and New York. A work from the 1990 "Art of Healing" show was used to illustrate the cover of psychiatrist Judith Lewis Herman's new book, *Trauma and Recovery*. The 1991 movie *Prince of Tides* also demonstrated that the most emotionally damaging aspect of child abuse is not being able to talk about what happened—a silence usually imposed by parents.

Installation artist Carter Kustera, like many other artists, feels the nuclear family is not a safe place for any of its members. In *Domicide,* exhibited at the Josh Baer Gallery, the nuclear family literally melted away: Wax figures of a mother, father, sister, and brother sitting on a couch were melted down by infrared lights, one figure each week of his exhibition.[68]

Kustera believes that everything that's misguided in society comes from the way children are treated in the family, and he feels the situation

is desperate. Two dining room installations dealt with the way families murder their members either literally or through noncommunication. A '30s vintage dining room featured a weapons table with implements used for killing—gun, rope, frying pan, ice pick—embedded in the wood under its glass top along with sepia family photographs. One person's head in each photograph was circled in red. A '50s dining room dealt with annihilation by noncommunication. TV monitors placed on the table revealed family members' thoughts and inattentiveness to each other. Kustera says he wants to "jolt people into the truth, so that families will realize they have to change what they're doing."[69]

For me and other '70s feminists this rising wave of political art dealing with domestic crises is cause for rejoicing. Curator Capasso attributes artists' current involvement with domestic violence to the ground-breaking work of feminism. Although he cites other contributing factors, such as the '80s return to narrative and figurative art, the influence of the healing arts movement (art therapy, New Age spirituality), and the vast amount of information coming from newspapers and talk shows he says, "I think it really is feminism that allowed these issues to be forefronted because 'the personal is political' has been so important. Feminism opened the doors for dealing with the body, the family, domestic life. Subjects like these were seen as not important before that."[70] Artists who raise issues of abuse, he says, are threatening patriarchal society at its roots.

Notes

1. Phyllis Rosser, "A Housewife's Log: What She *Really* Does All Day," *Ms.* magazine, March 1976, pp. 54–57.
2. Ibid., p. 55. Actual journal contained an average of fifty-two items per day.
3. Only the lives of white, heterosexual middle-class women will be discussed in this chapter. Women of color, particularly African-Americans, have experienced domestic life in very different ways.
4. Betty Friedan, *The Feminine Mystique* (New York: Dell Publishing, a Laurel Book, 1983), p. 306. The author's intention is not to trivialize the experience of Holocaust survivors with this comparison but to indicate the level of despair she felt at this time.
5. Friedan, *The Feminine Mystique*, p. 18.
6. Edith M. Stern, "Women Are Household Slaves," *American Mercury,* January 1949.
7. Friedan, *The Feminine Mystique*, p. 308.
8. Judith Lewis Herman, *Trauma and Recovery* (New York: Basic Books, 1992), p. 32.
9. Ibid., p. 28.
10. Marisol, *Women and Dogs* (1964), Collection of the Whitney Museum of American Art, New York.

11. Sandy Skoglund, *Gathering Paradise,* Installation at P.P.O.W. Gallery, New York, September 1991.

12. All quotations are from Sandy Skoglund's interviews with the author in New York, May 1992.

13. Karal Ann Marling, "City Bashing Through the Ages," review of Elizabeth Wilson, *The Sphinx in the City* (Berkeley: University of California Press, 1992), *New York Times Book Review,* May 10, 1992, p. 14.

14. Friedan, *The Feminine Mystique,* pp. 244, 250.

15. Ibid., p. 251.

16. *Ms.* magazine, Spring 1972, preview issue, pp. 54–59. Before *Womanhouse* only a few women artists had worked with "household imagery," according to critic Lucy R. Lippard (*From the Center: Feminist Essays on Women's Art* [New York: E. P. Dutton, 1976], pp. 56–60), because they feared these "feminine" subjects wouldn't be taken seriously. During the sixties women used domestic images to say something else—about isolation (Muriel Castanis's furnished domestic environments made from cloth stiffened with epoxy) or lost innocence (Sylvia Mangold's paintings of bare wooden floors close up)—rather than as ends in themselves. Men, on the other hand, "moved into woman's domain and pillaged with impunity" to create Pop Art, "the most popular American art movement ever," says Lippard. "Since it was mainly men who were painting and sculpting the ironing boards, dishwashers, appliances, food and soap ads or soup cans the choice of imagery was considered a breakthrough." Their art glorified household objects but not the work that was done with them.

17. Arlene Raven, *Crossing Over: Feminism and Art of Social Concern* (Ann Arbor: U.M.I. Research Press, 1988), pp. 91–115.

18. Ibid., p. 91.

19. Eleanor Munro, *Originals: American Women Artists* (New York: Simon & Schuster, 1979), pp. 280–81.

20. Raven, *Crossing Over,* p. 90.

21. Lippard, *From the Center,* p. 60.

22. Ibid., p. 58.

23. Susan Faludi, *Backlash* (New York: Crown Publishers, 1991), pp. 80–81.

24. Ibid., pp. 75–111.

25. Ibid., pp. 41–42.

26. Ibid., pp. 92–93.

27. Jerry Falwell, *Listen America* (Garden City, N.Y.: Doubleday/Galilee, 1980), p. 151; Paul Weyrich, *Conservative Digest,* 6, 6 (June 1980): 12. Cited in Faludi, *Backlash,* p. 232.

28. Faludi, *Backlash,* p. 124.

29. Ibid., p. 125.

30. Ibid., p. 124. Faludi notes that heroines in female quest movies did not withdraw into themselves. They became actively involved in issues beyond the domestic sphere, trying to transform not only themselves but the world around them. Vanessa Redgrave and Jane Fonda fought for human rights in *Julia;* Sally Field fought for workers' rights in *Norma Rae;* and Jane Fonda exposed nuclear hazards in *The China Syndrome.*

31. Ibid., p. 113.

32. Stephanie Harrington, "Mary Hartman: The Unedited, All-American Unconscious," *Ms.* magazine, May 1976, pp. 53–55.

33. Faludi, *Backlash,* pp. 160–67.

34. Ibid., p. 145.

35. Roseanne Arnold, "HBO Comedy Hour," *Roseanne,* July 2, 1992, 10:45 P.M.

36. Tamara K. Hareven, "American Families in Transition: Change and Continuity," in *Goodbye to Apple Pie: Contemporary Artists View the Family in Crisis,* ed. Nicholas Capasso (Lincoln, Mass.: DeCordova Museum and Sculpture Park, 1992), p. 12.

37. N. C. Andreasen, "Posttraumatic Stress Disorder," in *Comprehensive Textbook of Psychiatry,* 4th ed., ed. H. I. Kaplan and B. J. Sadock (Baltimore: Williams & Wilkins, 1985), pp. 918–24.

38. In 1977 in Los Angeles, Suzanne Lacy presented *Three Weeks in May,* a large-scale performance art work about rape that included thirty-three events intended to raise public consciousness and promote private healing. Described in Arlene Raven, *At Home* (Long Beach, Calif.: Long Beach Museum of Art, 1983), p. 36.

39. Susan Brownmiller, *Against Our Will: Men, Women and Rape* (New York: Bantam Books, 1976), p. 5.

40. Faludi, *Backlash,* p. xiv.

41. Cheri Gaulke, "At Home in Women's Performance Art," in Raven, *At Home,* p. 59. Another important exhibition on this subject, not mentioned in this chapter, was the "Home" show (1987) organized by Faith Ringgold at the Goddard-Riverside Community Center, New York City, which included the paintings, sculpture, photographs, drawings, and installations of eighty-two artists who dealt with both domestic violence and the plight of the homeless. (Arlene Raven, *Village Voice,* May 26, 1987.)

42. "Unlocking the Door: An Action Program for Meeting the Housing Needs of Women," Women and Housing Task Force, 1988, National Low-Income Housing Coalition, p. 8. Cited in Faludi, *Backlash,* p. xvii.

43. Faludi, *Backlash,* p. xvii.

44. Carol Lawson, "Violence at Home: 'They Don't Want Anyone to Know,'" *New York Times,* August 6, 1992, p. C1.

45. Diana Jean Schemo, "Amid the Gentility of the East End, A Town Confronts Domestic Abuse," *New York Times,* August 13, 1992, p. B7. Lawson, "Violence at Home."

46. Murray Strauss, cited in National Violence Prevention Fund, *National Domestic Violence Media Campaign Executive Summary,* San Francisco, Spring 1992, p. 1.

47. Raven, *Crossing Over,* p. 114.

48. Louise Armstrong, *Kiss Daddy Goodnight: Ten Years Later* (New York: Simon & Schuster, 1987), p. 275.

49. Ida Applebroog, *Boboli Gardens* (1987), Collection of the Williams College Museum of Art, Williamstown, Mass.

50. Arlene Raven, *Nancy Grossman* (Brookville, N.Y.: Hillwood Art Museum, C. W. Post Campus, Long Island University, 1991), p. 133, and author's interview with Nancy Grossman in New York, December 1991.

51. Alice Miller, *Banished Knowledge: Facing Childhood Injuries* (New York: Doubleday, 1990); John Bradshaw, *Bradshaw On: The Family* (Deerfield Beach, Fla.: Health Communications, 1988); Judith Lewis Herman, *Father-Daughter Incest* (Cambridge: Harvard University Press, 1981).

52. Peter Galassi, *Pleasures and Terrors of Domestic Comfort* (New York: The Museum of Modern Art, 1991), p. 54.

53. Herbert Mitgang, review of Bill McKibbon, *The Age of Missing Information* (New York: Random House, 1992), *New York Times,* April 22, 1992, p. C19.

54. Jesus Fuenmayor, Kate Haug, and Frazer Ward, *Dirt and Domesticity: Constructions of the Feminine* (New York: Whitney Museum of American Art, 1992), p. 6.

55. Judy Chicago, *Through the Flower: My Struggle as a Woman Artist* (New York: Doubleday, 1975), pp. 122–23.

56. Patricia Mainardi, "The Politics of Housework," *Ms.* magazine, May–June 1992, pp. 40–41.

Originally published in *Sisterhood Is Powerful,* ed. Robin Morgan (New York: Vintage Books, 1970), pp. 447–53.

57. Sherry Millner, "Protective Coloration," in *Working,* an exhibition of six media installations investigating power relations, at Artists Space, New York, November 21, 1991–January 11, 1992.

58. All quotations are from author's interview with Sherry Millner in Amherst, Massachusetts, May 1992.

59. Cindy Sherman, exhibition of photographs, Metro Pictures, New York, April 11–May 9, 1992.

60. Charles Hagen, "Cindy Sherman," *New York Times,* April 24, 1992, p. C32.

61. All quotations are from the author's interview with Peggy Diggs in Williamstown Massachusetts, May 1992. Sue Williams' show of drawings and sculpture at the 303 Gallery, New York (May 1992) graphically depicted physical violence against women. In *Lover,* a sculpted fist smashes into a woman's face. In *Irresistible,* the rubber body of a naked woman lying on the floor is covered with bruises and phrases that blame the victim—"Look what you made me do," "I think you like it Mom." The figure is based on Donna Ferrato's photographs of domestic violence. Art critic Elizabeth Hess says Williams "taps into a vein of female anger that verges on flying out of control" ("Spiritual America," *Village Voice,* May 19, 1992, p. 101).

62. Capasso, *Goodbye to Apple Pie,* p. 24.

63. Author's interview with curator Tom Grabowsky in Boston, July 1992.

64. Author's interview with Peggy Diggs in Williamstown, May 1992.

65. Nicholas Capasso, project description of the exhibition "Goodbye to Apple Pie: Contemporary Artists View the Family in Crisis," DeCordova Museum and Sculpture Park, Lincoln, Massachusetts, 1992.

66. Author's interview with Nicholas Capasso in Lincoln, Massachusetts, May 1992.

67. All quotations are from the author's interview with Judy Wilbur-Albertson in Portsmouth, New Hampshire, July 1992.

68. Carter Kustera, *Domicide,* installation, Josh Baer Gallery, New York, February 22–March 28, 1992.

69. Author's interview with Carter Kustera in New York, May 1992.

70. Author's interview with Nicholas Capasso, May 1992.

THE BODY IN QUESTION
Rethinking Motherhood, Alterity and Desire

Andrea Liss

In my continuous research toward thinking difference and desire other than markers of discrimination and inscriptions of unidirectional control, I turned to feminist philosopher Elizabeth Grosz's definition of ethics:

> In the work of French feminists, ethics is not opposed to politics but is a continuation of it within the domain of relations between self and other. Ethics need not imply a moral or normative code, or a series of abstract regulative principles. Rather, it is the working out or negotiation between an other (or others) seen as prior to and pre-given for the subject, and a subject. Ethics is a response to the recognition of the primacy of alterity over identity. Ethics, particularly in the work of Emmanuel Levinas, is that field defined by the other's need, the other's calling on the subject for a response. In this case, *the paradigm of an ethical relation is that of a mother's response to the needs or requirements of a child.*[1] (emphasis added)

I knew that my attraction to Grosz's way of thinking, even in this short excerpt, would yield areas of touching between difference and desire. The strategic import of recognizing interpersonal relations as political investment. Making room for an other who would not be construed as so distant that there could be no points of convergence between self and other. Not confusing places of merging as sameness. Respecting independent otherness. As I continued reading, my musing/theorizing

came to a halt when I reached the point in Grosz's discussion where the mother was introduced. I was riveted by her representation, following Emmanuel Levinas, that the perfect exemplar of the ethical relationship is that of the mother's lack of selfhood ("the primacy of alterity over identity") and her complete giving to the child. Indeed, is this not a contemporary reworking of the all-too-pervasive legacy of the sacrificial (virgin) mother? My feminist-mother self felt betrayed. How disheartening to find, in a book titled *Sexual Subversions,* the figure of mother again, ad infinitum, at the selfless center bearing the burden of representation and singular responsibility. We can't blame Grosz, my microconversation with myselves continued, she's not speaking for herself. She's offering a concise recapitulation of Levinas's complex and alluring conception of self and other in an encounter where they might meet in the new space of alterity.[2] Yet, for all of Levinas's attempts to detour the self-righteousness embedded in much of Judeo-Christian ethics in order to reconfigure an expanded sense of self, he nonetheless falls into some central unquestioned biblical conventions. This often occurs in the instances when he weaves the figures of woman and mother into his writing.[3]

Feeling I had fairly well satisfied my unease with that portion of Grosz's passage, I wanted to move on. But I couldn't cut myself loose from it: "the paradigm of an ethical relation is that of a mother's response to the needs or requirements of *a child.*" Wait a minute. There was something oddly impersonal in this description of the most perfect of intersubjective ethical relations. Why didn't the passage read "her child" rather than "a child"? Was this distancing the author's perhaps unconscious fear of the child and/or her recognition of the impossibility of the mother in this paradigmatic relation?

It's 2:30 P.M. already. Naptime at The Song of Songs Preschool. Miles is probably in luxurious sleep by now. I feel myself relax a bit. This is time I couldn't be with him anyway, so theoretically it doesn't have to be as productive as the hours when he is awake and out of the house. If only he could be transported here during naptime so we could be in each other's presence. I could continue to work, feel my love for him, but not have to attend to any of the care-giving. So I'm not the most ethical mother.

When Levinas was thinking about the ethical mother, he did not endow her to muse on child care, economic or professional concerns. But Marx and Darwin weren't thinking about their mothers at all. Freud thought about his perhaps in excess. Rather than being theoretically violated as the site of sensational lack as in Freud's conception, the Levinasian mother has the agency of caring, of not turning the other

cheek. Caring and empathy, you (and I) might say, are the quintessential qualities traditionally coded as feminine, maternal. Who wants them? Let's give them up. But watch out, what we just gave away could become valued commodities and we'll be written out of the profits. An infinitely more difficult strategy whose benefits would be longer term, however, is to embrace just these qualities and not allow them to be kept solely in the private realm, assigned to their "proper place." Much more subversive is to embrace maternal giving and set it into motion in unexpected places rather than to passively/aggressively let it be stolen from us and allow ourselves to become men-women in a man's world. In other words, to grant oneself the gift of what is normally taken for granted.

At stake then is strategically negotiating between engrained codes of maternity and embracing the lived complexities of chosen motherhood. This, as you can imagine, is hazardous double labor. There is no other body so cruelly and poignantly posed at the edges dividing the public and private realms. The taboo interdictions brought to bear on the body of the mother continue to be maintained precisely because notions of motherhood are so heavily laden with assumptions of naturalness and passivity. The issue may still be so silent, too, because of the uncertainties surrounding the issue of sacrifice related to women in a supposedly "postfeminist" culture. The dilemma becomes, indeed, how to speak of the difficulties and incomparable beauties of making space for another unknown person without having those variously inflected and complex experiences turned into clichés of what enduring motherhood is supposed to be. Such tyrannical moves occur in the propaganda where the diverse complexities are so flatly neutralized that the (feminist) mother finds part of herself being dumbly celebrated as the paradigm of domesticity and compliance to the limits of passivity in the (perverse) name of patriotism. Especially if that public mother has stepped too far out of her assigned place. Remember Hillary Clinton reduced to participating in a chocolate-chip cookie bake-off with Barbara Bush? The (Im)Moral Majority's failed rhetoric is also embedded, however differently and unconsciously, in the minds of many feminists. There is the silent sympathetic assumption that we will involuntarily lose part of our thinking creative (male) minds when children are borne from our all-too-female bodies.

How could I blame them for thinking this? During pregnancy and immediately afterward, I had my own always-in-flux fears. My anxieties kept the body and mind intact, time is what I couldn't make sense of. "Will you be going back to work in three months?" asked one of my maternity nurses in the disembodied voice of an unemployment benefits officer. Little did she know that my life was about constantly thinking and

working. Her foreign question was unwelcome and lodged itself in the private hospital room made public where my newborn child and I had come to know each other for only one day.

Then there is the false belief that these equally mindless creatures called infants will turn our heads to mush from our so-called idle hours of adoration or devour us by their own frighteningly relentless bodily needs. The hazards in approaching these half-truths are that, of course, these conditions exist, if only partially and temporarily. The taboo against representing motherhood again strikes deep because the real pleasures of caring for a new other and falling in love again differently are tyrannically conflated with essentialized, feminized qualities projected as implacable and designed to keep us assigned to our proper places. The "truth" is that we are constantly in motion, are never only in one place. We work against allowing "mother" to slip into a place of nostalgia for the norm. The mind and body of the mother are constantly in labor.

I wonder if I am risking too much here, conjoining my voice as an art historian–critic with my newly-acquired mother chords/cords? In a rare public forum on motherhood initiated by Mira Schor and Susan Bee in their *M/E/A/N/I/N/G* magazine (No. 12, November 1992), the editors posed a series of questions to a diverse group of women artists who are mothers. These included, "How has being a mother affected people's response or reaction to your artwork? How has it affected your career? Did you postpone starting your career or stop working when your children were young?" May Stevens chose not to respond to the questions the editors addressed to her. Here is what she offered as a counterresponse:

> How many artists are fathers? How has it affected their work, people's response to their work, their careers? Did Jeff Koons or Frank Stella postpone their careers in order to take their responsibilities as fathers seriously? Did Pace, Castelli, Sonnabend, or Mary Boone discriminate against Schnabel, Salle, or Marden because of fatherhood? . . .
> I will be very happy to discuss questions of motherhood after your journal seriously researches fatherhood among artists. In the present, when women bring up children alone and bear primary—often sole—responsibility, financial and emotional, for the next generation, it's fatherhood that needs looking at. (P. 40)

Indeed, Stevens's warning call is absolutely necessary, lest public discussions of the dilemmas facing artist-mothers involuntarily shield the "prolific artist" father who so gratuitously moves between the public and the private realms. But such a warning cannot be sent at the cost of silencing the mother, again. Indeed, as the editors wrote in their introduction to the forum, "[T]he subject proved too painful for some artists who

couldn't write responses. More than one artist wondered how we'd found out that she *had* a child, so separate had children been kept from art world life" (p. 3). When I recently told a male academic colleague that I was writing an essay on motherhood and representation, he enthusiastically suggested that there must be a great deal of visual work on the subject. He said, "I would think that it would be natural." "What is 'natural' is the repression," I responded. It's about time the taboo was unleashed, for mother's sake. As Dena Shottenkirk so aptly put it in M/E/A/N/I/N/G/:

> Like morality, good manners, and a criminal record, motherhood has nothing to do with making art. Its presence neither improves one's ability, nor does it sap one's creativity like Nietzsche's worried model of having one's vital powers drained from sperm ejaculations. Giving birth does not automatically mean giving up. (P. 34)

The "one's ability" and "one's creativity" in this section of Shottenkirk's account is strategically interpolated as both male and female. It is women, however, who give birth. And, as artist Joan Snyder put it, "The bottom line is that you don't have to be a mother or a daughter to be discriminated against in the art world . . . you just have to be a woman" (p. 37).

At stake in breaching this taboo and giving birth to a new provocation is recognizing that motherhood and woman are passed over in the unacknowledged name of devalued labor, whether in procreation or artistic-thinking activity, within a patriarchal scheme crafted to inflate supposedly male qualities of rigor and singularly driven creativity. The uneven distribution of interest between woman and artist-thinker becomes all the more cruelly amortized in the case of mother as artist-thinker. "Mother" hovers as the uneasy subset to "woman" as well as silently operating as its unacknowledged frame. The devaluation of mother is always at once the devaluation of women. Conversely, and especially in relation to the current hateful debates and legal dogma against abortion, the degradation of women/woman is being forcibly exercised on her decision not to mother. "Mother" takes on an especially irregular symmetry to women/woman. Psychoanalytically construed, woman is always at a loss. The exception to her lesser condition is pregnancy, which gives her a provisional status of phallic proportions and privilege— another of Freud's dreams of plenitude. She immediately loses that privilege in the postpartum state. She is further insulted through the processes by which her children gain accession to "proper" or normal sexual coding. The young boy is traumatized by the difference in his and his

mother's genitals; her gaping hole (we are inclined to write this abyss as a whole) signals primordial lack. He can proclaim what he has as distinct from hers and find clear-cut identification with the father. And with that, he can take a sigh of relief.

Have you ever tried to tell your young son that he has what his father has? I recently asked my three-year-old if he thought his genitals were like his daddy's. "Oh yukky, mommy," he most independently proclaimed, "daddy's are daddy's, and mine are mine." "Do you have balls, mommy?" he then asked. "No," I replied, "I have doors, and openings and other things inside." Miles looked at me thoughtfully, "Oh, that's good." Pause. "Can we make Jell-O now?"

According to the psychoanalytic scheme, the daughter's sense of identification is more marred, less distinct (we would write it as infused with oscillation, open-ended). Because the sign of "mature" sexual development in psychoanalytic terms is separation, the girl too must make her leave of the mother. But imagine her dilemma: she has what the mother has but must denounce it. This disavowal must not be too strong lest the young girl loses all identification with the mother and tries to accede toward male identity. She must not cast off the memory of her own tainted incompleteness for it is her legacy to pass it on. The girl then becomes a mother and must undergo a triple debasement—her daughter's repudiation. So for the mother, Freud's deaccessioning of the feminine is a multiple site of violation. If woman is bodiless and the daughter is always the indistinct shadow of her mother, the mother (once a daughter) bears the impossible burden of being both the figure of invisibility and the embodiment of vulnerability, of exposed body. So the asymmetrical relation of mother to women/woman becomes even more acute. Between "woman" (the projection) and women (the deceitful ones who don't match up, who always inscribe their multiple selves onto the scene) there is forceful play. Ironically, "mother" has not been accorded an oscillating, de-referential term that acknowledges there is a real mother and that there are both grave and joyful differences between tyrannical expectations and lived experience. "(M)other" thus conflates the uneasy absence/presence of the mother's body in the non-space between palpable body and its impossible representation.[4]

Father's Day, 1989. I am ten moons pregnant and could give birth any minute. My brother is given a package of wildflowers to disseminate, although everyone's eyes are on me. So I take out the snapshots of a recent bike-riding jaunt, half forgetting/remembering that the roll also contains frames of my posed naked pregnantness. No one said anything until the photographs reached my husband's mother. "I didn't know you

were such an exhibitionist!" she shrieked. I enjoyed her embarrassed surprise, for it seemed to be ever-so-coyly tinged with her own mischievous delight. So let the prepartum gazes be multiple. What I had been thinking about was making traces of pregnancy for myself and for my then-opaque child, far from the Demi Moore glamour on the cover of *Vanity Fair.*[5] Not to promenade my body, but to show her/him that there are no stigmata attached.

Susan Hiller documented the changes her body underwent during pregnancy. In her artist's book and photographic sequence, *Ten Months* (1977–79), she framed images of her expanding belly in a grid format. Strategically presented to ensure that the body would not be voyeuristically violated, the photographs distance the belly from its owner in images that nonetheless convey a lovely eroticism both estranged from and akin to medical illustrations. Although presentations of the mini-monumental moments of pregnancy are crucial, they often usher in other problems by coding maternity solely on the image of the female body. Astonishingly few are representations that bracket the differences between mother (the projection) and mothers (with child[ren]), living the conflation/complexities of their lives.[6] Mary Kelly's *Post-Partum Document,* which began in 1973, of course comes to mind.[7] Working both ironically within and outside the bounds/binds of psychoanalytic theory, Kelly's labor- and time-intensive project meticulously establishes that the mother is anything but passive in the infant and young child's development. *Post-Partum Document* grants the mother an active writing and thinking position and an often preoccupied space within the Lacanian scheme of the child's Imaginary. The mother may well be the mirror for the child's as-yet-uninterrupted sense of wholeness, but she also reflects herself back to herself. The mother who meticulously measures her infant's intake of food, registers his excrement as traces and, later, inscribes the parallel registers of their conceptual development is the artist-mother simultaneously claiming these mini-memorials as her own fetishes for exhibition. It is also the mother who, in terms clearly oppositional to patriarchy's incising of the romanticized mother, proclaims the mother and the child's in(ter)dependence while admitting her uncertain guilt around the notion of the "good mother." She thus inscribes the mother-child relationship both against and within the grain. Indeed, it is Kelly's very adherence to the psychoanalytic scheme, both in the timing and phrasing of the fetish/memorials and in her own writing within the book, that creates the necessary oscillation between psychoanalytic litany and how the mother-child/son relationship is played out in the everyday. In one particularly potent section of the *Post-Partum Document* dealing

with, as Kelly phrased it, "the mother's ambivalence about working outside the home" and the psychoanalytic scheme of separation anxiety, Kelly typed texts from her diary onto cut-up fragments of her son's comforter. At the mark of her son's two-and-a-half years, she wrote: "K's aggressiveness has resurfaced and made me feel anxious about going to work. I can't count the number of 'small wounds' I've got as a result of his throwing, kicking, biting etc. . . . I'm not the only object of his wrath but I'm probably the source. Maybe I should stay at home . . . but we need the money" (p. 101). When her son turned two years and seven months, she wrote again: "I'm really enjoying my present relationship with K. going out to lunch, to the park, shopping together. There're no potty problems and few tantrums. He's fulfilling my fantasy image of a son as little companion-lover" (p. 103). It is both Kelly's poignant honesty toward and her rhetorical insistence on the often claustrophobic mother-child relationship, among other factors, that has granted the *Post-Partum Document* so much attention. Yet the very hazards of reproducing motherhood on the grounds of near-exclusivity from the Symbolic must be critically reconsidered today.[8]

Post-Partum Document was a crucial factor in British feminist debates of the 1970s centered around the uneasy status of representing women's bodies. In a long moment when women were reclaiming their bodies for themselves and Laura Mulvey was establishing theoretical and practical links between Freudian looking and the male film spectator,[9] it was a strategic feminist move to eschew easily available mimetic representations of women's bodies. What I am of course bracketing here are the debates between female essentialism and a more analytic stance that posits bodies and identities as highly constructed and exploited entities. Strategic as these ways of thinking were in the 1970s, crucial now are ways of representing that do not continue to allow the patriarchal scheme that divides women's minds from our bodies and our desires. *Post-Partum Document*'s schematic and indexical objects were thus fashioned at the farthest remove from ethereal images of pregnant mothers surrounded in religiosity or from equally untenable romanticized representations of mothers in the aftermath of birth. So what sense can we make of the startling photograph of Mary Kelly seated with her son on her lap, the unspoken image which serves as the book's frontispiece? Her dark shirt (could it be crescent moons printed on it?!) helps to highlight K's light-toned body and underwear. He stands out against her; his genitals are hardly contained within. She bends over looking down, while he resolutely holds a speaker in his hand and looks out with a determined, anchored gaze. Is this image included here as Kelly's way of breaching the

taboo against mimetic representation, even against her own grain? Or is this phallic image present to remind us, before we move into the mother's assertions, that it is the boy who really reigns? Now let's be fair. It wasn't Kelly's fault that she had a boy. How differently we would read this photograph if a girl were couched in the mother's lap with that steadfast gaze. How different would the body of Kelly's *Post-Partum Document* be had her child been a girl?[10]

"Mommy," Miles said to me the way he does, inflecting this laden term with a healthy mix of wonder, curiosity and skepticism (my projections?), "Mommy, pee like me. Stand up and do it." Holding back my laughter, I tried not to say I "can't," but that I do it another way. He insisted, "No, do it like me." When I couldn't stall him any longer, he broke out in a scream and a torrent of tears such as I had never seen before. Then came the dreaded "I hate you." A few seconds later, calm. He embraces me to comfort him. "Mommy, I love you."

"Don't you think that risks reifying essentialism?" was the response one of my feminist colleagues gave me when I told her I was inviting into the classroom the facts, falsities and experiences of my being a mother. "No," I remember saying, "I am scheming on my 'mother' identity in order to bring out multiple, conflictive responses and encourage new ways of thinking." The conversation did not progress on those grounds and turned to more "objective" discussions of which feminist writers we were currently reading. What I would want to say, to continue the discussion, is that when only one student in my Feminist Issues class brings in an image of a mother to my call for images of working women, we have much more work to do. I would want to say that, indeed, this strategy does verge on provocative ways of acknowledging the body of woman/ women/mother, those sensual and very sexed virgin spaces that must be conceived. That such conceptions help to breach the obdurate wall of fear that has so vehemently separated women's public and private lives. Call it essentialism if you like, but realize that such name-calling wrapped in binarism risks its own stultification. I would rather use my body as a site of knowledge than rhetorically give it up.

Writing on what she terms "essentialism with a difference," Rosi Braidotti asserts that:

> First and foremost in the revaluation of experience is the notion of the bodily self: the personal is not only the political, it is also the theoretical. In redefining the self as an embodied entity, affectivity and sexuality play a dominant role, particularly in relation to what makes a subject *want* to think: the desire to

know. The "epistemo-philic" tension that makes the deployment of the knowing process possible is the first premise in the redefinition of "thinking as a feminist woman."[11]

The strategic move on Braidotti's part to affirm the sexed female "I" is not to be confused with a fantasized and ultimately patriarchal will toward exclusionary power. It is a provisional working politic that, it seems to me, would find an uneasy alliance with the essentialism of the 1960s and 1970s. In terms of visual representation I am thinking particularly about Judy Chicago's *Birth Project,* begun in 1980 and published in book form in 1985, whose emphasis is so insistently focused on the physical/spiritual body of the universalized mother that the complexities of her material body in a politicized world are kept out of reach.[12] The 1990s "essentialism with a difference" stands in closer relation with French feminism and *féminine écriture* and is careful not to pose itself in binary opposition with the history/culture dyad. As Braidotti thinks it:

> The "body" in question is the threshold of subjectivity: as such it is neither the sum of its organs—a fixed biological essence—nor the result of social conditioning—a historical entity. The "body" is rather to be thought of as the point of intersection, as the interface between the biological and the social, that is to say between the socio-political field of the microphysics of power and the subjective dimension. (P. 97)

The political project in redefining "essentialism with a difference" is precisely to disengage the female "I" from its bindings, as Braidotti puts it, "defined as the dark continent, or of 'femininity' as the eternal masquerade" (p. 103). "Far from being prescriptive in an essentialist-deterministic way," she writes, "it opens a field of possible 'becoming' " (p. 102).

To assert the sexed "I" of the woman then becomes, indeed, a doubled and risky reinvestment in the body of mother. Claiming there is a body in the maternal subject might be, to some, stating the obvious. But in the face of this "natural body," this material presence, the patriarchal mode has manufactured the mother/woman into a site upon which it occupies feminine territory as mystery, artificiality and emptiness. To reassert the sexed "I" of the mother engages her sexuality in a new field of becoming.

It is altogether fitting, if not inevitable, that Luce Irigaray's body of thinking would surface in any discussion about reinvesting the name of the mother. Merely coupling in the same sentence "essentialism" with Irigaray's own name enters the battlefields at war over her particularly provocative inflection on the body of woman and women's bodies.[13]

What I would like to highlight here is the special significance Irigaray gives to the body of woman and the doubled rhetorical insistence she accords the body of mother. Through her incisive and strategically "excessive" language, language rejoicing in women's bodily fluids and mindful openings, Irigaray renders psychoanalysis's feigned posturing an impostor. That is, male-inflected psychoanalytic theory tells us that we are being too literal if we read the phallus as solely biological and confined only to male member/ownership. It functions, after all, as a figure and a sign. But, let's remember, there is no corollary ambiguity when it comes to female members. Irigaray plays on this unbridgeable difference with a vengeance:

> Speculation whirls round faster and faster as it pierces, bores, drills into a volume that is supposed to be *solid* still. . . . Whipped along spinning, twirling faster and faster until matter shatters into pieces crumble into dust. Or into the substance of language? The matrix discourse? The mother's "body"? . . . *The/a woman never closes up into a volume.* . . . But the woman and the mother are not mirrored in the same fashion. A double specularization in and between her/them is already in place. And more. For the sex of woman is not one.[14]

In rethinking the body of mother as a palpable, thinking space, I think back to the 1976 film by Laura Mulvey and Peter Wollen, *The Riddle of the Sphinx*. Conceived within many of the debates out of which Mary Kelly's *Post-Partum Document* arose, this complex and lovely film reminds us, in our 1990s research for (im)possible representations of motherhood, that the issue is not necessarily about figuring mother as a paradigmatic body but endowing her with the space to look. Among many of its cinematic moves as well as the mother's economic and psychic transformations in the film, it is the camera's slow, sensuous caressing and often circular trajectories within the domestic/social spaces of the kitchen and the child's room that project a different guiding system for the gaze.

Indeed, that the Lacanian gaze has more recently been construed as male is not only one (unfortunate mis)reading of Lacan but a giving up of the very place where maternal touching can be reconfigured and differently insinuated. In his well-known essay "The mirror stage as formative of the function of the I as revealed in psychoanalytic experience," Lacan describes the mirror stage as the obscure border between the fragmented self and its imagined double, its *imago*.[15] On one level, Lacan's conception of the mirror stage is based on child development: that infants from about six to eighteen months find pleasure, comfort, and amusement (Lacan's translated wording is "jubilant assumption") in

viewing their specular image. The emphasis on the young child gazing into a mirror or at the mother's body is a highly appropriate image, steeped as it is in relations between vision and the body. It highlights the complex and patrolled intersections between the private and the public, the biographic and the collective, the psychic and the political. Indeed, the body is the stage on which these divisions leave their traces. It is especially significant that Lacan would place such weight on the image of two bodies facing each other in an asymmetrical relation. That is, the body of the infant/child not yet in full control of its motor faculties and the false fullness of its reflected image, either in a mirror or in the body of another/mother. Lacan handles the difficulty of conceiving both the processes and the effects of the reflected/projected image of the physical body onto the psychic body through thinking it in the following manner: "the mirror-stage would seem to be the *threshold* of the visible world" (p. 3, emphasis added). Thus, the mirror stage is not simply the self's entrance into another, more stabilizing form, leaving the mother behind in the Imaginary for accession to the realm of language. Nor is the transformation of the child into the Symbolic a clear-cut division. A threshold is decidedly that place always bridging the next stage of entry. It is also the sill of the door, its buffer between inside and outside. The term "threshold" also carries both a physiological and psychological significance, being the point at which an effect begins to be produced. If the threshold that the mother signifies is not easily crossed, it may well remain as a coherent trace of the splintery cushioning of the once unmarked self. Thus if the mother's body is coded as the site of specularization and assurance for the child, we know that the space of temporary intactness she holds for the child is maintained through her own touching and caressing, and that the surveying gazes are reciprocal.

"Ethics . . . is that field defined by the other's needs, the other's calling on the subject for a response. In this case, the paradigm of an ethical relation is that of a mother's response to the needs or requirements of a child." It has been two and a half years since that passage, in the echo of Levinas, arrested me. It seemed an impossible burden for the mother (me, and many others) to bear. Even outside of the mother paradigm, it has been noted that Levinas's philosophy puts an enormous weight of ethicalness not only on the subject, but also on the other who is asked to call the subject to responsibility.[16] Yet the mother's responsibility no longer seems so formidable. In the Levinasian sense, it simply is. And one responds. Responding and giving to the child's utter otherness is, indeed, an act of sacrifice. Rather than construing the mother-child relation as an essentialized binding, the coupling can be embraced as yielding the fruits

of reciprocal relations. The task now is to think the mother-child paradigm in its material complexities as well as a metaphor for new relations of alterity between sexes, races and classes. In relation to the infamous Baby M case, feminist legal contract lawyer Patricia J. Williams juxtaposes her mixed ancestry with the legal ramifications of "likeness":

> A white woman giving totally to a black child; a black child totally and demandingly dependent for everything, for sustenance itself, from a white woman. The image of a white woman suckling a black child; the image of a black child sucking for its life from the bosom of a white woman. The utter interdependence of such an image; the selflessness, the merging it implies; the giving up of boundary; the encompassing of other within self; the unbounded generosity, the interconnectedness of such an image. Such a picture says that there is no difference; it places the hope of continuous generation, of immortality of the white self in a little black face.[17]

Indeed, embedded in the notion of sacrifice is the act of giving. This giving need not always devalue her/him by giving under unfavorable conditions, but may be construed as enhancing the giver through the offering. To attempt to represent the unrepresentable, shifting beauties of being a mother to a very specific child is also to acknowledge our historical inscription as gendered bodies while refusing boundaries and reinscribing desire. The more historically inscribed and arguably less desirable notion of sacrifice implies the giving up that verges on selflessness, on the mother's internal deaths. In one of Jacques Derrida's most crucial texts on mourning, he weaves a discussion of transfigured narcissism in which the self comes to understand its imprecise proximities with the grieved other. He was writing about the actual death of a friend.[18] I am thinking about this text in relation to the transfigured places of living alterity between mother and child:

> Memory and interiorization: since Freud, this is how the "normal" "work of mourning" is often described. It entails a movement in which an interiorizing idealization takes in itself or upon itself the body and voice of the other, the other's visage and person, ideally and quasi-literally devouring them. This mimetic interiorization is not fictive; it is the origin of fiction, of apocryphal figuration. It takes place in a body. Or rather, it makes a place for a body, a voice, and a soul which although "ours," did not exist and had no meaning before this possibility that one must begin by remembering, and whose trace must be followed. . . . We can only live this experience in the form of an aporia; . . . where the possible remains impossible. Where success fails. And where faithful interiorization bears the other and constitutes him in me (in us) at once living and dead. It makes the other a part of us, between us—and then the other no longer quite seems to be the other, because we grieve for him and bear him in us, like an unborn child, like a future. And inversely, the failure

GLAAD ad, 1992
Chloe Atkins, photographer;
Diana Rich, designer, Elephant Graphics

succeeds: an aborted interiorization is at the same time a respect for the other as other, a sort of tender rejection, a movement of renunciation which leaves the other alone, outside, over there, in his death, outside of us. (Pp. 33–34)

In the context of the mother-child schema, the first part of Derrida's text on mourning reads like the child projecting itself on and through the mother's body. The trace of the mother cannot be "successfully" contained; nor can the mother overpower the child. The mutual renunciations are tender rejections and acts of love. Be/coming different: outside of oneself, inside the other, in both places at once. Neither occupying nor dominating. To love without domination might then be a coming to understand that one cannot overwhelm, cannot completely inhabit, cannot "have" the other. To love without overtaking might then be an admission of distance, a recognition of sorrow. A little bit of figurative mourning. The geographies of self expanding. Succumbing as powerful abandon.

"Mommy, are you done writing about women?" In his tenderly demanding voice issuing forth with uncanny timing, Miles interrupts my reverie. I cross over the threshold between the mindful Imaginary and the maternal Symbolic, a space women/mothers have been crossing for an eternity, knowing that my work on both sides of the mirror will never be finished.

Notes

1. Elizabeth Grosz, *Sexual Subversions: Three French Feminists* (Sydney: Allen & Unwin, 1989), p. xvii.
2. For Grosz's reading of Levinas's notion of alterity through Luce Irigaray's ethics of sexual difference, see her Chapter 5 in the book cited above. For Luce Irigaray's reading of Levinas and the touch of the other, see her "Fecundity of the Caress," in *Face to Face with Levinas,* ed. Richard A. Cohen (Albany: State University of New York Press, 1986), pp. 231–56. For Levinas's own writings, see especially his *Existence and Existents,* trans. Alphonso Lingis (The Hague: M. Nijhoff, 1978), "Ethics and the Face," in *Totality and Infinity: An Essay on Exteriority,* trans. Alphonso Lingis (The Hague: M. Nijhoff, 1979) and *Otherwise than Being or Beyond Essence,* trans. Alphonso Lingis (The Hague: M. Nijhoff, 1981).
3. Jacques Derrida notes Levinas's ambiguity toward "woman's place" in "Choreographies," interview with Christie V. McDonald, *Diacritics* (Summer 1982), pp. 72–73, footnote 5. It is interesting that Jacques Derrida, who himself weaves the figure of woman into some impossible projections (her "non-essence" within the fantasy of artificiality), would be so attentive to these slippages. For Derrida's use of the figure of woman, see especially the "Choreographies" interview as well as Gayatri Chakrovorty Spivak, "Displacement and the Discourse of Woman," in *Displacement: Derrida and After,* ed. Mark Krupnick (Bloomington: Indiana University Press, 1983), pp. 164–95 and her essay "Feminism and Deconstruction, Again: Negotiating with Unacknowledged Masculinism," in *Between Feminism and Psychoanalysis,* ed. Teresa Brennan (London and New York: Routledge, 1989), pp. 206–23.

4. The mother's in-between space of ever-presence and invisibility was again brought to the cultural surface when I was in search of the important and wonderful book *Narrating Mothers: Theorizing Maternal Subjectivities,* eds. Brenda O. Daly and Maureen T. Reddy (Knoxville: University of Tennessee Press, 1991). I first went to find it at a college bookstore whose critical studies section is especially good and whose buyer is very conscientious. When I queried him about why this particular reference was not ordered, he responded self-consciously, "I thought it was too specialized."

5. Annie Leibovitz's photographs of a seven-month's-pregnant Demi Moore were featured in *Vanity Fair*'s August 1991 issue. As cited in the magazine's October 1991 issue, in the United States alone ninety-five different television spots on the photographs reached 110 million viewers; sixty-four radio shows on thirty-one different stations were devoted to the subject; and more than 1,500 newspaper articles and editorial cartoons were generated. The movie star's nude appearance was also noticed in publications in the United Kingdom, Germany, Italy, Spain, Japan and South America. In a paper given by Susan Kandel on May 9, 1992, at the Whitney Museum's 15th Annual Symposium on American Art and Culture, whose theme was "Femininity and Masculinity: The Construction of Gender and the Transgression of Boundaries in 20th-Century American Art and Culture," the author noted that "while the self-righteous on the right lambasted the photos' flamboyant immodesty, the well-intentioned on the left hailed its progressiveness." In her paper Kandel makes the crucial point that despite the photographs' insistence that sexuality and motherhood are not mutually exclusive, their feigned feminism "is fashioned out of a set of conventions peculiar to the little-known subgenre of pregnancy porn: belly displayed as if it were—to borrow from the pornographic lexicon—tits, ass or bush; and woman displayed as an expanded object, happily complicit both with her expansion and her objectification."

6. A recent work is E. Ann Kaplan's *Motherhood and Representation: The Mother in Popular Culture and Melodrama* (London and New York: Routledge, 1992). Her discussions of projections of the mother in the films she treats is especially well situated between analysis of the psychoanalytic sphere and a sketching out of the rapid changes in the cultural representation of mothers and fathers in the 1980s and 1990s. See also *Mothering: Essays in Feminist Theory,* ed. Joyce Trebilcot (Savage, Md.: Rowman & Littlefield, 1983).

7. The installation was later formulated as a book, *Post-Partum Document* (London: Routledge & Kegan Paul, 1983).

8. Gail S. Rebhan is currently working on a project that extends the figure and negotiations of the mother clearly into the realm of the social world. Certainly the terms of her project would differ from Kelly's in that she is not focusing on the mother-child bond and she is dealing with two children rather than one. Rebhan, however, is concerned with her children's socialization processes and the difficult facilitation and representation of their word and image fragments. I thank Sally Stein for bringing Rebhan's work to my attention.

9. See Laura Mulvey's anticlassic essay "Visual Pleasure and Narrative Cinema," which originally appeared in *Screen* 16 (Autumn 1975): 6–18.

10. And how differently, indeed, Luce Irigaray reads and refashions the mother-child schema when the child is a girl. See especially "The Gesture in Psychoanalysis," trans. Elizabeth Guild in Brennan, ed., *Between Feminism and Psychoanalysis, op. cit.,* pp. 127–38. In this essay, Irigaray is particularly concerned with the differences she discerns between the girl's gestures and the boy's game of *fort-da,* coined by Freud, in which the boy masters his mother's absence. The boy's game is one of throwing out a reel on a string and then drawing it closer again. The mother is made the object in the boy's play, as differentiated from the girl's gestures that attempt "to reproduce around her or inside herself a movement whose energy is circular, and which protects her from dereliction" (p. 133).

11. Rosi Braidotti, "The Politics of Ontological Difference," in Brennan, ed., *Between Feminism and Psychoanalysis, op. cit.,* p. 95.

12. This comment is not meant to negate in any way the real effects the project created for the women who worked on it. The book's section on "Childbirth in America" and its discussion on the way midwives were maneuvered out of the profession is especially useful.

13. Arleen B. Dallery's essay, "The Politics of Writing (The) Body: Écriture Féminine," in *Gender/Body/Knowledge: Feminist Reconstructions of Being and Knowing,* eds. Alison M. Jaggar and Susan R. Bordo (New Brunswick and London: Rutgers University Press, 1989), pp. 52–67 is a particularly lucid and convincing argument for the political strategy of Irigaray's and Hélène Cixous's writing projects. Margaret Whitford, too, has been one of Irigaray's most steadfast interpreters. In her important essay "Rereading Irigaray," in Brennan, ed., *Between Feminism and Psychoanalysis, op. cit.,* pp. 106–26, she acknowledges that there are indeed problems with the attempt to use the psychoanalytic conceptual framework to make cultural diagnoses. However, in unacknowledged alignment with Elizabeth Grosz's work on Irigaray, Whitford is in deep accord with Irigaray's project to give sexual difference an ethical and ontological, autonomous status.

14. Luce Irigaray, *Speculum of the Other Woman,* trans. Gillian Gill (Ithaca: Cornell University Press, 1985), pp. 238–39.

15. This English version appears in *Écrits: A Selection,* trans. Alan Sheridan (New York and London: W. W. Norton, 1977), pp. 1–7. It was originally published in the *Revue française de psychoanalyse,* no. 4 (October–December 1949), pp. 449–55 and is a later reworked version of Lacan's 1936 essay "Le stade du miroir."

16. See Alphonso Lingis's translator's introductions to Levinas's works cited above (n. 2).

17. Patricia J. Williams, "On Being the Object of Property," *Signs,* vol. 14, no. 1 (Autumn 1988): p. 15. Williams's poignant and powerful essay conjoins personal and rhetorically autobiographical voices with her knowledge of the law field to think the possibilities of rewriting personal property contracts. Such contracts might be flexible enough to respond to racial, class and gender inequalities as well as changing emotions and appreciations of the normally nonremunerated acts of loving and caring for the elderly.

18. Jacques Derrida, *Mémoires for Paul de Man,* trans. Cecile Lindsay, Jonathan Culler, Eduardo Cadava and Peggy Kamuf (New York: Columbia University Press, 1986).

A SPACE OF INFINITE AND PLEASURABLE POSSIBILITIES

Lesbian Self-Representation in Visual Art

Harmony Hammond

I am an artist, a feminist, a lesbian, middle-class, white. When I'm good, I'm an artist. When I'm bad, I'm a feminist. And when I'm horrid, I'm a goddamn dyke. I feel like being horrid these days. Given the current political climate around art and the threat of being artistically silenced for being queer and female, I can't afford to be quiet or to let others define who I am and what kind of art I may or may not make.

I see art-making, especially that which comes from the margins of the mainstream, as a site of resistance, a way of interrupting and intervening in those historical and cultural fields that continually exclude me, a sort of gathering of forces on the borders. For the dominant hegemonic stance that has worked to silence and subdue gender and ethnic difference has also silenced difference based on sexual preference. It is essential that we bring sexual preference into the current discourses on difference and representation, along with race and gender, and that there be a strong lesbian presence in this discourse.[1]

Critic Martha Gever has written that "to be a lesbian means engaging in a complex, often treacherous, system of cultural identities, representations and institutions, and a history of sexual regulation."[2] So, then, what does it mean to identify oneself as a lesbian artist? As an artist who is "out" as a lesbian? Who sometimes makes work about the experience of being lesbian? Both "lesbian" and "artist" are problematic identities

open to interpretation and self-construction. As Trinh T. Minh-ha, a Vietnamese-American filmmaker and theoretician, asks, How do members of a minority or oppressed group establish identity without being limited or stereotyped? And how do we negotiate multiple identities? Which identity comes first? Which is most important?[3]

In questioning the language of cultural representation, identity and difference, Trinh has called for "distinctions" between the alienating notion of "otherness" (the other of man, the other of the West) and an empowering notion of "difference." But, she asks, "How do you inscribe difference without bursting into a series of euphoric narcissistic accounts of yourself and your kind? Without indulging in a marketable romanticism or in a naive whining about your condition? In other words, how do you forget without annihilating? Between the twin chasms of navel-gazing and navel-erasing, the ground is narrow and slippery. None of us can pride ourselves on being sure-footed there."[4]

Like Trinh, I believe that the answer lies not in accepting or choosing identity, but rather in creating it, and one way we create identity is through art. The great service of art is to tell us who we really are.[5] To use the words of critic Lucy Lippard, "Art would not have to speak for everyone if everyone could speak for themselves."[6] But how hard it is to find one's own voice. How difficult it is to affirm cultural identities, to recreate them so that they are not simply a counternarrative to the authoritative center, to what African-American poet Audre Lorde called the mythical norm or that which is "white, thin, male, young, heterosexual, christian, and financially secure."[7] How hard it is to get past the privileged authority who does not even have to be present to exert his influence. How hard to give form to oneself honestly.

For most gays and lesbians, sexual definitions have proved inadequate. Existing stereotypes (whether deriving from psychoanalysis, from pathological and pseudo-scientific texts of the nineteenth century, or from notions of political correctness within gay and lesbian communities) have been limiting and disempowering and have little to do with the reality and range of our lives as lived. There is no single homosexual identity or homosexual sensibility (which I see as the expression of that identity), but rather a dialectic between the homosexual's being articulated and articulating her or himself.

On a 1982 panel titled "Extended Sensibilities: The Impact of Homosexual Sensibilities on Contemporary Culture," sponsored by the New Museum, *Village Voice* critic Jeff Weinstein was quoted as saying, "There is no gay sensibility, and it has a tremendous amount of influence."[8] Everyone in the audience and on the panel laughed, for they knew what

he meant. Homosexual eroticism and sensibility is marketed to and lavishly consumed by heterosexual culture, thereby rendering it nonexistent, although as writer-sculptor Kate Millett pointed out, "[H]omosexual sensibility as it is generally understood . . . almost includes lesbians but doesn't quite. Really [it] mean[s] gay men." Millett suggested, "What if we were to rephrase this question and were to ask, 'What is the impact of lesbian sensibility on Contemporary Culture?' I would respond right off hand without even shifting gears, that it's zilch."[9] Again, everyone in the audience and on the panel laughed, for they knew what she, too, meant. Lesbians have no visible presence in the historical mainstream of Euro-western art, nor in contemporary popular culture. If, as Stuart Hall says, "identities are the names we give to the different ways we are positioned by, and position ourselves within, the narratives of the past,"[10] lesbian sensibility, given its invisibility, would have to be created out of nothing. It would establish a lesbian subject full of complexity and contradiction, unfixed, ever shifting and reinventing itself in order to embrace and reflect an articulation of difference not only from men and straight women, but among lesbians.

Michel Foucault has stated that "we have to not only affirm ourselves as an identity, but as a creative force."[11] In their interview with Foucault, Bob Gallagher and Alexander Wilson point out that this declaration raises important issues. "Should gay people embrace a social identity that was largely created from the sexual mores of the late nineteenth century, or pursue 'relationships of differentiation, of creation, of innovation . . . an identity unique to ourselves'?" "If gay people are truly to know themselves," suggests Foucault, "they must examine and rely on their own potential—in short, create themselves—rather than insist on conforming to the socially constructed role of 'the homosexual' a consciousness that has primarily been defined by others." Foucault said, "We must define who we are, who we can become, what our community consists of, and how we are going to change the world so it will accommodate us. . . . we are shaped by our sexual identity, and it, in turn, is shaped by us. It is not a simple matter of accepting or denying our sexual identity; we must continually construct it. Let us hope, that it will be an identity strong enough to protect us and flexible enough to liberate us."

Probably more than anyone else, Foucault, in his late writings, has had a major impact on the development of queer theory. While he addressed himself almost entirely to gay men, his discussion of the social construction of homosexual identity, its relationship to desire, pleasure and sexual practice, and his openness to exploration and invention in the reconfiguration of relationships is relevant and of interest to the construc-

tion of lesbian identities (it is also limited, given his disregard for gender politics). Foucault, who was involved with alternative forms of sexuality within the gay movement, embraced the potential of all segments of what today we would call the continuum of queer society, not just those sectors most politically correct or acceptable to the straight world. Like the leatherman, fag, transvestite or drag queen, the butch, femme, kiki, bull dagger, and lipstick lesbian may be identities "at least partially of one's own invention."[12]

It is this quality of "invention" that is apparent in lesbian art being made today and which differentiates it from earlier art by lesbians in the 70's. In a sense the art both reflects and contributes to ever shifting definitions of lesbian identity, and can be seen to mirror both the desexualization of lesbian feminism in the 70's and early 80's, and the exploration of lesbian fantasy and desire in the late 80's and 90's, which reasserts sexuality as central to lesbian identity.

In her 1992 article "Sisters and Queers: The Decentering of Lesbian Feminism," Arlene Stein reflects back and discusses the emergence of lesbian feminism as a political entity in the late sixties and early seventies.[13] Pre-Stonewall and prefeminist lesbian culture was semisecret, mostly urban and working class, and "formed in relation to the hegemonic belief that heterosexuality was natural and homosexuality an aberration." As author Jill Johnston says of this period, "Identity was presumed to be heterosexual unless proven otherwise. . . . There was no lesbian identity. There was lesbian activity."[14] Stein describes how lesbian feminism emerged out of the radical sectors of the women's movement with lesbians who felt neither at home in the left nor comfortable in mixed gay organizations like the Gay Liberation Front, or in primarily straight-identified organizations like the National Organization for Women (NOW). The many women like myself, primarily middle class, who "came out through feminism" in the early and mid-seventies did not believe that we were failed women, nor that we were necessarily straight or gay from birth, although some of us recognized that for many "primary lesbians" (old dykes), the latter was true. In a sense we became lesbians by choice. And our new bonding and connecting to a "class of women" extended quite pleasurably to sexual practice.

As it began to critique patriarchy and its institution of compulsory heterosexuality, lesbian feminism rapidly grew to be a collective identity and a political movement. *The Woman-Identified Woman,* authored by the Radical Lesbians in 1970, was important in broadening the definitions of lesbianism from a medical condition, or even just sexual preference, to a general sense of connectedness with other women based on mutuality

and similarity of the experience of being a woman in patriarchal culture. Lesbianism had become a gender issue.

Nineteen seventy-four saw the first of the National Women's Music Festivals, and 1975 was a summer of many national and regional feminist conferences, workshops and festivals (such as Sagaris: Institute of Radical Feminist Political Thought and the Socialist Feminist Conference). Women were literally coming out all over the place. It was said that if these gatherings were 80 percent lesbian to start with, they were 99.9 percent lesbian when over. As Stein says (and her discussion fills in many more of the details, shifts, and nuances of these idealist and expansionist times), "It [lesbian feminism] was a movement which spawned the most vibrant and visible lesbian culture that had ever existed in this country." . . . Never before had so much social space opened up so quickly to middle-class women who dared to defy deeply held social norms about their proper sexual place. As a result, the group of women who called themselves lesbian, became increasingly heterogeneous, at least in terms of sexuality. A popular slogan of the time said that "feminism is the theory, lesbianism is the practice." And Alix Dobkin sang, "Every woman can be a lesbian," on "Lavender Jane Loves Women," one of the earliest dyke albums. Thus, the definition of "lesbian" broadened at this time from women who are sexually attracted to women exclusively, act on it, and claim an identity based on this attraction, to "biological women who do not sleep with men and who embrace the lesbian label." This broadening of lesbian identification was paralleled in lesbian visual self-representation, which in the seventies moved away from images of subculture outlaws (rooted in sexual identification) to a more general female space that was by extension woman-identified or lesbian (rooted in gender).

In her important article "Dykes in Context: Some Problems in Minority Representation," Jan Zita Grover points out that the roots of lesbian self-representation lie in pre-Stonewall and prefeminist subculture magazines and journals, and personal snapshots passed privately among friends.[15] Old dykes documented their parties, friends, and lovers, and made real (as only a photo can do) an otherwise hidden culture of their own. Some of these photos were erotic, and all had a sense of secrecy as they were not meant for public viewing.

However, as Grover points out, by the early seventies feminist and lesbian feminist journals and publishers were rapidly proliferating and they wanted politically correct lesbian images. Soon, visual work by movement photographers such as JEB (Joan E. Biren) and Tee Corinne were visible on the pages and covers of journals such as *The Ladder,*

Amazon Quarterly, Sinister Wisdom, Conditions, and *13th Moon.* Art by lesbians was on the walls of women's bookstores, coffee houses, and restaurants, and occasionally the walls of women's co-op art galleries (although because these galleries operated on the peripheries of the art mainstream, with most of the membership straight-identified, they were very sensitive to being put down by the male-dominated art world as a "bunch of dykes" and thus seldom exhibited work that was overtly lesbian).

By the mid-seventies gay men and lesbians began to show together at the Gay Academic Union held annually in New York, and a few mixed gay galleries opened and closed. Most of the work being exhibited by gay men was erotic, worshipped the perfect male body, was without any political consciousness, and was put down by lesbians for being so. Most of the work by lesbians was in keeping with the current politically correct lesbian feminist position of not representing or objectifying women's bodies and downplaying sexuality. While one might have seen abstract images of labia, clits, breasts, and vaginas, or two women being chummy and hugging (the second woman being the lezzie signifier), you certainly never saw them "doing it."

There have always been a lot of lesbian artists. Since the seventies many have come out of the closet, although only a few in the art world made art with lesbian content (although a case could be made for the existence of coded imagery). Many women, especially on the West Coast, where performance was utilized as a consciousness-raising tool, came out simultaneously as lesbians and artists. Because the focus in lesbian feminism at the time was on gender issues, and lesbian definitions were being broadened to include any woman-identified women, female space depicted visually (say through landscape, fruit, and flower imagery) was by extension considered "lesbian." (A large group of lesbian-identified artists continue to work in this tradition.)

Other themes that reoccurred frequently were anger, concealment, secrecy, guilt, coming out, celebrating the female body, and generally creating a visible lesbian presence. There were humorous pieces relating food and sexuality such as Sharon Deevey's "Choc-clit Bar" (melts in your hand, melts in your mouth), Clsuf's "Hershe Kisses Her," and Sandy de Sando's plaster whipped cream–and-cookie pubic mounds. Portraits were common but often decontextualized, or avoided representing "deviant and perverted spaces such as bars" in favor of stable "dykes are people too" or "women working together" images. A few artists such as Lili Lakich, who works in neon, referenced historical lesbian writers

and artists such as Djuna Barnes, Natalie Clifford Barney, or Romaine Brooks.

Janet Cooling, Hollis Sigler, and Nancy Fried depicted woman-centered domestic environments: a kitchen, a living room, a bedroom as the stage for possible lesbian relationships, hinting at sexuality. Sigler, Nicole Ferentz, and Kate Millett (who also made calligraphic drawings of the female body) included diaristic text that referred to female lovers and the nuances and complexities of intimate relationships among women. Sigler's drawing with the words "Loving the Lady Inside My-self" can be read several ways. Janey Washburn and Ellen Turner dealt with anger and guilt. Louise Fishman's wall of "Angry Paintings" was meant for women, many of them lesbian, so they could confront and claim their anger which held them back in the world. Fishman, now working totally as an abstract painter, writes that her "early pieces have to do with the anger connected to trying to make art and trying to show that art while remaining identified as a Jew, a woman, and a lesbian."[16] Lesbian artists who wished to be taken seriously and to claim their whole selves and not suffer for it had to negotiate their many positionings—and it wasn't easy, for the art world wasn't welcoming women, much less lesbian, artists.

Jody Pinto and Fran Winant had their alter egos: Pinto's male persona, Henry, who could fly and swim in a sexual dreamscape, or Winant's dog Cindy. In "The Kiss," Winant depicts what appears to be a woman kissing her dog, with strange calligraphy—a secret language that Winant had devised years earlier for writing poetry that no one else could interpret—in the corner. In another painting, Cindy is surrounded by this secret language. Winant was not only able to illustrate a "different sexuality," a forbidden, or unnatural love, but also to refer to animals in work of earlier lesbian artists such as Rosa Bonheur and Romaine Brooks.

Some of my own work from this period dealt with coming out, homophobia, the difficulties of personal violence and political trust in lesbian relationships, and, later, in the early eighties, the creation of an overtly lesbian sensual-sexual presence and the social and political effect of such a presencing. For example, the wrapped-rag sculpture "Sneak" presented an ever multiplying army of black, white, and gray female forms insidiously banding together and marching forward. "Kudzu" referred to the Southern plant that was brought into the United States to control soil erosion and then went out of control, indiscriminately covering and consuming everything in its path. Created in North Carolina, the large, black, aggressive "Kudzu," with its finger or riblike forms, is a

conscious metaphor for xenophobia, racism, and homophobia, or people's fear of difference and being out of control.

Because feminists in the seventies opposed "the sexual exploitation of women and mounted specific critiques of the representation of women as exclusively sexual beings in advertising, media and pornography,"[17] there was a widespread reactive move away from representing the female body or female sexual experience. This, combined with the fact that lesbians were trying to combat being defined solely on the basis of sexual practice, meant that the lesbian, with few exceptions, was no longer even self-represented as a sexual being.

Grover talks about this loss, which was especially apparent in photography, the main art form where previously there had been a lesbian erotic presence. The older representations (like those gracing the covers of lesbian pulp novels), in their sex-role stereotyping, had acknowledged the power of lesbian sexuality. "Somehow in the 70's," as Grover points out, "in seeking to represent the female sexual outlaw, the dyke, as a whole person, many photographers have ceased imag(in)ing her as a hole person."[18]

While it was important at that time to show that lesbians made all kinds of art, much of the work, while raw and passionate, now sometimes seems simplistic, or "lesbian" only in that we knew that the artists were lesbian and that certain pieces were directed more to a lesbian audience than to the general art world. Often the works tended to romanticize or sentimentalize lesbian experience. It must not be forgotten, though, that just to be in these shows took strength and courage and was a radical and risky gesture not to be underestimated. It made one's personal life public, and artists risked everything, from family disapproval to job discrimination or dismissal to artistic stereotyping. At least one artist was threatened by her gallery: if she exhibited "as a lesbian," she could say goodbye to the gallery's exhibition and representation of her work. (She didn't show.)

On her page in the photo copied catalog for "A Lesbian Show" at the 112 Greene Street Workshop in 1978, artist Barbara Asch wrote above her delicate cave and germinating-flower forms, "This show frightens me."[19] Many of the participating artists felt this way. This first exhibition of lesbian art in New York grew out of the silence unearthed by the groundbreaking and beautiful "Lesbian Art and Artists," issue of *Heresies: A Feminist Publication on Art and Politics.* Generally speaking, the "lesbian issue" of *Heresies* (1977), "A Lesbian Show" at the 112 Greene Street Workshop (1978), "The Great American Lesbian Art Show" (GALAS) at the Women's Building in Los Angeles (1980), and even the

New Museum exhibition "Extended Sensibilities: Homosexual Presence in Contemporary Art" (1982) were fairly asexual and safe. While they attempted to discover and define an essential lesbian (or gay) sensibility, they simply presented a wide range of work by artists willing to be public about their sexual preference and willing to show in that context. In doing so, these shows and projects were successful in creating, for the first time, a public lesbian/homosexual presence in the visual arts and stimulating dialogue within the art world, and among lesbian and gay communities.

It was against this backdrop of expanded identities and dissolving boundaries between lesbians and straight feminists that Monique Wittig made her controversial presentation "The Straight Mind" at the Modern Language Association in 1978.[20] In response to the growing deconstructive focus "on the woman question," Wittig asked, "What is woman? . . . Frankly, it is a problem that lesbians do not have." For she says "lesbians are not women." Nor are they men. ". . . it would be incorrect to say that lesbians associate, make love, live with women for 'woman' has meaning only in heterosexual systems of thought and heterosexual economic systems." . . . Lesbians (who are not women) love lesbians (who are not women). "It is not as 'women' that lesbians are oppressed, but rather in that they are 'not women.' " Wittig views heterosexuality as "a cultural construct designed to justify the whole system of social domination based on the obligatory reproductive function of women and the appropriation of that reproduction." It tries to make the difference between the sexes a natural and not a cultural one, with reproduction as its goal and all else perversion. Since for lesbians, sexual pleasure is for the sake of sexual pleasure alone, lesbians exist outside of the heterosexist field, and might well "ask heterosexual society: 'what have you done with our desire?' " For "if desire could liberate itself, it would have nothing to do with the preliminary marking by sexes." "Lesbianism is the culture through which we can politically question heterosexual society on its sexual categories, on the meaning of its institutions of domination in general, and in particular on the meaning of that institution of personal dependence, marriage, imposed on women."

Lesbians and gay men, Wittig feels, must break through this heterosexist contract by refusing to be "women" or "men" and find a means to "do away with genders, the linguistic indicator of political oppositions." Wittig's presentation at the MLA and her other writings and presentations from around that time, in the extremity of their views regarding the separation of lesbian from straight women, departed from the main flow of lesbian feminist thinking. She was criticized by many as separatist. However, in her shift away from a definition of lesbian identity based on

gender to one based on sexual preference, as well as her deconstruction of sex, gender, and the lesbian body (in order to (re)member it), Wittig, like Foucault, anticipated and influenced much of today's rich discourse around the body and sexuality.

By the early eighties, as Stein has documented, "a series of structural and ideological shifts conspired to decenter the lesbian-feminist model of identity." As "the predominantly white and middle class women who comprised the base of the movement aged" and changed, women of color, working-class women, and sexual minorities asserted their presence and forced an acknowledgment and reexamination of multiple identities and difference within lesbian communities. In particular " 'sexual difference' posed a challenge to lesbian-feminist constructions of identity."[21]

Coming out of the seventies activism combating sexual violence against women—Women Against Violence Against Women (WAVAW) and Women Against Violence in Pornography—and the sex debates on pornography and censorship in the eighties, sexuality burst forth as a major feminist issue. More than anything else, pornography (and there are a range of feminist definitions) continues to cause debates and splits within the feminist community. This debate is relevant here, because erotic art, like pornography, is in the domain of sexual expression. Both are intended to arouse sexual pleasure and both raise issues of censorship versus creative freedom of expression.

A series of projects in the feminist art communities of the early eighties contributed to and were in response to these "hot and heavy" debates. The "Sex Issue" of *Heresies* (1981), far more controversial than its earlier and tamer sister, "Lesbian Art and Artists"; "The Second Coming" (1984), an exhibition curated by Carnaval Knowledge at Franklin Furnace in New York that attempted to explore the possibility of a feminist pornography; the 1982 conference "Towards a Politics of Sexuality" at Barnard College, "where anti-s/m activists picketed a speak-out on politically incorrect sex,"[22] along with its subsequent publications, *Pleasure and Danger,*[23] which brought together all the papers and talks from the conference, and *Diary of a Conference on Sexuality,*[24] which discussed the process of the organizers and presenters; and *Caught Looking,*[25] focusing on the sex debates and porn wars, which was compiled by the Seattle Feminist Anti-Censorship Task Force and published in 1986—all of these addressed issues of sexual expression and representation and raised questions:

How do women get sexual pleasure in patriarchy?
How do we develop a language to talk about female sexual pleasure?

Can woman be both subject and object?
Who possesses the right of looking?
Is there or can there be a feminist pornography?
What kind of sexual behaviors are feminist?
How does this relate to our desires, private fantasies, and actual
sexual practice?
Are there other kinds of sexuality than genital?

In response to the antiporn movement, which they saw as a potential
threat to creative freedom (under antiporn legislation all sexual imagery
can be censored), the women who worked on these projects applauded
sexual experimentation and diversity, decried the policing of desire, and
saw the necessity to safeguard the circulation of fantasy and creative
expression of the erotic imagination. Instead of focusing on patriarchal
violence, they opened up potential sexual possibilities for women. A new
kind of sex radicalism appeared, which tried to think through the rela-
tions of power and sexuality as well as the complexities of butch-femme
exchange. Largely in response to being targeted by antiporn groups, a
lesbian S&M community emerged and "a burgeoning sexual literature
reasserted the centrality of desire and sexuality in lesbian identity and
culture."[26] However, this lesbian presence got lost on the way to the art
community, where until the very late eighties sex radicalism as it mani-
fested itself in visual art seemed peculiarly straight. Fighting the battle
against art censorship brought out the homophobia not only from the
power centers, but from the various nooks and crannies along the mar-
gins. In its absence, lesbianism became a subtext.

For instance, a lesbian voice was strangely absent in feminist art
dialogues like the 1987 New Museum panel where essentialism was pitted
against theory (highly questionable polarities, given the nature of the
most interesting feminist art being made at that time). In cool, dry,
theoretical language, two feminist critics told us unequivocally, "It is
only through images of women that female sexuality is constructed," and
for women, "There is no experience of the body outside of representa-
tion." No one referred to actual art, much less to Ana Mendieta's work,
which surrounded us and which would have provided an excellent start-
ing point to discuss the problem of an art that attempts to combine
essentialism, activism, and theory. I agree with Lucy Lippard, who later
wrote in *Heresies* that while we would all agree "that language and the
visual representation of women mediates much of our experience," the
position being represented by several members of the panel was so narrow
that there was no room for dialogue, exploration, supposition or fantasy.

For if "there is no experience of the body outside of representation, we are deprived of a center from which to venture forth to change that misrepresentation. . . . Why not concentrate on what the male gaze cannot see?"[27]

Sitting in the audience, I found myself thinking that what was said wasn't entirely true for lesbians, that we had such a small history of visual representation of any kind. And I certainly felt that I had an experience of my body outside of those representations. Not one lesbian on the panel or in the audience, including myself, spoke up and said that perhaps, just perhaps, the lesbian—whose body is least represented and colonized by man—would offer the greatest potential or possibility for creating or inventing a "woman" that is not a patriarchal construct, a woman totally free from restrictions or conventional forms and behaviors. While artist Nancy Spero did quote Simone de Beauvoir, no one recalled Wittig's theories of 1978. The lesbian was not in attendence at this panel, and in this case, postmodernism seemed like a particularly heterosexual dead-end.

Even within what many are calling the current "renaissance of gay art," lesbians have been in danger of being left out once again. It has taken the activism and strong street visuals of ACT UP and QUEER NATION (continued by the Women's Action Coalition [WAC], which is committed to combating "lesbophobia"), along with the development of academic queer theory to help lesbians burst forth and assert a visual presence. I like the label "queer" and use it often because it is genderless, challenges clear-cut categories of sex and gender, and jumps off the page or out of the sentence. Like I said, these days, one must be horrid, be a goddamn dyke, claim and flaunt identities on one's own terms, even while these very identities are constantly changing. Labels like "dyke," "faggot," or "queer," originally meant to mark, wound, and scar, can be turned around, claimed, and flaunted (with style, of course) to empower both artist and audience. Actually to employ these labels visually in one's art, as some artists are doing, lets there be no question in anyone's mind as to what this work is about.

I believe in a strong and united queer presence with gay male artists and other fellow "deviants," but I continue to worry about the lagging visibility of and theory around lesbian art. For just as visual art by lesbians has been consistently and conspicuously absent in feminist art dialogues like the one at the New Museum, until very recently it has also been absent from most discussions of gay or queer art. Caught between the straight feminists and the gay male agenda, lesbians, as historian

Cassandra Langer puts it, often don't exist at all, or they are "deprived of a political existence by their inclusion as female versions of male homosexuality. Being lesbian is being marginal in an already marginal network."[28]

The fact is that since lesbians don't have the mainstream-museum and market-certified counterparts of Warhol, Hockney, Haring, and Mapplethorpe, our work, while it is no longer limited to subculture venues (though thankfully these still exist too), is seen primarily in alternative spaces (some more prestigious or legitimized than others), and rarely in commercial galleries or museums. Those galleries that do make an effort to support gay and lesbian artists are often run by well-meaning gay men who don't have easy access to lesbian networks, and who tend to focus on salable homoerotic work by gay male artists that appeals to wealthy gay male collectors. For example, the exhibition "Queer: Out in Art" at the Wessel O'Connor Gallery in New York in 1990 included work by only nine women compared to fifty-five men.[29] However, this imbalance seems slowly to be changing. Generally speaking, in exhibitions that are co-curated with lesbians, representation is equal. It is in these exhibitions (along with those that are all-lesbian such as "All But the Obvious: A Program of Lesbian Art," curated by Pam Gregg for the Los Angeles Center for Exhibitions [LACE] in 1990) that we get to see the diversity of emerging work that challenges expectations and assumptions about lesbian art. "All But the Obvious" is "not concerned with defining a lesbian aesthetic or sexual identity; rather raising questions about the construction of sexual identity and the intersection of personal and public territory."[30]

Writing about the exhibit in *High Performance,* Terry Wolverton, who was one of the organizers of "GALAS" a decade earlier at the Women's Building, discusses the differences between the two exhibits:

> A new generation of lesbian artists came of age between 1980 and 1990. Perhaps at no time in history was it easier to be a queer woman. These young women have inherited the legacies of Stonewall and radical feminism. . . .
>
> One unmistakable point is that this generation of lesbians approaches the representation of sexuality much differently than their predecessors. Where ten years ago GALAS participant Tee Corinne was arranging multiple prints of women engaged in oral sex into mandalas, equating sex with spirituality, Della Grace makes no attempt to prettify hardcore S/M imagery.
>
> . . . Catherine Saalfield's collaborative video installation with Jacqueline Woodson insists that "the presence of AIDS has necessitated an unromanticized candor about sex." Other artists seem to be reacting against a perceived "anti-sex" bias among feminists (who strove to eliminate images of violence against

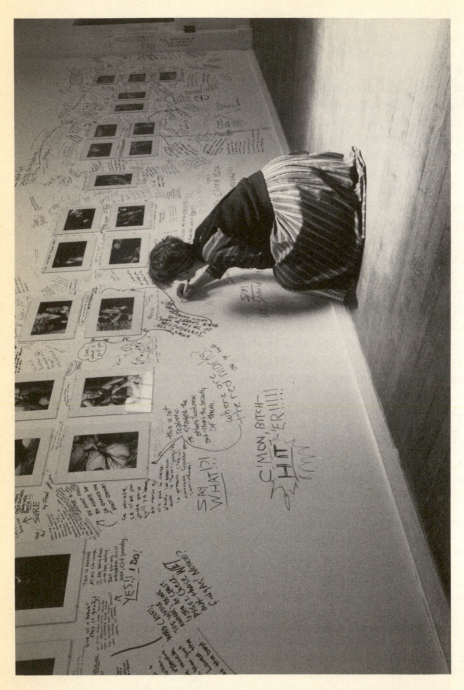

Isa Massu, *Untitled*
Photograph, © 1990 by Isa Massu

or sexual exploitation of women). The lesbian artists of the 90's insist on defining their own pleasure in their own terms, demanding access to all images of themselves, including those generated in pornography.[31]

Most of the work was either photography or photo-based and, in its representation of sexuality, asserted a lesbian presence while refusing a monolithic definition of "lesbian."[32] Work ranged from Janet Cooling's painted portraits of dyke couples and Gaye Chan's photographs of women engaged in intimate sexualized activities to Tracey Mostovoy's *Naked Women in Public Places* and Collier Schorr's mixed-media diptych using text to refer cynically to the betrothal of two women. Woodson and Saafield's video installation *Among Good Christian Peoples* explored Woodson's experience of growing up lesbian and black in a religious family.[33]

Despite these changes, however, one aspect that outrageously remains the same is the near invisibility of lesbian artists of colors. Wolverton points out that in 1980, "GALAS" included two Third World artists out of ten. In 1990, "All But the Obvious" included three out of fifteen.[34] "This fact," she continues, "has many causes including the racism and homophobia in Third World communities. But at a time when segments of the art world are achieving multiculturalism, it is disappointing. Perhaps artists who are already marginalized by virtue of their cultural background feel reluctant to adopt the still more tenuous position of sexual difference.[35]

Why are there so few visual artists of colors who make work about being lesbian compared to writers and poets who are "out" in their work? Given the expense of workspace and materials, do fewer women have the privilege or opportunity to make art in the first place? Or is there something inherently different about oral traditions and the written word versus traditional object-making and visual images? Some artists have explained their reluctance to deal with lesbian content or to exhibit in lesbian shows by pointing out that a support community of sorts exists among lesbian writers of colors that is virtually absent among artists. For many, just the word "lesbian" signifies a white cultural context that is exclusionary, or doesn't adequately describe one's identity. Perhaps as a white woman I can't read lesbian content cross-culturally, but it seems that many artists who are "out" as lesbians, who claim that label, don't make work about identity issues, nor do they choose to focus on race and/or gender over sexuality. Thinking about race and sexuality together is difficult, complex, and scary—an area that needs continued exploration and (re)presentation by lesbians of colors and white lesbians. To truly

explore identities of difference we need to expand the dialogues and ask questions such as "How is one's sexuality racialized?" and "How is race sexualized?"[36]

Only a few artists of colors come to mind who regularly bring lesbian content into their work—in addition to Woodson, Chan, and Yamaoka I am thinking of Laura Aguilar and Ester Hernandez, although I am sure there are many others who are not as well known. Carrie Yamaoka has photographed a page of text from Radclyffe Hall's quintessential lesbian novel *The Well of Loneliness.* The words "Her hair was quite short" stand out in darker typeface from the rest of the text, which seems almost erased, allowing the viewer-reader to focus on the lesbian signifier of short hair and to read between the lines. Ester Hernandez, an ex-farmworker of Yaqui and Mexican ancestry, is well known for her images of *"la mujer Chicana."* Her silkscreen "La Ofrenda," reproduced on the cover of *Chicana Lesbians: The Girls Our Mothers Warned Us About,*[37] presents the back of a woman with hairstyle, makeup, and earring signifying Chicana style of *"las buenas amigas,"* and a large tattoo of the Virgen de Guadalupe, who as the fusion of mysticism and Mexican nationalism represents a strong female force. The hand of a second woman holds a rose (female genitalia) out as an offering to both the Virgen and the first woman, thus incorporating references of sexuality along with race and gender.

Like the community that produces it, lesbian art is diverse. What is clear is that there is no single fixed lesbian identity and thus no single fixed sensibility, and we lesbians like it that way. By nature we do not want to be domesticated, commodified, or consumed. Even our theory can't entirely embrace our art or vice versa. Perhaps sensibility, like sexuality, is a way of perceiving, of feeling "a space of inarticulation," or simply a space of possibilities. In reaction to the political correctness of the seventies Lesbian Nation, art today asks questions, poses contradictions, explores problematics, and proposes that if indeed we are creating ourselves, then the concept of sexual difference is one of "engaging possibilities."

The multiplicity of work and theoretical discourse is rich in the area of time-based arts (film, video, and performance) and to a much lesser degree in object-making, where photography, because of its movement history, dominates. Perhaps painting and sculpture are too identified with male traditions and institutions, or perhaps it is that the fluid, decentered, layered identity of the lesbian refuses to be framed or fixed in the art object. Generally speaking, painting and sculpture are just beginning to explore the terrain of gender and sexuality.[38] Because a large body of

theoretical work focusing on film, video, and performance already exists, and because I myself am interested in the possibilities and problematics of object-making/constructing, I'm focusing my discussion here on examples of 2-D and 3-D work that contribute to the visual discourse around "lesbian identity."

One way that marginalized artists authenticate themselves is to "paint" themselves into the dominant art-historical or popular cultural mainstream. Lesbians, too, are employing this strategy and interrupting the central authoritative narrative by inserting/asserting themselves wherever they wish to be (spaces previously occupied only in the wildest of fantasies), responding to or displacing the existing representations.

In her photomontage series "Dream Girls," Deborah Bright pastes her "constructed butch-girl self-image into conventional heterosexual narrative stills from old Hollywood films," thus actualizing her adolescent proto-dyke fantasies in the sixties, when (as now) Hollywood offered few desirable images of lesbians. As Bright explains with pleasure, "The lesbian roams from still to still, movie to movie, disrupting the narrative and altering it to suit her purposes." The film is lesbianized, for in addition to allowing Bright to light Audrey Hepburn's cigarette, to flirt with Glenda Jackson, or seduce Katharine Hepburn, her montages construct a new lesbian subject. As gender changes or becomes ambiguous, power relationships among characters are subverted and the heterosexist narrative is sabatoged.[39]

In her wall-sized photo-text arrangements, Kaucyila Brooke "considers lesbian relationships within American popular culture"[40] and within lesbian and queer communities. Her pieces demonstrate "the absence of women's desire in classic narratives."[41] Appropriating and subverting popular forms such as cartoons, westerns, soap operas, and photo-novellas, Brooke manipulates their formal devices and inserts lesbian and queer dialogue:

"So do you want to sign up for more of this sexual fiction?"
"We are surrounded by the language. There is no turning back."
"Let's talk about dominance and submission."
"Black and white are not the only positions."

The images are staged with actors, photographed, blown up like gigantic film stills, and arranged in various configurations with comic balloons for text to suggest sequential narratives. But Brooke's stories are fragmented: they don't read easily, and, like the identity she proposes, have no climax or closure. As historian-critic Joanna Frueh points out,

"Brooke inserts serious content into what is most often used for humor or for stories that can be taken lightly. The small scale of the comic strip is blown up, both made huge and exploded, so that the content itself becomes monumental and disruptive," and the cultural form is critiqued for its role in the construction of stereotyped identities.[42] In "Unknown Deviancies (What a Dish)," "Badgirl," played by Brooke herself, "following the storyline of Spiderwoman and Batgirl . . . finds herself on the streets of Corporate America uncertain about her future or identity but destined to stage and fight (as all superheroes must do) the battle for women's desire."[43]

Other photographers continue in the portrait tradition, documenting a wide range of lesbian life-styles: Ann Meredith, Nancy Rosenblum, Laura Aguilar, Danita Simpson, Nan Goldin, Lola Flash, Gaye Chan, Catherine Opie, Terry Rozo, Kathleen Sterck, and Della Grace. Laura Aguilar's Latina Lesbian Series, with text below the informal portraits, allows each photo subject to speak actively about her life, while Nan Goldin's photos include unromanticized portraits of lovers and queer friends as well as images of herself in a halfway house for drug treatment. Lola Flash and Gaye Chan present women engaged in sexual activities. In one of Chan's intimate images, a woman has her head up under another woman's sweater, and in a second image, two women part from a kiss with a thread of saliva still connecting their mouths.

While in the past photographers often felt a need to present only "positive" images of lesbians to the public, they are no longer interested in proving that they are nice girls, but rather in flaunting their bad-girl sexual-outlaw status. Those territories of contraband dyke culture and activity that used to remain hidden or alienated—bars, softball teams, locker rooms, butch-femme drag, motorcycle gangs, and S/M sex—because they were working class or were disapproved of by straight society or politically correct lesbian feminists, are now common subject matter. While lesbian feminism of the sixties and seventies rejected butch-femme behavior as regressively imitative and patriarchal, there is currently a new and visible interest in cross-dressing and in gender bashing and bending— all of which reassert the sexuality in lesbianism. Gender, and therefore sexuality, is called into question in Zoe Leonard's photos dealing with the scientific and cultural constructions of "femininity" and "femaleness." Drag is no longer considered to be the exclusive domain of gay men, as photographers such as Catherine Opie create and document cross-dressers. Both Kathleen Sterck and Terry Rozo photograph biker dykes. In her series on the New York City gang the Sirens, Rozo presents images where role signifiers of dress are scrambled, thus subverting stereotypes

or easy readings. Her portrait of one biker clad in helmet, boots, and rhinestone-studded strapless gown is a study in butch-femme mixed metaphors that both biker and artist clearly enjoy.

Both Danita Simpson and Della Grace photograph lesbians within the context of bar culture. Simpson's low-light, seemingly random and spontaneous shots do not feel voyeuristic. In direct contrast to this are the photographs of Della Grace, who is consciously toying with issues of pornography, voyeurism, and the boundaries between pleasure and pain in her explicit lesbian S/M images of rough sex. The photos, which are very self-conscious, seem less about actual S/M sex and the exploration of roles and power for the depicted participants than about a literal positioning and posturing for the camera eye and the photographic frame. For this reason, they do not appear to document lesbian S/M sexual practices, but rather to stage a stylish "look of lesbian S/M." Perhaps they were meant to parody the fashion photographs of Helmut Newton, but if that's the case, they end up dangerously close to the very sensationalized images they are parodying.

Some of these photos are included in Grace's book *Love Bites: Photographs,* along with her images and portraits from punk and leather bar scenes and sex clubs in London and the United States.[44] Because of their contextual and therefore documentary nature, these photographs are interesting not only for presenting alternative sexuality, but because they depict a lesbian sexual subculture. It should be noted that when first published in Britain in 1991, *Love Bites* was seized at the border by U.S. customs officials, who threatened to destroy all copies. Only media outrage and a phone call from *Publishers Weekly* "convinced customs to release *Love Bites* to a lesbian public starved for images of itself. Grace's striking photographs are now familiar currency: they've appeared on the covers of lesbian anthologies, in gay arts journals and on Queer Nation flyers, and have been shown in a number of exhibits both here and in Britain."[45]

However, images of explicit and suggested sexuality are not limited to photographs. Nicole Eisenman's crude, stream-of-consiousness sketches and G. B. Jones's pencil drawings of motorcycle girls, in the style of Tom of Finland, emphasize the cruising eye of the lesbian, while Monica Majoli's tiny meticulous paintings on wood have moved from images of gay male sex in the baths to women with dildoes strapped on, engaged in sexual activities. The work is transgressive in that it visualizes forbidden or taboo sexual fantasies (usually imaged in photography, not painting). A second series of paintings depicts body parts such as a wrist with a tiny scratch or cut, heightening the erotic edge between pain and

pleasure. In "Mystery Date," Catherine Opie combines color photographs with actual objects in a framed assemblage of sexually suggestive items such as dildoes, handcuffs, a leather jacket, lace, studs, whips, and plastic gloves. The piece is either a portrait of a date or the suggestion of fantasy within the frame of S/M role playing.

Millie Wilson intends to "invade high modernism with a queer discourse"[46] in her installation works that examine gender, sexual stereotyping, and the construction of lesbian identity through the exploration of cross-dressing, roles, and masquerade. "In response to the conspicuous absence of the lesbian in post-modern theory," and paralleling the construction of "the artist" and her "body of work" with the construction of "the lesbian," Wilson utilizes specific art-historical references and museum praxis to focus on the role of "presentation" in creating, legitimizing, and authenticating.[47]

In *Fauve Semblant,* Wilson created a retrospective of a fictitious lesbian artist, a young English girl named Peter who worked in Paris at the turn of the century. Using museum conventions such as an entrance wall with large signage and a life-sized black-and-white photograph of the artist (in drag of course), Wilson critiques the grand museum retrospective designed to bestow importance upon an oeuvre by creating a historical narrative fiction that related it to other important modernist art.

Peter is a lesbian who cross-dresses (Wilson "maintains that any woman who undertakes the historically male act of painting is forced to engage in aesthetic cross-dressing"[48]). All that remains of her life are a few artifacts: her smoking jacket, shoes, cane, bow tie, glasses, her last painting palette (a comment on the class privilege of those historical lesbians who could afford to be out?), and a single painting, all represented in the exhibition by life-sized photographs. Together they form the documentative basis of the life and work of this artist. Starting with the male clothing as a sign of sexual orientation, the mannish lesbian artist must be constructed. In a sense, Wilson's piece is more about presentation than representation, for how the lesbian artist is presented is crucial to the legitimization of the very male institution that confers authenticity value and prestige upon her.

Peter's one surviving painting (presented as a treasured artifact in a plexi-box) hints at exotic lesbian sexuality through symbols of a leopard (bestiality?) and tropical flower (female sexuality) and refers to Les Fauves, thus legitimizing Peter's work by connecting it to the male modernist mainstream.

Continuing her Duchampian commentary on the museum as the container of the official narrative (a strategy used by other marginalized

artists such as Jimmie Durham, James Luna, and Fred Wilson), Millie Wilson critiques medical and pathological stereotypes of lesbian identity in an "anthropological" installation entitled "The Museum of Lesbian Dreams," where she pokes fun at the absurdity of psychoanalytic interpretation of lesbian dreams as a way to understand lesbian desire and identity (a theory very popular in psychiatric texts on sexual deviancy from the 1950s and '60s). Parodying minimalism, surrealism, and conceptual art, Wilson isolates Freudian dream symbols of sexuality like the potato and turnip and turns them into serious bronze sculptures on a pedestal. She concretizes them and literally gives them weight. Also among the many artifacts of lesbian desire included in this museum are photo reproductions of a 1761 drawing of periwigs, symbols of authority for men, by Hogarth, which outrageously resembles images of deviant female genitals depicted in a 1948 drawing from *Gynecology of Homosexuality*. Both images are displayed (along with text) on either side of a sculpture of a wig that has been styled to resemble a woman's genitalia. This piece, as well as her genital wig–shaped series "Merkins," pokes fun at the masquerade of authority and successfully exposes and underscores the absurdity of cultural, sexual, and artistic stereotypes and the institutions that try to create and authenticate them.

The museum as institution is also important to much of Zoe Leonard's work. For years she has photographed supposedly objective, scientific exhibits in medical history museums throughout Europe, thereby calling into question "the male-dominated origin of much that we assume is neutral." While this work dovetailed with her involvement with ACT UP and women's health issues, little of it dealt specifically with lesbianism. However, Leonard states that "being a lesbian has informed my point of view. The work that I do with Fierce Pussy, a lesbian artist collectice, is clearly very lesbian work." At last summer's Documenta in Kassel, Germany, Leonard exhibited a series of close-ups of women's genitalia and hung them on the walls between traditional nineteenth-century paintings in the town museum. She says of this installation:

> I requested a suite of four rooms in an old museum at Documenta because I wanted people to walk through what a museum was, and then see my work in relation to what already exists. I'm installing the photography amidst all these paintings that are ostensibly mythological or historical. But what they really are is naked women. Putting the pussy shots in that setting is cutting to the chase. They're totally erotic images for me, as well as a real mirror, in a sense, of what the viewer's relationship is to female genitals. As far as I know, I'm the only out dyke at Documenta. And this is really gay work. This is me really putting myself out there as a lesbian.[49]

The context is important, or, as Jan Zita Grovers has stated, the issue is not just what lies within the frame but the context around the frame.[50] While the photos in and of themselves are not new and continue a body of work begun by earlier lesbian feminists, the context is new and different. The fact that Leonard inserted her pubic portraits into the historical museum system underscores the hypocrisy of "neutral" fine art by men, which depicts women as sexual objects, thereby implying a male subject, and allows Leonard to participate in the contemporary critique of the cultural institutions of authority. These images function as a kind of intervention, an invasion of the female sexual subject which in turn allows for different readings by viewers of differing sexual persuasions. The context and the theoretical underpinnings of the work minimize possible spectatorship and commodification. The work is a strong statement of female sexual power and the taking of space—a very prestigious space at that, one lesbians in the seventies and eighties didn't have access to. It is to Leonard's credit that she didn't try to be a "good girl" but rather utilized her privileged "inclusion" in the male-dominated Documenta to present her most highly charged and unsafe work to date.

Marcia Salo's color photographs examine the shifting nature of lesbian desire and fantasy. Like Bright, she utilizes the heterosexist narrative of Hollywood films to explore lesbian response to identification and identities in the construction of desire. However, since her images overlap, merge, melt, and dissolve, they suggest a more fluid range of roles and fantasies. In *Vertigo,* installed in the women's bathroom of the Gay and Lesbian Community Center in New York City in 1989 as part of a twenty-five-artist project commemorating the twentieth anniversary of the Stonewall riots, Salo combined image and text to suggest a range of roles and fantasies. She describes the installation:

> The following text ran at eye level around the walls of the second floor bathroom: WHEN YOU WATCH THE FILM *VERTIGO,* ARE YOU SCOTTIE WANTING MADELEINE, OR ARE YOU MADELEINE WANTING SCOTTIE TO WANT YOU? OR BOTH? ALTERNATELY OR SIMULTANEOUSLY? IN WHAT PROPORTIONS AND INTENSITIES?

> Two photos, one with Scottie, and the other with Madeleine projected onto my face, were printed in multiples and arranged in a variety of configurations on the bathroom walls, and the backs of the stall doors were painted white so people could respond to the question. In addition, a text describing the installation's intent was installed over the sink.

> Within one month of the opening, three quarters of the photos were torn off the wall, remarks had spread from the doors to the bathroom walls and the name Scottie was removed from the running text. The photo text installation had become a text installation.[51]

Since the piece was installed in the non-art context of the public bath-room at the Community Center, Salo could assume that most of the audience would be lesbians. And because of the "saturated space," which suggested illicit or secret sex, an erotic tone was created not only to explore but to express anonymously one's own intimate fantasies and desires. There was no need to be politically correct here. In its encourage-ment and incorporation of graffiti, the piece involved the lesbian audience in a dialogue not only about the construction of lesbian identity and the nature of lesbian desire and fantasy, but about art and politics.

Among the graffiti responses to Salo's installation:

I'm usually Madeleine, but sometimes I feel as though I *should* be
 Scottie.
I'm me wanting Kim.
We all want Kim, and she wants us.
I don't feel compelled to be either one.
Actually I'm Scarlet wanting Melanie, Melanie wanting Sue Ellen,
 Sue Ellen wanting Mammy, all simultaneously.
I just want tongue.
I won't answer this question because it's a sexist movie about a man
 who molds a woman to his wishes, against hers.
Lighten up, *Vertigo's* a great film.
I'm Liz, wanting dicks out of dykeland.
Lesbian visibility now.
Why is a man's picture in a woman's bathroom?
She's talking about images we get from heterosexist society. Who are
 we? Who tells us who we are? Do we believe them as sister A.
 does or hate them as sister B. does, or wonder about them as the
 artist does?
Madeleine wanting Scottie to want her is classic female submission.
 I understand this piece was done by a *heterosexual* woman.
 Why? It shows!
One would think from all this that lesbians were the most narrow
 minded individuals on the planet. Go back to your island.
I'd love to.
Why won't anyone answer the woman's question? Me, I'm Scottie
 wanting Madeleine. I'm a bull dyke and I always identify with
 the boys in the movies.
Who the hell are you to indicate we're men with movie pictures?
 We're lesbians. I'm glad this shit was ripped off our walls. Don't
 invade our lesbianism.
Are you so fucking insecure that you can't stand to see art that

doesn't appeal to the lowest common denominator of dyke-
dom? Can't stand a little bit of ambiguity? A little complexity?
The dykes who destroyed this exhibit are an embarrassment.
Grow up women.
Put a paintbrush in a dyke's hand and there's a mess.
Whether you like art or not, its not right to destroy it.
Free speech for all.
Amen.
A women.
Stop censoring art work. Keep your stupid hands off the walls.
 Offended dyke.
Censorship = death.
I would *never* put my art on a toilet seat.
Then you're obviously not an artist.[52]

"Drawing the Line," an interactive photo exhibit by Kiss and Tell (a
three-woman collective from Vancouver), is somewhat similar to Salo's
Vertigo in its focus on roles and the incorporation of viewer participation.
But it is more confrontational and controversial because it specifically
addresses issues of sexuality and censorship while exploring the borders
between pornography and erotica. Is there a difference? Where is the line
between the two? Where are you uncomfortable and why?

"Drawing the Line" consists of one hundred 11- × 14-inch black-and-
white photographs of the same two women (from the collective, but not
lovers in real life; the third collective member is the photographer). They
are engaged in a range of sexual or sexualized activities—from hugging,
making love in the bathtub, kissing and cunnilingus to butch/femme
role-playing, fist-fucking, S/M, and bondage. The images move from
gentle, soft, and tender to hard, stylized, and sado-masochistic as they
question lines between pleasure and pain, power and trust.

The viewer is asked to comment on the images by writing on the
walls around the photographs.

> The comments form part of the piece. Women mark their comments directly on
> the wall. Men's comments are in a book mounted near the end of the photo
> series. The book contains prints of the photos 3 × 5″ in the order they appear
> on the wall, and room for longer commentary. Men's and women's voices are
> separate in acknowledgement of our historically different relationship to sexu-
> ally explicit images. The resultant dialogue—among men, among women, be-
> tween models—is multileveled.[53]

We are asked to form opinions about sexual imagery and what can go
public. Do we draw the line at the sexual practice or at its representation?

What is politically correct sex? What is your secret desire? What is a turn on? Are images exploitative only if women were exploited while making them?

The comments proved to be far more interesting than the photographs themselves, which are provocative and transgressive simply because we don't usually see public images of explicit lesbian sex. Jan Zita Grover, while applauding the exhibit, has written, "After spending five minutes reading viewers' reactions, it's impossible to believe that photographs have any fixed meaning—instead, we see in them what we want or need to see."[54]

Lines were drawn in many different places. What was highly erotic to one woman was boring, threatening, or violent to another. "Woman has sex organs just about everywhere," writes French feminist writer Luce Irigaray. "She experiences pleasure almost everywhere. The geography of her pleasure is much more diversified, more multiple in its differences, more subtle, more complex than is imagined." The diversity of responses in "Drawing the Line" spoke of "choice," and "constructed a female subject as the site of difference, not a fragmentary subject, but one that is whole, with differences intact."[55]

However, the representation of two women engaged in sexual or sexualized activity is extremely problematic, for traditionally lesbians have been portrayed as objects for male fantasies of lesbian eroticism. This consuming eye of spectatorship is wonderfully spoofed in Joyce Kozloff's watercolor, "Inside the Amber Palace or the Pasha Peeks" from the "Pornament Is A Crime" series where, in the middle of sexual embellishment and ornamentation of the Turkish bath, one woman is going down on another, under the ever present watchful eye of the Pasha who is getting off on it. Unlike gay men, who have been able to depict differing modes of sexual practice for their own pleasure, lesbians have had difficulty escaping the ever present male gaze.

As Martha Gever has written, "The important issue is how to get past this—how to get free from the male gaze, to reconfigure the terms of lesbian representation to negate the past stereotypes and to create a new erotic self,"[56] or, to repeat Lippard, to "depict what the male gaze cannot see." To date, most erotic art, like pornography, has been rooted in photography and thus in figuration. While *Drawing the Line* with its walls of impassioned text subverted old frameworks of photography, minimizing passive voyeurism and appropriation, the photos could be consumed by any viewer, male or female, straight or gay. To try to get around this problem posed by figuration, lesbian artists have been employing a range of devices and strategies that have been only partially successful: blurring, overlaying, superimposing, fragmenting, abstract-

ing, or symbolizing. For instance, in order "to imply sexuality between women without actually showing it," Tee Corinne has used solarized abstract images of body parts, or sexually symbolic images as stand-ins for women. A photo like *Women Eating Flowers* is really about women eating women.[57]

This hesitation, shared by many lesbian artists, to depict explicit lesbian sex comes from the fact that often we don't know and can't control who is in the viewing audience. Cindy Patton, who has been exploring a "pornographic vernacular"—gay and lesbian porn films and videos—as vehicles for safe sex education, talked about her ambivalence at showing a lesbian sex tape to accompany a lecture she was giving at Duke University, where the audience was mostly straight white men. Because she wasn't sure what it meant for them to see lesbians "doing it," she censored herself, and stopped short of showing the tape.[58] I, too, frequently find myself in similar situations when I give slide presentations of work by lesbian artists. If the audience is mixed (male-female) I feel very uncomfortable showing images of female genitals or women engaged in sexual or sexualized activities. While I want to claim a public lesbian erotic space in the way that gay men have been able to do, I find that I also want to protect our bodies from spectatorship and consumerism.

This hesitation may also reflect our hesitancy to limit our pleasure, for to rely on boundaries of figuration may restrict the erotic invention. Perhaps it is the invention that turns us on. Lesbian pleasure is multiple and not fixed, and I would suggest that it is precisely in this unfixedness that the lesbian erotic is located. I have long been interested in the potential of erotic abstraction in which the body part or sexual act is not depicted but rather referenced from a combination of abstract form, and the associations and physical manipulations of the materials themselves. For instance, human hair off the body always has sexual overtones, and a material like latex rubber usually suggests skin or body fluids. Since materials can reflect marginalization and minimal forms can evoke emotional states, abstraction offers the possibility of an erotic art that bypasses the problematics of figuration. Instead of focusing on the figure with its fixed contour and impermeable surface of skin, abstraction opens up time and space, allowing us (other women/lesbians) to feel/respond sexually "in the body" (versus "to the figure") to what we see. And since the lesbian gaze is not focused on the "image of orgasm" but rather on how it feels, it can avoid the male gaze and be extended indefinitely.

My own wrapped-rag sculptures of the late seventies and early eighties were intended to create a lesbian sensual/sexual presence in the world. They were not about mummifying, binding, or bandaging, but

rather about making something out of itself from the inside out, with the insides showing on the outside—a kind of presence as essence made visible. I thought of works such as *Adelphi, Durango, Grasping Affection,* and *Radiant Affection* as lesbian pieces not so much because of the female body parts they referenced, but rather because of the visual qualities and manipulation of materials to convey the interior female body—the muscle, tissue, membrane, fluid body. While related to the work of Eva Hesse and Louise Bourgeois, at the time I made them I was thinking about Wittig. The sculptures, like her *Lesbian Body,* created a raw, passionate, and sometimes violent sexuality, a body (re)membered and whole, taking up a space beyond its physical space. Beautiful and powerful.[59]

In my large-scale mixed-media installation paintings such as *Inappropriate Longings,* old fragments of linoleum are pieced together and combined with paint and latex rubber surfaces as a kind of excavation of memory. The words "goddamn dyke" incised into the rubber skin suggest a narrative of emotional and sexual violence within the domestic site. Gutters and water troughs normally used to collect water become a metaphor for circulatory systems of life fluids which are dysfunctional—empty or clogged with dried leaves. The crime is not clear. Who or what was violated? By whom? And why? Is the murder real, fiction, or fantasy? Is it self-inflicted? The installation suggests a narrative, but does not provide closure.

Because of the metaphoric possibilities a good number of lesbian artists are working in installational formats, often combining photographic images or elements of text along with a range of painting and sculptural materials. This loosely defined territory which can also include time-based arts (sound/light/film/video/performance), allows for a range of identities and sensibilities and the possibility of not just making work about being lesbian but rather making it from the perspective of being lesbian, and in this way totally reconfiguring lesbian representation. As sites, bodies, interiors, exteriors, danger and pleasure combine, dissolve, and splinter, bodies of knowledge are constructed and lesbian experience and identities can be suggested without being fixed or consumed.

Mindy Mills, a young artist and ex-student of mine, incorporates cropped images of women engaged in various sexual activities on fragments of orthofilm along with found and weathered materials from the streets, vacant city lots, and construction sites. The photo fragments combine with nails, burnt wood, metal lathe, cement, wire and light to create a shadowy and dangerous site of destruction, deconstruction, and construction. It is a heightened, intense environment where sexuality can

be felt lurking and shifting but, because of the fragmented images, cannot be possessed. While she runs the risk that everyone may not recognize the images as that of two women sexually involved, to most lesbians the space is all too recognizable and familiar. Seemingly about power and survival, her site of desire is a dangerous place to enter in that it speaks of unclear boundaries between pain and pleasure, disintegration and (re)member-ing. No matter how one identifies sexually one cannot relax here for a moment—to enter this space is dangerous because there is no sure foot-ing.

Sallie McCorkle's formal bench installations suggest a tension be-tween separation and integration. In a funky little Brooklyn waterfront park, McCorkle turned a bench into a one-person fortress looking out at the Manhattan skyline. The piece emphasizes the overwhelming sense of isolation that a lesbian and/or artist might have while gazing out at the large city of New York, where "It's all happening." In contrast, *Bench: A Long Seat for Two or More Persons* is about camaraderie. The piece incorporates a 1920 photo of women workers who are holding hands inside each other's pockets. Not particularly interested in questions of sexual identity, McCorkle speaks of the need for women, lesbians and gays to bond together "to embrace each other and create stronger voices." By providing diagrams and instructions for building the bench she is "saying that you too can make the bench and we can all sit there. Or, we can make the bench together."[60]

Martha Fleming and Lyne Lapointe have worked together on large-scale site-specific works in Montreal since 1983. Renovating old aban-doned buildings that are charged with emotional and ideological mean-ings—such as former warehouses, museums, post offices, and theaters—as sites to combine architecture, objects, text, light, sound, and perform-ance, Fleming and Lapointe have been able to construct fictions that suggest social structures and their effects on the lives of under- or de-valued peoples such as women, lesbians, the insane, or criminals.

In an unusual installation at the New Museum in New York City, they "propose a quest for sites of pleasure." *Eat Me/Drink Me/Love Me* was based on "Goblin Market," a highly erotic "allegorical poem of feminine temptation and redemption" by the nineteenth-century poet Christina Rossetti.[61] Fleming and Lapointe created a "haven of sensual delight," a country home with bowls of fruit, baskets of coal, branches of red berries, and secret gardens. Portraits of Rossetti and her contempo-rary Emily Dickinson were placed in the entry to this domestic space, where "women have traditionally enjoyed each other," thus alluding to passionate bonds for women expressed in Rossetti's and Dickinson's

poetry. The lush seductive ambience with its images of bees and flies suggested that "abandonment may lead to liberating possibilities," and a curious buzzing sound heightened the erotic sense alluding to passionate bondings between women and a lesbian subtext in the form of an "impossible love affair."

Catherine Saalfield and Zoe Leonard's collaborative piece *Outlaws* takes up "the lesbian as both spoken and speaking," and was created out of a fold-away bed with sheets and pillow cases printed with drafts of proposed antigay legislation. A TV next to the bed alternates images of two women making love with ACT UP demonstration footage. *"Outlaws* suggests both the repressive codes and resistances to them."[62]

As much of this work demonstrates, the field of gender and sexuality is wide open and is occupied by a proliferation of identities. If in a sense "all gender is drag," where men and women impersonate an ideal that no one inhabits,[63] then sexuality, too, is called into question. Lesbian artists are not only challenging the hegemonic, heterosexual regime, but also disrupting and destabilizing many established codes of representation. The art is not stuck on the margins, but free to move about. If, indeed, as Foucault stated, "Our sexuality is something we make in our everyday experimentation with sex and pleasure,"[64] then the diverse and shifting nature of lesbian identity as it is reflected and constructed in art continues to occupy a space of infinite and pleasurable possibilities. . . .

Lesbian Art Chronology

1973–76
Lesbian and gay artists exhibit at the Gay Academic Union held each year in New York.

1975
Los Angeles League for the Advancement of Lesbianism in the Arts (LALALA) founded.

1977
"Lesbian Art and Artists," *Heresies: A Feminist Publication on Art and Politics,* Issue No. 3. Editorial collective included Cynthia Carr, Betsy Crowell, Betsy Damon, Rose Fichtenholtz, Louise Fishman, Su Friedrich, Harmony Hammond, Marty Pottenger, Amy Sillman, Christine Wade, Kathy Webster. New York City.

1977–80
Lesbian Art Project, Los Angeles. Three-year educational program
originated by Arlene Raven.

1978
"A Lesbian Show," 112 Greene Street Workshop, New York City.
Curated by Harmony Hammond, and performances and read-
ings coordinated by Betsy Damon. Exhibiting artists included
Barbara Asch, Betsy Damon, Sandy de Sando, Jessica Falstein,
Maxine Fine, Louise Fishman, Dona Nelson, Harmony Ham-
mond, Mary Ann King, Gloria Klein, Kate Millett, Flavia
Rando, Ellen Turner, Janey Washburn, Ann Wilson, Fran
Winant.

1980
"The Great American Lesbian Art Show" (GALAS), The Woman's
Building, Los Angeles. Curated by Bia Lowe, Louise Moore,
Jody Palmer, Barbara Stopha, Tyaga, Terry Wolverton. Exhib-
iting artists included Lula Mae Blockton, Tee Corinne, Betsy
Damon, Louise Fishman, Nancy Fried, Harmony Hammond,
Debbie Jones, Lili Lakich, Gloria Longval, Kate Millett, plus
over fifty sister exhibits in North America.

1982
"Extended Sensibilities: The Homosexual Presence in Contemporary
Art," The New Museum for Contemporary Art, New York
City. Curated by Daniel J. Cameron. Eight out of nineteen
artists were lesbians: Janet Cooling, Betsy Damon, Nancy Fried,
Harmony Hammond, Lili Lakich, Jody Pinto, Carla Tardi,
Fran Winant.

1990
"A Survey of Lesbian and Gay Artists," Penine Hart Gallery,
New York City. Curated by Lewis Holman. Exhibition of six
men and six women included Lola Flash, Louise Fishman,
Ester Hernandez, Ann Wilson, Nancy Brooks Brody and Zoe
Leonard.

1990
"All But the Obvious," Los Angeles Contemporary Exhibitions
(LACE). Curated by Pam Gregg, the exhibition included Laura
Aguilar, Laurel Beckman, Kaucyila Brooke, Gaye Chan, Janet
Cooling, Della Grace, Monica Majoli, Tracey Mostovy, Cather-
ine Opie, Beverly Rhoads, Nancy Rosenblum, Collier Schorr,
Millie Wilson, Catherine Saafield, and Jackie Woodson. Accom-
panied by performances, video, and readings.

1990

"Queer: Out in Art," Wessel O'Connor Gallery, New York City. Curated by John Wessel and Bill O'Connor. Exhibition included work by fifty-five men and nine women: Millie Wilson, Eve Ashcraft, Linda Matalon, Carrie Yamaoka, Martha Fleming, Melissa Harris, Lyne Lapointe, Collier Schorr, and Marcia Salo.

1991

"Outrageous Desire: The Politics and Aesthetics of Representation in Recent Works by Lesbian and Gay Artists," Rutgers University, Mason Gross School of the Arts, New Brunswick, New Jersey. Given in conjunction with the Fifth Annual Lesbian and Gay Studies Conference. Over fifty artists exhibited, of whom half are lesbian: Diane Bonder, Deborah Bright, Nancy Brooks Brody, Tee Corinne, Liz Deschenes, Cheryl Dunye, Joy Episalla, Claire Gravonsky, G. B. Jones, Deborah Kass, Carole Hepper, Julia Kunin, Zoe Leonard, Shelly Marlowe, Tracey Mostovy, Ellen Neipris, Pin Martin, Margo Pelletier, Terry Rozo, Catherine Saafield, Marcia Salo, Annie Sprinkle, Elizabeth Stephens, Kathleen Sterck, Fran Winant, Carrie Yamaoka.

1991

"Visible for a Change: Contemporary Lesbian Artists, U.S.A." Slide-show installation of work by over one hundred contemporary lesbian artists, and discussions, as part of the Sixth Annual Colloquium on Gender, Culture, and Society, sponsored by the Committee on Degrees in Women's Studies. The theme of the colloquium was "Women, Art, and Politics." The ongoing slide installation included work by lesbian artists from the early seventies to work by artists emerging in the nineties.

1991

"Situations," New Langston Arts, San Francisco. Co-curated by Nyland Blake and Pam Gregg. Work by thirty-six lesbians and gay men under forty years of age.

**The Gay
90's**

As we enter the decade being called by many journalists as the "Gay 90's," exhibitions (too numerous to list here) of gay, lesbian, and queer art are proliferating throughout the United States and play an important part in the ongoing discourse around the social construction of gender, and gay, lesbian, bisexual and transgenderal sexuality.

Acknowledgments

This chapter is part of an ongoing series of ideas and images that were first presented as a paper entitled "The Incredible Queerness of Being (on the Border) . . ." at the Midwest College Art Association Conference in Tucson, Fall 1990. At that time I focused on the need to develop queer identity and to bring sexual preference into the dialogues around difference and representation in visual art, along with race and gender. In the two and a half years since this initial presentation, sexual preference has come to play an important role in these discourses, and I have shifted my focus to lesbian identity and self-representation. Versions of this paper have been presented as part of the symposium "Excluded Voices: Combating Racism and Homophobia," University of Minnesota, 1991; on the panel "Women and Creativity," University of New Mexico, 1992; as part of the Multicultural Dialogue Series sponsored by Spiderwomen at the College of Santa Fe, 1992; as a slide presentation to the art/dyke community in Christchurch, New Zealand, 1992 and most recently at the Center for Contemporary Arts (Cosponsored with Through the Flower) in Santa Fe, 1992.

I wish to thank Lucy Lippard for her much needed editing of the final version, and to thank Joyan Saunders, Carolyn Hinkley, Lucy Lippard, Judy Chicago, Cassandra Langer, Arlene Raven, May Stevens, Elizabeth Hess, Paul Ivey, David Hirsch, John Wessel, Geoffrey Hendricks, and Bruce Kurtz for sharing information and ideas and for providing support to "just keep going."

Notes

1. I mean more than a superficial acknowledgment, more than merely adding it to what Kobena Mercer has called the "mantra of race, class and gender." Kobena Mercer, "Skin Head Sex Thing: Racial Difference and the Homoerotic Imaginary," in *How Do I Look? Queer Film and Video,* ed. Bad Object-Choices (Seattle: Bay Press, 1991).
2. Martha Gever, "The Names We Give Ourselves," in *Out There: Marginalization and Contemporary Cultures,* ed. Russell Ferguson, Martha Gever, Trinh T. Minh-ha, Cornel West (Cambridge and New York: The New Museum of Contemporary Art and MIT Press, 1990).
3. Trinh T. Minh-ha, *Woman, Native, Other: Writing Postcoloniality and Feminism* (Bloomington: Indiana University Press, 1989).
4. Ibid.
5. This is a variation on Bertha Harris's statement, "The great service of literature is to show us who we are," "What We Mean to Say: Notes Toward Defining the Nature of Lesbian Literature," "Lesbian Art and Artists," *Heresies: A Feminist Publication on Art and Politics,* no. 3, Fall 1977.
6. Critic Lucy Lippard has repeatedly made this statement in numerous lectures on multiculturalism and the arts.
7. Audre Lorde, "Age, Race, Class, and Sex: Women Redefining Difference," in *Out There,* ed. Ferguson et al.
8. Jeff Weinstein quoted by Edmund White, panel discussion (Nov. 29, 1982), "Extended Sensibilities: The Impact of Homosexual Sensibilities on Contemporary Culture," New School, New York. Sponsored by the New Museum of Contemporary Art in conjunction with their exhibition (Oct. 16–Dec. 30, 1982), "Extended Sensibilities: Homosexual Presence in Contemporary Art," curated by Daniel Cameron. Panel transcript published in *Discourses: Conversations in Postmodern Art and Culture,* ed. Russell Ferguson, William Olander, Marcia Tucker, and Karen Fiss (Cambridge and New York: the New Museum and MIT Press, 1990).
9. Kate Millett, panel discussion, "Extended Sensibilities."

10. Stuart Hall quoted by Gever, "The Names We Give Ourselves."

11. Michel Foucault, quoted in "Sex and the Politics of Identity: An Interview with Michel Foucault," Bob Gallagher and Alexander Wilson, in *Gay Spirit: Myth and Meaning,* ed. Mark Thompson (New York: St. Martin's Press, 1987).

12. Ibid.

13. Arlene Stein, "Queer Innovation: Transforming Gender, Sexuality, and Social Movements," *Socialist Review,* 22, no. 1 (1992).

14. Jill Johnston, quoted in Stein, "Sisters and Queers."

15. Jan Zita Grover, "Dykes in Context: Some Problems in Minority Representation," in *The Contest of Meaning: Critical Histories of Photography,* ed. Richard Bolton (Cambridge, MA, MIT Press, 1990).

16. Personal letter from Louise Fishman to Harmony Hammond, 1992.

17. Terry Wolverton, "Portraying Sexuality," *The Advocate,* April 9, 1991, p. 71.

18. Grover, "Dykes in Context," p. 165.

19. Barbara Asch, *Statements by Lesbian Artists,* catalogue for exhibition "A Lesbian Show," 112 Greene Street Workshop, New York, 1978.

20. Monique Wittig, "The Straight Mind." Text first read in New York at the Modern Language Association Convention, 1978. It was later printed in Monique Wittig, *The Straight Mind and Other Essays* (Boston: Beacon Press, 1992). The ideas I've presented are drawn and quoted from Wittig's "The Straight Mind" and "One Is Not Born a Woman," presented at the Second Sex Conference in 1979 and also published in this volume, along with "Paradigm: What Have You Done with Our Desire?" in *Homosexualities and French Literature: Cultural Contexts/Critical Texts,* ed. George Stambolian and Elaine Marks (Ithaca: Cornell University Press, 1979).

21. Stein, "Sisters and Queers." These shifts are also documented in Lillian Faderman, *Odd Girls and Twilight Lovers: A History of Lesbian Life in Twentieth-Century America* (New York: Penguin, 1992).

22. Stein, "Sisters and Queers."

23. Carole Vance, ed., *Pleasure and Danger: Exploring Female Sexuality* (Boston: Routledge & Kegan Paul, 1984), papers presented at the Scholar and the Feminist IX Conference, April 24, 1982, at Barnard College, New York City.

24. *Diary of a Conference on Sexuality,* Barnard College, 1982.

25. *Caught Looking: Feminism, Pornography and Censorship,* essays and visuals compiled by the Feminist Anti Censorship Task Force, 1976–86, 2nd ed. (Seattle: Real Comet Press, 1988).

26. Stein, "Sisters and Queers."

27. Lucy R. Lippard, "Both Sides Now (a Reprise)," in *Heresies: A Feminist Publication on Art and Politics,* "12 Years," issue 24 (1989).

28. Cassandra L. Langer, "The Queer Show," in *Woman Artist News* (Winter 1991). Also, unpublished paper, "The Lesbian Feminist World View and the Gaze."

29. It should be said, however, that the Wessel O'Connor Gallery has primarily and consistently supported and exhibited work by gay men and lesbians that deals with queer identity. Unfortunately, it and the shorter-lived Penine Hart Gallery are temporarily closed as of this writing. Other galleries that regularly exhibit lesbian and gay art include Feature, Trial Balloon (lesbian), Fiction/Nonfiction, PPOW, Paula Cooper, and Mary Boone in New York and New Langston Arts in San Francisco.

30. Press release for "All but the Obvious: A Program of Lesbian Art," LACE, Los Angeles, 1990.

31. Terry Wolverton, "Generations of Lesbian Art," *High Performance* (Spring 1991).

32. Pam Gregg, catalogue essay, "All But the Obvious."

33. Pam Gregg, "All But the Obvious."

34. Terry Wolverton, "Generations of Lesbian Art," *High Performance,* Spring 1991, p. 10. While Wolverton states that there are three artists of colors in this exhibit, it seems that there

might have been four. However, the point of inadequate representation is the same. I wish to point out here that "A Lesbian Show" in New York in 1978 did not include work by any lesbian artists of colors and was rightly criticized for not doing so. I curated that exhibit, and while several artists were invited to participate, they chose not to for various personal reasons. While this was a serious shortcoming of the exhibit, dialogues were started that have continued throughout the years and encouraged artists of colors to participate in future lesbian exhibitions and art projects. Betsy Damon, who organized the accompanying performances and readings, was also criticized for not including enough lesbians of colors. Since there were many writers and performers eager to participate, the program was opened up, and many events by lesbians of colors were scheduled every night for the duration of the exhibit. It should be noted that Damon has continuously been committed to encouraging and facilitating the participation of artists of colors throughout the feminist art world, and in particular the Women's Caucus for Art of the College Art Association. I mention this because I think that racism is something that we all continue to work on over a period of time, that the ongoing process of self-examination and dialoguing is crucial to activism, and that sometimes the means are more important than the immediate situation and ultimately move toward long-range goals.

35. Wolverton, "Generations."
36. Judith Butler, "The Body You Want," interview with Liz Kotz, *Art Forum,* November 1992. Questions raised by Judith Butler in the interview.
37. Carla Trujillo, ed., *Chicana Lesbians: The Girls Our Mothers Warned Us About* (Berkeley: Third Woman Press, 1991).
38. Artists working with lesbian identity in their work include painters (Monica Majoli, Maxine Fine, Marlene McCarty, Nicole Eisenmann, Lutz Bacher, Hollis Sigler, Margo Pellatier, Deborah Kass, Fran Winant, Shelley Marlow, and Beverly Rhoades) and sculptors (Carol Hepper, Julia Kunin, and Linda Matalon).
39. Deborah Bright, "Dream Girls," in *Stolen Glances: Lesbians Take Photographs,* ed. Tessa Boffin and Jean Fraser (London: Pandora, 1991).
40. Liz Kotz, "Strategies for Lesbian Representation: Kaucyila Brooke's Photography," *SF Camerawork Quarterly,* Summer 1990.
41. Artist's statement, Kaucyila Brooke, n.d.
42. Joanna Frueh, "How Do You Play? The Deviant Narratives of Kaucyila Brooke," *After Image,* 17, no. 9 (April 1990).
43. Artist's statement, Kaucyila Brooke, n.d.
44. Della Grace, *Love Bites: Photographs* (London: GMP Publishers, 1991).
45. Gail Shepherd, "Positive Images," in *The Women's Review of Books,* no. 5 (Feb., 1992).
46. David Bonetti, "Things Are Not What They Seem," *San Francisco Examiner,* Feb. 28, 1992.
47. Terry Wolverton, "Thoroughly Post Modern Millie," *The Advocate,* Nov. 20, 1990.
48. Ibid.
49. Faye Hirsch, "A Spy in the Museum," *QW,* May 24, 1992, p. 41.
50. Jan Zita Grover, "Dykes in Context," p. 168.
51. Grover Project Description, Marcia Salo, Oct. 14, 1989.
52. Ibid.
53. Kiss and Tell Collective (Persimmon Blackbridge, Lizard Jones, Susan Stewart), statement for "Drawing the Line," n.d. Some of the photos and comments are available as a postcard book, *Drawing the Line: Lesbian Sexual Politics on the Wall* (Vancouver: Press Gang Publishers, 1991).
54. Jan Zita Grover, " 'Drawing the Line,' " *Outlook,* no. 10 (Fall 1990).
55. Marusia Bociurkiw, "The Transgressive Camera," *Afterimage,* Jan. 1989. Bociurkiw also quotes Irigaray as cited in Rosalind Jones, "Writing the Body," *Feminist Studies* 2 (1981).
56. Gever, "The Names We Give Ourselves."

57. Jan Zita Grover, "Framing the Questions: Positive Imaging and Scarcity in Lesbian Photographs," in Boffin and Fraser, *Stolen Glances.*
58. Cindy Patton, "Safe Sex and the Pornographic Vernacular," in *How Do I Look? Queer Film and Video,* ed. Bad Object Choices (Seattle: Bay Press, 1991).
59. Monique Wittig, *The Lesbian Body* (New York: Avon Books, a Bard Printing, 1976).
60. David Hirsch, "Isolation and Sharing," *New York Native,* July 8, 1991, p. 39.
61. Alice Yang, catalogue essay, "Eat Me/Drink Me/Love Me: An Installation by Martha Fleming and Lyne Lapointe," The New Museum for Contemporary Art, New York, 1990.
62. Marcia Salo, "Particles in Motion: Lesbian Thermodynamics," catalogue essay for exhibit "Outrageous Desire," Rutgers University, New Jersey, 1991, p. 13.
63. Butler, "The Body You Want."
64. Michel Foucault, quoted in Gallagher and Wilson, "Sex and the Politics of Identity."

THE MASCULINE IMPERATIVE
High Modern, Postmodern

Laura Cottingham

Postwar feminism has consistently placed equal, if often uneasy, emphasis on both the symbolic and the material. In the United States, it was an "image protest" that carried the second wave to national prominence.[1] During subsequent decades, activists and academics have waged a continuing (though far from unilateral) critique on the representation of women as constructed according to the conventions of literature, film, psychoanalysis, pornography, advertising, television, and all other forms of cultural production. Coextensive with these investigations of ideological constructions, feminists have been working against the immediate and experiential obstacles that restrict women's autonomy, such as those contained in discriminatory employment, unequal pay, inadequate health care, marriage laws and conventions, rape and other forms of sexualized abuse, and the systemic exclusion of women from positions of social and governmental influence. The question of ascertaining a causality between the ideological and the material constrictions of women's experience has inspired some of recent feminism's most significant ruptures, including the segue toward psychoanalysis that occurred in England and France in the '70s, and the arguments around pornography that emerged in the United States during the early '80s.

How the iconographic affects and constructs lived experience is still an open debate: the material effects of recent activism are a bit less

intangible. Social changes wrought by the Women's Liberation, Black Power, and Gay Rights movements have affected all areas of American life, including the production and reception of art. Since the late '60s, political/activist demands for inclusion have inspired and often been concurrent with an emergence of related (fine) art practices and art practitioners: feminist art and female artist, antiracist art and nonwhite artists, gay art and "out" gay artists. Postmodernism, the slippery term currently in usage to describe the present moment, could be defined as exactly this politically engendered disruption of the (hegemonic) discourse of traditional European aesthetics.

The calls for an adjustment to the Eurocentric paradigm have met resistance in the art world, just as they have within other sectors of American society. One overt form of this resistance has been a resurgence, beginning in the early '80s, of "masculine" assertion from a significant number of heterosexual white male American artists. Before addressing the new (old) exclusionary character of the work, and how, despite its self-avowed "postmodernity," their work moves back to traditional and tradition-upholding male supremacy, it is necessary to uncover some aspects of the political bias of American High Modernism.[2] In the "new" masculinity of the postmodernity of the '80s and '90s, the masculine imperative of High Modernism continues unabated. In fact, it is almost as if the controlling codes of American social dominance that contained the '50s but were sublimated in the most successful art of the period reemerge, this time aggressively and overtly, in the celebrations of capitalism, male hegemony, and Eurocentrality that arrived within the so-called postmodernity of the early '80s.

Implicit messages about the male as normative are complicit with High Modernism's coterminous insistence on form over content, on white male artists over anybody else; although the exclusionary ramifications of High Modernism are not expressively articulated within the doctrine because they are so neatly assumed and subsumed by it. During its heyday in the '50s, American Modernist art and criticism seemed, in many respects, to overthrow convention. Its retention of some of the Western tradition's central assumptions—i.e., the superiority of the male—has been difficult to see, and feminist art criticism has usually been looking elsewhere. The revisionist efforts of feminist art history and criticism since the seventies has largely focused on the necessary tasks of reclaiming the "lost" contri-

butions of female practitioners and theoretically exploring the consistent and different devaluations of the female image within the West's fine art continuum. Less attention has been paid to the cultural production of femininity's supposed "opposite": masculinity. Yet the construction and maintenance of a male identity, according to an essentialized male-supremacist understanding of the male as normative and dominant, has been a central symbolic component of twentieth-century American art and of the European tradition from within which it finds meaning.

Apologists of High Modernism unabashedly proclaimed their purpose to maintain, through formalism and the eschewing of content, what Clement Greenberg called "the historical essence of civilization." Maintenance of any kind is, by definition, conservative: the aims of High Modernism were the conservation and uncritical valuation of European, especially "Parisian," civilization. The "triumph" of American Modernism during the '50s was not an attack of the colony on the colonizer: New York Abstract Expressionism hoped to pick up the mantle of European civilization, not discard it. The recent revisionism of this period by art historians such as Serge Guilbaut and T. J. Clark, while astute concerning many of the defining forces that characterized postwar America, still collaborate with the sexism of the pre-feminist period.[3]

Reconstructing Modernism (1990), for instance, a collection of essays edited by Guilbaut, features on its cover a Cecil Beaton photograph from a 1951 issue of American *Vogue.* The well-known image presents a thin white woman in a black satin strapless gown trimmed with a hot-pink bow, standing, gaze averted, in front of a huge, black and pink Jackson Pollock, *Autumn Rhythm* (1951). For *both* Guilbaut and Clark, the *Vogue* photo represents a crisis of intention, situation, and use for Pollock and Abstract Expressionism. In his extensive essay on Pollock included in the same anthology, Clark considers the *Vogue* photos at length: he is compelled to explain them, to understand them, to interrogate them, to position them, to deconstruct them. His chief concern is how these "fashion photographs" represent a "misuse" of Pollock and whether this "misuse" of "art" is inevitable. "The Vogue photographs matter," he writes, "because they bring to mind—or stir up in us—the most depressing of all suspicions we might have about modern art: the bad dream of modernism, I shall call it." Yet how different are my nightmares from those of T. J. Clark! His concerns are that Pollock is reduced to "the fashionable," or to "the decorative." For him, the photographs are "nightmarish" because "they speak to the hold of capitalist culture, the way it outflanks any work against the figurative and makes it an aspect of its own figuration." Amazingly, Clark, while fixated on the woman/

figure positioned in the fore of Pollock's canvas, cannot see her. He accepts, a priori it seems, that Pollock has been "trivialized" by the *Vogue* photographs—without bothering to consider what allows him so easily to define what it is that for him constitutes "the trivial." Clark takes for granted that *Vogue,* the magazine and the context within which Beaton's photographs first appeared, is trivial. And he assumes, by extension, that blonde women in strapless gowns are, likewise, the very Sign of the trivial. This is not at all what I see when I look at that by-now infamous series of *Vogue* photographs: I don't see the Pollock rendered decorative by the woman, I see the woman, already proscribed as decorative by her position within male supremacy, further *reinscribed* as decorative, as object, by the painting. I don't moan the loss of abstraction's meaning, I cry that a Modernist painting is imbued, by Clark and others, with more serious intentionality and purpose than they ascribe a woman—perhaps especially a thin blonde woman in a black strapless.[4] The "crisis" the *Vogue* photographs represent for some contemporary art historians is the same crisis they must have represented for Pollock and Greenberg: that the "art" was rendered trivial in being rendered "feminine." Pollock's work appeared in other magazines during the '50s and '60s, but it's the woman's fashion magazine *Vogue* that inspires/inspired alarm. Somehow, if Pollock is standing in front of his own canvas, as he appears in numerous other images of the period, the "art" isn't lost the way it is, for Clark, if a "fashion model" takes the artist's place. What is it that determines why *Life* magazine and a male body are synonymous with art but *Vogue* magazine and a female body put art in a "crisis" that calls forth "the bad dream of modernism"?

II

In one of his most famous essays, Greenberg equates practitioners of formalist Modernism, who conform to an elite and exclusionary tradition, with defenders of democratic ideals—and he designates those who criticize culture from a subordinated position as "plebeian" and "reactionary": "Then the plebeian finds courage for the first time to voice his opinions openly. Most often this resentment toward culture is to be found where the dissatisfaction with society is a reactionary dissatisfaction which expresses itself in revivalism and puritanism, and latest of all, in fascism."[5]

Greenberg, an educated white heterosexual male at the propellant center of (American) High Modernism's aims and audience, could not

anticipate how those marginalized by this discourse—the "plebeian," the nonwhite, the nonmale—might arrive at an emancipatory, rather than a reactionary, criticism of the avant-garde.[6] Greenberg's "avant-garde" carried the United States and its white male practitioners into new heights of cultural imperialism and individuated economic and professional success; and it faithfully adhered to its program of essentialized civilization. It neither sought nor effected any disruption of Euro-derived cultural hegemony, except that it tilted the center toward the American side of the Atlantic. During the '50s and '60s, those who attempted to enter art production from outside its heterosexual-male, Euro-American, urban center—women, nonwhites, gay men—were either prohibited from participating or were forced to deny difference and assimilate. In his attempt to explain how a few gay male artists identified with Pop came to eclipse the hetero-male Abstract Expressionists and dominate fine art during the repressive late '50s and early '60s, Jonathan Katz suggests that Robert Rauschenberg and Jasper Johns, because of their "closet" tradition as gay men, were best placed to conform to the politics of containment that defined the height of the Cold War period, that they were already positioned as "organizational men" who could "work, as they had all their lives, within the terms of the national consensus." And if gay codes and personal homosexual experience both influenced and were even then obvious in Pop, as Katz observes, "To identify that queer voice is of course to self-identify as well, especially in the context of the '50s. So it's equally not surprising that the gay content of this artwork rarely made it into print."[7]

Similarly, women artists, whose political status was not as easily rendered opaque, still attempted to be "men" artists: like their literary precedents in the previous century, many tried to alter the public's awareness of their gender by eliminating or changing their female-coded first names. For instance, in the '50s and early '60s, Lee Krasner and Elaine De Kooning both chose to sign their work with initials only, Grace Hartigan briefly adopted "George" as her professional first name, and Elaine Sturtevant began and continues to work under the name "Sturtevant" only. American women artists active during the decades between World War II and the feminist movement of the '70s utilized a variety of strategies in their attempts to be accepted as artists, not women—because to be a woman was by definition not to be an artist. The masculinist bias that informs the critical and historical interpretation of the Pop Movement still prevails in two recent museum exhibitions devoted to the movement, "Pop Art: An International Perspective" (mounted in 1991 by The Royal Academy of Arts, London) and "Hand Painted Pop: American

Art in Transition 1955–1962" (presented in 1993 by The Museum of Contemporary Art, Los Angeles). In her catalogue essay for the Los Angeles show, co-curator Donna De Salvo admits that artists not included in either of the two recent major exhibitions "like Martha Edelheit, Lettie Eisenhower, Roslyn Drexler, Niki de Saint-Phalle, and Marjorie Strider have been omitted from most studies of the period."[8] Other active (female) participants similarly excluded include Lee Bontecou, Carollee Schneemann, and Sturtevant. Women artists not only face different, and more emphatic, career obstacles than their male counterparts, they are also much more likely to be *written out* of history, even when they have (supposedly) succeeded. But this continued erasure cannot be considered surprising given the blatant sexism which informs art's reception. Writing about the '70s, Lucy Lippard noted: "When somebody said 'You paint like a man,' you were supposed to be happy, and you *were* happy, because you knew you were at least making neutral art instead of feminine art—god forbid."[9]

The phrase "neutral art" succinctly expresses the requisites, and the myth, of High Modernism, which calls for an art that is hermetically sealed, an art separated from social and political circumstance and devoted only to itself, its "neutrality." Of course, the "neutral" art first championed by Greenberg, New York Abstract Expressionism, was not and is not "neutral." Like the conceptualized "objectivity" in Continental philosophy and science upon which it is based, High Modernism is not "neutral": it is nationalized, racialized, and gendered. Whatever the importance of abstract art to shattering fine art's preoccupation with realism, whatever its "beauty," whatever its other intentions or affects, formalism's genesis and the continuation of its tradition cannot be separated from its celebration of nationalism and its sociopolitical formation as a white male American "triumph."[10]

The "value" that has been attributed to and continues to be accrued to American abstraction cannot be considered as in any way distinct from those cultural values most cherished during the historical period that permitted the movement's "triumph." Even to consider the art objects, the paintings, as distinct, isolatable cultural phenomena is entirely specious: the cultural evaluation of art is always too overdetermined by the categorical directives imposed by the site of its production and the social position of its producer. Jackson Pollock's paintings, for instance, cannot be considered distinct from those attributes Pollock, the straight white man, possessed that allowed for Greenberg to proclaim him "the greatest American painter of the 20th century," and for others to concur and (continue to) sustain that assessment. As Pollock's friend Bill Hopkins

remarks in a recent biography of the artist, "He *was* the great American painter. If you conceive of such a person, first of all, he has to be a real American, *not* a transplanted European. And he should have the big macho American virtues—he should be rough-and-tumble American—taciturn, ideally—and if he is a cowboy, so much the better."[11]

Not a lot has changed in the profile of the American artist: with few exceptions, the successful ones, and the ones to whom success accrues most easily, are still white men.[12] In contemporary New York art, a revenge against the sociopolitical disruption of straight white male centrality is visible in the work of numerous man-boy artists. A visible, or iconographic, assertion of masculinity was not a necessary feature of formalism because the prerogatives of straight white maleness were contained within High Modernism's "objectivity," and the legal, educational, and social apparatus of the United States effectively discouraged the entrance, and prohibited the success, of anyone else.

Beginning in the seventies and into the eighties, art that visibly critiqued High Modernism and asserted social difference began to emerge from practitioners outside the historically valued class. Although this was of course not the first time women, nonwhites, or homosexuals "made art," it was during this decade that a widespread embrace of the social value contained in critiques of Eurocentrism, male supremacy, and compulsory heterosexuality began to take hold within art criticism and some museum institutions.

By the early 1980s, for the first time in Euro-American history, heterosexual white men could not expect to have complete control of all material resources. Coming after a few thousand years of nearly absolute rights to property, education, money, jobs, prestige, government control, and cultural production as defined within and institutionalized by the laws and customs of the European tradition, the material effects of the black power, women's liberation, and gay rights movements caused psychic anxiety among those who had previously enjoyed nearly absolute privilege: straight white men. The art community in the United States was not just tangentially affected by the activist movements that slowly emerged out of the '50s and to become dominant forces from the mid-'60s into the late '70s. Although the civil rights and Black Power movements, the anti-Vietnam War campaigns, and the emergence of Gay Rights mobilizing efforts have continued to influence American art since the '70s, the Women's Liberation Movement had the most immediate impact because, unlike the other political mobilizations, it spawned an immediate visual arts movement. As an eruption against the prevailing aesthetics of Late Modernism as contained in Minimalism, the Feminist Art Move-

ment introduced radical anti-Modernist concepts such as the refusal of formalism, championing of content, embracement of autobiography, denial of the fine art/craft hierarchy, and, perhaps the most radical of all, the acknowledgment of female experience as a viable and necessary subject for art. The pervasive impact of the Feminist Art Movement in the United States, which included thousands of participants, hundreds of organizations, dozens of publications, and at least two now-defunct educational institutions, has yet to be formally acknowledged by either the academic or museum apparatuses (both a written history and a survey exhibition are awaited). But the Movement's effect is apparent in the success of such feminist-influenced artists as Barbara Kruger, Jenny Holzer, Sherrie Levine, and Cindy Sherman, who are indebted to both the ideological and the structural changes forged by the Feminist Art Movement during the '70s. The legacy of the Movement continues on in the work of younger (women) artists, such as Janine Antoni, Kiki Smith, and Sue Williams. But it also informs the production and reception of numerous other contemporary artists, not because they are working within an appreciation of the insights of feminism, but because they are working against them.

III

Epitheted by one London critic as "America's premiere bad boy artist," Jeff Koons was one of the divergent group of "bad boys" who emerged onto the American art scene of the 1980s. "Bad Boys" are no longer abstract expressionists/abstract painters (Ross Bleckner and Caroll Dunham, for instance, are '80s "good boys"), but always antiintellectual and favor an "in yer face" aesthetic similar to that employed by the boy in a Norman Rockwell painting who mischievously pushes a frog under a girl's nose. Hence the faux-dangerous term "bad boy." Probably the most commercially successful of the New York artists of the '80s, Koons's first exhibited works included inflatable plastic flowers, vacuum cleaners sealed in plexiglass boxes, and appropriated advertisements. The most internally consistent and interesting aspect of his work has been its attempt to assault and subvert High Modernist "taste." Koons has routinely taken objects of mundane utility, such as vacuum cleaners and basketballs, and items of Greenbergian "kitsch," such as plastic bunnies and cheap roadside souvenirs, and successfully sold them into the fine art continuum—although the ostensible joke on capitalism, on commodity fetishism, is itself a joke: the artist's experience as a stockbroker success-

fully informed his marketing strategies. Though packaged and sold as the product of a "rebel," Koons's work does nothing to disrupt the dominant aesthetics of straight white male centrality. In fact, it reinscribes it.

In the late 1980s, Koons shifted his interest in hypercommodification away from exclusively inanimate objects. A 1988 sculpture of two caucasian children, *Naked,* marked a turn that would inspire the artist's production for the next five years. Koons has described *Naked* as follows: "The young boy and young girl are like Adam and Eve, overly sentimental, standing on a heart that's flowered."[13] The piece was first exhibited with twenty kitsch-inspired sculptures, including others with Biblical references such as serpents and John the Baptist. *Naked* calls forth the Judeo-Christian determination for female subjugation made cohesive in the Adam and Eve myth. In Genesis, the male preexists the female, and, in fact, the female is a parasite, created from the male rib. Genesis is also the primary Western text to establish the female as evil: Eve is the original heretic, liar, and sinner, and because of her disobedience all of her female descendants deserve and will receive punishment. After Eve eats a piece of (forbidden) fruit, "God said to the woman, 'You shall bear children in intense pain and suffering; yet even so, you shall welcome your husband's affections, and he shall be your master' " (Genesis 3:16). Genesis assigns woman/women responsibility for her oppression, designates her as heterosexual, dictates reproductive intercourse as normative sex, and names man as woman's rightful master. Koons's *Naked,* as a "faithful" illustration of Judeo-Christianity, depicts two caucasian children genitally marked as male and female, as inscriptions of whiteness and heterosexuality. The "sentimentality," of which Koons is conscious, is a fantasy of innocence romanticized according to the mythic prerequisites of Europatriarchy.

Few narratives in Western history carry either the misogyny or the historical influence of the Old Testament's first book. Koons is evidently fascinated with the story of Adam and Eve: much of his work since 1988, which frequently uses the nude body of his wife, Ilona Staller, maps and remaps that narrative. And perhaps the artist's desire to "return to the Garden of Eden" is a trip of less historical distance than the site of his interest at first glance suggests. Perhaps, for Koons and other straight white American men, "the Garden of Eden" is the 1950s, when, like the biblical Adam, they reigned supreme.

In 1988–89, Koons exhibited a series of self-advertisements in four art magazines. In the first, published in *Flash Art,* his face is between two pigs. The word "pig" holds a specific place in American slang and consciousness: as a derogatory term for a member of the police force and/or,

more generalized, for a bigoted person, as in "male chauvinist pig." To one critic Koons has explained: "I wanted to debase myself, and call myself a pig, before the viewer had a chance to."[14] In the *Arts* ad Koons sits clad in a crested robe before a cabaña flanked by two seals; unlike the pigs in the earlier image, the seals are visual subordinates, not equals. Centrally positioned in the frame, Koons is constructed as the "master," perhaps the king, of a tropical paradise; the seals are stand-ins for (black) slaves. In the *Artforum* ad, Koons assumes another power position, that of teacher. He appears before a class of white schoolchildren in front of a blackboard that proclaims a Greenbergian-like mock aphorism: "Exploit the Masses/Banality as Saviour."[15] In a fourth Koons ad, paid for in *Art in America,* women are added to animals and children as another class subjugated to Koons. Koons is dressed in artist black and two women are (un)dressed in bikinis. One woman is seated, her legs open, on the ground, her left hand holding the open mouth of a miniature horse whose head is located in front of Koons's crotch. A second woman is offering Koons a cake. This fantasy is set, like many of Koons's scenic works, in an outdoor, "natural" setting, his "Garden of Eden," that mythic site where God made man master over woman. Koons further perpetuates Euro-Christian mythology in rendering "the original humans" white.

In 1990, Koons began exhibiting photography-based paintings and various sculptural forms of himself and his wife engaged in sexual activities. It has been suggested, albeit unconvincingly, that pornography is simply an addition to Koons's repertoire of hypertrophied kitsch. For instance, Carter Ratcliff states that Koons asserts "the dreariest generalities of banal taste and pornographic sexuality, including the cliché of the insatiable child-woman with hairless pudenda."[16] This dismissal, itself banal, completely denies the function the conventions of pornography play to maintain a sexualized class system: the ideological components activated, for instance, by "the cliché of the insatiable child-woman with hairless pudenda" normalize sexualized violence: of children, by mystifying and misinterpreting their powerlessness as consciousness ("Lolita" or "child-woman"); of women, by displacing male violence onto female desire (she is "insatiable").

The pornographic paintings and sculptures Koons exhibited at the Venice Aperto in 1990 and at the Sonnabend Gallery in 1991 are complicit in reinscribing the narrative of straight white male valuation, based as they are on the "original" text of female subordination. Koons has repeatedly stated that "Ilona and I are the contemporary Adam and Eve." Interestingly, Koons situates himself as Adam when Adam was still

in God's favor, while Staller is visually constructed as a "fallen" Eve. According to Genesis, Adam and Eve, in shame, clothe themselves "after the fall." But in Koons's reenactment, he appears nude (not guilty) while Staller is always semi-clothed, fetishized in lace, high heels, and heavy makeup (guilty). The work makes visible and asserts, literally, both that Koons is a "straight, white male" and that he is entitled, by virtue of that, to the (sexual) possession of women and to the status of artist.

Sometime in 1989, Koons announced his plans to make a film, *Made in Heaven,* that would feature himself fucking/raping/plugging/ploughing—or whatever transitive verbs are implied by the contemporary use of the term "pornography" by a heterosexual male—his wife. The title of the film, and Koons's comments about it, place it, like *Naked,* within the sentimentalized and symbolic space of Genesis, with Adam and Eve. While declaring himself "Adam" and his wife "Eve," the film's title also suggests that we accept Koons as "God," just as his self-advertisements suggest we accept him as "king" and "teacher"—even if we know he is a "pig." One can also assume that Koons is speaking for himself, within his (dominant) position as a straight white male when he asserts, about *Made in Heaven:* "There are no barriers at all in the world, and this is one of the things that the film is communicating." *Whose world?* is the question he chooses to skip. Is it not possible to interpret Koons's need to assert his "straight white maleness" as a response to the threat posed by non-straight-white males to his historically previous centrality?

At the 1990 Venice Biennale, where Koons was included in the Aperto section, he succeeded, using Staller as his prop, in upstaging the (woman) artist chosen for the more prestigious American Pavilion. As *Vogue* noted, "At the Biennale, where Jenny Holzer represented the United States and won the prize for 'best pavilion,' the talk was all about Koons."[17] Who is doing all the talking? Perhaps an art world still committed to the patriarchal values Holzer and others begin to challenge but Koons reinscribes; so that even if Holzer "wins the prize," the talk is still "all about Koons." That Koons could, and in many ways did, upstage the first woman to be chosen to represent the United States at Venice, is an instance of the masculine imperative, how art produced by a man is considered more valuable than that made by a woman, by virtue of the cultural assumption that men are more valuable than women. Of course, the valuation of art has been and continues to be determined as much by *who* produces it as by *what* that art might be. Even prestigious awards, such as the Venice prize, do not elevate the contributions of women (or non-whites) when bestowed upon them, but rather lower the "value" of the award (until another white male receives it).

If Koons were the only artist involved in reactivating an art of white male domination, it might be possible to isolate his individuated psychic needs from those of a more generalized cultural apparatus. But he isn't. Since the mid-'80s, during the period when a number of American women artists began to accept the institutional laurels of "super star" status, there has been a backlash of visibly misogynist art produced and shown in New York, and rewarded by the most prestigious collectors, galleries, and museums. Actually, a backlash against feminism and the women's art movement of the mid-'70s was already firmly in place by the beginning of the eighties, when Neo-Expressionism dominated New York's critical and financial markets with artists such as Eric Fischl and David Salle, who revived the 19th-century tradition of objectifying the female nude, and Julian Schnabel and Ross Bleckner, who reintroduced the gestural grandiosity of Expressionism and the all-maleness associated with it. But the most consistent perpetrator of the angriest sexism to rear its phallic head during the eighties was art produced by Richard Prince.

Like Koons, Prince began his New York career in the early '80s with exhibitions of advertisements and other "rephotographed" images from magazines. In 1988 he began to exhibit paintings for the first time. The large monochrome canvases, as Gary Indiana noted then, "index the high spiritual ambitions of Abstract Expressionism—what might be called America's aesthetic establishment,"[18] and, what might be called America's late-great all-male art club. The first "Joke" paintings included text; later they would include cartoon imagery, mostly drawn from the '50s, the American male modernist's "Garden of Eden," when men were men and women were their subordinates and American Abstract Expressionism reigned supreme. The textual elements in the joke paintings, which Prince is still producing, include varied referents, such as talking animals, the Vietnam War, salesmen, and psychologists. But the most persistent theme running through the series is sexism: the completion of Prince's "jokes" depend on the viewer's agreement, and sympathy, with the social/sexual order constructed in the text.

Four typical recent paintings from Prince's "Joke" series, exhibited at the "Metropolis" exhibition in Berlin in 1991, reproduce a narrative of white male domination and female subordination. The silkscreened imagery on each canvas, although variously configured, includes a line drawing of a domestic interior juxtaposed with images of a white male boxer(s). The white male athlete, cropped variously, is gloved, in the ring, fighting. His struggle, according to the visual and verbal syntax of these canvases, is with the home, and "the female," although he could also be fighting to "get back in the ring," to be that "great white hope." Ameri-

can boxing, originally an all-white male sport, then a racially segregated all-male sport, has been successfully dominated by black men since 1959, when the U.S. Supreme Court declared the sport's racial ban unconstitutional.

In *Good Revolution* (1991), Prince's white male boxer heroically dominates the canvas: he is centrally positioned and takes up most of the space. The "home" interior, including two beds and a bit of kitchen, occupies a small area. It is, in fact, "behind" the boxer, which has been silkscreened on top of it. The text reads, "Do you know what it means to come home at night to a woman who'll give you a little love, a little affection, a little tenderness? It means you're in the wrong house, that's what it means." The text, which Prince has used often before, the title, *Good Revolution,* and the boxer's visual domination of the "home," suggest a reassertion of male prerogative. It inscribes the place of woman as "the home," and her occupation within it to "give," and asserts that women's labor should continue to be, as it has been throughout most of history, unpaid, for free, a (legally and socially enforced) "gift." The boxer's domination of the home is constructed as a response to the male anger articulated in the text: the "good revolution" of the title is a hope, fantasized in the visual iconography, that men will "reclaim" their power over women. It is also a hope whose reason rests on a sociological delusion: men still dominate women, in the home as elsewhere, just as white men still dominate black men, even if black men now dominate boxing.

In *Sampling the Chocolate* (1991), the visual construction is similar: three variously cropped white male boxer images are juxtaposed over line drawings of an interior and a cityscape. The text across the bottom reads, "GOOD NEWS AND BAD NEWS: A man walked into a doctor's office to get a check-up. After the examination the doctor says to the man, I've got good news and I've got bad news. The bad news is you're going to die in a year and there's nothing you can do about it. The good news is I'm having an affair with my secretary." Here the "joke" may seem to be the disjunction between the doctor's news, that the "good" news is of no relevance to the "dying" man. Yet from a male supremacist position, the disjunctive element is rendered continuous: while one man is going to die ("bad" for the male power class), another, living, is maintaining male power through the economic and sexual subordination of "my secretary."

In *Why Did the Nazi Cross the Road?* (1991), the home sketches occupy most of the space and the boxer is positioned walking off the right side of the canvas. The text reads, "A man was on safari with his native

guide when they came upon a beautiful blond bathing naked in the stream. 'My god, who's that?' the man asked. 'Daughter of missionary, bwana,' came the reply. 'I haven't seen a white woman in so long,' the man sighed, 'that I'd give anything to eat her.' So the guide raised his rifle to his shoulder and shot her." The racist implications here are obvious: the woman is shot because the "native" is a cannibal, and the cannibal assumes the white man means "to eat" literally. And perhaps the woman must be killed because the white's man's desire "to eat her" doesn't conform to patriarchy's system of female sexual subordination, which requires the man to fuck/rape her, to subordinate her through sexual violence and/or the resultant childbearing.

Of course Prince probably claims he doesn't mean what he says: one consistent feature of post-1980 New York bad boy/white boy art is that it frequently attempts to situate itself as irony and even "critique." One begins to wonder, though, why commercially and critically successful American art employs so much so-called irony and so little critique.[19] Koons and Prince, for instance, have usually been permitted to read as "mirrors" (rather than inscribers) of dominant and reactionary cultural values, especially that of male supremacy. But mirroring is, of course, a reproductive strategy. Though Prince's work, like Koons's, may assault standards of "gentility," neither artist ever assaults the basic power prerequisites that determine meaning in contemporary American society: money, class, masculinity, and a Euro-derived ethnicity. In fact, quite the opposite. Koons and Prince, while engaged with a mass culture visual play similar to that first offered in the Pop Art of the late '50s and early '60s, remain faithful adherents to conservative mass culture values— especially the "value" of maleness.

An assertion of male superiority is of limited use value unless it also establishes whom the male is superior *to* (i.e., the female): most visual inscriptions of maleness include, as Koons's and Prince's do, the denigration of the female. The works of Pruitt-Early also feature objectified female nudes and utilize the pornographic, as Koons does, to reinscribe the male prerogative of female sexual availability.[20] In the scribbled narratives of Sean Landers, female sexual availability is often equated with art world success. His texts, on yellow legal paper and exhibited at eye level at PostMasters and Andrea Rosen in 1991 and 1992, put forth a male narrator whose self-pity derives from the injustices he perceives to be perpetrated on him by the refusal of galleries to show him, and the refusal of women to be fucked by him. In Landers's narratives his art and his penis consistently meet the same fates, they collapse into/are the same thing.

Within the practice of artist Matthew Barney this construction of "the male" as a sign of value reaches dizzying heights. It is no coincidence that Barney's first New York solo show, which was preestablished to proclaim him as an art star, appeared in the autumn of 1991, during the height of economic anxiety within the New York art community. The sense of despair and of impending catastrophe was so high that the summer months had been dominated by a unquenchable rumor that the Mary Boone Gallery was going bankrupt. Mary Boone *is* the 1980s in the New York art world: the crazy rumors, and the fire that carried them for months, testify to the incredible fear during that time, a fear, quite simply, that the whole New York art world, the whole " '80s," was "going bankrupt."

Matthew Barney was presented, and accepted, as the "great white hope." Under twenty-five, straight, white, male, and a fashion model with a Yale BFA, Barney was in the autumn of 1991 for Barbara Gladstone and conservative critics what Pollock was in the postwar period for Betty Parsons and Clement Greenberg: America's art opportunity. Of course, the stakes were considerably different: whereas in the '50s the U.S.A. had to prove itself capable of leading fine art, in the early '90s the U.S.A. had to prove itself capable of holding on to the lead.

All art careers exist, of course, within a social and professional matrix. What was most compelling about the Barney ascension was how predictable it was.[21] In desperation, the art community attempted to resurrect the past: the straight white man as savior. Straightness and whiteness were necessary to the marketing, but the most crucial aspect to Barney, the foundation of his work, was and is its insistence on masculinity as the determinant of value.

Barney's 1991 show at Barbara Gladstone, his earlier works at Yale University at Stuart Regan in Los Angeles, and his subsequent installations in San Francisco, at Documenta 9, all revolve around a formulation of maleness constructed by (male) athletics.[22] Unlike other male purveyors of debased female iconography, Barney doesn't visually or verbally index women in his work. Like professional American football, Barney eliminates the female before the game even gets started—or perhaps Barney is Adam *before* God created Eve from his rib. Although within Barney's work man *does,* like Adam, create woman: The only female images are those of men in women's clothes, that is, men creating (themselves as) women. His work consistently utilizes various forms of male-coded biologiclike materials, such as wax that looks like cum, and tapioca that resembles sperm. These oozy materials collaborate to form various sports-resemblant devices, such as bench presses and shoulder pads and

other accoutrements of football players, weight lifters, and various male athletes. It suggests that the body of man produces, biologically and therefore inevitably, athletic prowess, and this characteristic is, within an art context, the production of value itself.

Barney's videos, which document the artist's adventures with his objects and are considered by many to be his "real" work, are enactments of a male identity continually reconstructed against a crisis of fragmentation. Often in the videos Barney is wearing women's clothes, but always this masquerade is utilized to underline and reassert a maleness, an assurance evoked within the social inscription around the work—everybody "knows" Barney is not gay, and anybody can "see" he's not a woman. While perhaps "about" male homosexual anxiety and fear of the female, Barney's videoed drag shows and compulsive acts of physical zeal reassert the phallus: whatever anxiety is produced within the videos is denied in the videos and then further denied by what Barney calls his "sculptural remnants." The sculptural pieces (seminal in a literal sense?) assert a seamless masculinity, and unlike the videos, they are fixed, stable—and for sale! Whatever fluctuations of sexual identity occur in the video, in the locker-room maleness of the sculptures, sexual difference asserts itself as male domination. Reliant on biological and essentialist understandings of maleness, Barney's sports-coded objects, like Prince's Boxer, index and celebrate the only remaining all-male arena in U.S. society: professional sport. In doing so, Barney's work calls back to the moment, still within memory, when fine art was as all-male exclusive as the Oakland Raiders, when women were cast as cheerleaders and only men were allowed to play the field.

The regressive fantasies of male exclusivity activated in the work of Koons, Prince, Barney, and their less famous fellow travelers on the road to that last big football game in the sky coexist with contemporaries who are actively pursuing an art that doesn't rely on the reification of traditionally historicized power. One of the most potentially emancipatory features of some recent American art is its continued struggle to wrestle meaning out from under the formalist entrenchment proscribed under High Modernism. Not satisfied by the possibilities of a merely descriptive or sociologically based practice, the most radical artistic investigations utilize a strategy that relies on criticality and eschews the pretense of neutrality. Artists engaged with this type of production work with various visual strategies and according to different ethical and political priorities. The impetuses that have produced such a wide range of activity, including the work of Adrian Piper, Hans Haacke, Louise Lawler, Barbara Kruger, Renee Green, David Hammons, Felix Gonzalez-Torres, Jenny Holzer,

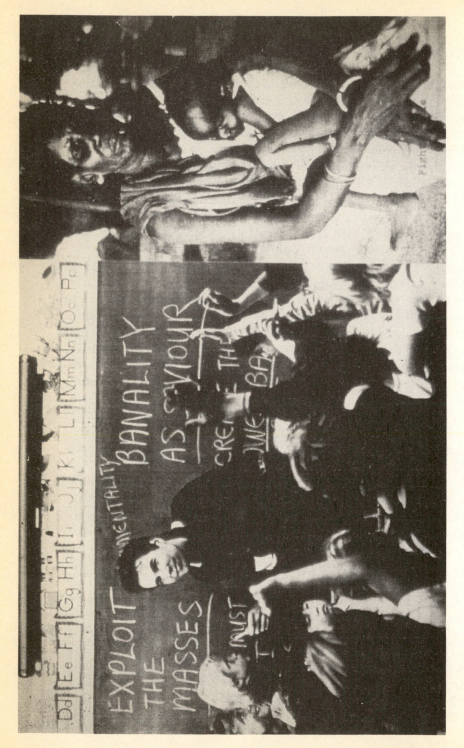

Adrian Piper, *Ur Mutter #8*, Photo-text collage with silkscreen text, 1989, 36″ × 59½″
Courtesy of John Weber Gallery

Sue Williams, Fred Wilson, Donald Moffett, Gary Simmons, Susan Silas, Sherrie Levine, Lorna Simpson, as well as that of so many other critically engaged contemporary artists are as simple as they are complex. They stem from a basic Enlightenment premise of hope based in knowledge and the destruction of (false) myth; excepting Haacke, who is working from an economistic Marxist perspective, this aesthetic criticality is embodied in contemporary American art drawn from the hopes and demands of the Black Power, Women's Liberation and Gay Rights movements. But art that legitimizes the power relations of Euro-derivative male domination has been a steady American cultural product during the 20th century. We must continue to interrogate who and what our society values—and why.

Notes

1. To "protest the image of Miss America, an image that oppresses women in every area in which it purports to represent us," demonstrators in Atlantic City in September 1968 threw bras, girdles, curlers, false eyelashes, lipsticks and copies of "women's" magazines into a trash can, according to the leaflet *No More Miss America!,* reprinted in *Sisterhood is Powerful,* edited by Robin Morgan (New York: Random House, 1970), p. 585.
2. I use "High Modernism" to refer to the understanding of Modernism put forth by Clement Greenberg.
3. Sexism is a central impasse in the development of contemporary neo-Marxist theory. How completely traditional Marxism, with its assumption of a (male) working class, is rendered inadequate when problematized by the "woman question" is manifest in the glaring instability of just one line from British Marxist academic Terry Eagleton's *Ideology* (London: Verso, 1991). Attempting to be "sensitive" to feminism, Eagleton introduces shifting pronouns (sometimes "he," sometimes "she") into his book—but without bothering to shift the matrix of social oppression as first offered by Marx. So that during a discussion of Lukacs, Eagleton asks, "How does the worker constitute herself as a subject on the basis of her objectification?" (p. 103). With the use of shifting pronouns, Eagleton attempts to degender "the revolutionary subject," but that is, of course, impossible, because the class matrix is gendered, and the worker who seeks to constitute *herself* as a subject is objectified in ways that the worker who seeks to constitute *himself* as a subject is not. That women are historically determined as both "commodity" and as "class," as materialist feminists such as Christine Delphy and Catharine MacKinnon have argued, must be made central to Marxism, if its critical theory is to hold any emancipatory value.
4. Timothy J. Clark, "Jackson Pollock's Abstraction," in *Reconstructing Modernism,* edited by Serge Guilbaut (Cambridge: MIT Press, 1990). In the afterword to this essay, Clark admits that he has neglected "the matter of Pollock's gender." For him this means his omission of the discussion of Pollock's "drips" as a construction of "sexual difference."
5. Clement Greenberg, "Avant-Garde and Kitsch," first published in *Partisan Review,* Fall 1939; reprinted in *Clement Greenberg: The Collected Essays and Criticism, vol. 1,* edited by John O'Brian (Chicago: University of Chicago Press, 1986), pp. 5–22. Greenberg almost certainly is thinking here of Nietzsche's argument about the "politics of resentment"; but he too

willingly transposes the historical situation of Europe in the 1920s to the American scene of the late 1930s.

6. Cassandra Langer has suggested that Greenberg's positioning of himself as a critic "for exclusion" should be considered in relationship to the social prejudice and assimilation process American Jews endured during and after World War II.

7. Jonathan Katz, "Culture and Subculture: On the Social Utility of Queer Artists in Cold War American Art," paper delivered at the College Art Association Convention, Washington, D.C., 1991. For another discussion of the context of gayness that informs Johns, see Jonathan Weinberg, "It's in the Can: Jasper Johns and the Anal Society," *Genders* (Spring 1988), University of Texas Press: 41–56.

8. Donna de Salvo, " 'Subjects of the Artists': Towards a Painting Without Ideals," *Hand-Painted Pop: American Art in Transition 1955–62,* edited by Russell Ferguson (Los Angeles: Museum of Contemporary Art, 1993), p. 70.

9. Lucy R. Lippard, "What is Female Imagery?" *Ms.,* May 1975; reprinted in Lucy R. Lippard, *From the Center* (New York: E. P. Dutton, 1976), p. 89.

10. The political use of High Modernism, specifically abstraction, as a symbol of antifascism and, after World War II, anticommunism, is documented by Serge Guilbaut in *How New York Stole the Idea of Modern Art,* trans. Arthur Goldhammer (Chicago: University of Chicago Press, 1983).

11. Budd Hopkins, as quoted in *Jackson Pollock,* by Steven Naifeh and Gregory White Smith (New York: Clarkson N. Potter, 1989; reprint, New York: HarperCollins, HarperPerennial, 1991), p. 595.

12. Tavia M. Fortt and Terry R. Myers call into question how the white boy politics of the New York School continue to be played out, not only in the ongoing legacy of "white boy abstraction," but in the white boy basis/bias that continues to inform all and various visual practices. "White Boy as Abstraction: Do We Really Need Another New York School?" *Arts Magazine,* February 1991, pp. 42–43. Other artists engaged with various kinds of masculine assertion and the essentialization of a "male identity" include Vito Acconci, Chris Burden and Mike Kelley. Thanks to Adrian Piper for reminding me of these three "Bad Little Boys," as she calls them.

13. Jeff Koons, as quoted in "Super Star," by Andrew Renton, *Blitz,* January 1990, p. 55.

14. Jeff Koons, as quoted in "Jeff Koons and the Art of the Deal," by Andrew Renton, *Performance* (London), September 1990, p. 26.

15. The *Artforum* ad was included in Adrian Piper's photo-text collage *Ur Mutter #8,* 1989, next to an image of an impoverished black African woman holding a child. As a contrast to Koons's smug, well-fed face and his suggestion to "exploit the masses," the words "fight or die" appear under Piper's image, suggesting that Piper does not interpret Koons's work with the "irony" his supporters insist upon.

16. Carter Ratcliff, "Not for Repro," *Artforum,* February 1992, pp. 82–85.

17. Dodie Kazanjian, "Koons Crazy," *Vogue,* August 1990, p. 338.

18. Gary Indiana, "Tell Me Everything," *Village Voice,* art supplement, May 3, 1988, pp. 8, 10–11.

19. One of the more interesting aspects of the contemporary American visual art "world"—of artists, dealers, critics, collectors—is how so many wish to be considered participants on the emancipatory side of history, and so *few* do the work necessary to be so.

20. For a discussion of the masculine construct in Pruitt-Early and Candy Ass, see my "Negotiating Masculinity and Representation," *Contemporanea,* December 1990, pp. 46–51.

21. Before his first solo show in New York, Barney exhibited in Los Angeles at the gallery of Barbara Gladstone's son, Stuart Regan. Before the nearly identical show opened in New York at Gladstone's gallery, Barney was featured in a full-page review in *Flash Art,* in a two-page rave review in *Arts,* and on the cover of *Artforum*—the first time any artist has ever

been featured on the cover of *Artforum* without ever having had a show in New York. The Gladstone show was then featured in a longish review in the *New York Times,* written by the spouse of the reviewer who had given the rave in *Arts,* which, significantly, appeared during the earlier part of the show's run (first-time solo shows, if ever covered in the *Times,* are more often run just before the show closes, and most often they occupy under three column inches; the piece on Barney's show ran over twelve). Barbara Gladstone also represents Richard Prince.

22. This discussion of Matthew Barney is taken from my column, "Art & Thought," *NYQ,* November 24, 1991, p. 41.

OLYMPIA'S MAID
Reclaiming Black Female Subjectivity*

Lorraine O'Grady

The female body in the West is not a unitary sign. Rather, like a coin, it has an obverse and a reverse: on the one side, it is white; on the other, not-white or, prototypically, black. The two bodies cannot be separated, nor can one body be understood in isolation from the other in the West's metaphoric construction of "woman." White is what woman is; not-white (and the stereotypes not-white gathers in) is what she had better not be. Even in an allegedly postmodern era, the not-white woman as well as the not-white man are symbolically and even theoretically excluded from sexual difference.[1] Their function continues to be, by their chiaroscuro, to cast the difference of white men and white women into sharper relief.

A kaleidescope of not-white females, Asian, Native American, and African, have played distinct parts in the West's theater of sexual hierarchy. But it is the African female who, by virtue of color and feature and the extreme metaphors of enslavement, is at the outermost reaches of "otherness." Thus she subsumes all the roles of the not-white body.

The smiling, bare-breasted African maid, pictured so often in Victorian travel books and *National Geographic* magazine, got something more than a change of climate and scenery when she came here.

Sylvia Ardyn Boone, in her book *Radiance from the Waters* (1986), on the physical and metaphysical aspects of Mende feminine beauty, says

*The first part of this article was published in *Afterimage* 20, 1 (Summer 1992).

of contemporary Mende: "Mende girls and women go topless in the village and farmhouse. Even in urban areas, girls are bare-breasted in the house: schoolgirls take off their dresses when they come home, and boarding students are most comfortable around the dormitories wearing only a wrapped skirt."[2]

What happened to the girl who was abducted from her village, then shipped here in chains? What happened to her descendants? Male-fantasy images on rap videos to the contrary, as a swimmer, in communal showers at public pools around the country, I have witnessed black girls and women of all classes showering and shampooing with their bathing suits *on,* while beside them their white sisters stand unabashedly stripped. Perhaps the progeny of that African maiden feel they must still protect themselves from the centuries-long assault which characterizes them, in the words of the *New York Times* ad placed by a group of African-American women to protest the Clarence Thomas–Anita Hill hearings, as "immoral, insatiable, perverse; the initiators in all sexual contacts—abusive or otherwise."[3]

Perhaps they have internalized and are cooperating with the West's construction of not-white women as not-to-be-seen. How could they/we not be affected by that lingering structure of invisibility, enacted in the myriad codicils of daily life and still enforced by the images of both popular and high culture? How not get the message of what Judith Wilson calls "the legions of black servants who loom in the shadows of European and European-American aristocratic portraiture,"[4] of whom Laura, the professional model that Edouard Manet used for Olympia's maid, is in an odd way only the most famous example? Forget euphemisms. Forget "tonal contrast." We know what she is meant for: she is Jezebel *and* Mammy, prostitute and female eunuch, the two-in-one. When we're through with her inexhaustibly comforting breast, we can use her ceaselessly open cunt. And best of all, she is not a real person, only a robotic servant who is not permitted to make us feel guilty, to accuse us as does the slave in Toni Morrison's *Beloved* (1987). After she escapes from the room where she was imprisoned by a father and son, that outraged woman says: "You couldn't think up what them two done to me."[5] Olympia's maid, like all the other "peripheral Negroes,"[6] is a robot conveniently made to disappear into the background drapery.

To repeat: castrata and whore, not madonna and whore. Laura's place is outside what can be conceived of as woman. She is the chaos that must be excised, and it is her excision that stabilizes the West's construct of the female body, for the "femininity" of the white female body is ensured by assigning the not-white to a chaos safely removed from sight. Thus only the white body remains as the object of a voyeuristic, fetishiz-

ing male gaze. The not-white body has been made opaque by a blank stare, misperceived in the nether regions of TV.

It comes as no surprise, then, that the imagery of white female artists, including that of the feminist avant-garde, should surround the not-white female body with its own brand of erasure. Much work has been done by black feminist cultural critics (Hazel Carby and bell hooks come immediately to mind) that examines two successive white women's movements, built on the successes of two black revolutions, which clearly shows white women's inability to surrender white skin privilege even to form basic alliances.[7] But more than politics is at stake. A major structure of psychic definition would appear threatened were white women to acknowledge and embrace the sexuality of their not-white "others." How else explain the treatment by that women's movement icon, Judy Chicago's *Dinner Party* (1973–78) of Sojourner Truth, the lone black guest at the table? When thirty-six of thirty-nine places are set with versions of Chicago's famous "vagina" and recognizable slits have been given to such sex bombs as Queen Elizabeth I, Emily Dickinson, and Susan B. Anthony, what is one to think when Truth, the mother of four, receives the only plate inscribed with a face?[8] Certainly Hortense Spillers is justified in stating that "the excision of the genitalia here is a symbolic castration. By effacing the genitals, Chicago not only abrogates the disturbing sexuality of her subject, but also hopes to suggest that her sexual being did not exist to be denied in the first place."[9]

And yet, Michele Wallace is right to say, even as she laments further instances of the disempowerment of not-white women in her essay on *Privilege* (1990), Yvonne Rainer's latest film, that the left-feminist avant-garde "in foregrounding a political discourse on art and culture" has fostered a climate that makes it "hypothetically possible to publicly review and interrogate that very history of exclusion and racism."[10]

What alternative is there really—in creating a world sensitive to difference, a world where margins can become centers—to a cooperative effort between white women and women and men of color? But cooperation is predicated on sensitivity to differences among ourselves. As Nancy Hartsock has said, "We need to dissolve the false 'we' into its real multiplicity."[11] We must be willing to hear each other and to call each other by our "true-true name."[12]

To name ourselves rather than be named we must first see ourselves. For some of us this will not be easy. So long unmirrored in our true selves, we may have forgotten how we look. Nevertheless, we can't theorize in a void, we must have evidence. And we—I speak only for black women here—have barely begun to articulate our life experience. The heroic

recuperative effort by our fiction and nonfiction writers sometimes feels stuck at the moment before the Emancipation Proclamation.[13] It is slow and it is painful. For at the end of every path we take, we find a body that is always already colonized. A body that has been raped, maimed, murdered—that is what we must give a healthy present.

It is no wonder that when Judith Wilson went in search of nineteenth-century nudes by black artists, she found only three statues of nonblack children—Edmonia Lewis's *Poor Cupid,* 1876; her *Asleep* (1871); and one of the two children in her *Awake* (1872)[14] (though Wilson cautions that, given the limits of current scholarship, more nudes by nineteenth-century blacks may yet surface).[15] Indeed, according to Wilson, the nude, one of high art's favorite categories, has been avoided during most of "the 200-year history of fine art production by North American blacks."[16] Noting exceptions that only prove the rule, i.e., individual works by William H. Johnson and Francisco Lord in the thirties and Eldzier Cortor's series of Sea Island nudes in the forties, she calls "the paucity of black nudes in U.S. black artistic production prior to 1960 . . . an unexamined problem in the history of Afro-American art."[17] And why use 1960 as a marker of change? Because, says Wilson, after that date there was a confluence of two different streams: the presence of more, and more aggressive, black fine artists such as Bob Thompson and Romare Bearden, and the political use of the nude as a symbol of "Black Is Beautiful," the sixties slogan of a programmatic effort to establish black ethnicity and achieve psychic transformation.[18]

Neither of these streams, however, begins to deal with what I am concerned with here: the reclamation of the body as a site of black female subjectivity. Wilson hints at part of the problem by subtitling a recent unpublished essay "Bearden's Use of Pornography." An exterior, pornographic view, however loving, will not do any more than will the emblematic "Queen of the Revolution." But though Wilson raises provisional questions about Bearden's montaging of the pornographic image, her concerns are those of the art historian, while mine must be those of the practitioner.[19] When, I ask, do we start to see images of the black female body by black women made as acts of auto-expression, the discrete stage that must immediately precede or occur simultaneously with acts of auto-critique? When, in other words, does the present begin?

Wilson and I agree that, in retrospect, the catalytic moment for the subjective black nude might well be Adrian Piper's *Food for the Spirit* (1971), a private loft performance in which Piper photographed her physical and metaphysical changes during a prolonged period of fasting and reading Immanuel Kant's *Critique of Pure Reason.*[20] Piper's performance,

unpublished and unanalyzed at the time (we did not have the access then that we do now), now seems a paradigm for the willingness to look, to get past embarrassment and retrieve the mutilated body, as Spillers warns we must if we are to gain the clearsightedness needed to overthrow hierarchical binaries: "Neither the shameface of the embarrassed, nor the not-looking-back of the self-assured is of much interest to us," Spillers writes, "and will not help at all if rigor is our dream."[21]

It is cruelly ironic, of course, that just as the need to establish our subjectivity in preface to theorizing our view of the world becomes most dire, the idea of subjectivity itself has become "problematized." But when we look to see just whose subjectivity has had the ground shifted out from under it in the tremors of postmodernism, we find (who else?) the one to whom Hartsock refers as "the transcendental voice of the Enlightenment" or, better yet, "He Who Theorizes."[22] Well, good riddance to him. We who are inching our way from the margins to the center cannot afford to take his problems or his truths for our own.

Though time may be running out for such seemingly marginal agendas as the establishment of black female subjectivity (the headlines remind us of this every day) and we may feel pressured to move fast, we must not be too conceptually hasty. This is a slow business, as our writers have found out. The work of recuperation continues. In a piece called *Seen* (1990) by the conceptual artist Renee Greene, two of our ancestresses most in need, Saartjie Baartman ("the Hottentot Venus") and Josephine Baker, have been "taken back." Each in her day (early nineteenth and twentieth century, respectively) was the most celebrated European exhibit of exotic flesh. Greene's piece invites the viewer to stand on a stage inscribed with information about the two and, through a "winkie" of eyes in the floor and a shadow screen mounted on the side, to experience how the originals must have felt, pinned and wriggling on the wall. The piece has important attributes: it is above all cool and smart. But from the perspective being discussed here—the establishment of subjectivity—because it is addressed more to the other than to the self and seems to deconstruct the subject just before it expresses it, it may not unearth enough new information.

The question of to whom work is addressed cannot be emphasized too strongly. In the 1970s, African-American women novelists showed how great a leap in artistic maturity could be made simply by turning from their male peers' pattern of "explaining *it* to *them*," as Morrison once put it, to showing how it feels to *us*.[23]

Besides, pleading contains a special trap, as Gayatri Spivak noted in her discussion of the character Christophine in Jean Rhys's *Wide Sar-*

gasso Sea: "No perspective *critical* of imperialism can turn the Other into a self, because the project of imperialism has always already historically refracted what might have been the absolutely Other into a domesticated Other that consolidates the imperialist self."[24] Critiquing *them* does not show who *you* are; it cannot turn you from an object into a subject of history.

The idea bears repeating: self-expression is not a stage that can be bypassed. It is a discrete moment that must precede or occur simultaneously with the deconstructive act. An example may be seen in the work of the painter Sandra Payne. In 1986, at the last show of the now legendary black avant-garde gallery Just Above Midtown in SoHo, Payne presented untitled drawings of joyously sexual and sublimely spiritual nudes. The opening reception was one of those where people speak of everything but what is on the walls. We do not yet have the courage to look.

Understandably, Payne went into retreat. Three years later, she produced attenuated mask drawings that, without the hard edge of postmodern*ism,* are a postmodern speech act in the dialogue of mask and masquerade. Without the earlier subjective nudes, she may not have arrived at them.

A year ago, as a performance artist in a crisis of the body (how to keep performing without making aging itself the subject of the work?), I opted for the safety of the wall with a show of photomontages. My choice of the nude was innocent and far from erotic; I wanted to employ a black self stripped of as many layers of acculturation as possible. The one piece in the show with explicitly represented sexuality, *The Clearing,* a diptych in which a black female engaged with a white male, was to me less about sex than it was about culture. It was not possible to remain innocent for long, however. I soon encountered an encyclopedia of problematics concerning the black body: age, weight, condition, not to mention hair texture, features, and skin tone. Especially skin tone. Any male and female side by side on the wall are technically married. How to arrange a quadriptych such as *Gaze,* composed of head and shoulder shots of differently hued black men and women? Should I marry the fair woman to the dark man? The dark woman to the fair man? What statements will I be making about difference if I give them mates matching in shade? What will I be saying about the history of class?

There was another problematic, as personal as it was cultural. Which maimed body would be best retrieved as the ground of my biographic experience? Young, or middle-aged? Jezebel, or Mammy? The woman I was, or the woman I am now? And, which body hue should I use to generalize my upper-middle-class West Indian–American experience? A

black-skinned "ancestress," or the fairer-skinned product of rape? I hedged. In the end, I chose an African-British high-fashion model, London-born but with parents from Sierra Leone. For me, she conveyed important ambiguities: she was black-skinned, but her nude body retained the aura of years of preparation for runway work in Europe. In *The Strange Taxi: From Africa to Jamaica to Boston in 200 Years,* where the subject was hybridism itself, my literal ancestresses, who to some may have looked white, sprouted from a European mansion rolling on wheels down the African woman's back. Although they may have been controversial, I liked the questions those beautifully dressed, proudly erect, ca. World War I women raised, not least of which was how the products of rape could be so self-confident, so poised.

As I wrestled with ever shifting issues regarding which black woman to shoot, I came to understand and sympathize with Lorna Simpson's choice of a unified response in such montages as *Guarded Conditions* (1989), in which a brown-skinned woman in a shapeless white shift is shot from behind—with every aspect of subjectivity both bodily and facial occluded, except the need to cover up itself—and then multiplied. No doubt about it. This multiple woman showers and shampoos in her shift.

But, I tell myself, this cannot be the end. First we must acknowledge the complexity, and then we must surrender to it. Of course, there isn't any final answering of the question, "What happened to that maid when she was brought here?" There is only the process of answering it and the complementary process of allowing each answer to come to the dinner party on its own terms. Each of these processes is just beginning, but perhaps if both continue, the nature of the answers will begin to change and we will all be better off. For if the female body in the West is obverse and reverse, it will not be seen in its integrity—neither side will know itself—until the not-white body has mirrored herself fully.

Postscript

The paragraphs above were drafted for delivery before a panel of the College Art Association early in 1992.[25] Rereading them, I can see to how great an extent they were limited by the panel's narrowly feminist brief. The topic assigned was "Can the naked female body effectively represent women's subjectivity in contemporary North American media culture, which regularly presents women's bodies as objects for a voyeuristic and fetishizing male gaze?"

I think I was invited because I was the only black female artist employing the nude anyone on the panel had heard of. I felt like the extra

Lorraine O'Grady, *Gaze 3*
Robert M. Ransick, 24″ × 20″, black and white photomontage
Lorraine O'Grady

guest who's just spilt soup on the tablecloth when I had to reject the panel's premise. The black female's body needs less to be rescued from the masculine "gaze" than to be sprung from a historic script surrounding her with signification while at the same time, and not paradoxically, it erases her completely.

Still, I could perhaps have done a better job of clarifying "what it is I think I am doing anyway."[26] Whether I will it or not, as a black female artist my work is at the nexus of aggravated psychic and social forces as yet mostly uncharted. I could have explained my view, and shown the implications for my work, of the multiple tensions between contemporary art and critical theory, subjectivity and culture, modernism and postmodernism, and, especially for a black female, the problematic of psychoanalysis as a leitmotif through all of these.

I don't want to leave the impression that I am privileging representation of the body. On the contrary: though I agree, to alter a phrase of Merleau-Ponty, that every theory of subjectivity is ultimately a theory of the body,[27] for me the body is just one artistic question to which it is not necessarily the artistic answer.

My work in progress deals with what Gayatri Spivak has called the " 'winning back' of the position of the questioning subject."[28] To win back that position for the African-American female will require balancing in mental solution a subversion of two objects which may appear superficially distinct: on the one hand, phallocentric theory; and on the other, the lived realities of Western imperialist history, for which all forms of that theory, including the most recent, function as willing or unwilling instruments.

It is no overstatement to say that the greatest barrier I/we face in winning back the questioning subject position is the West's continuing tradition of binary, "either:or" logic, a philosophic system that defines the body in opposition to the mind. Binaristic thought persists even in those contemporary disciplines to which black artists and theoreticians must look for allies. Whatever the theory of the moment, before we have had a chance to speak, we have always already been spoken and our bodies placed at the binary extreme, that is to say, on the "other" side of the colon. Whether the theory is Christianity or modernism, each of which scripts the body as all-nature, *our* bodies will be the most natural. If it is poststructuralism/postmodernism, which through a theoretical sleight of hand gives the illusion of having conquered binaries, by joining the once separated body and mind and then taking this "unified" subject, perversely called "fragmented," and designating it as all-culture, we can be sure it is *our* subjectivities that will be the most culturally determined.

Of course, it is like whispering about the emperor's new clothes to remark that nature, the other half of the West's founding binary, is all the more powerfully present for having fallen through a theoretical trapdoor.

Almost as maddening as the theories themselves is the time lag that causes them to overlap in a crazy quilt of imbrication. There is never a moment when new theory definitively drives out old. Successive, contradictory ideas continue to exist synchronistically, and we never know where an attack will be coming from, or where to strike preemptively. Unless one understands that the only constant of these imbricated theories is the black body's location at the extreme, the following statements by some of our more interesting cultural theorists might appear inconsistent.

Not long ago, Kobena Mercer and Isaac Julien felt obliged to argue against the definition of the body as all-nature. After noting that "European culture has privileged sexuality as the essence of the self, the innermost core of one's 'personality,' " they went on to say: "This 'essentialist' view of sexuality . . . *already contains racism.* Historically, the European construction of sexuality coincides with the epoch of imperialism and the two interconnect. [It] is based on the idea that sex is the most basic form of naturalness which is therefore related to being *un*civilized or *against* civilization."[29]

Michele Wallace, on the other hand, recently found herself required to defend the black body against a hermeneutics of all-culture. "It is not often recognized," she commented, "that bodies and psyches of color have trajectories in excess of their socially and/or culturally constructed identities."[30] Her statement is another way of saying: now that we have "proved" the personal is political, it is time for us to reassert that the personal is not *just* political.

Wallace and Mercer and Julien are all forced to declare that subjectivity belongs to *both* nature *and* culture. It's true, "both:and" thinking is alien to the West. Not only is it considered primitive, it is now further tarred with the brush of a perceived connection to essentialism. For any argument that subjectivity is partly natural is assumed to be essentialist. But, despite the currency of antiessentialist arguments, white feminists and theorists of color have no choice: they must develop critiques of white masculinist "either:or-ism," even if this puts them in the position of appearing to set essentialism up against antiessentialism. This inherent dilemma of the critique of binarism may be seen in Spivak's often amusing ducking and feinting. To justify apparent theoretical inconsistencies, Spivak once explained her position to an interviewer as follows: "Rather than define myself as specific rather than universal, I should see what in

the universalizing discourse could be useful and then go on to see where that discourse meets its limits and its challenge within that field. I think we have to choose again strategically, not universal discourse but essentialist discourse. I think that since as a deconstructivist—see, I just took a label upon myself—I cannot in fact clean my hands and say, 'I'm specific.' In fact I must say I am an essentialist from time to time. There is, for example, the strategic choice of a genitalist essentialism in anti-sexist work today. How it relates to all of this other work I am talking about, I don't know, but *my search is not a search for coherence.*"[31] Somebody say Amen.

If artists and theorists of color were to develop and sustain our critical flexibility, we could cause a permanent interruption in Western "either:or-ism." And we might find our project aided by that same problematic imbrication of theory, whose disjunctive layers could signal the persistence of an unsuspected "both:and-ism," hidden, yet alive at the subterranean levels of the West's constructs. Since we are forced to argue both that the body is more than nature, and *at the same time* to remonstrate that there is knowledge beyond language/culture, why not seize and elaborate the anamaly? In doing so, we might uncover tools of our own with which to dismantle the house of the master.[32]

Our project could begin with psychoanalysis, the often unacknowledged linchpin of Western (male) cultural theory. The contradictions currently surrounding this foundational theory indicate its shaky position. To a lay person, postmodernism seems to persist in language that opposes psychoanalysis to other forms of theoretical activity, making it a science or "truth" that is not culturally determined. Psychoanalysis's self-questioning often appears obtuse and self-justifying. The field is probably in trouble if Jacqueline Rose, a Lacanian psychologist of vision not unsympathetic to third world issues, can answer the question of psychoanalysis's universality as follows: "To say that psychoanalysis does not, or cannot, refer to non-European cultures, is to constitute those cultures in total 'otherness' or 'difference'; to say, or to try to demonstrate, that it can, is to constitute them as the 'same.' This is not to say that the question shouldn't be asked."[33]

The implication of such a statement is, that no matter how many times you ask the question of the universality of psychoanalysis or how you pose it, you will not arrive at an answer. But the problem is not the concept of "the unanswerable question," which I find quite normal. The problem is the terms in which Rose frames the question in the first place: her continuing use of the totalizing opposition of "otherness" and "same-

ness" is the sign of an "either:or" logic that does not yet know its own name.

If the unconscious may be compared to that common reservoir of human sound from which different peoples have created differing languages, all of which are translated more or less easily, then how can any of the psyche's analogous products be said to constitute *total* "otherness" or "difference"? It's at this point that one wants, without being *too* petulant, to grab psychoanalysis by the shoulders and slap it back to a moment before Freud's Eros separated from Adler's "will-to-power," though such a moment may never have existed even theoretically. We need to send this field back to basics. The issue is not whether the unconscious is universal, or whether it has the meanings psychoanalysis attributes to it (it is, and it does), but rather that, in addition, it contains contradictory meanings, as well as some that are unforeseen by its current theory.

Meanwhile, psychoanalysis and its subdisciplines, including film criticism, continue having to work overtime to avoid the "others" of the West. Wallace has referred to "such superficially progressive discourses as feminist psychoanalytic film criticism which one can read for days on end without coming across any lucid reference to, or critique of, 'race.' "[34]

But that omission will soon be redressed. We are coming after them. In her most brilliant theoretical essay to date, "The Oppositional Gaze," bell hooks takes on white feminist film criticism directly.[35] And Gayatri Spivak brooks no quarter. She has declared that non-Western female subject constitution is the main challenge to psychoanalysis and counterpsychoanalysis and has said: "The limits of their theories are disclosed by an encounter with the materiality of that other of the West."[36]

For an artist of color, the problem is less the limits of psychoanalysis than its seeming binarial *rigidity*. Despite the field's seeming inability to emancipate itself from "either:or-ism," I hope its percepts are salvageable for the non-West. Psychoanalysis, after anthropology, will surely be the next great Western discipline to unravel, but I wouldn't want it to destruct completely. We don't have time to reinvent that wheel. But to use it in our auto-expression and auto-critique, we will have to dislodge it from its narrow base in sexuality. One wonders if, even for Europeans, sexuality as the center or core of "personality" is an adequate dictum. Why does there have to be a "center:not-center" in the first place? Are we back at that old Freud-Adler crossroad? In Western ontology, why does somebody always have to win?

"Nature:culture," "body:mind," "sexuality:intellect," these binaries don't begin to cover what we "sense" about ourselves. If the world comes

to us through our senses—and however qualified those are by culture, no one would say culture determines *everything*—then even they may be more complicated than their psychoanalytic description. What about the sense of balance, of equilibrium? Of my personal *cogito*'s, a favorite is "I dance, therefore I think." I'm convinced that important, perhaps even the deepest, knowledge comes to me through movement, and that the opposition of materialism to idealism is just another of the West's binarial theorems.

I have not taken a scientific survey, but I suspect most African-Americans who are not in the academy would laugh at the idea that their subjective lives were organized around the sex drive and would feel that "sexuality," a conceptual category that includes thinking about it as well as doing it, is something black people just don't have time for. This "common sense" is neatly appropriated for theory by Spillers in her statement: "Sexuality describes another type of discourse that splits the world between the 'West and the Rest of Us.' "[37]

Not that sex isn't important to these folks; it's just one center among many. For African-American folk wisdom, the "self" revolves about a series of variable "centers," such as sex and food; family and community; and a spiritual life composed sometimes of God or the gods, at others of esthetics or style. And it's not only the folk who reject the concept of a unitary center of the "self." Black artists and theorists frequently refer to African-Americans as "the first postmoderns." They have in mind a now agreed understanding that our inheritance from the motherland of pragmatic, "both:and" philosophic systems, combined with the historic discontinuities of our experience as black slaves in a white world, have caused us to construct subjectivities able to negotiate between "centers" that, at the least, are double.[38]

It is no wonder that the viability of psychoanalytic conventions has come into crisis. There is the gulf between Western and non-Western quotidian perceptions of sexual valence, and the question of how psychic differences come into effect when "cultural differences" are accompanied by real differences in power. These are matters for theoretical and clinical study. But for artists exploring and mapping black subjectivity, having to track the not-yet-known, an interesting question remains: Can psychoanalysis be made to triangulate nature and culture with "spirituality" (for lack of a better word) and thus incorporate a sense of its own limits? The discipline of art requires that we distinguish between the unconscious and the limits of its current theory, and that we remain alive to what may escape the net of theoretical description.

While we await an answer to the question, we must continue assert-

ing the obvious. For example, when Elizabeth Hess, a white art critic, writes of Jean-Michel Basquiat's "dark, frantic figures" as follows, she misses the point: "There is never any one who is quite human, realized; the central figures are masks, hollow men. . . . It can be difficult to separate the girls from the boys in this work. *Pater* clearly has balls, but there's an asexualness throughout that is cold."[39] Words like "hot" and "cold" have the same relevance to Basquiat's figures as they do to classic African sculpture.

The space spirituality occupies in the African-American unconscious is important to speculate upon, but I have to be clear. My own concern as an artist is to reclaim black female subjectivity so as to "de-haunt" historic scripts and establish worldly agency. Subjectivity for me will always be a social and not merely a spiritual quest.[40] To paraphrase Brecht, "It is a fighting subjectivity I have before me," one come into political consciousness.[41]

Neither the body nor the psyche is all-nature or all-culture, and there is a constant leakage of categories in individual experience. As Stuart Hall says of the relations between cultural theory and psychoanalysis, "Every attempt to translate the one smoothly into the other doesn't work; no attempt to do so can work. Culture is neither just the process of the unconscious writ large nor is the unconscious simply the internalization of cultural processes through the subjective domain."[42]

One consequence of this incommensurability for my practice as an artist is that I must remain wary of theory. There have been no last words spoken on subjectivity. If what I suspect is true, that it contains a multiplicity of "centers" and all the boundaries are fluid, then most of what will interest me is occurring in the between-spaces. I don't have a prayer of locating these by prescriptively following theoretical programs. The one advantage art has over other methods of knowledge, and the reason I engage in it rather than some other activity for which my training and intelligence might be suited, is that, except for the theoretical sciences, it is the primary discipline where an exercise of calculated risk can regularly turn up what you had not been looking for. And if, as I believe, the most vital inheritance of contemporary art is a system for uncovering the unexpected, then programmatic art of any kind would be an oxymoron.

Why should I wish to surrender modernism's hard-won victories, including those of the Romantics and Surrealists, over classicism's rear-guard ecclesiastical and statist theories? Despite its "post-ness," post-modernism, with its privileging of mind over body and culture over nature, sometimes feels like a return to the one-dimensionality of the classic moment. That, more than any rapidity of contemporary socio-

cultural change and "fragmentation," may be why its products are so quickly desiccated.

Because I am concerned with the reclamation of black female subjectivity, I am obliged to leave open the question of modernism's demise. For one thing, there seems no way around the fact that the method of reclaiming subjectivity precisely mirrors modernism's description of the artistic process. Whatever else it may require, it needs an act of will to project the inside onto the outside long enough to see and take possession of it. But, though this process may appear superficially *retardataire* to some, repossessing black female subjectivity will have unforeseen results both for action and for inquiry.

I am not suggesting an abandonment of theory: whether we like it or not, we are in an era, postmodern or otherwise, in which no practitioner can afford to overlook the openings of deconstruction and other poststructural theories. But as Spivak has said with respect to politics, practice will inevitably norm the theory instead of being an example of indirect theoretical application: "Politics is assymetrical [*sic*]," Spivak says, "it is provisional, you have broken the theory, and that's the burden you carry when you become political."[43]

Art is, if anything, more asymmetrical than politics, and since artistic practice not only norms but, in many cases, self-consciously produces theory, the relation between art and critical theory is often problematic. Artists who are theoretically aware, in particular, have to guard against becoming too porous, too available to theory. When a well-intentioned critic like bell hooks says, "I believe much is going to come from the world of theory-making, as more black cultural critics enter the dialogue. As theory and criticism call for artists and audiences to shift their paradigms of how they see, we'll see the freeing up of possibilities,"[44] my response must be: Thanks but no thanks, bell. I have to follow my own call.

Gayatri Spivak calls postmodernism "the new proper name of the West," and I agree. That is why for me, for now, the postmodern concept of *fragmentation*, which evokes the mirror of Western illusion shattered into inert shards, is less generative than the more "primitive" and active *multiplicity*. This is not, of course, the cynical *multi* of "multiculturalism," where the Others are multicultural and the Same is still the samo. Rather, paradoxically, it is the *multi* implied in the best of modernism's primitivist borrowings, for example in Surrealism, and figured in Éluard's poem: "Entre en moi toi ma multitude/Enter into me, you, my multitude."[45] This *multi* produces tension, as in the continuous equilibration of

a *multiplicity of centers,* for which dance may be a brilliant form of training.

Stuart Hall has described the tensions that arise from the slippages between theory development and political practice and has spoken of the need to live with these disjunctions without making an effort to resolve them. He adds the further caveat that, in one's dedication to the search for "truth" and "a final stage," one invariably learns that meaning never arrives, being never arrives, we are always only becoming.[46]

Artists must operate under even more stringent limitations than political theorists in negotiating disjunctive centers. Flannery O'Connor, who in her essays on being a Catholic novelist in the Protestant South may have said most of what can be said about being a strange artist in an even stranger land, soon discovered that though an oppositional artist like herself could choose what to write, she could not choose what she could make live. "What the Southern Catholic writer is apt to find, when he descends within his imagination," she wrote, "is not Catholic life but the life of this region in which he is both native and alien. He discovers that the imagination is not free, but bound."[47] You must not give up, of course, but you may have to go below ground. It takes a strong and flexible will to work both with the script and against it at the same time.

Every artist is limited by what concrete circumstances have given her to see and think, and by what her psyche makes it possible to initiate. Not even abstract art can be made in a social or psychic vacuum. But the artist concerned with subjectivity is particularly constrained to stay alert to the tension of differences between the psychic and the social. It is her job to make possible that dynamism Jacqueline Rose has designated as "medium subjectivity" and to avert the perils of both the excessively personal and the overly theoretical.

The choice of *what* to work on sometimes feels to the artist like a walk through a minefield. With no failproof technology, you try to mince along with your psychic and social antennae swiveling. Given the ideas I have outlined here, on subjectivity and psychoanalysis, modernism and multiplicity, this is a situation in which the following modest words of Rose's could prove helpful: "I'm not posing what an ideal form of medium subjectivity might be; rather, I want to ask where are the flashpoints of the social and the psychic that are operating most forcefully at the moment."[48]

I would add to Rose's directive the following: the most interesting social "flashpoint" is always the one that triggers the most unexpected and suggestive psychic responses. This is because winning back the position of the questioning subject for the black female is a two-pronged goal.

First, there must be provocations intense enough to lure aspects of her image from the depths to the surface of the mirror. And then, synchronously, there must be a probe for pressure points (which may or may not be the same as flashpoints). These are places where, when enough stress is applied, the black female's aspects can be reinserted into the social domain.

I have only shadowy premonitions of the images I will find in the mirror, and my perception of how successfully I can locate generalizable moments of social agency is necessarily vague. I have entered on this double path knowing in advance that, as another African-American woman said in a different context, it is more work than all of us together can accomplish in the boundaries of our collective lifetimes.[49] With so much to do in so little time, only the task's urgency is forcing me to stop long enough to try and clear a theoretical way for it.

Notes

1. Hortense J. Spillers, "Interstices: A Small Drama of Words," in Carole S. Vance, ed., *Pleasure and Danger: Exploring Female Sexuality* (Boston: Routledge & Kegan Paul, 1984), p. 77.

2. Sylvia Ardyn Boone, *Radiance from the Waters: Ideals of Feminine Beauty in Mende Art* (New Haven: Yale University Press, 1986), p. 102.

3. "African American Women in Defense of Ourselves," advertisement, *New York Times,* Nov. 17, 1991, p. 53.

4. Judith Wilson, "Getting Down to Get Over: Romare Bearden's Use of Pornography and the Problem of the Black Female Body in Afro-U.S. Art," in *Black Popular Culture,* ed. Gina Dent (Seattle: Bay Press, 1992), p. 114.

5. Toni Morrison, *Beloved* (New York: Alfred A. Knopf, 1987), p. 119.

6. George Nelson Preston, quoted in Wilson, *Getting Down,* p. 114.

7. For an examination of the relationship of black women to the first white feminist movement, see Hazel V. Carby, *Reconstructing Womanhood: The Emergence of the Afro-American Woman Novelist* (New York: Oxford University Press, 1987), Chs. 1 and 5, and bell hooks, *Ain't I a Woman: Black Women and Feminism* (Boston: South End Press, 1981), *passim.* For insights into the problems of black women in the second white feminist movement, see Audre Lorde, "Age, Race, Class, and Sex: Women Redefining Difference," in Russell Ferguson, Martha Gever, Trinh T. Minh-ha, Cornel West, eds., *Out There: Marginalization and Contemporary Cultures* (New York: The New Museum of Contemporary Art, 1990), and Bernice Johnson Reagon, "Coalition Politics: Turning the Century," in Barbara Smith, ed., *Home Girls: A Black Feminist Anthology* (New York: Kitchen Table: Women of Color Press, 1983). For problems of women of color in a white women's organization at the start of the third feminist movement, see Lorraine O'Grady on WAC, "Dada Meets Mama," *Artforum,* vol. 31, no. 2 (October 1992): 11–12.

8. See Judy Chicago, *The Dinner Party: A Symbol of Our Heritage* (New York: Anchor/Doubleday, 1979).

9. Spillers, p. 78.

10. Michele Wallace, "Multiculturalism and Oppositionality," in *Afterimage* 19, 3 (Oct. 1991): 7.

11. Nancy Hartsock, "Rethinking Modernism: Minority vs. Majority Theories," in *Cultural Critique* 7, special issue: "The Nature and Context of Minority Discourse II," edited by Abdul R. JanMohamed and David Lloyd, p. 204.

12. See the title story by Merle Hodge in Pamela Mordecai and Betty Wilson, eds., *Her True-True Name* (London: Heinemann Caribbean Writers Series, 1989), pp. 196–202. This anthology is a collection of short stories and novel extracts by women writers from the English, French, and Spanish-speaking Caribbean.

13. The understanding that analysis of the contemporary situation of African-American women is dependent on the imaginative and intellectual retrieval of the black woman's experience under slavery is now so broadly shared that an impressive amount of writings have accumulated. In fiction, a small sampling might include, in addition to Morrison's *Beloved,* Margaret Walker, *Jubilee* (New York: Bantam, 1966); Octavia E. Butler, *Kindred,* (1979; reprint, Boston: Beacon Press, 1988); Sherley A. Williams, *Dessa Rose* (New York: William Morrow, 1986); and Gloria Naylor, *Mama Day* (New York: Ticknor & Fields, 1988). For the testimony of slave women themselves, see Harriet A. Jacobs, edited by Jean Fagan Yellin, *Incidents in the Life of a Slave Girl* (Cambridge: Harvard University Press, 1987); *Six Women's Slave Narratives,* the Schomburg Library of Nineteenth Century Black Women Writers (New York: Oxford University Press, 1988), and Gerda Lerner, ed., *Black Women in White America: A Documentary History* (New York: Vintage Books, 1972). For a historical and sociological overview, see Deborah Gray White, *Ar'n't I a Woman?: Female Slaves in the Plantation South* (New York: W. W. Norton, 1985).

14. Wilson, p. 121, note 13.

15. Ibid., p. 114.

16. Ibid.

17. Ibid.

18. Judith Wilson, telephone conversation with the author, Jan. 21, 1992.

19. Wilson, op. cit., pp. 116–18.

20. Adrian Piper, "Food for the Spirit, July 1971," in *High Performance* 13 (Spring 1981). This was the first chronicling of "Food" with accompanying images. The nude image from this performance first appeared in Piper's retrospective catalogue, Jane Farver, *Adrian Piper: Reflections 1967–87* (New York: Alternative Museum, April 18 – May 30, 1987).

21. Hortense J. Spillers, "Mama's Baby, Papa's Maybe: An American Grammar Book," in *Diacritics* 17, 2 (Summer 1987): 68.

22. Hartsock, "Rethinking Modernism," pp. 196, 194.

23. Toni Morrison, in Charles Ruas, "Toni Morrison's Triumph," an interview, in *Soho News,* March 11–17, 1981, p. 12.

24. Gayatri Chakravorty Spivak, "Three Women's Texts and a Critique of Imperialism," in Henry Louis Gates, Jr., ed., *"Race," Writing, and Difference* (Chicago: University of Chicago Press, 1986), p. 272.

25. "Carnal Knowing: Sexuality and Subjectivity in Representing Women's Bodies," a panel of the College Art Association, 80th Annual Conference, Chicago, February 15, 1992.

26. A riff on Barbara Christian's title, "But What Do We Think We're Doing Anyway: The State of Black Feminist Criticism(s)," in Cheryl A. Wall, ed., *Changing Our Own Words: Essays on Criticism, Theory, and Writing by Black Women* (New Brunswick, N.J.: Rutgers University Press, 1989), which is itself a riff on Gloria T. Hull's title, "What It Is I Think She's Doing Anyhow: A Reading of Toni Cade Bambara's *The Salt Eaters,"* in Smith, ed., *Home Girls,* which is in turn a riff on Toni Cade Bambara's autobiographical essay, "What It Is I Think I'm Doing Anyhow," in Janet Sternberg, ed., *The Writer on Her Work* (New York: W. W. Norton, 1980).

27. "But by thus remaking contact with the body, and with the world, we shall also discover ourselves, since, perceiving as we do with our body, the body is a natural self and, as it were, the subject of perception." Quoted by Edward R. Levine, unpublished paper delivered at College Art Association, 80th Annual Conference, Chicago, February 13, 1992.

28. Gayatri Chakravorty Spivak, "Strategy, Identity, Writing," in *The Post-Colonial Critic: Interviews, Strategies, Dialogues,* ed. Sarah Harasym (New York: Routledge, 1990), p. 42.

29. Kobena Mercer and Isaac Julien, "Race, Sexual Politics and Black Masculinity: A Dossier," in Rowena Chapman and Jonathan Rutherford, eds., *Male Order: Unwrapping Masculinity* (London: Lawrence & Wishart, 1987), pp. 106–7.

30. Wallace, op. cit., p. 7.

31. Spivak, "Criticism, Feminism, and The Institution," p. 11 (italics mine).

32. See the oft-quoted phrase, "For the master's tools will never dismantle the master's house," in Lorde, "Age, Race," p. 287.

33. Jacqueline Rose, "Sexuality and Vision: Some Questions," in Hal Foster, ed., *Vision and Visuality,* Dia Art Foundation, Discussions in Contemporary Culture no. 2 (Seattle: Bay Press, 1988), p. 130.

34. Wallace, op. cit., p. 7.

35. bell hooks, *Black Looks: Race and Representation* (Boston: South End Press, 1992), pp. 115–31.

36. Spivak, op. cit., p. 11.

37. Spillers, "Interstices," p. 79.

38. See the famous description of African-American "double-consciousness" in W. E. B. DuBois, *The Souls of Black Folk* (New York: New American Library, 1982), p. 45.

39. Elizabeth Hess, "Black Teeth: Who Was Jean-Michel Basquiat and Why Did He Die?" in *Village Voice,* Nov. 3, 1992, p. 104.

40. "The expressionist quest for immediacy is taken up in the belief that there exists a content beyond convention, a reality beyond representation. Because this quest is spiritual not social, it tends to project metaphysical oppositions (rather than articulate political positions); it tends, that is, to stay within the antagonistic realm of the Imaginary." Hal Foster, *Recodings: Art, Spectacle, Cultural Politics* (Seattle: Bay Press, 1985), p. 63.

41. Teresa de Lauretis, *Feminist Studies/Critical Studies* (Bloomington: Indiana University Press, 1986), p. 17.

42. Stuart Hall, "Theoretical Legacies," in Lawrence Grossberg, Cary Nelson, Paula Treichler, eds., *Cultural Studies* (New York and London: Routledge, 1992), p. 291.

43. Spivak, op. cit., p. 47.

44. bell hooks, interviewed by Lisa Jones, "Rebel Without a Pause," in the *Voice Literary Supplement,* Oct. 1992, p. 10.

45. Paul Éluard, quoted in Mary Ann Caws, *The Poetry of Dada and Surrealism: Aragon, Breton, Tzara, Éluard, and Desnos* (Princeton: Princeton University Press, 1970), p. 167.

46. Hall, *passim.*

47. Flannery O'Connor, *Mystery and Manners: Occasional Prose,* selected and edited by Sally and Robert Fitzgerald (New York: Farrar, Straus & Giroux, 1961), p. 197.

48. Rose, op. cit., p. 129.

49. Deborah E. McDowell, "Boundaries," in Houston A. Baker, Jr., and Patricia Redmond, eds., *Afro-American Literary Study in the 1990s* (Chicago: University of Chicago Press, 1989), p. 70.

(re)-ORIENTING

Margo Machida

In March and April 1991 Margo Machida organized a public symposia series on Asian American women artists, held in New York City. The following is her summary of those sessions. *

Invented images of Asian women have long occupied a distinct place in American popular culture, appearing in a multitude of incarnations as "exotic" objects of desire, sexual playthings, treacherous seductresses, scheming Dragon Ladies, deferential geishas, self sacrificing sidekicks to Caucasian male heroes, war and mail order brides and, more recently, aggressive Asian professionals—members of a successfully assimilated model minority. In recent years, Asian American women have responded to these stereotypes by finding alternative means to "name" themselves within a culture that provides few models capable of engaging the complexity of their experience. While challenges to traditional Asian and "Orientalist"-inspired Western expectations of what Asian women "ought to be" increasingly appear in Asian American literature, film and theatre, the visual arts receive comparatively little attention as an emergent vehicle for self-representation.

This project, *(re)-ORIENTING: Self Representations of Asian American Women Through the Visual Arts*—a three-part public panel series co-sponsored by Henry Street Settlement and The Barnard Center for Research on Women—was a direct outgrowth of my work as an artist. What had originally begun as an attempt at self-examination

*This article is reprinted from *Harbour*, vol. 1, no. 3 (August–October 1991): 37–43, by permission of the publisher.

through ethnic and gender identity led, by necessity, to an ongoing investigation of the work of other Asian American visual artists involved with similar issues. Since public forums specifically addressing Asian women's issues in the visual arts have been few and far between, I felt that organizing this program would be especially timely in stimulating further discussion. Conceived as exploratory dialogues among artists and curators, historians and writers, each panel focused on a different Asian American woman.

The artists—respectively of Korean, Japanese and Chinese descent—reflected a range of perspectives, from that of the recently arrived immigrant to a third generation Asian American. In these symposia, held during the spring of 1991, my goal was to open a space that placed their experience at the center of a dialogue investigating the relative positions that gender, race and ethnicity occupy in Asian American women's definitions of self. In this, I hoped to identify a body of concerns *specific* to that experience—what makes it *different* as well as what is shared with other women in America.

Because there is no *single,* all encompassing Asian American women's experience, nationality, generation, class, and variant histories in America and Asia, must be considered—as broader themes emerge in common concerns. Further, where contradictions arise between Asian traditions, familial expectations, and Western values, Asian Americans often have to decide what they choose to continue as sustaining, and what they must discard or reinvent. In this, I have found that *generational factors are critical in determining artists' priorities.*

THE PANELISTS

Given infrequent opportunities for serious dialogue that emphasize Asian American women's involvement in a multicultural environment, I intentionally broadened the panels to include discussants from diverse backgrounds and disciplines. In seeking to provide an optimal situation for the artists, I asked each to identify women with whom she most wanted to have a discourse; in all cases, those invited graciously chose to participate.

The respondents for the first panel, featuring Yong Soon Min, were Arlene Raven, a feminist critic, art historian and author; and Lowery Sims, art historian and associate curator in the Department of Twentieth Century Art at the Metropolitan Museum. The second event, focused on Tomie Arai, included widely published feminist literary scholar bell hooks, and Eunice Lipton, a feminist activist, writer and independent

critic. For the final panel on Hung Liu, the discussants were Vishakha Desai, art historian and Director of the Galleries at The Asia Society, and Laura Trippi, curator at The New Museum of Contemporary Art.

THE ARTISTS

Yong Soon Min is an artist and an activist. Born in South Korea, she immigrated with her family to join her father in California at the age of seven. Min's early life was spent in a nation devastated by warfare and divided by allegiance to the competing ideological blocs that had formed after the Second World War. Having settled here as a youngster, she positions herself as a child of the Cold War whose life was completely changed by international conflict. Min's work reflects a highly politicized sense that personal history is tied to worldwide power struggles. Consequently, Western foreign policy, capitalism and racism are among her primary concerns. Yet by engaging in politics, and explicitly representing herself in her artwork as a participant in global events, she consciously opposes restrictive Confucian expectations that limit women to the domestic realm. In this, she expands notions of what can be considered Asian women's issues. As she has said, "I want to put myself out there in the world . . . engage in [what] at least in Confucian terms, has always been considered the male domain. Issues like world affairs."[1]

Min's oppositional stance to Confucian values highlights an issue of central concern to many Asian American women. Referring to the pervasive influence of Confucianism, especially in her early years in Korea, she alludes to an ethos that enshrines patriarchal authority, and continues to be expressed in the hierarchical social structures of East Asian cultures— where many women remain in a position markedly inferior to men. Confucianism is a body of beliefs and practices—religious, ethical, social, political and economic—originating in the diverse teachings of ancient Chinese texts. It was first elaborated and transmitted as a system by its namesake, Confucius (the latinized version of K'ung Fu-tzu), a scholar, educator and bureaucrat who lived from 551–479 B.C. In this doctrine, which idealized antiquity and above all valued earthly harmony, respect for age and authority, the nature of social relationships and rules of conduct were established for all members of society and a woman's "place" was rigidly defined by familial roles, whether as daughter, wife or mother.

Today, Confucian mores persist in new guises as social ideals and moral expectations that imply that a "good" Asian daughter should

Yong Soon Min, *Make Me*, Nos. 1–4 of a four-part photo installation, 1989
Each approximately 16" × 20"
Photographs by Karen Bell

respect and obey figures of authority, especially parents, elders, and males. Many younger Asian American women find these traditional expectations oppressive and frequently have to contend with their enduring impact in relationships with families and other Asians.

Tomie Arai is a third generation Japanese American printmaker and muralist, raised on the Upper West Side of Manhattan, an ethnically mixed community that included a small Japanese enclave. Going to schools that were mostly African American and Latino, Arai came to see New York as a "third world city" with Asians part of a larger racial and ethnic "majority" culture. Being very Americanized, Arai did not actively seek connections with her Asian heritage, or question identity until she became involved with the civil rights, antiwar and community arts movements of the sixties and seventies. This process of self discovery led to her activism in the Asian American community.

In seeking to affirm and project the unique experience of being an Asian woman in America, Arai constructs images of intergenerational continuity based on women's relationships in Asian families, thereby linking her personal history to the immigrant legacy of all Asian women. As she states, "Throughout my work, family and tradition form the principal connection between the past and the present; between 'there' and 'here' . . . the link between the life left behind [in Asia] and the endless possibilities of the life that lies before us."[2]

Arai envisions pan-Asian experiences rooted in a common history, in which Asian American women's identities intertwine through family, motherhood, and community. Given the primacy of a sense of family for many Asian Americans, Arai's imaging of positive, nurturing relationships between mothers and children celebrates immigrants' resilience—in a society that frequently discriminated against them, and enacted legislation to limit their settlement by preventing the formation of families. Arai's work joins this continuing Asian immigrant experience with images of traditional Asian culture and pride through continuity and renewal.

The shaping of Asian communities in America, through deliberate disruption and painful separation of families, is a recurrent theme for many artists. Beginning with Chinese immigration to California in the 1840s, each successive national group has encountered hostility and, once here, endured recurrent episodes of anti-Asian xenophobia. During the second half of the nineteenth century a series of federal and state laws prevented many Asian wives from joining husbands in America and ultimately barred most Asians from entering this country. In 1882, the

Chinese Exclusion Act suspended immigration for ten years, and by 1894, a total prohibition on Chinese immigration was enacted—the first federal law ever promulgated to exclude a specific nationality. Although this legislation was gradually amended during this century, to at least provide for a discriminatory quota system, it wasn't until 1965 that immigrants from all nations were accepted in equal numbers. Since the 1970 census, Asians have become the fastest growing ethnic minority group in America.

Hung Liu, a first-generation Chinese artist, arrived in the United States in 1984. During China's Cultural Revolution, she laboured in the countryside for four years. After being allowed to continue her education at the Central Academy of Fine Art in Beijing, and to teach art, she came here to attend graduate school, and currently is a faculty member at Mills College in California.

As a recent immigrant, Hung Liu constructs her identity in relation to her country of origin, believing her responsibility is to clearly express her sense of Chineseness in America. Seeing herself within a centuries-old tradition of Chinese scholar-painters, Liu calls her work *media-age history painting.* Juxtaposing images from Chinese history with contemporary events like the pro-democracy demonstrations at Tiananmen Square, Liu alludes to the continuity of authoritarian traditions in China. Throughout her work is a consistent questioning of authority and the mechanisms of social control, especially when underscoring disparities she perceives between official images and the difficult realities of people's lives. For Hung Liu, "Each generation, Chinese heroes pry open the lid of their homeland's ancient repressions. . . . I am of a newer generation, one that is trying to excavate and then open ancient vessels in the belief that their contents are worth recovering and recovering from."[3]

Central to Hung Liu's art is an investigation of the historic treatment and status of Chinese women, who she says suffer multiple oppressions—those shared with all Chinese, and others originating in the patriarchal legacy of confucianism. In the image of a Chinese woman exposing bound feet, for example, she finds a vivid metaphor for the shaping of women as objects for male desire, as well as for the distortion of the larger society through various forms of domination. For this artist, exposing and linking such conditions is an *oppositional act,* necessarily part of a larger struggle for human rights—a situation given particular urgency by recent events in China. Liu sees exposing women's oppression as essential to this process, given a heritage and contemporary situation that resist the full and free expression of Chinese women, especially on women's issues.

SUMMARY OF KEY ISSUES

Following are short summaries of the major issues raised by the three symposia, in which I acted as moderator and commentator. (For brevity the discussants' remarks are summarized rather than individually attributed; transcripts will be available on request.)

Gender: Gender is not necessarily given primacy by many Asian American women artists because they see it as inseparable from a matrix of compelling social and political concerns—such as responding to racism, and maintaining community and cultural integrity in America. For many newer Asian Americans, addressing contemporary situations in Asia and investing America with these things Asian are central.

Race: Race, not gender, is often seen as the primary marker that distinguishes Asian women in a predominantly white society. As was remarked, the fundamental experience of discrimination has been through racial identity—being Asian is to automatically be seen as "different" and alien.

A significant consideration is the position of Asian women on the American racial spectrum. Within multiracial politics, issues specific to Asian Americans tend to be invisible, subsumed to larger groups' concerns. The current American racial model remains primarily bipolar, focused on tensions between blacks and whites, while Asians are viewed as either perpetual aliens, middle man minorities, white wannabes, or, in minority politics, as adjuncts to other people of colour. Further, due to the prevailing model minority stereotype, Asian women are perceived as having fewer problems, and therefore dismissable in what has ironically been called the hierarchy of oppression.

Yet, while divisive events consistently make the news, we were reminded that little is written or said about solidarity experienced by Asian and African women—as well as other women of colour. Besides recognizing connections forged through common struggles against racism, ethnic stereotyping, colonialism, and other forms of domination, we were urged to examine what is sustaining in parallel traditions and values. Also noted were the influences of African American writings in providing potent alternative models for Asian American self definition and activism.

Feminism: As with other women of color, Asian American women's relationship to feminism is conflicted. A major problem is that main-

stream feminism remains primarily associated with a gender focus, whereas women of color, by necessity, see themselves in relationship to interrelated factors including race, gender, sex, and class.

Further, the traditional Western feminist movement, originating in white middle-class women's concerns, is frequently seen as insisting that the behavior and needs of women from other cultures and ethnic backgrounds be evaluated by their standards. Because Asian women often consider white feminists' critiques of patriarchy and emphasis on individual independence as a threat to family unity—such work as Arai's, with its positive emphasis on the Asian American family, highlights a significant fact of difference.

Despite these differing positions, the positive influence of feminism was also affirmed as providing Asian American women with examples of collective action and a "politicized voice." In attempting to locate the work of Asian women artists within a larger body of women's art in America, common concerns about the insufficiency of existing language and images to fully express women's experiences were underscored. It was proposed that the use of collage, fractured images, divided formats, and devices like wordplay, indicated a need shared with other women artists to find flexible frameworks that could be adjusted to "fit" women's complex realities.

Tradition: Reconciling traditional Asian cultural values and feminism has often been described as engaging in a balancing act. To uncritically accept mainstream feminism can be seen as a denial of heritage by internalizing another group's beliefs—even as liberating and desirable aspects of feminism are recognized. Yet, by considering existing feminist models, Asian American women are challenged to constructively critique Asian traditions without rejecting them wholesale. Because cultural activists often feel tension between their need to establish positive images that are self empowering, and a desire to address problems specific to the Asian American community such as the patriarchal legacy, this area is especially controversial.

Family: The centrality of the family for many Asian Americans must be viewed against an immigration history of separated spouses and stunted communities. Thus, for many, the family is primary as a means of resistance against control or disruption by dominant culture. Although many Asian traditions are often considered to be problematic in the American context, they embody values people may wish to respect. Underlying discussions of such issues are power relationships between

women of different backgrounds—who is determining the feminist agenda for whom—and, as a corollary, the sense of empowerment gained by defining and naming one's own experience.

Concepts of self: A generalized distinction was posited between the Western concept of self originating in the uniqueness of individuals, versus Asian traditions of self as a social construct—a composite sense of identity embedded in interpersonal relationships. Such an "outer-directed" attitude toward self, although modified in American culture, reverberates in the work of Asian American artists who continue to find sustenance in identities informed by family, community, history and politics.

Sexuality: The relative absence of imaging of the nude female body, or overt expressions of sexuality in Asian American women's work was questioned. Yet because Asian American women's images in this culture are often resonant as erotic objects for white male desire—infused with the exoticizing legacy of European Orientalism—their representation will remain a highly charged issue, especially where such depictions seem to recapitulate or reinforce existing stereotypes. Although imaging sexuality and the female body can be important in giving women control over images of desire, many feel that emphasizing such representations imposes white feminist attitudes on Asian women. Further, traditional Asian American communities are reluctant to deal with sexual issues or their depiction, especially by women. As a result, some artists believe that introducing such images at this time is divisive and would alienate those they try hardest to reach.

Transiting cultures: Limited knowledge of other cultures frequently creates "blind spots" when approaching unfamiliar artwork. Although a lively interplay has indeed developed between contemporary Asian and Western art, one cannot automatically assume that Asian artists' use of seemingly familiar idioms and formal devices transits cultures intact. Western viewers, often made uneasy by such unconventional terrain, may simply have to acknowledge their difficulty in attempting "readings." As a speaker emphasized, such discomfort must be faced to expand one's mental "archive."

The extent to which the transition to American culture influences the material that recently-arrived Asian women artists choose to examine raised an issue: How does one's sense of self shift across cultures; and, are specific bicultural themes emerging in reponse to American audiences

that encourage such work? As immigrant artists strive to be understood and accepted in the West, they may select certain Asian images because they are recognizable—a strategy that was considered problematic by some, in offering limited or possibly stereotypic views of Asian society.

COMMENTARY

Clearly, these panels have only begun to suggest the range of issues involved in Asian American women's conceptions of self, and the varying degrees to which each takes precedence for individuals. However, they have emphasized that as Asian American women define themselves in relation to: feminism, gender roles, sexuality, racism, inter-racial relations, Asian men, family, community, national origin, and traditional cultural attitudes—a sense of distinct identity(ies) emerges.

Although Asian women are certainly objectified by gender—an experience shared with all women—they are further objectified by race in America. To experience one form of discrimination in gender is not necessarily to understand (or even be able to perceive) the experience of objectification by other criteria. The central point in understanding this distinction is in recognizing the additional factors an Asian American woman must contend with—and not conflating all women's experience by blurring real differences. For women of color, as well as women from non-privileged classes (often one and the same), gender discrimination alone is not the overriding concern when experiences of oppression derive from multiple modes of objectification.

Thus, many Asian women artists often resist being "claimed" by other communities. As Hung Liu wrote, "Sometimes I feel more labeled than embraced . . . labeled . . . as a minority artist . . . an artist of colour, a woman artist (feminist?). . . . I am an artist from China, and in China the terms by which I am defined here make little sense."[4] Participation in a multicultural environment demands that interaction among groups be based on mutual respect. It must not be dominated by language and issues originating in any single entity. Claims or assumptions of centrality deny the distinct needs and aspirations of others, especially when only those "others" whose positions accord with one's own are deemed acceptable.

Numerous symbols and forms now readily traverse cultures and, in doing so, undergo a complex recontextualizing process in which external similarities are often retained. Crosscultural transmission assures that meaning and purpose will alter as images and ideas are inevitably rede-

fined in terms comprehensible for another cultural matrix. Interpretation of art emanating from other cultures—even where Western idioms are used—often requires specific knowledge, much as American art historians are trained to decipher European iconographies.

In this, immigrant artists challenge American audiences to see Asia—and what is Asian in our society—in new ways. In the signs and symbols of the Asian diaspora and for some, in "Orientalist" images in the West, they also find unique means to speak to and renegotiate their relationship with their cultures of origin. The increasing visibility of Asian immigrants and the introduction of Asian symbolic systems into American culture suggest that a major shift is occurring. With the current wave of Asian immigration widening existing communities, Asian influences are receiving greater recognition in American society. Further, as Asian nations emerge as global powers, subjects and things Asian become more compelling for the West.

With both Asian and American scholarship on Asian art primarily devoted to historical research on traditional Asian forms and antiquities, many arts professionals are unaware of the vitality and diversity of work produced by contemporary Asian American and Asian women. Given the complex mix of social and personal factors in which Asian women artists' lives are embedded, it is essential that their art and ideas be investigated on an individual basis. Only by making these artists primary sources can their work be fully understood and related to a larger framework that speaks to the Asian American community, multicultural America, and Asia. Hopefully these symposia will inspire women from the entire spectrum of Asian ethnic and national backgrounds to contribute to making this series part of a continuing dialogue.

Notes

I want to thank all the panelists for their enthusiastic participation and support; special thanks to Susan Fleminger and the Henry Street Settlement for providing the opportunity to realize this project under the auspices of a 1990–91 New York State Council on the Arts Artist in Residence Award; and to Temma Kaplan and Ruth Farmer at the Barnard Center for Research on Women for cosponsoring these events. Finally, my thanks to members of GODZILLA: Asian American Art Network for their encouragement and assistance with these events.

1. Yong Soon Min, interview with the author, December 27, 1990, New York City.
2. Tomie Arai, artist's statement, 1991.
3. Hung Liu, artist's statement for "The Vessel" exhibition, Dallas, Texas, 1990.
4. Hung Liu, artist's statement, March 1991.

MULTICULTURAL STRATEGIES FOR AESTHETIC REVOLUTION IN THE TWENTY-FIRST CENTURY

Charleen Touchette

Creating a credible global aesthetic that embraces cultural diversity is the leading challenge confronting the arts as we approach the twenty-first century. It is time to facilitate a change at the root of aesthetic critical thinking. It is time to abandon divisive hierarchical thinking and, instead, celebrate our pluralism by practicing inclusivity. It is imperative that arts institutions and organizations promote diversity throughout the system. They must make achieving inclusivity a priority. It is imperative that mainstream artists, administrators, art historians, and critics begin now to share power at every level. Mainstreamers must finally realize that they are merely one group among many—all of which are entitled to equal consideration. All art should be evaluated according to a new multicultural aesthetic that recognizes and incorporates the wide spectrum of valid ideologies which determine art quality throughout the world. Developing this new aesthetic has the potential to revolutionize the creative process as well as the current art apparatus. We who are committed to inclusivity must fight diligently to effect the changes necessary to achieve parity. We will undoubtedly face the opposition of those in power. Nevertheless, now is the time to recognize the indisputable exigency of a multicultural aesthetic revolution. Now is the time to work together to create an art system where diverse artistic expressions can thrive. If we actively meet the challenge our cultural diversity presents, the rewards will be

immeasurable and our collective world culture will be enriched in ways we cannot yet even imagine.

The global village, envisioned by Marshall McLuhan in the sixties, is now our reality, and so-called "minorities" are the world's majority. Here in the United States, the biracial and multiracial population is growing rapidly, Native Americans are the fastest-growing population, followed by African Americans, whereas demographers project that the Euro American population will have stopped growing by the year 2029. The people the dominant culture has relegated to a "minority" position for hundreds of years, with all the diminished economic, political and cultural status that term connotes, are now the majority. These demographic changes combined with the fact that women are the majority gender worldwide present the opportunity and responsibility for women and multicultural people to take the lead in redefining global aesthetics. The dominant cultural aesthetic and the economic structure that supports its hegemony must be replaced with one that represents the cultural thinking of the world's people. The challenge of our time is to accept the irrefutable fact that we live in a global village and that all cultures can, must, and do exist concurrently. It is our mandate to cast off the violence, mistrust, and discrimination that is the legacy of Western civilization's hierarchical cultural and political domination and begin to coexist and interact peacefully with people of other cultures.

White women artists are in a unique position with respect to the fight for inclusivity. They can either choose to identify with the male-dominated status quo from which they derive status and privilege because of their color, or with women and men from nonwhite cultures with whom they share the experience of oppression. If they choose to work for change, women artists, particularly feminists, can play a pivotal role in the transformation of aesthetic values. If they oppose the ongoing strategy of divide and conquer that operates to fuel dissension among powerless groups and, instead, build coalitions, multicultural art groups and feminist organizations would be a powerful fulcrum for change.

We need to support the creation of organizations and art institutions whose agendas address the concerns of a wide spectrum of people. What is needed is a broadening of aesthetic criteria so that the Euro American aesthetic will become just one of many equally valid and respected modes of judging artistic expression. Jamake Highwater in *The Primal Mind* questioned the very concept of a "universe," when in indigenous societies, the word "multiverse" best describes the mind's ability to perceive and accept a multitude of simultaneous realities.[1] When mainstream Americans are able to perceive the world as a "multiverse" and to accept the

reality of simultaneous contradicting aesthetics without putting them into a hierarchy or competition, perhaps then there can be fairness in multicultural diversity.

The metaphor of the United States as a cultural melting pot is a failed myth. Despite centuries of forced assimilation and cultural genocide, by economic pressure and violence, people continue to assert their ethnic identity. The vitality of the artistic expression of multiracial people shatters accepted assumptions about the way cultures can survive change and the way cultural information can be transmitted from one generation to another. Sophisticated mass media and communication technologies have made it possible for cultures throughout the world to interact. Although we have the technology to access the world's cultures, we lack a critical theory to evaluate their artistic differences justly. We are faced with challenges that parallel our diversity: to learn to live together peacefully and to develop an ethical philosophy to guide our use of technology. We must have the will to face the future with a vision that is inclusive and respects the right of creative expression of people of all colors and cultures.

What qualities would characterize such an aesthetic revolution? First, the very concept of a dominant aesthetic and the hierarchical thinking that fuels it must be relinquished. The current dominant aesthetic is a narrow view that reflects the cultural values and goals of only a small part of the world body. Rather than a mainstream, it is a small tributary that wields a disproportional amount of power because of its unequal share of economic and political resources garnered through hundreds of years of cultural imperialism. The richness and quality of art objects found in archeological sites throughout the world proves that, contrary to the mainstream "history of art," world art has been culturally diverse from the beginning of time. The ability to make powerful art transcends culture. It is the unequal distribution of economic power and control of art "history" that has allowed mainstream art institutions to systematically devalue the art of non-Western cultures.

Currently there is a strong mandate for mainstream art institutions, granting organizations, and arts educators to increase multicultural diversity in their programs. Though this long overdue, new "multicultural imperative" is indisputably important and timely, to be effective, it must address and resolve crucial issues. Its potential impact upon both arts institutions and multicultural artists raises complicated questions. Whose needs is this mandate, in its current form, really designed to meet? Granting organizations now require information on the ethnic heritage and race of applicants or the constituencies they serve. Often, they manipulate

the statistics to make it appear that more women and artists of color are being served by double-counting individuals who fall into more than one category. They emphasize whichever part of a biracial or multiethnic artist's background makes the art institution "appear" more diverse. For example, an exhibition of my art was promoted by a state arts organization solely as Native American art, despite my repeated objections. Are arts institutions motivated by self-interest or egalitarian impulses when they focus on multicultural art? Clearly, those that feature artists of Asian, Native American, Hispanic, and African American descent now receive increased grant monies and media attention. Further, the mainstream art world is known for its pursuit of the shock of the new and quickly moving on. Is infatuation with an exotic fad the real motivating force behind these seemingly egalitarian impulses? The leading question remains, Will the mainstream art institutions' interest be as short-lived as most art market trends and soon leave multicultural artists as marginalized and invisible as before?

The "multicultural arts imperative" brings into sharp focus the all-pervasive inequities in the art world today. Access to opportunities for arts education, exhibitions, and critical authentication has been systematically limited for or denied to women artists and artists of color. Given this history, it should be no surprise that multicultural artists are suspicious of the mainstream's recent attention. Political and economic power determine which art is legitimized by the mainstream. The mainstream art world and the economic structure which supports it is controlled by white, male Euro Americans who promote and privilege art created by their own. Only a few token "outsiders" are allowed access. Most often, their art is legitimized only if it reaffirms the status quo. Given this context, what are the ulterior motives propelling the current interest in multicultural art?

Because the dominant culture defines power as *control over others,* the power to legitimize becomes the power to control. Central to the exercise of power by the mainstream is the tacit acceptance of those it controls. The first step to break down this type of control is refusal to acknowledge their dominance as legitimate. It is imperative that multicultural people in the arts insist upon a total restructuring of the art world at every level.

Arts administrators, curators, and critics often justify their exclusion of multicultural art on the basis of subjective judgments that they assert are professional evaluations of "universal art quality." In reality, the true motive of these judgments is to exclude art that makes them uncomfort-

able because it reflects experiences that are culturally different from their own. As critic, Lucy Lippard wrote:

> Ethnocentrism in the arts is balanced on a notion of Quality that "transcends boundaries"—and is identifiable only by those in power. According to this lofty view, racism has nothing to do with art; Quality will prevail; so-called minorities just haven't got it yet.[2]

As all multicultural artists know from painful experience, racism has everything to do with art. "Universality" and "quality" are in fact red-herring issues used to systematically exclude their art from the mainstream by elevating the *subjective* Euro American cultural viewpoint to the position of sole arbitrator of what is quality for all people. The sad truth is that it is the mainstream arts professionals who "just haven't got it yet." They close themselves off to the richness of artistic diversity by refusing to see the plain truth that though criteria vary widely among cultures, classes, and genders, they can all be simultaneously valid and can produce art that profoundly explores and illuminates the human experience.

Entrenched attitudes, behavior, and language that are racist, sexist, ageist, ethnocentric, anti-Semitic, homophobic, and classist are pervasive within the current system. These ingrained, hierarchical patterns present formidable obstacles to cross-cultural communication and interaction. In addition to their practice by consciously racist individuals and institutions, these patterns are so deeply ingrained in the dominant culture and so accepted in common usage that many people who consider themselves open-minded express racism unintentionally by using inappropriate language that objectifies and dehumanizes those of other cultures. For instance, people who would be highly offended by racial slurs directed at African American or Jewish Americans think nothing of brandishing the "tomahawk chop" at an Atlanta Braves game or teaching their children to do a "war whoop," both practices that are extremely offensive to Native Americans. Racism has also been internalized by some members of historically oppressed groups who, though victims themselves, use it to oppress vulnerable individuals in their own group.

These hierarchical behavior patterns perpetuate the dominance of those in power. This destructive behavior must be broken down wherever it occurs before authentic cross-cultural interaction can begin. Miscommunication often occurs because different cultures have divergent expectations about what is appropriate. Cross-cultural communication is further complicated by the inequities of economic and political power. Because of the legacy of oppression and discrimination, people of color

sometimes take offense at behavior that may not be intended to offend. The offense is then exacerbated by anger and misunderstanding, and the opportunity to open up communication is lost. A misunderstanding that could easily be dispelled simply by explaining the cultural difference that engendered it is allowed to develop into a chasm separating people, sometimes irrevocably.

One reason cultural differences prevent the voices of people of color from being heard is that every culture has different ideas about the context in which verbal expression is appropriate. For example, Native American women come from long traditions of respect for oratorial skill. However, while they are usually comfortable about speaking in public in a tribal context, they will rarely speak out in a mixed cultural group unless the forum is structured to allow uninterrupted oration. Many ethnic women identify with Chinese American painter Florence Wong when she describes how Asian American women are taught to be silent and remain invisible to fulfill their culture's definition of a good woman. Latina women, while usually highly expressive verbally in Spanish with one another, will often remain silent when English is spoken in a group, even if they are proficient in the language. Many Spanish-speaking people, whose language is highly formal, are accustomed to elaborate verbal conventions that carefully define the parameters of interpersonal communication to show respect to the person addressed. Thus, they are sometimes offended by the informal, direct way that people talk to each other in English.

Euro American chauvinism defines art influenced by so-called "primitive" art from Africa, Asia, and Native America to be avant-garde if made by those embraced by the mainstream, but characterizes the art of contemporary artists from these same cultures as derivative and naive. The history of endemic racism and cultural imperialism in Western culture is at the root of this unfair valuation. The entrenchment of cultural imperialism and its divisive attitudes is so pervasive that it is often expressed unknowingly by individuals who are sincere about desiring multicultural inclusivity. In my teaching curriculum, "Native American Art is World Art," I include a comparison of two slides of sculptures of the skull, one in bronze by Picasso, the other in obsidian by a pre-Columbian Aztec sculptor. Inevitably, people assume that the crudely formed skull is by the Aztec and the highly refined skull is by Picasso, when actually the opposite is true. People are conditioned to expect "primitive" art to be crude, when in fact, most primal art is pristine abstraction of idealized forms. The motive behind the continual, pervasive marginalization of all

women artists and artists of color is that when this art is relegated to the outside, it is easier to justify the appropriation of its images, symbols, and forms and "transform" them into significant mainstream "cutting-edge" art.

It is true that an integral part of the creative process of all human beings is the appropriation of cultural material from one's own and other cultures. All art has been created by the synthesis that occurs through the artist's manipulation of materials, ideas, and imagination. The essential element that distinguishes the natural free exchange of ideas and images from outright theft and cultural imperialism is the artist's success in transforming these influences by the power of her own sensibility into art that is intrinsically her own. Native American artists, for example, have consistently appropriated materials and forms from Europeans since the time of initial contact. Many of the art forms that people associate with traditional Native American art, such as beadwork and silverwork, were developed only after the Plains Indians traded for Czech beads with the French and the Navajos had contact with Spanish silverwork. Beadworkers exploit the qualities of flexibility and bright color of the beads to expand traditional patterns used in quillwork, but they use these materials to create art that expresses a tribal worldview. Contemporary Native American artists use nonindigenous media such as the two-dimensional canvas, printmaking, photography, and video, as well as the formal language learned from exposure to Western art and other world cultures to express their own sensibility as twentieth-century Native Americans. Their expressions, when successful, are as distinct from those of artists from other tribes as they are from Western contemporary artists and reflect their individualistic response to being contemporary Americans tied to ancient tribal cultures that continue to survive today.

However, the predominant legacy of the history of Western cultural imperialism is anger, misunderstanding, and mistrust surrounding the perception of appropriation. As Lippard observed

> The West has historically turned to the Third World for transfusions of energy and belief. In less than a century, the avant-garde has run through some five centuries of Western art history and millennia of other cultures with such a strip-mining approach that it has begun to look as though there were no "new" veins to tap.[3]

Lippard's description accurately describes the wholesale ransacking of others' cultures by Western modernists and postmodernists and calls to mind the image of a gluttonous monster devouring everything in its path. This monster is what terrifies artists from the cultures that have

been plundered, who wonder if any part of their culture is sacred to mainstreamers, and can be protected from being digested and diluted by the Western cultural apparatus.

However, cultural appropriation is a complex, two-sided issue. Much of the current political rhetoric against it is well founded, but some of it is unfair, unrealistic, self-serving, and bigoted. It is unrealistic to claim that cultural images that have become part of the global consciousness through mass media can only be used by those who are directly descended from the original creators of those images. It is bigoted to claim only Hispanic artists can be influenced by or portray Frida Kahlo in performance art pieces. While it is true that efforts should be made to cast a Latina artist in the movie portraying her life, it is important to remember that Frida was also half Eastern European Jew. Shouldn't Jewish women, at least, also be allowed to claim her as an ancestress? Following that logic to its ludicrous extreme, the role of Frida could only be acted by a Mexican-Jewish woman. More to the point, it is extremely dangerous to insist that actors only portray characters of their own ethnicity. Such thinking would also make the outstanding performances of Shakespeare by all African American casts, and Guthrie Theater's wonderful casting of the Greek plays—with African American Isabell Monk as Clytemnestra and Euro American and Asian American actresses playing her daughters, Iphigenia and Electra—impossible. In truth, all human beings are heirs to the creative genius of artists like Shakespeare, Aeschylus, the Anasazi potters, the Northwest Coast maskmakers, and Frida Kahlo too. Our multicultural world offers exciting opportunities to cross cultural barriers and use the transformative powers of theater, poetry, and art-making to materialize unexpected revelations about our common humanity and rich diversity.

Much of the history of Western culture recounts the appropriation and reshaping of idioms and forms from Greco-Roman culture. Modernism owes much of its inspiration to the ideas of the cultures of Africa, Asia, and Native America. The influence of Japanese woodblock prints on the art of Manet and others, and of African masks on the art of Picasso, Bracque, and their contemporaries has been well documented. The influence of Native American philosophy and sacred architecture on Robert Wilson, Charles Simmonds, Michelle Stuart, and other "earthwork" sculptors of the seventies, and that of ritual dance on Jackson Pollock, Martha Graham, and performance artists such as Mary Beth Edelson is obvious. However, the valuation given to the powerful art that influenced Western artists has never approached equity. Henry Moore credited the monumental stone sculpture of Chac Mool, the rain god at

Chichén Itzá, with inspiring his reclining sculpture for UNESCO, and many subsequent sculptures.

But the art world, entranced by his creation of forms considered "new" to the Western eye, failed to give respect and recognition to the art and civilization that inspired them. This lack of acknowledgment of sources from non-Western cultures is more often the rule than the exception. Further, as Lippard commented, "The Western concept of primitivism denigrates traditions with which many contemporary artists identify and fortify themselves."[4] Western artists are taught to be influenced by and to appropriate any of the available aesthetic stimuli from world cultures. They are encouraged to feel that the art of all world cultures, ancient and contemporary, is a sort of huge catalogue from which they can choose and discard forms, ideas, and artistic idioms to incorporate into their own work. Because they are mainstream artists, their work will be considered "high art." Rarely are they taught to respect the creators of these aesthetic forms and idioms. They digest them without a thought to the dignity and feelings of the real human beings who generated them. Nor do they wonder whether the culture itself has a frame of reference that allows cross-cultural appropriation. It does not occur to them that, just as they are required by law to give credit to Euro American artists and writers whose ideas they appropriate, a higher law requires they give the same credit to their sources from other cultures.

The increased exposure to cross-cultural diversity made possible by advances in media transmission and access has greatly speeded up this process. But a fundamental change in art education on processing cross-cultural experiences is essential to avoid perpetuating the long history of cultural imperialism and its patterns of racism and resentment which make authentic intercultural exchange impossible. Respect distinguishes appropriate incorporation of outside influences in the creation of an individual's art from cultural imperialism. What deeply concerns me about the wholesale ransacking of "Third World" cultures for nearly a century by Western artists is the clear evidence that for the majority of these artists, the artists they plagiarize are somehow less than human. Because they see their sources as subhuman, they feel justified in helping themselves to their ideas with impunity. Even those individuals who sincerely respect the sources of the ideas that influence them operate in an art world that systematically denigrates those same ideas as "low art" when created by a multicultural artist, yet elevates them to "high art" when incorporated into a white artist's work. Thus, these artists benefit professionally and economically by the perpetuation of a system that excludes the creators of the ideas they use to fuel their own inspiration.

The many living artists of these same cultures embarrass and conflict the mainstream art world, particularly when the indigenous artists are influenced by aspects of their own cultures which have inspired the modernists and postmodernists. Often their contemporary expression of these ancient spiritual and political beliefs is much more cogent and powerful than that of the mainstream appropriators. The art world attempts to neutralize the authentic impact of their art by claiming it is derivative and jejune.

The fact is, our increasingly complex, fast-moving mass media culture influences all artists with its collage of images, ideas, sights, and sounds from around the world. Kiowa-Caddo contemporary painter T. C. Cannon was influenced by the art of Matisse, Vuillard, and other modernists as well as his own tribes' art forms, his art was like a mirror reflecting back upon itself, since the modernists had all in some way been influenced by primal arts, including those of Native America. The actual history of multicultural art is a complicated weaving of cross-fertilization where the ancient, primal art of all cultures influence both Western modernists and multicultural artists, and they in turn influence each other. This view of cultural cross-fertilization lacks hierarchical characterization and better describes the free exchange of artistic ideas in the information age. That all artists are influenced by and appropriate from cultural material is not in itself a problem; issues arise after that art is created because of the unequal valuation art by multicultural artists receives in the highly stratified, exclusionary art marketplace.

Multicultural art is often excluded by hierarchical distinctions between traditional and contemporary art. The bias against media considered to be crafts is rooted in the fact that most traditional arts are created by women and "ethnic" artists. When artists of color explore traditional iconography or media, their art is considered "low art" or craft. This, despite the accomplishments of artists like Santa Clara potter Margaret Tafoya, whose enormous handbuilt black and sienna polished storage jars embody a purity and perfection of form that fulfill every criterion of excellence in fine art epitomized by the pristine forms of Brancusi, himself a folk artist. However, because he was European, Brancusi was embraced by the mainstream and his forms became part of the Western fine art heritage, whereas Tafoya's are confined to the "ghetto" of the limited, narrowly defined category of Southwest Indian ceramics.

Traditional art, contrary to its characterization as stagnant, constantly evolves by incorporating new influences, materials, and interpretations by each successive generation. Created by living artists carrying on ancient traditions, it, too, *is* contemporary art. Traditional cultures

have the ability to adapt, change, and survive while maintaining basic values regardless of the nature of the change, or whether it is self-generated or imposed by outside pressures such as war and genocide. The stagnant repetition of established styles the public associates with "traditional art" has in most cases been perpetuated by white, mostly male, patrons who have directed and stifled the natural evolution of these art forms.

Multicultural artists face a double bind. As twentieth-century Americans, they often walk in two worlds. They experience many of the same artistic, cultural, and political influences as Anglo artists, but are also influenced by the values and culture of their heritages and by the historical and political devaluation of their culture by the mainstream. When they are proud of and connected to their heritage and draw inspiration from its forms and idioms, many multicultural artists are pressured to confine and limit their artistic expression by expectations both inside and outside their cultures. Just as people tend to stereotype others by their physical appearance, they stereotype art based on their preconceptions of the culture that generated it. The art world has neat boxes to pigeonhole work created by those it considers "other." Categories like African American art, women's art, feminist art, Asian American art, Latin American art, Native American art, and outsider art are one-dimensional. They dehumanize the artists by negating their individuality. The classification of the art by the race or ethnicity of the artist, rather than by the same formal, media, or contextual categories used for mainstream art, is institutionalized racism. When institutions confine art into areas that are separate from the mainstream, they devalue it by marginalization. Artists who are biracial or bicultural are most always categorized by whichever aspect of their identity best serves the institution's own interests. Even when artists insist upon asserting their complex, unique identities, the art apparatus will consistently ignore or deny the reality of the less politically advantageous cultural identity. The bottom line is that whatever the ethnicity of the multicultural artist, his or her work will rarely be acknowledged as connected to the mainstream regardless of its competence, inspiration, or professionalism.

Cross-cultural interaction is complicated by the well-founded distrust based upon prior experience that many "ethnic" artists feel toward mainstream art institutions. When they present well-developed bodies of work solidly based in their cultural aesthetic, they are dismissed by arts administrators who trivialize their work and tell them their vision is "naive." When they enroll at fine arts colleges, they are denigrated and

ridiculed if they make art grounded in their spiritual cultural reality. Charlene Teeters, a member of the Spokane Nation, speaks movingly of her experiences at the masters program at the University of Illinois. The only other Native American student enrolled with her dropped out and returned to the reservation because of the negation of his cultural values by his professors and fellow students. "There are so few Native Americans who survive the reservation school systems and go on to college. When we lose one student that is already too many."[5]

Breaking down stereotypes is essential to eliminate barriers separating people. When people stereotype others on the basis of their race, ethnicity, or sex, both they and the object of their prejudice are diminished. The depth and richness of our diversity as individual human beings is so much greater than any stereotypical image can confer. When we are stereotyped, we are robbed of our three-dimensionality. It is nearly impossible to communicate through the barriers of expectations and projections imposed by prejudice, and true relationship is unattainable. But if people are allowed to speak from their hearts and others are required to listen, a channel for changing perceptions is irrevocably opened. When people speak about who they really are, culturally, ethnically, and individually, the reality of their complexity surprises and shocks others, who are forced to see the fullness and many layers of an individual's perception of themselves. Thus, it becomes impossible to fit that person into previously comfortable pigeonholes.

The most valuable tool to dispel prejudice is open communication. I have found that the most effective structure for facilitating communication between people of different cultures is the "talking circle," a Plains Indian forum where each person is allowed to speak uninterruptedly from the heart about their own experiences. I use the talking circle tradition as the basis for the following discourse on the personal experiences of myself and selected multicultural artists and our interaction with mainstream arts institutions.

Throughout my career, I have struggled to avoid being stereotyped and pigeonholed because of my ethnicity. This is complicated because of my physical appearance. To many people I look Native American, to others white. No matter how many times I have explained my ethnic background orally and in writing, there are those who persist in seeing me solely as Native American and others who persist in seeing me solely as French. The true complexity of my own background, like that of many other multiracial and multiethnic people, is difficult for some people to comprehend, but it is *my* reality.

For over sixteen years I have worked cross-culturally with artists in grass roots community organizations, through curating and networking, in arts education by teaching and developing a multicultural curriculum, and in mainstream and feminist arts organizations to achieve inclusivity. I was born in the small French Canadian mill town of Woonsocket, Rhode Island. Raised bilingually in French and English, I was told of my Native American ancestry by my grandparents. Because of our mixed blood we are considered Métis. Many of the images in my art are inspired by my culture, which is largely unknown and invisible. At times my art has explored the documentation of the cultural milieu that I grew up in, which was rapidly vanishing due to economic decline. I have always been a dreamer and have painted my dreams and visions, women birthing, nursing, or teaching their children, and images of Spirit women. I, like many other bicultural artists, endeavor to serve as a bridge between my culture and the outside world. My experiences as an "outsider" have prompted me to network with other artists from different cultures and races with similar experiences.

My own art is informed by a complex web of influences and connections between my cultural and personal identities. My roles as a woman, mother, daughter, and artist have been central to my artistic expression. In addition, like most artists, I endeavor to address issues that have meaning and cogency to all human beings. However, when a painting such as *My Vision Is My Shield* is viewed by an art world that has no tools to decipher its unique symbolism, it is often misinterpreted as a Native American myth, which it decidedly is not. This triptych portrays a sequential exploration of attack, injury, self-healing, and trusting in the power of vision. Read from right to left, the first panel, *Unprovoked Attack,* depicts the pain and shock of injury. The knives in the back evoke the metaphor of "back-stabbing." The attack occurs while the artist is in the act of creating and wears the antlers that connect her to the ancestors, striking at the core of her creativity. A wolf simultaneously attacks her small parrot, a symbol of the anima. The central panel, *You Must Heal Yourself,* shows the woman sewing her heart, which had been ripped out, back into her chest as she holds a shield emblazoned with her animal spirit helper, a serpent. This shield becomes an iridescent mirror when the ambient light changes. The lightning bolt above her head symbolizes change and the serpent's power for transformation. The left panel, *Walk the Spiritual Path,* shows an enormous antlered Sun Goddess or Elk Woman pointing the way to a red road leading to a mountain. The artist has donned the mask and antlers of the visionary Elk Woman and carries a shield depicting her vision before her for protection. Some of the images

and symbols, such as the red road signifying the spiritual path and the mountain signifying the site of Vision Quests, come from my experience and learning of Native American spiritual practice. But the most powerful imagery comes from my own personal vision of the Elk Woman and the Serpent and the many ways they have manifested themselves in my work for over fifteen years. My understanding of the symbolic meaning of this powerful vision is continually being expanded by the contributions of countless people of different cultures who have told me of the meaning of similar images to their people and by the many manifestations of similar entities in world mythology. These entities are archetypes that appeared to me and I have interpreted them through my own complex cultural and individual identity. The triptych is simultaneously extremely personal and universal. It addresses the fear of violence that all women and all people experience and explores the possibility of healing through self-visualization.

Abstract painter Kay WalkingStick credits her inspiration to the two sources of her identity as a Cherokee woman and her belief that art can be magical and transcendental.[6] Her diptychs explore the relationship between the abstract and the visual world; they represent two kinds of memory of the earth, one solid and abstract, the other sketchy, ephemeral, and representational. WalkingStick creates the abstract evocation of the earth with thick, labored layers of acrylic and wax impasto embedded with small objects connected to the site. Its imagery is bold, vibrating with symbolic power. Rapidly sketched in acrylic on unstretched linen, the other side is a realistic landscape but feels illusionary. WalkingStick considers herself a part of the continuum of Western art. She believes that contemporary abstraction connects the two sources fundamental to her art-making. This mainstream art mode has provided her with the formal language to express the transcendental connection she feels to the land. She enriches that mainstream tradition with her knowledge that the earth is sacred, thus connecting it to her ancestral traditions. Her diptychs embody the duality of her sources and the cultural reciprocity her art process initiates with a physicality that reconciles their opposition. Each part extends the other; alternately expanding and contracting, they create a visual dialogue. WalkingStick's art is a powerful example of how a mainstream aesthetic can be enriched, informed, and expanded by the contributions of multicultural artists. She is a rare example of a multicultural artist who has succeeded in the mainstream art world.

Native Santa Fean artist Bernadette Vigil vividly paints the ceremonies and daily life of her people, expanding the genre tradition by incorporating her visionary power to create vignettes vibrating with intense

Charleen Touchette, *My Vision Is My Shield*
Mixed media/canvas triptych, 30″ × 109″
© 1990 by Charleen Touchette

color and spiritual movement. Vigil's spiritual, visionary approach accurately reflects the all-pervasive visionary milieu of the Catholicism of Northern New Mexico. Her use of bird's-eye perspective, simultaneous narrative, and skillful manipulation of the space-frame reveals a sophisticated understanding of formal considerations as well as of the history of art. Her use of color, content, and composition refers to the visionary paintings of Paul Gauguin. Here, cross-fertilization encompasses the influence of primal cultures upon Gauguin, and his influence upon Vigil, who is also influenced by her own culture. The distinction is that Gauguin always remained an outside observer of Tahitian culture, whereas Vigil is an integral member of her community, which continues to thrive and evolve.

Contemporary artists such as Ramona Sakiestewa and Faith Ringgold have used traditional media, weaving and quilting, respectively, to expand the visual language of these forms and cross boundaries between art and craft, traditional and contemporary art, and tribal and universal issues. Sakiestewa, of Hopi and German ancestry, crossed a major boundary when she chose to weave cloth, a media traditionally done only by Hopi men. Her designs are perfectly balanced abstract and symbolic forms in a complex variety of pure hue. Some are generated from her experience of Hopi traditional ceremonial life and symbology, as is her *Basket Dance* series, which are her tapestry versions of the woven plaque baskets traditionally made by women of her village. She has also created series of abstractions as divergent as Mediterranean, Kabuki, and Frank Lloyd Wright–inspired designs. Articulate and impassioned, she is a brilliant advocate for multicultural inclusivity and argues convincingly for the importance of free and equitable cross-cultural exchange.

Faith Ringgold incorporates the traditional women's art of quilting with portraiture, silkscreen printmaking, photo etching, painting, and text into her large-scale, narrative contemporary art. She combines her solid training in Western art practice and theory, her strong sense of color and composition, and her deep experience of contemporary African American life to create powerful, transcendent art that erases the artificial distinctions between art and craft. As Thalia Gouma-Peterson astutely observed, "By merging portraiture, a high art form, with quilting and piecing, Ringgold crosses artistic hierarchies and boundaries and claims for a traditionally female craft the voice of authority."[7]

Japanese-American Ruth Asawa's fully realized sculptural forms are considered by many to be expressions of Western contemporary art, despite a presence and balance rooted in her Asian heritage. Perhaps because so much contemporary art has assimilated, digested, and incor-

porated Japanese aesthetics in composition and intent, Asawa's abstractions appear to reflect the mirror of minimalist contemporary art rather than the ancient Zen aesthetic that is their direct source. One can only imagine the variety of possible cross-fertilizations as the mirror reflects the mirror to infinity, and Asawa's art influences generations of artists from many different cultures.

Asawa, Ringgold, Sakiestewa, Vigil, WalkingStick, and I are merely a fraction of the multicultural people in the arts. All of us and our colleagues are connected to a vast network of highly accomplished professionals in every arts-related field of every different ethnicity. Despite this, every one of us repeatedly hears the comment from mainstream art professionals: "We don't know any qualified people of color in our field." Recently, I was shocked to hear a well-meaning British woman ask, "Is there such a thing as a woman of color art historian?" These questions haunt us. These people have access to the same information as we all do. Most often, they have access to much more sophisticated communication and research technologies than our grass root networks do. Yet they see no one, where we see hundreds of colleagues who bring depth and understanding to the creative process. It is patently clear that their field of vision is tragically limited because of either racism or ignorance. Ultimately, it matters little to multicultural people whether this lack of knowledge is inspired by malice or unawareness. The result is the same—continued invisibility and lack of access. Arts institutions should be in the forefront of dispelling this kind of ignorance; instead they legitimize and perpetuate it.

All too often, those who work to increase inclusivity in the arts hear the old excuse, "We invited them, but they didn't come." This apologist behavior, whether well-meaning or consciously racist, again exhibits acute insensitivity to the inequities of access to power in the art world and shows ethnocentric bias by its lack of respect for artists outside the mainstream. This prevalent attitude completely misunderstands the motivation behind the struggle for multicultural diversity. Ethnic artists do not want to "come" to be part of an art organization, institution, or event that is already defined and controlled by the Eurocentric aesthetic.

The present art apparatus has enabled predominately white Euro American males to enjoy privilege at the expense of the majority. For parity to be achieved, that minority must relinquish its privilege and share the power. Because of the small gains achieved in recent years, multicultural people in the arts are already being forced to confront a strong backlash among segments of the mainstream determined to continue to

exclude them. Many of those who have profited from the unjust system are loath to give up the status they gained and will stop at nothing to retain their privilege. Recently, artist and Native American arts activist Jaune Quick-to-See Smith cautioned the Coast to Coast Women of Color Caucus to "remember to watch our backs." She wisely reminded us that for every advance preciously fought for and gained, there were those who were waiting in the wings to chip away at our victory and snatch it back even as we were celebrating it.

The fight for inclusivity must also continually guard against tokenism. Presently, only a few token artists from each community are allowed to participate in the mainstream art world. These artists are besieged by invitations to exhibit and lecture, which often alienates them from their own communities, which resent their visibility. When they attempt to suggest less well-known colleagues to take their place and broaden the base of inclusion for their communities, the arts institutions reject them because they are not famous and/or professional enough.

Mainstream art organizations too often fuel competition within and between different groups rather than designing their programs to foster the growth of cross-cultural cooperation. Since most mainstream and feminist organizations are themselves modeled on forms that encourage competition rather than cooperation, they usually try to impose these forms upon multicultural groups with which they attempt to interact. Conversely, many ethnic communities stress cooperation and harmony of the whole above individualistic achievement. Often the goals and methods of mainstream organizations conflict with their own internal goals. Also, the mainstreams' valuation of "art for art's sake," is at odds with most ethnic artists' commitment to art that has spiritual depth, social meaning, and serves the community. Cross-cultural communication is complex because different groups often have conflicting values, and their definitions of key words used to discuss issues are sometimes diametrically opposed. Often, anger and terrible disagreements are caused by cultural misunderstandings that could have been avoided with more skillful communication.

Trust is most often broken by self-serving actions of some arts administrators who try to manipulate various constituencies to buttress their own advancement. Mainstreamers and well-intentioned arts professionals must guard against this because most people from communities that have been historically oppressed are very quick to perceive insincerity. One unscrupulous person can quickly undo the progress achieved by many who are sincere about cross-cultural interchange. There is also the danger that some unscrupulous individuals may use the multicultural

mandate as an opportunity for self-aggrandizement at the expense of others in their communities. Just as positive qualities of professionalism, integrity, and honesty are not limited to those of the dominant culture, greed and selfishness are human traits that cross all color and cultural lines.

The women's art movement has recently embraced the notion of promoting multicultural inclusivity. Unfortunately, like the women's liberation movement, it has been slow to put its rhetoric into practice. At the 1987 National Women's Study Conference focusing on empowerment, Audre Lorde posed a challenge to feminists to work for empowerment for all women of all colors, not just white middle- and upper-class educated women. Regrettably, the women's liberation movement has damaged its credibility, diminished its critical position, and prevented itself from achieving its revolutionary potential by consistently ignoring and excluding the significant contributions of African American, Native American, Latina, Asian and working-class white women in the struggle for equality. Even though African American women such as Lorde, Angela Davis, bell hooks, Michele Wallace, and Faith Ringgold have achieved considerable visibility in the feminist movement during the past few decades, they are still but a small percentage of the many qualified women of color working on feminist issues who are acknowledged in their own and other communities of color, but ignored by white feminists. As Marcia Tucker, director of the New Museum of Contemporary Art in New York, pointed out:

> The failure of the women's movement in the late '60's was its almost exclusively white middle- and upper-class orientation. It basically remains that way, but the difference is that white women are inviting women of color to participate, and unless women of color join them in their endeavor, no amount of change can actually take place.[8]

An obstacle that makes women of color reluctant to join feminists is that many who consider themselves feminists decry the need to distinguish the struggles of women artists of color from that of all women. "We are all women," "We are all oppressed," "We should all work together." These statements ignore the fact that the struggles of women artists of color are qualitatively different because the oppression of sexism is amplified by that of racism, classism, and religious and ethnic discrimination. If sexism were to be overcome in our lifetime, ethnic artists would still face inequity in access, visibility, and employment in the arts. Only 0.3 percent of the artists featured in fourteen Whitney Biennials from 1973 to 1987 were women of color. As were only 8 out of 87, or 8 percent, of the

artists in "Making Their Mark: Women Artists Move into the Mainstream, 1970–85," which traveled nationally, defining women's art for the masses.[9] Nonmainstream artists confront racism, overt or subtle, daily. Too often, bigoted behavior is exhibited by feminists, who though articulate about their own oppression because of systemized inequality, are unwilling or unable to see how their actions, while they strive for their own visibility, can oppress and marginalize artists of color. They perpetuate marginalization by lobbying to maintain biased selection processes that favor artists already integrated into the art market and opposing changes that would even out the playing field to enable multicultural artists' entrance. For example, in 1990 two women artists attempted to undermine the adoption of exhibition guidelines by the Women's Caucus for Art (WCA) designed to increase multicultural participation. They went so far as to change the place of the exhibition committee meeting without informing any of the women of color. Then, they unilaterally vetoed guidelines adopted earlier by the full committee. Throughout the entire process, they adamantly denied that racism motivated their exclusionary ploy. Fortunately, they did not ultimately prevail. Despite their opposition, in 1992, the WCA adopted progressive exhibition guidelines to stimulate increased multicultural visibility.

Multicultural artists are marginalized when tokenism is practiced, access to decision-making denied, and characterizations are based primarily upon race or ethnicity rather than the countless distinctive features that distinguish human beings. It is shocking how often feminists in the arts resort to these dehumanizing tactics whenever they feel they are being required to compete with women artists of color.

Tokenism is demeaning. It reveals the insincerity and racism of the person or institution practicing it. It places the "token" in an untenable position, able to argue her proposals but never to prevail. Tokenism is the chief reason for the quick turnover of participation in many mainstream organizations by artists of color and for the persistent mistrust of current rhetoric about multiculturalism by mainstreamers. Sadly, these individuals and their institutions are slow to realize the reasons for the revolving door.

The current infatuation with multiculturalism has dramatically increased the number of organizations who claim to be multicultural, but are not. They merely use tokenism to project the "appearance" of inclusivity. Actually, they are unwilling to make the long-term commitment necessary to achieve inclusion because they are terrified of the changes that implementing real inclusivity requires. Many of us have felt used by groups that entreat us to outreach to diverse communities. When we do,

we soon discover that most often these groups only want to change their "look." They rarely allow their policies and programs to change to reflect the views of people of color, nor do they share any significant decision-making power. When differences in philosophy, politics, and tactics arise, the agenda of the dominant white mainstream culture always prevails. We are tired of mere lip service to multiculturalism. These practices are transparent, mendacious ploys, readily recognized and rejected. In reaction, most artists of color choose to devote more of their time to their own work and communities and to leave such organizations to come to self-realization alone.

Too often, women of the dominant culture do not understand why they should care about the grass roots struggles against racism, sexism, poverty, and job discrimination by Native American, African American, Asian American, Latina, and white working-class women. Howardena Pindell reports that she has "had conversations and experiences with white women who've said they don't want the issue of racism to dilute the issues of feminism."[10] These women fail to see how the issues of racism and feminism are inextricably linked. Because we are all connected, our struggles are also connected. Discrimination against any group diminishes all people. Victory over bigotry enriches everyone. These simple truths demand that we all care. These struggles should be of immediate concern to mainstream white women because the advances of women of color, just as those of any segment of the female population, will ultimately benefit all women. Examples of women artists and multicultural artists sharing the experience of discrimination abound in art disciplines that have been traditionally defined as craft such as fiber arts, pottery, and wearable art. Hierarchical distinctions between "high art" and crafts are used by the mainstream art apparatus to systematically exclude artists in these disciplines in both groups. Coalition building around this issue could provide common ground and be effective to shatter the artificial distinctions between arts and crafts. For instance, the groundbreaking art of both Miriam Schapiro and Faith Ringgold has contributed to increasing respect for media traditionally associated with women. Their accomplishments have benefited individuals of all races, genders, and ethnicities, not just members of their own group.

Currently, some feminist organizations such as the Women's Action Coalition (WAC) are experimenting with open forums that operate without traditional leadership. WAC has gotten considerable media attention for its direct actions with some immediate results. Hopefully it will have a positive impact on issues important to women. However, their current organizational structure would make it close to impossible for them to

achieve multicultural inclusivity and significant participation from large groups of women of color.

Since only 28 percent of the U.S. population is nonwhite, if people of color are to have meaningful participation, policies must be enacted to ensure parity. Because multiculturalism is not a priority in the guidelines that direct WAC's activities, and there is ostensibly no leadership, there is no ongoing apparatus to implement policies that could even the field. WAC's meetings, run by facilitators, theoretically give everyone the opportunity to speak out and make proposals or comments which are voted upon by those in attendance. Those who win the vote prevail, even if the group has not reached a consensus. But WAC's stated goal of democracy, while seemingly noble, inevitably results in an unfair outcome for multicultural people if there are disagreements about a proposed action based in cultural difference and the rule of one woman, one vote prevails. This process can result in anarchy, at best, tyranny of the majority, at worst.

Groups using this form have rarely been multicultural. There were individuals who cautioned WAC early in its development to build a strong multicultural base before going public, but they chose to begin their direct action "WAC attacks" immediately with a group of women that was 80 percent white and to hope that "multicultural outreach committees" could make their constituency more diverse.

> WAC's multicultural caucus recruits nonwhite members—of which there are dramatically few—and explores multicultural issues. Though some women of color have taken up the caucus' invitation to join, others dismiss the subgroup as yet another means to marginalization.[11]

Although WAC is a national organization based in New York, it has sprouted branches in various cities throughout the country. An incident occurred in one of the WAC groups recently, which illustrates the difficulties the process WAC has adopted can cause when cultural differences erupt over a proposed action. WAC proposed an action that the multicultural caucus felt would be extremely objectionable to the native Hispanics and Native Americans in Santa Fe. WAC representatives from the Hispanic community expressed disapproval and warned that the action would be divisive in the community, destroy WAC's credibility, and make it difficult for them to get women of color to join WAC. Their impassioned plea was discounted and overruled by the majority, who decided that the feminist position on this issue was the "correct" one. This situation was aggravated by the presence of WAC representatives from New York who had come to help organize the Santa Fe group. These outsiders were the most vocal proponents of the action and their votes overrode

those of the Hispanic New Mexicans. Their dismissal of local concerns confirmed the suspicions and prejudice of many local Santa Feans against outsiders, who they believe are taking over their town. The New Yorkers undoubtedly believed that they were doing the right thing. They probably were trying to educate the local women about the "correct" feminist position. But in dismissing and belittling the local women's concerns they displayed the ethnocentricism that has made so many multicultural women cautious about feminists. Howardena Pindell described this arrogant attitude when she said, "I've run into a fair number of white women who want to appear to be liberal but whose personal interactions indicate that they want to be in charge, they want to colonize the issues of women of color."[12]

In this instance, the multicultural caucus could only have prevailed if they could have garnered sufficient numbers to win the vote. Given the unequal representation of people of color in this group as in most like it, they inevitably lost. But WAC lost more, it lost many potential supporters and an opportunity to prove that it could be open to the discussion and compromise necessary to make any group multicultural. The group's simplistic definition of democracy really could only work if everyone were already equal.

Another issue is that most multicultural art is relegated to ethnographic approaches in museums of natural history or ethnology. Until recently, only historical art by Native Americans, Africans, and Oceanic peoples, usually collected by conquest and categorized as artifacts, was found in museums worldwide. The disrespect inherent in showing this art in museums of natural history in the context of dead and extinct animals seems to be apparent only to the descendants of those people, who are in fact not extinct and continue to struggle, survive, and thrive as we near the beginning of the twenty-first century. Further, when Native Americans, Africans, and Oceanic contemporary artists approach the art marketplace, they are invariably directed to approach ethnographic or natural history museums or galleries that specialize in traditional art by their group. Many of the exhibits organized by ATLATL, a Native American arts network based in Phoenix, Arizona, found their first most receptive venues to be ethnographic museums, even though they organize exhibitions of art that explores contemporary idioms and media. It is a widely held bias by mainstreamers that art made by an ethnic person must be traditional, low art, or craft.

In the late sixties and early seventies, fed up with being rendered invisible due to racism or cultural bigotry, a number of "outsider" communities began curating exhibitions intended to highlight the excellent art

that had been excluded from mainstream art institutions. These exhibitions were generated by the communities that supported them and received cultural affirmation from them. It was an exciting time when, despite limited resources and limited access to suitable exhibition spaces, communities would work together to put on multimedia events that highlighted art and enriched the community.

Unfortunately, one of the by-products of the new interest in multiculturalism in the arts is that such exhibitions are being co-opted by outside institutions. Instead of including ethnic curators to define the exhibition concept and select the art, they are curated by mainstream art professionals who impose their own Euro American bias in choosing the art and setting up the context within which it is viewed. This results in exhibitions such as the major Hispanic exhibit, which caused controversy and anger as it traveled across the country in 1986 because it did not adequately address the complexity of the political and cultural divisions in the many different Spanish-speaking communities.

Because outsiders to an ethnic community rarely have the background or expertise to understand its complexities, these exhibits are often selected solely on the basis of race or ethnicity. This calls into question the aesthetic quality of the art and results in the artists' being increasingly singled out and ghettoized. The credibility of these ethnic theme exhibitions is diminished and the reputation of the included artists suffers when the quality of the art is uneven and not up to any culture's standards for quality. They become divisive for communities when policies based on racist criteria exclude excellent artists, and give undeserved exposure to inferior artists. Whether organized by mainstream or multicultural curators, these exhibitions are problematic because they rely on a racial criterion, which often takes precedence over considerations more crucial to judging art. Jane Livingston, former chief curator at the Corcoran Gallery of Art, commented on the tokenism of such shows at the Contemporary American Indian Art Symposium at the Smithsonian's Hirshhorn Museum in 1990.

> The "us" and "them" thinking tends to guide exhibition planning, relegating ethnic groups to special shows apart from the mainstream. Special shows, Livingston noted, equate to tokenism. "The only basis on which to select shows is quality."[13]

However, as discussed earlier, "quality" is a subjective judgment determined by one's cultural background. These shows will continue to be problematic as long as the selection of the art is controlled by Euro American curators who deny the subjectivity of their criteria.

Furthermore, artists who are identified with exhibiting in such ethnic-specific venues are often invited only when their culture is being highlighted and are denied access to more mainstream exhibitions that are considered more important by the art apparatus of critics, dealers, collectors, and museum curators. When one reads the résumés of some of the most competent, mature Native American artists, such as George Longfish and Frank LaPena, it is appalling how few entries include exhibits with a non–Native American focus, even though their art has power and quality equal to and surpassing many of the mainstream's current superstars.

In 1987, Angela Davis, while defining the most efficacious strategy for empowering African American women, illuminated an approach that should be adopted by all those working for inclusivity:

> We must strive to "lift as we climb." In other words, we must climb in such a way as to guarantee that all of our sisters, regardless of social class, and indeed all of our brothers, climb with us. This must be the essential dynamic of our quest for power—a principle that must not only determine our struggles as Afro-American women, but also govern all authentic struggles of dispossessed people. Indeed, the overall battle for equality can be profoundly enhanced by embracing this principle. . . . We must begin to create a revolutionary, multiracial women's movement that seriously addresses the main issues affecting poor and working-class women.[14]

If existing cultural institutions and organizations are truly serious about becoming multicultural, they must broaden the makeup of the players in the art system to reflect the range of racial, ethnic, and gender diversity in the population. It is essential that they also expand the range of cultural aesthetics and value systems that determine their decision-making criteria. They must be willing to make profound changes in the criteria's structure, content, and focus. These changes should be generated and directed by multicultural people themselves, who should take the lead in deciding what changes are needed and their most effective implementation. It is essential that people of color sit on executive boards where policy is made. It is essential that multicultural people be integrated into every level of the power structure of organizations and institutions. It is essential that they be involved in every phase of programs: as arts administrators, exhibition designers, museum personnel, jurors, curators, artists, critics, and commentators, from the initial development through implementation to outreach to their communities. Existing and new institutions and organizations must recruit leadership and member-

ship from both genders and all races and cultural groups, different age groups, sexual preferences, and different physical and mental abilities and must consider issues of accessibility for disabled persons for all programs in the arts. New organizations should begin with a foundation that makes multicultural diversity a priority. They have a rare opportunity from the start to develop a structure and leadership that are inclusive, diverse, and, most important, respectful of the views of different communities. With the participation of diverse people from the beginning, they can identify the interests and needs of multicultural people in the arts and develop agendas and policies that address them. Feminist and multicultural artists should support new arts organizations whose structures facilitate multicultural decision-making and should refuse to work with any arts organizations that are not *actively* working to increase diversity.

To actualize inclusivity, organizations' goals must include opening up intercultural communication, promoting mutual respect, breaking down stereotypes, and developing a wholistic multicultural valuation theory. They must employ simple strategies to achieve these goals. They should explore the talking circle and other alternative cultural modes to foster communication. While striving to promote mutual respect, they must understand that not all cultures agree about what constitutes proper behavior. They can enlist persons familiar with different cultures through birth, work, or circumstances to serve as bridges, acting as peacemakers to keep the lines of communication open and helping to explain cultural misunderstandings. These people can assist by facilitating cross-cultural communication and recruiting participants from different communities.

Institutions must become interested in hearing from diverse elements in these communities and must enable many multicultural artists to enter the mainstream to build their careers. To empower the "ethnic" artist to enter and successfully compete in the mainstream art market, programs that provide access to exhibition opportunities, career development workshops, arts-in-education and art in public places must be developed, funded, and enacted. Organizations must also create new forms and forums that cross boundaries, such as those that juxtapose traditional and contemporary arts with scholarship elucidating their relationship, those that erase the distinctions between arts and crafts, and those that incorporate all media, for example, art exhibitions that include music, poetry, dance, and theater.

Fundamental to the successful evolution of a new multicultural aesthetic is the insistence upon mutual respect and the willingness to explore many different cultural aesthetics with an open mind. There will certainly be points upon which different cultures are diametrically opposed in

aesthetic valuation which will have to be accommodated with sensitivity and skillful diplomacy. It is crucial that people realize it is possible for two or more totally opposing aesthetic criteria to be true within their own cultural contexts.

Everyone should be treated with respect for their human dignity. However, showing another person respect can take on many forms, some of them contradictory, from one culture to another. For example, in Euro American culture looking someone directly in their eyes when addressing them is considered respectful, sincere, and forthright, whereas in traditional Plains Indian cultures, it is considered rude and disrespectful.

Because education is the key to making changes for the future, new programs should include educational components that explore issues of cultural diversity, different cultural aesthetics, recognizing white privilege as a barrier to pluralism, traditional art-making in different cultures, and overcoming racism and hierarchical thinking. It is essential that art professionals charged with implementing the multicultural mandate be required to pursue continued education in these areas related to multiculturalism.

The current multicultural imperative in arts education is an important opportunity to make the systemic changes necessary to achieve diversity. Feminists should join multicultural artists in demanding equal valuation of the art of all cultures with the same urgency with which they insist upon that of art by women. Teaching children an aesthetic that is nonethnocentric would ultimately broaden both the way art is made and the way it is judged, in ways that are unimaginable today.

Community forums should be organized to feature diverse cultures and races, reflect the cultural makeup of local communities, represent different media, viewpoints, and political perspectives, and focus on participants of varied age, professional stature, and experience. However, in order for organizations to create forums where all the different voices can be heard, they must use a variety of forms of group communication rather than expect all people to conform to the traditional Western form. There are many different modes of communication that can be explored, experimented with, and modified to enhance cross-cultural communication. By employing a variety of forms, the organization will be able to hear, often for the first time, from individuals who never before felt there was a forum for their ideas and creativity. This broadening of communication modes can ultimately enrich the creative process and the arts in general.

It is imperative that mainstream museums of fine art *consistently* seek out and include the great art by people of all races and cultures in

their regular exhibitions and present them in the context of great world art. The Whitney and Corcoran Biennials must include more art by women and people of color. The Gugghenheim, Whitney, and MOMA must be lobbied to purchase multicultural art for their permanent collections. The older collections of American art should be expanded to reflect the true history of American art, which has always included artists of all colors and both sexes. Finally, the history of art should be corrected to include the undeniable, concrete contributions of these diverse art-makers.

It is essential to decentralize mainstream art institutions in administration, curatorial decision-making, and exhibition design to include local and regional input and diverse cultural input from all communities, i.e., Native American, Asian American, African American, Hispanic, Chicano, Ethnic European, Arab American and Jewish American, and the increasing number of biracial and multiracial individuals.

The decision-making process must be structured by arts administrators to maximize diversity. Exhibitions should be curated by a panel of judges who are chosen for their knowledge, sensitivity, and acceptance of different cultural views, gender identities, and artistic media rather than by one mainstream curator representing only one cultural viewpoint. Jurying by a diverse panel would not simply be a case of rubber-stamping and reinforcing a shared point of view, but instead would encourage dialogue. It could stimulate an ongoing conversation, which is also very much in the tradition of a talking circle. It would offer a stimulating challenge for diplomacy and negotiation that would inevitably broaden the frame of reference of all involved. Searching for diverse curatorial panels would force institutions to seek out and become aware of the large numbers of arts professionals in communities of color. However, they must not place one token "minority" on a jury and expect that person to advocate for all the different "minority" viewpoints, unless that person is sensitized and/or trained in multicultural awareness. All cultures are different. That simple fact is self-evident, yet it is often the most difficult concept for many mainstreamers to comprehend. It is important to point out that each cultural group is at least as complex and diverse as the European. There are even more Native American and African nations than European countries. They all have their own languages and cultures, and though similar, the differences between them are as striking and meaningful to them as those between the Italians and Germans are to Europeans. For example, an African American can not necessarily advocate for the issues of Native Americans or Asian Americans. Also, Native American and Asian nations are sometimes as different from each other

as Navajos and Hopis or Japanese and Chinese, who each have exceedingly different worldviews. Though Chicanas, Latinas, and Hispanics share a language, they have very different political belief systems. Arts administrators should try to become aware of the various political factions within different communities, and avoid being manipulated by the negative elements that exist in every community. They should listen to many sides of the issues to ascertain who is working divisively and destructively and who is working for the common good. This is not an easy task, but if one listens to a broad base of advisers who are respected within their own communities, it is usually possible to discern where the best possible course lies.

Broadening the scope of art evaluation to include contextual as well as formal considerations can contribute to creating a climate where multicultural art can receive equitable treatment. For instance, in most indigenous communities, art is made within the context of ritual and ceremony. Understanding the role of the art object within the culture can enhance one's appreciation of it. When evaluating art, many cultures consider qualities such as the spiritual function of art, its role in building community cohesiveness, its ability to create sacred spaces, and its function to symbolically deal with grief. All these qualities are not considered purely aesthetic in late twentieth-century mainstream culture. Instead, they are considered merely to be a vestige of preverbal expression that is devalued. In contrast, indigenous cultures value the qualities that are connected to magic and healing far more than the formal aspects of an art object. Many Native Americans and Asian Americans consider art made by mainstream Euro American artists to be empty materialistic form, devoid of spiritual power. Each culture's viewpoint has its own merits and its own biases. Artists and theoreticians of all cultures should endeavor to consider, weigh, and balance these merits and biases when evaluating a work of art. A wholistic critical theory that considers both the context and formal aspects of art is one method that is more conducive to evaluating the true importance of art and its impact upon human consciousness than the current Eurocentrist mode.

Two institutions that are promising models for museums which include the population they serve in conception, execution, and directorship of its programs are the new National Museum of the American Indian at the Smithsonian Institution and the Institute of American Indian Arts Museum's National Collection of Contemporary Native American Art in Santa Fe. Both museums are being conceived and developed with Native Americans at the helm and will do much to dispel the prevailing myth that Native Americans and their art are dead. The inau-

gural exhibition at the New York site of the National Museum of the American Indian, "Pathways of Tradition: Indian Insights into Indian Worlds," curated by Tuscarora Indian Rick Hill, provides an innovative model for curating Native American art that is very much rooted in the Indian way of working cooperatively in community. Hill himself selected 100 of the 900 objects chosen and then invited 28 Indian artists from nations throughout the country to choose the remaining 800 objects from the vast Heye Collection of Native American Art and to write about the objects' cultural relevance to the current generation of Indians. Through the words of the Indian selectors, the viewer is able to hear directly from Indian people themselves about the significance of this art. Rick Hill writes, "The 'Pathways of Tradition' continue to support the Indian people of today, as they carry the knowledge and values of their ancestors into the future."[15]

The WCA (Women's Caucus for Art) is one feminist organization that is working to become inclusive by welcoming women of color into the power structure as integral players with an active role in policy making. The WCA has been more successful than other women's art organizations in attracting multicultural women because of the persistence of artists like Faith Ringgold and others who refuse to let women act like feminism is only for white women. Ringgold says,

> I *am* the feminist movement. There were always women of color involved with the liberation of women in this country. I don't have to be white to work for women's rights. I may have to work with white women to do that, but I certainly have my own issues which have to do with being a black woman.[16]

Faith has constantly reminded the board of the WCA that we are here. She has been instrumental in encouraging other women of color to join the WCA and has forced the board to respect their leadership abilities and include them on the board of directors. I will always be grateful to Faith for her support when I was fighting to ensure that the WCA exhibition committee would develop guidelines that promoted inclusivity. As most of us have discovered, it takes perserverance and hard work to open up organizations to input from multicultural people. Though my tactic of choice is always negotiation, it is often necessary to "fight the good fight" to prevail against the reactionary forces in every organization that set themselves against inclusivity.

Though the WCA's statement of purpose commits it to work for visibility and parity in the arts for all women and people of color, there was, at that time, a vocal, persistent minority who because they were

terrified of losing their political advantage and control of WCA's agenda resisted opening up the WCA to input from communities of women of color. Fortunately, Betsy Damon, Annie Shaver-Crandell, Judith Brodsky and others early on recognized the exigency of making inclusivity a primary goal for the WCA and persistently lobbied the executive board to recruit women of color to sit on the board of directors. In 1985, prompted by Damon, the WCA solicited advice from several women of color on strategies to attract more participation at their annual conferences. I told the WCA that if they wanted to attract a more diverse audience, the programs could not continue to be initiated and controlled solely by mainstream women. Panels should be developed by and address issues vital to multicultural women, or inviting women outside the mainstream would continue to be fruitless.

In 1988, Damon proposed that the board enact guidelines requiring conference planners to ensure that one-third of future panels be generated and moderated by women of color and all panels include women from diverse communities. Despite some opposition, this guideline was skillfully negotiated by the WCA president at the time, Annie Shaver-Crandell, and became WCA policy in 1989.

In 1987, a group of artists from different ethnic communities formed a multicultural caucus within the WCA. This caucus, initiated by Ringgold and developed and led by Clarissa Sligh, is called Coast to Coast: Women of Color, because it includes women throughout the country from the East coast to the West coast. Coast to Coast has organized three exhibition projects which have traveled to museums and exhibition spaces across the nation. Each project has focused on one medium: books, boxes, quilting, and FAX's. They are designed around feminist themes with limitations on size that enable Coast to Coast to show the work of a large number of artists simultaneously. These traveling exhibitions have been successful in generating positive press attention and prestige for the artists included.

In 1990, the board of directors established a position on the executive board of Vice-President—Women of Color, to prove the WCA's commitment to being diverse. This position, now held by Imna Arroyo, has enabled the Women of Color (WOC) caucus to have direct input and a powerful vote in every aspect of decision and policy making. The WOC caucus has been instrumental in applying pressure on the WCA board to take a proactive position on issues related to inclusivity.

The WCA has been very successful in awarding its Honor Awards to an increasingly diverse group of women. The Honor Award Selection Committee is made up of artists and art historians from many different

communities who have diligently reached out to identify and honor outstanding women of color as well as mainstream women. This prestigious recognition of the artistic accomplishments of Native American, Asian American, African American and Hispanic women, such as Betye Saar, Ruth Asawa, Margaret Tafoya, and Doña Agueda Martinez provides a source of pride and inspiring role models for younger women artists of color.

The good intentions and actions of many WCA women notwithstanding, women of color continue to be underrepresented in the membership, particularly on the chapter level. But the leadership has been successful in developing a culturally and racially diverse executive board whose energy and input will propel the WCA into the future with a vision of inclusivity and a growing multicultural membership.

In February 1990, a new group of women in the arts was founded in Santa Fe, New Mexico, that from its inception included women of all colors, cultural communities, ages, and disciplines in its leadership, decision-, and policy-making. The Spiderwomen World Arts Network is headed by a council of thirteen women from diverse communities who wrote a powerful statement of purpose that defines their goals as working interculturally to address the spiritual, political, and emotional aspects of classism, racism, and sexism through art and discourse. The most effective and moving activities of the Spiderwomen Network have been "talking circles," where each woman has the opportunity to speak uninterrupted about her observations, feelings, and experiences relating to a specific topic. A talking circle allows every individual in the group to be heard because when one person speaks, no one may interrupt. This is very different from Western culture's discourse, where open argument is encouraged and usually dominated by the loudest, most aggressive, competent, and persuasive public speakers. With a talking circle, everyone has the chance to express themselves and be listened to by the group; thus, they feel honored by the process.

Spiderwomen Network sponsored a series of forums on multiculturalism which featured women in the arts as diverse as the following: Asian Americans—writer Jocelyn Lieu, painter Mimi Ting, and photographer Maibao Nee; Euro Americans—painter Harmony Hammond, photographer Janet Russick, and Scottish community artist Chrissie Orr; Native Americans—weaver Ramona Sakiestewa, installation artist Charlene Teeters, and painter B. J. Quintana; African Americans—poet Doris Fields, playwright and actress Linda Piper, and Japanese–African American multicultural educator Shadi Letson; Latinas and Chicanas—painter,

poet, and enjarradora Anita Rodriguez and painter and educator Gloria Maya, Chilean/Cuban singer and songwriter Consuelo Luz, Native Santa Fean painter Bernadette Vigil; and Iranian art aesthetics professor Havva Houshmand. These extraordinarily accomplished women were all connected to New Mexico but this was the first time such diverse forums were held giving the community the opportunity to experience their work and to their ideas about intercultural issues. The response was overwhelming and the network is planning to continue these forums and other arts-related events. The central focus remains communication, mutual respect, and active listening to break down stereotypes and form cross-cultural alliances. This network, while still in its infancy, presents a promising alternative approach, one that bases its genesis, goals, and ongoing process upon inclusivity.

I propose a revolutionary challenge to the women's art movement. We must claim our own voice of authority. Stop lobbying for inclusion in the mainstream. Instead, question and undermine the legitimacy of the very concept of a mainstream art world. Infiltrate and change from within mainstream art institutions to truly reflect the diversity of world art-makers. Research and write world art history to reflect the contributions of artists of *all* colors and *both* sexes. Work for multicultural diversity in the arts and in arts education because it is the right thing to do. It is essential to work to improve the status of all people when fighting for one's own group. *Become an activist!* Each person has the right and responsibility to activate her awareness and to act in a constructive way for change. Follow the example of artist Betty La Duke, whose lifelong commitment to multicultural inclusivity has taken her around the world to search out, document, and publicize the art of multicultural women, thus making their art accessible to the mainstream. Support multiethnic artists in their fight for inclusion by (1) refusing to accept invitations to exhibit in shows that are not inclusive; (2) speaking at institutions and writing for publications that include diverse artists; (3) asking if exhibitions and programs will be held in places that are accessible to handicapped people; (4) if your schedule is full, suggesting artists who are younger, less well known, and from diverse cultural backgrounds to take your place; (5) explaining your reasons to the curator, director, and/or arts administrators; (6) publicizing your reasons for refusal to other artists and the press. If you have access to the power brokers of the art world and are considered a gatekeeper, in addition to writing about multicultural artists, curating their art into exhibits and speaking about their art, suggest that publishers ask them to write, that arts administra-

tors ask them to curate and be jurors, and that institutions hire them to speak. Lobby for more solo or two-person exhibits that showcase an individual's work better than large group theme shows and invite sensitized critics and writers to do your catalogues and edit publications. Don't just use your interest to build your own career, open up access so that multicultural artists, critics, educators, and curators can also build theirs.

It is time that we, the majority, stop allowing ourselves to be defined and limited. It is crucial to assert our right to define ourselves and to support and defend artists of all ethnicities and races who create art out of their own experiences. As we stand at the threshold of a new century, we are at a crossroad where we can choose to accept and authenticate our wonderful diversity as human beings. The harsh lessons of the past must compel us to reject divisiveness and, instead, work toward actualizing a creative environment worldwide in which all people are free to reach their potential without limits to make art that is without boundaries.

Notes

Throughout this essay I use the terms "multicultural," "people of color," "ethnic," and "multiethnic" interchangeably to refer to those who are not mainstream Euro Americans, particularly Anglo-Saxons, i.e., Native Americans, Alaskan Natives, Asian Americans, African Americans, Hispanics, Chicanas, Latinas, East Indians, Muslims, Ethnic Europeans, Arab Americans, and Jewish Americans, and the increasing number of biracial and multiracial individuals.

1. Jamake Highwater, *The Primal Mind* (New York: Lippincott/Crowell, 1978).
2. Lucy Lippard, *Mixed Blessings* (New York: Pantheon Books, 1990), p. 7.
3. Ibid., p. 25.
4. Ibid.
5. Charlene Teeters, Spiderwomen Network forum on "Multiculturalism in the Arts," Santa Fe, New Mexico, May 14, 1992.
6. Kay WalkingStick, "Artist's Statements," 1989, 1991, and 1992.
7. Thalia Gouma-Peterson, "Faith Ringgold's Narrative Quilts," *Change: Painted Story Quilts* (New York: Bernice Steinbaum Gallery, 1987), p. 13.
8. Margot Mifflin, "Feminism's New Face," *ARTnews*, November 1992, p. 121.
9. Ibid., p. 123.
10. Ibid., p. 121.
11. Ibid., p. 124.
12. Ibid., p. 121.
13. David Maxfield, "Symposium probes views of Native American Art," *Smithsonian Runner*, September–October 1990, p. 4.
14. Angela Davis, *Women, Culture and Society* (New York: Random House, 1989), pp. 4, 7.
15. Rick Hill, "Indian Insights into Indian Worlds," *Native Peoples Magazine*, vol. 6, no. 1 (Fall 1992): 16.
16. Mifflin, op. cit., p. 121.

PASSING FOR WHITE, PASSING FOR BLACK

Adrian Piper

It was the New Graduate Student Reception for my class, the first social event of my first semester in the best graduate department in my field in the country. I was full of myself, as we all were, full of pride at having made the final cut, full of arrogance at our newly recorded membership among the privileged few, the intellectual elite, this country's real aristocracy, my parents told me; full of confidence in our intellectual ability to prevail, to fashion original and powerful views about some topic we represented to ourselves only vaguely. I was a bit late, and noticed that many turned to look at—no, scrutinize me as I entered the room. I congratulated myself on having selected for wear my black velvet, bell-bottomed pants suit (yes, it was that long ago) with the cream silk blouse and crimson vest. One of the secretaries who'd earlier helped me find an apartment came forward to greet me and proceeded to introduce me to various members of the faculty, eminent and honorable faculty, with names I knew from books I'd studied intensely and heard discussed with awe and reverence by my undergraduate teachers. To be in the presence of these men and attach faces to names was delirium enough. But actually to enter into casual social conversation with them took every bit of poise I had. As often happens in such situations, I went on automatic pilot. I

don't remember what I said; I suppose I managed not to make a fool of myself. The most famous and highly respected member of the faculty observed me for a while from a distance and then came forward. Without introduction or preamble he said to me with a triumphant smirk, "Miss Piper, you're about as black as I am."

One of the benefits of automatic pilot in social situations is that insults take longer to make themselves felt. The meaning of the words simply don't register right away, particularly if the person who utters them is smiling. You reflexively respond to the social context and the smile rather than to the words. And so I automatically returned the smile and said something like, "Really? I hadn't known that about you"— something that sounded both innocent and impertinent, even though that was not what I felt. What I felt was numb, and then shocked and terrified, disoriented, as though I'd been awakened from a sweet dream of unconditional support and approval and plunged into a nightmare of jeering contempt. Later those feelings turned into wrenching grief and anger that one of my intellectual heroes had sullied himself in my presence and destroyed my illusion that these privileged surroundings were benevolent and safe; then guilt and remorse at having provided him the occasion for doing so.

Finally, there was the groundless shame of the inadvertent impostor, exposed to public ridicule or accusation. For this kind of shame, you don't actually need to have done anything wrong. All you need to do is care about others' image of you, and fail in your actions to reinforce their positive image of themselves. Their ridicule and accusations then function to both disown and degrade you from their status, to mark you not as having *done* wrong but as *being* wrong. This turns you into something bogus relative to their criterion of worth, and false relative to their criterion of authenticity. Once exposed as a fraud of this kind, you can never regain your legitimacy. For the violated criterion of legitimacy implicitly presumes an absolute incompatibility between the person you appeared to be and the person you are now revealed to be; and no fraud has the authority to convince her accusers that they merely imagine an incompatibility where there is none in fact. The devaluation of status consequent on such exposure is, then, absolute; and the suspicion of fraudulence spreads to all areas of interaction.

Mr. S. looked sternly at Mrs. P., and with an imperious air said, *"You* a colored woman? You're no negro. Where did you come from? If you're a negro; where

are your free papers to show it?" . . . As he went away he looked at Mr. Hill and said, "She's no negro."

<div align="right">

—The Rev. H. Mattison,
*Louisa Picquet, the Octoroon Slave and Concubine:
A Tale of Southern Slave Life* (1861), 43

</div>

The accusation was one I had heard before, but more typically from other blacks. My family was one of the very last middle-class, light-skinned black families left in our Harlem neighborhood after most had fled to the suburbs; visibly black working-class kids my age yanked my braids and called me "paleface." Many of them thought I was white, and treated me accordingly. As an undergraduate in the late 1960s and early 1970s, I attended an urban university to which I walked daily through a primarily black working-class neighborhood. Once a black teenage youth called to me, "Hey, white girl! Give me a quarter!" I was feeling strong that day, so I retorted, "I'm not white and I don't have a quarter!" He answered skeptically, "You sure look white! You sure act white!" And I have sometimes met blacks socially who, as a condition of social acceptance of me, require me to prove my blackness by passing the Suffering Test: They recount at length their recent experiences of racism and then wait expectantly, skeptically, for me to match theirs with mine. Mistaking these situations for a different one in which an exchange of shared experiences is part of the bonding process, I instinctively used to comply. But I stopped when I realized that I was in fact being put through a third degree. I would share some equally nightmarish experience along similar lines, and would then have it explained to me why that wasn't really so bad, why it wasn't the same thing at all, or why I was stupid for allowing it to happen to me. So the aim of these conversations clearly was not mutual support or commiseration. That came only after I managed to prove myself by passing the Suffering Test of blackness (if I did), usually by shouting down or destroying their objections with logic.

> The white kids would call me a Clorox coon baby and all kinds of names I don't want to repeat. And the black kids hated me. "Look at her," they'd say. "She think she white. She think she cute."

<div align="right">

—Elaine Perry, *Another Present Era* (1990), 177

</div>

These exchanges are extremely alienating and demoralizing, and make me feel humiliated to have presumed a sense of connectedness between us. They also give me insight into the way whites feel when they are made the circumstantial target of blacks' justified and deep-seated anger. Because the anger is justified, one instinctively feels guilty. But

because the target is circumstantial and sometimes arbitrary, one's sense of fairness is violated. One feels both unjustly accused or harassed, and also remorseful and ashamed at having been the sort of person who could have provoked the accusation.

As is true for blacks' encounters with white racism, there are at least two directions in which one's reactions can take one here. One can react defensively and angrily, and distill the encounter into slow-burning fuel for one's racist stereotypes. Or one can detach oneself emotionally and distance oneself physically from the aggressors, from the perspective of which their personal flaws and failures of vision, insight and sensitivity loom larger, making it easier to forgive them for their human imperfections but harder to relate to them as equals. Neither reaction is fully adequate to the situation, since the first projects exaggerated fantasies onto the aggressor, while the second diminishes his responsibility. I have experienced both, toward both blacks and whites. I believe that the perceptual and cognitive distortions that characterize any form of racism begin here, in the failure to see any such act of racist aggression as a defensive response to one's perceived attack on the aggressor's physical or psychological property, or conception of himself, or of the world. Once you see this, you may feel helpless to be anything other than who you are, anything or anyone who could resolve the discord. But at least it restores a sense of balance and mutually flawed humanity to the interaction.

My maternal cousin, who resembles Michelle Pfeiffer, went through adolescence in the late 1960s and had a terrible time. She tried perming her hair into an Afro; it didn't prevent attacks and ridicule from her black peers for not being "black enough." She adopted a black working-class dialect that made her almost unintelligible to her very proper, very middle-class parents, and counted among her friends young people who criticized high scholastic achievers for "acting white." That is, she ran the same gantlet I did, but of a more intense variety and at a much younger age. But she emerged intact, with a sharp and practical intellect, an endearing attachment to stating difficult truths bluntly, a dry sense of humor, and little tolerance for those blacks who, she feels, forego the hard work of self-improvement and initiative for the imagined benefits of victim status. Now married to a WASP musician from Iowa, she is one tough cookie, leavened by the rejection she experienced from those with whom she has always proudly identified.

In my experience, these rejections almost always occur with blacks of working-class background who do not have extended personal experience with the very wide range of variation in skin color, hair texture and facial features that in fact has always existed among African-Americans,

particularly in the middle class. Because light-skinned blacks often received some education or training apprenticeships during slavery, there tend to be more of us in the middle class now. Until my family moved out of Harlem when I was fourteen, my social contacts were almost exclusively with upper-middle-class white schoolmates and working-class black neighborhood playmates, both of whom made me feel equally alienated from both races. It wasn't until college and after that I re-encountered the middle- and upper-middle-class blacks who were as comfortable with my appearance as my family had been, and who made me feel as comfortable and accepted by them as my family had.

So Suffering Test exchanges almost never occur with middle-class blacks, who are more likely to protest, on the contrary, that "we always knew you were black!"—as though there were some mysterious and inchoate essence of blackness that only other blacks have the antennae to detect.

> "There are niggers who are as white as I am, but the taint of blood is there and we always exclude it."
> "How do you know it is there?" asked Dr. Gresham.
> "Oh, there are tricks of blood which always betray them. My eyes are more practiced than yours. I can always tell them."
>
> —Frances E. W. Harper, *Iola Leroy, or Shadows Uplifted* (1892), 229

When made by other blacks, these remarks function on some occasions to reassure me of my acceptance within the black community, and on others to rebuke me for pretending to indistinguishability from whiteness. But in either case they wrongly presuppose, as did my eminent professor's accusation, an essentializing stereotype into which all blacks must fit. In fact no blacks, and particularly no African-American blacks, fit any such stereotype.

My eminent professor was one of only two whites I have ever met who questioned my designated racial identity to my face. The other was a white woman junior professor, relatively new to the department, who, when I went on the job market at the end of graduate school, summoned me to her office and grilled me as to why I identified myself as black and exactly what fraction of African ancestry I had. The implicit accusation behind both my professors' remarks was, of course, that I had fraudulently posed as black in order to take advantage of the department's commitment to affirmative action. It's an extraordinary idea, when you think about it; as though someone would willingly shoulder the stigma of being black in a racist society for the sake of a little extra professional

consideration that guarantees nothing but suspicions of foul play and accusations of cheating. But it demonstrates just how irrationally far the suspicion of fraudulence can extend.

In fact I had always identified myself as black (or "colored" as we said before 1967). But fully comprehending what it meant to be black took a long time. My acculturation into the white upper middle class started with nursery school when I was four, and was largely uneventful. For my primary and secondary schooling my parents sent me to a progressive prep school, one of the first to take the goal of integration seriously as more than an ideal. They gave me ballet lessons, piano lessons, art lessons, tennis lessons. In the 1950s and early 1960s they sent me to integrated summer camps where we sang "We Shall Overcome" around the campfire long before it became the theme song of the civil rights movement.

Of course there were occasional, usually veiled incidents, such as the time in preadolescence when the son of a prominent union leader (and my classmate) asked me to go steady and I began to receive phone calls from his mother, drunk, telling me how charming she thought it that her son was going out with a little colored girl. And the time the daughter of a well-known playwright, also a classmate, brought me home to her family and asked them to guess whether I was black or white, and shared a good laugh with them when they guessed wrong. But I was an only child in a family of four adults devoted to creating for me an environment in which my essential worth and competence never came into question. I used to think my parents sheltered me in this way because they believed, idealistically, that my education and achievements would then protect me from the effects of racism. I now know that they did so to provide me with an invincible armour of self-worth with which to fight it. It almost worked. I grew up not quite grasping the fact that my racial identity was a disadvantage. This lent heat to my emerging political conviction that of course it shouldn't be a disadvantage, for me or anyone else, and finally fueled my resolution not to allow it to be a disadvantage if I had anything at all to say about it.

> I will live down the prejudice, I will crush it out . . . the thoughts of the ignorant and prejudiced will not concern me. . . . I will show to the world that a man may spring from a race of slaves, yet far excel many of the boasted ruling race.
>
> —Charles Waddell Chestnutt, *Journals* (1878, 1880), 4

But the truth in my professors' accusations was that I had, in fact, resisted my parents' suggestion that, just this once, for admission to this

most prestigious of graduate programs, I decline to identify my racial classification on the graduate admissions application, so that it could be said with certainty that I'd been admitted on the basis of merit alone. "But that would be passing," I protested. Although both of my parents had watched many of their relatives disappear permanently into the white community, passing for white was unthinkable within the branches of my father's and mother's families to which I belonged. That would have been a really, authentically shameful thing to do.

> "It seems as if the prejudice pursues us through every avenue of life, and assigns us the lowest places. . . . And yet I am determined," said Iola, "to win for myself a place in the fields of labor. I have heard of a place in New England, and I mean to try for it, even if I only stay a few months."
> "Well, if you *will* go, say nothing about your color."
> "Uncle Robert, I see no necessity for proclaiming that fact on the house-top. Yet I am resolved that nothing shall tempt me to deny it. The best blood in my veins is African blood, and I am not ashamed of it."
>
> —Harper, *Iola Leroy,* 207–208

And besides, I reasoned to myself, to be admitted under the supposition that I was white would *not* be to be admitted under the basis of merit alone. Why undermine my chances of admission by sacrificing my one competitive advantage, when I already lacked not only the traditionally acceptable race and gender attributes, but also alumni legacy status, an Ivy League undergraduate pedigree, the ability to pay full tuition or endow the university, war veteran status, professional sports potential, and a distinguished family name? I knew I could ace the program if I could just get my foot in the damn door.

Later, when I experienced the full force of the racism of the academy, one of my graduate advisers, who had remained a continuing source of support and advice after I took my first job, consoled me by informing me that the year I completed the program I had, in fact, tied one other student for the highest grade-point average in my class. He was a private and dignified man of great integrity and subtle intellect, someone who I had always felt was quietly rooting for me. It was not until after his death that I began to appreciate what a compassionate and radical gesture he had made in telling me this. For by this time, I very much needed to be reminded that neither was I incompetent, nor my work worthless; that I could achieve the potential I felt myself to have. My choice not to pass for white in order to gain entry to the academy, originally made out of naiveté, had resulted in more punishment than I would have imagined possible.

It wasn't only the overt sexual and racial harassment, each of which exacerbated the other, nor the gratuitous snipes about my person, my life-style, or my work. What was even more insulting were the peculiar strategies deployed to make me feel accepted and understood despite the anomalies of my appearance, by individuals whose racism was so profound that this would have been an impossible task: the WASP colleague who attempted to establish rapport with me by making anti-Semitic jokes about the prevalence of Jews in the neighborhood of the university; the colleague who first inquired in detail into my marital status, then attempted to demonstrate his understanding of my decision not to have children by speculating that I was probably concerned that they would turn out darker than I was; the colleague who consulted me on the analysis of envy and resentment, reasoning that since I was black I must know all about it; the colleague who, in my first department faculty meeting, made a speech to his colleagues discussing the research that proved that a person could be black without looking it.

These incidents and others like them had a peculiar cognitive feel to them, as though the individuals involved felt driven to make special efforts to situate me in their conceptual mapping of the world, by not only naming or indicating the niche in which they felt I belonged, but by seeking my verbal confirmation of it. I have learned to detect advance warnings that these incidents are imminent. The person looks at me with a fixed stare, her tension level visibly rising. Like a thermostat, when the tension reaches a certain level, the mechanism switches on: out comes some comment or action, often of an offensive personal nature, that attempts to locate me within the rigid confines of her stereotype of black people. I have not experienced this phenomenon outside the academic context. Perhaps it's a degenerate form of hypothesis-testing, an unfortunate side-effect of the quest for knowledge.

> She walked away. . . . The man followed her and tapped her shoulder.
> "Listen, I'd really like to get to know you," he said, smiling. He paused, as if expecting thanks from her. She didn't say anything. Flustered, he said, "A friend of mine says you're black. I told him I had to get a close-up look and see for myself."
>
> —Perry, *Another Present Era,* 19

The irony was that I could have taken an easier entry route into this privileged world. In fact, on my graduate admissions application I could have claimed alumni legacy status and the distinguished family name of my paternal great-uncle, who had not only attended that university and

sent his sons there, but had endowed one of its buildings and was commemorated with an auditorium in his name. I did not because he belonged to a branch of the family from which we had been estranged for decades, even before my grandfather—his brother—divorced my grandmother, moved to another part of the country, and started another family. My father wanted nothing more to do with my grandfather or any of his relatives. He rejected his inheritance and never discussed them while he was alive. For me to have invoked his uncle's name in order to gain a professional advantage would have been out of the question. But it would have nullified my eminent professor's need to tell me who and what he thought I was.

Recently I saw my great-uncle's portrait on an airmail stamp honoring him as a captain of industry. He looked so much like family photos of my grandfather and father that I went out and bought two sheets' worth of these stamps. He had my father's and grandfather's aquiline nose, and their determined set of the chin. Looking at his face made me want to recover my father's estranged family, particularly my grandfather, for my own. I had a special lead: A few years previously, in the South, I'd included a phototext work containing a fictionalized narrative about my father's family—a history chock-full of romance and psychopathology—in an exhibition of my work. After seeing the show, a white woman with blue eyes, my father's transparent rosy skin and auburn-brown hair, and that dominant family nose walked up to me and told me that we were related. The next day she brought photographs of her family, and information about a relative who kept extensive genealogical records on every family member he could locate. I was very moved, and also astounded that a white person would voluntarily acknowledge blood relation to a black. She was so free and unconflicted about this. I just couldn't fathom it. We corresponded and exchanged family photos. And when I was ready to start delving in earnest, I contacted the relative she had mentioned for information about my grandfather, and initiated correspondence or communication with kin I hadn't known existed and who hadn't known that I existed or that they or any part of their family was black. I embarked on this with great trepidation, anticipating with anxiety their reaction to the racial identity of these long-lost relatives, picturing in advance the withdrawal of warmth and interest, the quickly assumed impersonality and the suggestion that there must be some mistake.

> The dread that I might lose her took possession of me each time I sought to speak, and rendered it impossible for me to do so. That moral courage requires more than physical courage is no mere poetic fancy. I am sure I should have

found it easier to take the place of a gladiator, no matter how fierce the Numidian lion, than to tell that slender girl that I had Negro blood in my veins.

—James Weldon Johnson, *The Autobiography of an Ex-Coloured Man* (1912), 200

These fears were not unfounded. My father's sister had, in her youth, been the first black woman at a Seven Sisters undergraduate college and the first at an Ivy League medical school; had married into a white family who became socially, politically and academically prominent; and then, after taking some family mementos my grandmother had given my father for me, had proceeded to sever all connections with her brothers and their families, even when the death of each of her siblings was imminent. She raised her children (now equally prominent socially and politically) as though they had no maternal relatives at all. We had all been so very proud of her achievements that her repudiation of us was devastating. Yet I frequently encounter mutual friends and colleagues in the circles in which we both travel, and I dread the day we might find ourselves in the same room at the same time. To read or hear about or see on television her or any member of her immediate family is a source of personal pain for all of us. I did not want to subject myself to that again with yet another set of relatives.

> Those who pass have a severe dilemma before they decide to do so, since a person must give up all family ties and loyalties to the black community in order to gain economic and other opportunities.
>
> —F. James Davis, *Who Is Black? One Nation's Definition* (1991), 143

Trying to forgive and understand those of my relatives who have chosen to pass for white has been one of the most difficult ethical challenges of my life, and I don't consider myself to have made very much progress. At the most superficial level, this decision can be understood in terms of a cost-benefit analysis: Obviously, they believe they will be happier in the white community than in the black one, all things considered. For me to make sense of this requires that I understand—or at least accept—their conception of happiness as involving higher social status, entrenchment within the white community and corresponding isolation from the black one, and greater access to the rights, liberties and privileges the white community takes for granted. What is harder for me to grasp is how they could want these things enough to sacrifice the history, wisdom, connectedness and moral solidarity with their family and community they must sacrifice in order to get them. It seems to require so

much severing and forgetting, so much disowning and distancing, not simply from one's shared past, but from one's former self—as though one had cauterized one's long-term memory at the moment of entry into the white community.

But there is, I think, more to it than that. Once you realize what is denied you as an African-American simply because of your race, your sense of the unfairness of it may be so overwhelming that you may simply be incapable of accepting it. And if you are not inclined toward any form of overt political advocacy, passing in order to get the benefits you know you deserve may seem the only way to defy the system. Indeed, many of my more prominent relatives who are passing have chosen altruistic professions that benefit society on many fronts. They have chosen to use their assumed social status to make returns to the black community indirectly, in effect compensating for the personal advantages they have gained by rejecting their family.

Moreover, your sense of injustice may be compounded by the daily humiliation you experience as the result of identifying with those African-Americans who, for demanding their rights, are punished and degraded as a warning to others. In these cases, the decision to pass may be more than the rejection of a black identity. It may be the rejection of a black identification that brings too much pain to be tolerated.

> All the while I understood that it was not discouragement or fear or search for a larger field of action and opportunity that was driving me out of the Negro race. I knew that it was shame, unbearable shame. Shame at being identified with a people that could with impunity be treated worse than animals.
>
> —Johnson, *The Autobiography of an Ex-Coloured Man,* 191

The oppressive treatment of African-Americans facilitates this distancing response, by requiring every African-American to draw a sharp distinction between the person he is and the person society perceives him to be; that is, between who he is as an individual, and the way he is designated and treated by others.

> The Negro's only salvation from complete despair lies in his belief, the old belief of his forefathers, that these things are not directed against him personally, but against his race, his pigmentation. His mother or aunt or teacher long ago carefully prepared him, explaining that he as an individual can live in dignity, even though he as a Negro cannot.
>
> —John Howard Griffin, *Black Like Me* (1960), 48

This condition encourages a level of impersonality, a sense that white reactions to one have little or nothing to do with one as a person and an

individual. Whites often mistake this impersonality for aloofness or un-friendliness. It is just one of the factors that make genuine intimacy between blacks and whites so difficult. Because I have occasionally encountered equally stereotypical treatment from other blacks and have felt compelled to draw the same distinction there between who I am and how I am perceived, my sense of impersonality pervades most social situations in which I find myself. Because I do not enjoy impersonal interactions with others, my solution is to limit my social interactions as far as possible to those in which this restraint is not required. So perhaps it is not entirely surprising that many white-looking individuals of African ancestry are able to jettison this doubly alienated and alienating social identity entirely, as irrelevant to the fully mature and complex individuals they know themselves to be. I take the fervent affirmation and embrace of black identity to be a countermeasure to and thus evidence of this alienation, rather than incompatible with it. My family contains many instances of both attitudes.

There are no proper names mentioned in this account of my family. This is because in the African-American community, we do not "out" people who are passing as white in the European-American community. Publicly to expose the African ancestry of someone who claims to have none is not done. There are many reasons for this, and different individuals cite different ones. For one thing, there is the vicarious enjoyment of watching one of our own infiltrate and achieve in a context largely defined by institutionalized attempts to exclude blacks from it. Then there is the question of self-respect: If someone wants to exit the African-American community, there are few blacks who would consider it worth their while to prevent her. And then there is the possibility of retaliation: not merely the loss of credibility consequent on the denials by a putatively white person who, by virtue of his racial status, automatically has greater credibility than the black person who calls it into question; but perhaps more deliberate attempts to discredit or undermine the messenger of misfortune. There is also the instinctive impulse to protect the wellbeing of a fellow traveler embarked on a particularly dangerous and risky course. And finally—the most salient consideration for me in thinking about those many members of my own family who have chosen to pass for white—a person who seeks personal and social advantage and acceptance within the white community so much that she is willing to repudiate her family, her past, her history, and her personal connections within the African-American community in order to get them is someone who is already in so much pain that it's just not possible to do something that you know is going to cause her any more.

Many colored Creoles protect others who are trying to pass, to the point of feigning ignorance of certain branches of their families. Elicited genealogies often seem strangely skewed. In the case of one very good informant, a year passed before he confided in me that his own mother's sister and her children had passed into the white community. With tears in his eyes, he described the painful experience of learning about his aunt's death on the obituary page of the *New Orleans Times-Picayune*. His cousins failed to inform the abandoned side of the family of the death, for fear that they might show up at the wake or the funeral and thereby destroy the image of whiteness. Total separation was necessary for secrecy.

—Virginia R. Domínguez, *White by Definition:
Social Classification in Creole Louisiana* (1986), 161

She said: "It's funny about 'passing.' We disapprove of it and at the same time condone it. It excites our contempt and yet we rather admire it. We shy away from it with an odd kind of revulsion, but we protect it."
"Instinct of the race to survive and expand."
"Rot! Everything can't be explained by some general biological phrase."
"Absolutely everything can. Look at the so-called whites, who've left bastards all over the known earth. Same thing in them. Instinct of the race to survive and expand."

—Nella Larsen, *Passing* (1929), 185–86

Those of my grandfather's estranged relatives who welcomed me into dialogue instead of freezing me out brought tears of gratitude and astonishment to my eyes. They seemed so kind and interested, so willing to help. At first I couldn't accept for what it was their easy acceptance and willingness to help me puzzle out where exactly we each were located in our sprawling family tree. It is an ongoing endeavor, full of guesswork, false leads, blank spots and mysteries. For just as white Americans are largely ignorant of their African—usually maternal—ancestry, we blacks are often ignorant of our European—usually paternal—ancestry. That's the way our slavemaster forebears wanted it, and that's the way it is. Our names are systematically missing from the genealogies and public records of most white families, and crucial information—for example, the family name or name of the child's father—is often missing from our black ancestors' birth certificates, when they exist at all.

A realistic appreciation of the conditions which exist when women are the property of men makes the conclusion inevitable that there were many children born of mixed parentage.

—Joe Gray Taylor, *Negro Slavery in Louisiana* (1963), 20

Ownership of the female slave on the plantations generally came to include owning her sex life. Large numbers of white boys were socialized to associate physical and emotional pleasure with the black women who nursed and raised

them, and then to deny any deep feelings for them. From other white males they learned to see black girls and women as legitimate objects of sexual desire. Rapes occurred, and many slave women were forced to submit regularly to white males or suffer harsh consequences. . . . as early as the time of the American Revolution there were plantation slaves who appeared to be completely white, as many of the founding fathers enslaved their own mixed children and grandchildren.

—Davis, *Who Is Black?*, 38, 48–49

So tracing the history of my family is detective work as well as historical research. To date, what I *think* I know is that our first European-American ancestor landed in Ipswich, Massachusetts, in 1620 from Sussex; another in Jamestown, Virginia, in 1675 from London; and another in Philadelphia, Pennsylvania, in 1751, from Hamburg. Yet another was the first in our family to graduate from my own graduate institution in 1778. My great-great-grandmother from Madagascar, by way of Louisiana, is the known African ancestor on my father's side, as my great-great-grandfather from the Ibo of Nigeria is the known African ancestor on my mother's, whose family has resided in Jamaica for three centuries.

I relate these facts and it doesn't seem to bother my newly discovered relatives. At first I had to wonder whether this ease of acceptance was not predicated on their mentally bracketing the implications of these facts and restricting their own immediate family ancestry to the European side. But when they remarked unselfconsciously on the family resemblances between us I had to abandon that supposition. I still marvel at their enlightened and uncomplicated friendliness, and there is a part of me that still can't trust their acceptance of me. But that is a part of me I want neither to trust nor to accept in this context. I want to reserve my vigilance for its context of origin: the other white Americans I have encountered—even the bravest and most conscientious white scholars—for whom the suggestion that they might have significant African ancestry as the result of this country's long history of miscegenation is almost impossible to consider seriously.

She's heard the arguments, most astonishingly that, statistically, . . . the average white American is 6 percent black. Or, put another way, 95 percent of white Americans are 5 to 80 percent black. Her Aunt Tyler has told her stories about these whites researching their roots in the National Archives and finding they've got an African-American or two in the family, some becoming so hysterical they have to be carried out by paramedics.

—Perry, *Another Present Era*, 66

Estimates ranging up to 5 percent, and suggestions that up to one-fifth of the white population have some genes from black ancestors, are probably far too

high. If these last figures were correct, the majority of Americans with some
black ancestry would be known and counted as whites!

—Davis, *Who Is Black?*, 21–22

The detailed biological and genetic data can be gleaned from a careful
review of *Genetic Abstracts* from about 1950 on. In response to my
request for information about this, a white biological anthropologist once
performed detailed calculations on the African admixture of five different
genes in British whites, American whites, and American blacks. American
whites had from two percent of one gene to 81.6 percent of another.
About these results he commented, "I continue to believe five percent to
be a reasonable estimate, but the matter is obviously complex. As you can
see, it depends entirely on which genes you decide to use as racial 'mark-
ers' that are supposedly subject to little or no relevant selective pressure."
Clearly, white resistance to the idea that most American whites have a
significant percentage of African ancestry increases with the percentage
suggested.

"Why, Doctor," said Dr. Latimer, "you Southerners began this absorption
before the war. I understand that in one decade the mixed bloods rose from
one-ninth to one-eighth of the population, and that as early as 1663 a law was
passed in Maryland to prevent English women from intermarrying with slaves;
and, even now, your laws against miscegenation presuppose that you apprehend
danger from that source."

—Harper, *Iola Leroy*, 228

(That legislators and judges paid increasing attention to the regulation and
punishment of miscegenation at this time does not mean that interracial sex and
marriage as social practices actually increased in frequency; the centrality of
these practices to legal discourse was instead a sign that their relation to power
was changing. The extent of uncoerced miscegenation before this period is a
debated issue.)

—Eva Saks, "Representing Miscegenation Law," *Raritan* (1991), 43–44

The fact is, however, that the longer a person's family has lived in this
country, the higher the probable percentage of African ancestry that
person's family is likely to have—bad news for the D.A.R., I'm afraid.
And the proximity to the continent of Africa of the country of origin from
which one's forebears emigrated, as well as the colonization of a part of
Africa by that country, are two further variables that increase the proba-
bility of African ancestry within that family. It would appear that only
the Lapps of Norway are safe.

In Jamaica, my mother tells me, that everyone is of mixed ancestry

is taken for granted. There are a few who vociferously proclaim themselves to be "Jamaican whites" having no African ancestry at all, but no one among the old and respected families takes them seriously. Indeed, they are assumed to be a bit unbalanced, and are regarded with amusement. In this country, by contrast, the fact of African ancestry among whites ranks up there with family incest, murder, and suicide as one of the bitterest and most difficult pills for white Americans to swallow.

> "I had a friend who had two beautiful daughters whom he had educated in the North. They were cultured, and really belles in society. They were entirely ignorant of their lineage, but when their father died it was discovered that their mother had been a slave. It was a fearful blow. They would have faced poverty, but the knowledge of their tainted blood was more than they could bear."
>
> —Harper, *Iola Leroy*, 100

> There was much apprehension about the unknown amount of black ancestry in the white population of the South, and this was fanned into an unreasoning fear of invisible blackness. For instance, white laundries and cleaners would not accommodate blacks because whites were afraid they would be "contaminated" by the clothing of invisible blacks.
>
> —Davis, *Who Is Black?*, 145

> Suspicion is part of everyday life in Louisiana. Whites often grow up afraid to know their own genealogies. Many admit that as children they often stared at the skin below their fingernails and through a mirror at the white of their eyes to see if there was any "touch of the tarbrush." Not finding written records of birth, baptism, marriage, or death for any one ancestor exacerbates suspicions of foul play. Such a discovery brings glee to a political enemy or economic rival and may traumatize the individual concerned.
>
> —Domínguez, *White by Definition*, 159

A number of years ago I was doing research on a video installation on the subject of racial identity and miscegenation, and came across the Phipps case of Louisiana in the early 1980s. Susie Guillory Phipps had identified herself as white and, according to her own testimony (but not that of some of her black relatives), had believed that she was white, until she applied for a passport, when she discovered that she was identified on her birth records as black in virtue of having $1/32$ African ancestry. She brought suit against the state of Louisiana to have her racial classification changed. She lost the suit, but effected the overthrow of the law identifying individuals as black if they had $1/32$ African ancestry, leaving on the books a prior law identifying an individual as black who had any African ancestry—the "one-drop" rule that uniquely characterizes the classifica-

tion of blacks in the United States in fact, even where no longer in law. So according to this long-standing convention of racial classification, a white who acknowledges any African ancestry implicitly acknowledges being black—a social condition, more than an identity, that no white person would voluntarily assume, even in imagination. This is one reason why whites, educated and uneducated alike, are so resistant to considering the probable extent of racial miscegenation.

This "one-drop" convention of classification of blacks is unique not only relative to the treatment of blacks in other countries but also unique relative to the treatment of other ethnic groups in this country. It goes without saying that no one, either white or black, is identified as, for example, English by virtue of having some small fraction of English ancestry. Nor is anyone free, as a matter of social convention, to do so in virtue of that fraction, although many whites do. But even in the case of other disadvantaged groups in this country, the convention is different. Whereas any proportion of African ancestry is sufficient to identify a person as black, an individual must have *at least* one-eighth Native American ancestry in order to identify legally as Native American.

Why the asymmetry of treatment? Clearly, the reason is economic. A legally certifiable Native American is entitled to financial benefits from the government, so obtaining this certification is difficult. A legally certifiable black person is *disentitled* to financial, social, and inheritance benefits from his white family of origin, so obtaining this certification is not just easy, but automatic. Racial classification in this country functions to restrict the distribution of goods, entitlements and status as narrowly as possible, to those whose power is already entrenched. Of course this institutionalized disentitlement presupposes that two persons of different racial classifications cannot be biologically related, which is absurd.

> [T]his [one-drop] definition of who is black was crucial to maintaining the social system of white domination in which widespread miscegenation, not racial purity, prevailed. White womanhood was the highly charged emotional symbol, but the system protected white economic, political, legal, education and other institutional advantages for whites. . . . American slave owners wanted to keep all racially mixed children born to slave women under their control, for economic and sexual gains. . . . It was intolerable for white women to have mixed children, so the one-drop rule favored the sexual freedom of white males, protecting the double standard of sexual morality as well as slavery. . . . By defining all mixed children as black and compelling them to live in the black community, the rule made possible the incredible myth among whites that miscegenation had not occurred, that the races had been kept pure in the South.
>
> —Davis, *Who Is Black?*, 62–63, 113–114, 174

But the issues of family entitlements and inheritance rights are not uppermost in the minds of most white Americans who wince at the mere suggestion that they might have some fraction of African ancestry and therefore be, according to this country's entrenched convention of racial classification, black. The primary issue for them is not what they might have to give away by admitting that they are in fact black, but rather what they have to lose. What they have to lose, of course, is social status; and, in so far as their self-esteem is based on their social status as whites, self-esteem as well.

> "I think," said Dr. Latrobe, proudly, "that we belong to the highest race on earth and the negro to the lowest."
> "And yet," said Dr. Latimer, "you have consorted with them till you have bleached their faces to the whiteness of your own. Your children nestle in their bosoms; they are around you as body servants, and yet if one of them should attempt to associate with you your bitterest scorn and indignation would be visited upon them."
>
> —Harper, *Iola Leroy,* 227

No reflective and well-intentioned white person who is consciously concerned to end racism wants to admit instinctively recoiling at the thought of being identified as black herself. But if you want to see such a white person do this, just peer at the person's facial features and tell her, in a complementary tone of voice, that she looks as though she might have some black ancestry, and watch her reaction. It's not a test I or any black person finds particularly pleasant to apply (that is, unless one dislikes the person and wants to inflict pain deliberately), and having once done so inadvertently, I will never do it again. The ultimate test of a person's repudiation of racism is not what she can contemplate *doing* for or on behalf of black people, but whether she herself can contemplate calmly the likelihood of *being* black. If racial hatred has not manifested itself in any other context, it will do so here if it exists, in hatred of the self as identified with the other; that is, as self-hatred projected onto the other.

> Since Harry had come North he had learned to feel profound pity for the slave. But there is a difference between looking on a man as an object of pity and protecting him as such, and being identified with him and forced to share his lot.
>
> —Harper, *Iola Leroy,* 126

> "Let me tell you how I'd get those white devil convicts and the guards, too, to do anything I wanted. I'd whisper to them, 'If you don't, I'll start a rumor that you're really a light Negro just passing as white.' That shows you what

the white devil thinks about the black man. He'd rather die than be thought a Negro!"

<div align="right">

—Malcolm X to Alex Haley, "Epilogue,"
The Autobiography of Malcolm X (1965), 391

</div>

When I was an undergraduate minoring in Medieval and Renaissance musicology, I worked with a fellow music student—white—in the music library. I remember his reaction when I relayed to him an article I'd recently read arguing that Beethoven had African ancestry. Beethoven was one of his heroes, and his vehement derision was completely out of proportion to the scholarly worth of the hypothesis. But when I suggested that he wouldn't be so skeptical if the claim were that Beethoven had some Danish ancestry, he fell silent. In those days we were very conscious of covert racism, as our campus was exploding all around us because of it. More recently I premiered at a gallery a video installation exploring the issue of African ancestry among white Americans. A white male viewer commenced to kick the furniture, mutter audibly that he was white and was going to stay that way, and start a fistfight with my dealer. Either we are less conscious of covert racism twenty years later, or we care less to contain it.

Among politically committed and enlightened whites, the inability to acknowledge their probable African ancestry is the last outpost of racism. It is the litmus test that separates those who have the courage of their convictions from those who merely subscribe to them; and that measures the depth of our dependence on a presumed superiority—of any kind, anything will do—to other human beings—anyone, anywhere—to bolster our fragile self-worth. Many blacks are equally unwilling to explore their white ancestry—approximately 25 percent on average for the majority of blacks—for this reason. For some, of course, acknowledgment of this fact evokes only bitter reminders of rape, disinheritance, enslavement, and exploitation, and their distaste is justifiable. But for others, it is the mere idea of blackness as an essentialized source of self-worth and self-affirmation that forecloses the acknowledgment of mixed ancestry. This, too, is understandable: Having struggled so long and hard to carve a sense of wholeness and value for ourselves out of our ancient connection with Africa after having been actively denied any in America, many of us are extremely resistant to once again casting ourselves into the same chaos of ethnic and psychological ambiguity our diaspora to this country originally inflicted on us.

Thus blacks and whites alike seem to be unable to accord worth to others outside their in-group affiliations without feeling that they are taking it away from themselves. We may have the concept of intrinsic

self-worth, but by and large we do not understand what it means. We need someone else whom we can regard as inferior to whom to we can compare ourselves favorably, and if no such individual or group exists, we invent one. For without this, we seem to have no basis, no standard of comparison, for conceiving of ourselves favorably at all. We seem, for example, truly unable to grasp or take seriously the alternative possibility, of measuring ourselves or our performances against our own past novicehood at one end and our own future potential at the other. I think this is in part the result of our collective fear of memory as a nation, our profound unwillingness to confront the painful truths about our history and our origins; and in part the result of our individual fear of the memory of our own pasts—not only of our individual origins and the traumas of socialization we each suffered before we could control what was done to us, but the pasts of our own adult behavior: the painful truths of our own derelictions, betrayals, and failures to respect our individual ideals and convictions.

When I turned forty a few years ago, I gave myself the present of rereading the personal journals I have been keeping since age eleven. I was astounded at the chasm between my present conception of my own past, which is being continually revised and updated to suit present circumstances, and the actual past events, behavior and emotions I recorded as faithfully as I could as they happened. My derelictions, mistakes and failures of responsibility are much more evident in those journals than they are in my present, sanitized and virtually blameless image of my past behavior. It was quite a shock to encounter in those pages the person I actually have been rather than the person I now conceive myself to have been. My memory is always under the control of the person I now want and strive to be, and so rarely under the control of the facts. If the personal facts of one's past are this difficult for other people to face, then perhaps it is no wonder that we must cast about outside ourselves for someone to feel superior to, even though there are so many blunders and misdeeds in our own personal histories that might serve that function.

For whites to acknowledge their blackness is, then, much the same as for men to acknowledge their femininity and for Christians to acknowledge their Judaic heritage. It is to reinternalize the external scapegoat through attention to which they have sought to escape their own sense of inferiority.

> Now the white man leaned in the window, looking at the impenetrable face with its definite strain of white blood, the same blood which ran in his own veins, which had not only come to the negro through male descent while it had come

to him from a woman, but had reached the negro a generation sooner—a face composed, inscrutable, even a little haughty, shaped even in expression in the pattern of his great-grandfather McCaslin's face. . . . He thought, and not for the first time: *I am not only looking at a face older than mine and which has seen and winnowed more, but at a man most of whose blood was pure ten thousand years when my own anonymous beginnings became mixed enough to produce me.*

—William Faulkner, *Go Down, Moses* (1940), 70–71

I said. . . . that the guilt of American whites included their knowledge that in hating Negroes, they were hating, they were rejecting, they were denying, their own blood.

—Malcolm X, *The Autobiography of Malcolm X,* 286

It is to bring ourselves face to face with our obliterated collective past, and to confront the continuities of responsibility that link the criminal acts of extermination and enslavement committed by our forefathers with our own personal crimes of avoidance, neglect, disengagement, passive complicity, and active exploitation of the inherited injustices from which we have profitted. Uppermost among these is that covert sense of superiority a white person feels over a black person that buttresses his enjoyment of those unjust benefits as being no more or less than he deserves. To be deprived of that sense of superiority to the extent that acknowledgment of common ancestry would effect is clearly difficult for most white people. But to lose the social regard and respect that accompanies it is practically unbearable. I know, not only because of what I have read and observed of the pathology of racism in white people, but because I have often experienced the withdrawal of that social regard first hand.

For most of my life I did not understand that I needed to identify my racial identity publicly; and that if I did not I would be inevitably mistaken for white. I simply didn't think about it. But since I also made no special effort to hide my racial identity, I often experienced the shocked and/or hostile reactions of whites who discovered it after the fact. I always knew when it had happened, even when the person declined to confront me directly: the startled look, the searching stare that would fix itself on my facial features, one by one, looking for the telltale "negroid" feature, the sudden, sometimes permanent withdrawal of good feeling or regular contact—all alerted me to what had transpired. Uh-oh, I would think to myself helplessly, and watch another blossoming friendship wilt.

In thus travelling about through the country I was sometimes amused on arriving at some little railroad-station town to be taken for and treated as a white man, and six hours later, when it was learned that I was stopping at the

house of the coloured preacher or school-teacher, to note the attitude of the whole town change.

—Johnson, *The Autobiography of an Ex-Coloured Man,* 172

Sometimes this revelation would elicit a response of the most twisted and punitive sort: for example, from the colleague who glared at me and hissed, "Oh, so you want to be black, do you? Good! Then we'll treat you like one!" The ensuing harassment had a furious, retaliatory quality that I find difficult to understand even now; as though I'd delivered a deliberate and crushing insult to her self-esteem by choosing not to identify with her racial group.

> You feel lost, sick at heart before such unmasked hatred, not so much because it threatens you as because it shows humans in such an inhuman light. You see a kind of insanity, something so obscene the very obscenity of it (rather than its threat) terrifies you.

—Griffin, *Black Like Me,* 53

And I experienced that same groundless shame, not only in response to those who accused me of passing for black, but also in response to those who accused me of passing for white. This was the shame caused by people who conveyed to me that I was underhanded or manipulative, trying to hide something, pretending to be something I was not, by not telling them I was black, like the art critic in the early 1970s who had treated me with the respect she gave emerging white women artists in the early days of second-wave feminism, until my work turned to issues of racial identity; she then called me to verify that I was black, reproached me for not telling her, and finally disappeared from my professional life altogether. And there were the colleagues who discovered after hiring me to my first job that I was black, and revised their evaluations of my work accordingly. It was the groundless shame caused by people who, having discovered my racial identity, let me know that I was not comporting myself as befitted their conception of a black person: the grammar-school teacher who called my parents to inquire whether I was aware that I was black, and made a special effort to put me in my place by restricting me from participating in certain class activities and assigning me to remedial classes in anticipation of low achievement; and the graduate-school classmate who complimented me on my English; and the potential employer who, having offered me a tenure-track job in an outstanding graduate department (which I declined) when he thought I was white, called me back much later after I'd received tenure and he'd found out I was black,

to offer me a two-year visiting position teaching undergraduates only, explaining to a colleague of mine that he was being pressured by his university administration to integrate his department. And the art critic who made elaborate suggestions in print about the kind of art it would be appropriate for someone with my concerns to make; and the colleague who journeyed from another university and interviewed me for four and a half hours in order to ascertain that I was smart enough to hold the position I had, and actually congratulated me afterward on my performance. And there was the colleague who, when I begged to differ with his views, shouted (in a crowded restaurant) that if I wasn't going to take his advice, why was I wasting his time?

> I looked up to see the frowns of disapproval that can speak so plainly and so loudly without words. The Negro learns this silent language fluently. He knows by the white man's look of disapproval and petulance that he is being told to get on his way, that he is "stepping out of line."
>
> —Griffin, *Black Like Me,* 45

> When such contacts occurred, the interaction had to follow a strict pattern of interracial etiquette. The white person had to be clearly in charge at all times, and the black person clearly subordinate, so that each kept his or her place. It was a master-servant etiquette, in which blacks had to act out their inferior social position, much the way slaves had done. The black had to be deferential in tone and body language, . . . and never bring up a delicate topic or contradict the white. . . . this master-servant ritual had to be acted out carefully lest the black person be accused of "getting" out of his or her subordinate "place." Especially for violations of the etiquette, but also for challenges to other aspects of the system, blacks were warned, threatened, and finally subjected to extralegal violence.
>
> —Davis, *Who Is Black?,* 64, 78

In a way this abbreviated history of occasions on which whites have tried to put me in my place upon discovering my racial identity was the legacy of my father who, despite his own similar experiences as a youth, refused to submit to such treatment. He grew up in a Southern city where his family was well known and highly respected. When he was thirteen, he once went to a movie theater and bought a seat in the orchestra section. In the middle of the feature, the projectionist stopped the film and turned up the lights. The manager strode onto the stage and, in front of the entire audience, called out my father's name, loudly reprimanded him for sitting in the orchestra, and ordered him up to the balcony, where he "belonged." My father fled the theater, and, not long after, the South. My grandmother then sent him to a private prep school up North, but it was

no better. In his senior year of high school, after having distinguished himself academically and in sports, he invited a white girl classmate on a date. She refused, and her parents complained to the principal, who publicly rebuked him. He was ostracized by his classmates for the rest of the year, and made no effort to speak to any of them.

My mother, being upper-middle-class Jamaican, had no experience of this kind of thing. When she first got a job in this country in the 1930s, she chastised her white supervisor for failing to say "Thank you," after she'd graciously brought him back a soda from her lunch hour. He was properly apologetic. And when her brother first came to this country, he sat in a restaurant in Manhattan for an hour waiting to be served, it simply not occurring to him that he was being ignored because of his color, until a waitress came up to him and said, "I can see you're not from these parts. We don't serve colored people here." My father, who had plenty of experiences of this sort, knew that I would have them, too. But he declined to accustom me to them in advance. He never hit me, disparaged me, or pulled rank in our frequent intellectual and philosophical disagreements. Trained as a Jesuit and a lawyer, he argued for the joy of it, and felt proud rather than insulted when I made my point well. "Fresh," he'd murmur to my mother with mock annoyance, indicating me with his thumb, when I used his own assumptions to trounce him in argument. It is because of his refusal to prepare me for my subordinate role as a black woman in a racist and misogynistic society that my instinctive reaction to such insults is neither resignation nor depression nor passive aggression, but rather the disbelief, outrage, sense of injustice, and impulse to fight back actively that white males often exhibit at unexpected affronts to their dignity. Blacks who manifest these responses to white racism reveal their caregivers' generationally transmitted underground resistance to schooling them for victimhood.

A benefit and a disadvantage of looking white is that most people treat you as though you were white. And so, because of how you've been treated, you come to expect this sort of treatment, not, perhaps, realizing that you're being treated this way because people think you're white, but falsely supposing, rather, that you're being treated this way because people think you are a valuable person. So, for example, you come to expect a certain level of respect, a certain degree of attention to your voice and opinions, certain liberties of action and self-expression to which you falsely suppose yourself to be entitled because your voice, your opinion, and your conduct are valuable in themselves. To those who in fact believe (even though they would never voice this belief to themselves) that black people are not entitled to this degree of respect, attention, and liberty, the

sight of a black person behaving as though she were can, indeed, look very much like arrogance. It may not occur to them that she simply does not realize that her blackness should make any difference.

> Only one-sixteenth of her was black, and that sixteenth did not show. . . . Her complexion was very fair, with the rosy glow of vigorous health in the cheeks, . . . her eyes were brown and liquid, and she had a heavy suit of fine soft hair which was also brown. . . . She had an easy, independent carriage—when she was among her own caste—and a high and "sassy" way, withal; but of course she was meek and humble enough where white people were.
>
> —Mark Twain, *Pudd'nhead Wilson* (1893), 8

But there may be more involved than this. I've been thinking about Ida B. Wells, who had the temerity to suggest in print that white males who worried about preserving the purity of Southern white womanhood were really worried about the sexual attraction of Southern white womanhood to handsome and virile black men; and Rosa Parks, who refused to move to the back of the bus; and Eartha Kitt, who scolded President Lyndon Johnson about the Vietnam War when he received her at a White House dinner; and Mrs. Alice Frazier, who gave the Queen of England a big hug and invited her to stay for lunch when the Queen came to tour Mrs. Frazier's housing project on a recent visit to the United States; and Congresswoman Maxine Waters, who, after the L.A. Rebellion, showed up at the White House uninvited and gave George Bush her unsolicited recommendations as to how he should handle the plight of the inner cities. I've also been thinking about the legions of African-American women whose survival has depended on their submission to the intimate interpersonal roles, traditional for black women in this culture, of nursemaid, housekeeper, concubine, cleaning lady, cook; and about what they have been required to witness of the whites they have served in those capacities. And I've been thinking about the many white people I've admired and respected who have lost my admiration and respect by revealing in personal interactions a side of themselves that other whites rarely get a chance to see: the brand of racism that surfaces only in one-on-one or intimate interpersonal circumstances, the kind a white person lets you see because he doesn't care what you think and knows you are powerless to do anything about it.

> When we shined their shoes we talked. The whites, especially the tourists, had no reticence before us, and no shame since we were Negroes. Some wanted to know where they could find girls, wanted us to get Negro girls for them. . . . Though not all, by any means, were so open about their purposes, all of them

showed us how they felt about the Negro, the idea that we were people of such low morality that nothing could offend us. . . . In these matters, the Negro has seen the backside of the white man too long to be shocked. He feels an indulgent superiority whenever he sees these evidences of the white man's frailty. This is one of the sources of his chafing at being considered inferior. He cannot understand how the white man can show the most demeaning aspects of his nature and at the same time delude himself into thinking he is inherently superior.

—Griffin, *Black Like Me*, 30, 81

It may indeed be that we African-American women as a group have special difficulties in learning our place and observing the proprieties because of that particular side of white America to which, because of our traditional roles, we have had special access—a side of white America that hardly commands one's respect and could not possibly command one's deference.

To someone like myself, who was raised to think that my racial identity was, in fact, irrelevant to the way I should be treated, there are few revelations more painful than the experience of social metamorphosis that transforms former friends, colleagues or teachers who have extended their trust, good will and support into accusers or strangers who withdraw them when they discover that I am black. To look visibly black, or always to announce in advance that one is black, is, I submit, never to experience this kind of camaraderie with white people, the relaxed, unguarded but respectful camaraderie that white people reserve for those whom they believe are like them: those who can be trusted, who are intrinsically worthy of value, respect and attention. Eddie Murphy portrays this in comic form in a wonderful routine in which he disguises himself in whiteface, then boards a bus on which there is only one visibly black passenger. As long as that passenger is on the bus, all of them sit silently and impersonally ignoring one another. But as soon as the visibly black passenger gets off, the other passengers get up and turn to one another, engaging in friendly banter, and the driver breaks open a bottle of champagne for a party. A joke, perhaps, but not entirely. A visibly black person may, in time, experience something very much like this unguarded friendship with a white person, if the black person has proven herself trustworthy and worthy of respect, or has been a friend since long before either was taught that vigilance between the races was appropriate. But I have only rarely met adult whites who have extended this degree of trust and acceptance at the outset to a new acquaintance they knew to be black. And to have extended it to someone who then *turns out* to be black is instinctively felt as a betrayal, a violation. It is as though one had been

seduced into dropping one's drawers in the presence of the enemy.

So a white person who accuses me of deceit for not having alerted her that I am black is not merely complaining that I have been hiding something about myself that is important for her to know. The complaint goes much deeper. It is that she has been lured under false pretenses into dropping her guard with me, into revealing certain intimacies and vulnerabilities that are simply unthinkable to expose in the presence of someone of another race (that's why it's important for her to know my race). She feels betrayed because I have failed to warn her to present the face she thinks she needs to present to someone who might choose to take advantage of the weaknesses that lie behind that public face. She may feel it merely a matter of luck that I have not taken advantage of those weaknesses already.

As the accused, I feel as though a trusted friend has just turned on me. I experience the social reality that previously defined our relationship as having metamorphosed into something ugly and threatening, in which the accusation is not that I have *done* something wrong, but that I *am* wrong for being who I am: for having aped the white person she thought I was, and for being the devalued black person she discovers I am. I feel a withdrawal of good will, a psychological distancing, a new wariness and suspicion, a care in choosing words, and—worst of all—a denial that anything has changed. This last injects an element of insensitivity—or bad faith—that makes our previous relationship extremely difficult to recapture. It forces me either to name unpleasant realities that the white person is clearly unable to confront; or else to comply with the fiction that there are no such realities, which renders our interactions systematically inauthentic. This is why I always feel discouraged when well-intentioned white people deny to me that a person's race makes any difference to them, even though I understand that this is part of the public face whites instinctively believe they need to present: I know, first hand, how white people behave toward me when they believe racial difference is absent. And there are very few white people who are able to behave that way toward me once they know it is present.

But there are risks that accompany that unguarded camaraderie among whites who believe they are among themselves, and ultimately those risks proved too much for me. I have found that often, a concomitant of that unguarded camaraderie is explicit and unadorned verbal racism of a kind that is violently at odds with the gentility and cultivation of the social setting, and that would never appear if that setting were visibly integrated.

I will tell you that, without any question, the *most* bitter anti-white diatribes that I have ever heard have come from "passing" Negroes, living as whites, among whites, exposed every day to what white people say among themselves regarding Negroes—things that a recognized Negro never would hear. Why, if there was a racial showdown, these Negroes "passing" within white circles would become the black side's most valuable "spy" and ally.

—Malcolm X, *The Autobiography of Malcolm X*, 277

I have heard an educated white woman refer to her husband's black phys. ed. student as a "big, black buck"; I have heard university professors refer to black working-class music as "jungle music"; and I have heard a respected museum director refer to an actress as a "big, black momma." These remarks are different in kind from those uttered in expressions of black racism toward whites. When we are among ourselves we may vent our frustration by castigating whites as ignorant, stupid, dishonest or vicious. That is, we deploy stereotyped white *attitudes* and *motives*. We do not, as these remarks do, dehumanize and animalize whites themselves. From these cases and others like them I have learned that the side of themselves some whites reveal when they believe themselves to be among themselves is just as demeaning as the side of themselves they reveal privately to blacks. This is, I suspect, the weakness whites rightly want concealed behind the public face; and the possibility that I might witness—or might have witnessed—it is the source of their anger at me for having "tricked" them. For part of the tragedy here is that the racism I witness when their guard is down is often behavior they genuinely do not understand to be racist. So the revelation is not only of racism, but of ignorance and insensitivity. The point of adopting the public face when whites are warned that a black person is among them is to suppress any nonneutral expression of the self that might be interpreted as racist.

Of course this brand of self-monitoring damage control cannot possibly work, since it cannot eliminate those very manifestations of racism that the person sees, rather, as neutral or innocuous. No one person can transcend the constraints of his own assumptions about what constitutes respectful behavior, in order to identify and critique his own racism from an objective, "politically correct" standpoint when it appears. We need trusted others, before whom we can acknowledge our insufficiencies without fear of ridicule or retaliation, to do that for us, so as to genuinely extend our conceptions of ourselves and our understanding of what constitutes appropriate behavior toward another who is different. The fact of the matter is that if racism is present, which it is in *all* of us, black as well as white, who have been acculturated into this racist society, it will emerge

despite our best efforts at concealment. The question should not be whether any individual is racist; that we all are to some extent should be a given. The question should be, rather, how we handle it once it appears. I believe our energy would be better spent on creating structured, personalized community forums for naming, confronting, owning and resolving these feelings rather than trying to evade, deny, or suppress them. But there are many whites who believe that these matters are best left in silence, in the hope that they will die out of their own accord; and that we must focus on right actions, not the character or motivations behind them. To my way of thinking, this is a conceptual impossibility. But relative to this agenda, my involuntary snooping thwarts their good intentions.

My instinctive revulsion at these unsought revelations is undergirded by strong role-modeling from my parents. I never heard my parents utter a prejudicial remark against any group. But my paternal grandmother was of that generation of very light-skinned, upper-middle-class blacks who believed themselves superior both to whites and to darker-skinned blacks. When I was young I wore my hair in two long braids, but I recall my mother once braiding it into three or four, in a simplified cornrow style. When my grandmother visited, she took one look at my new hairstyle and immediately began berating my mother for making me look like a "little nigger pickaninny." When my father heard her say these words he silently grasped her by the shoulders, picked her up, put her outside the front door, and closed it firmly in her face. Having passed for white during the Great Depression to get a job, and during World War II to see combat, his exposure to and intolerance for racist language was so complete that no benefits were worth the offense to his sensibilities, and he saw to it that he never knowingly placed himself in that situation again.

> "Doctor, were I your wife, . . . mistaken for a white woman, I should hear things alleged against the race at which my blood would boil. No, Doctor, I am not willing to live under a shadow of concealment which I thoroughly hate as if the blood in my veins were an undetected crime of my soul."
>
> —Harper, *Iola Leroy,* 233

My father is a very tough act to follow. But ultimately I did, because I had to. I finally came to the same point, of finding these sudden and unwanted revelations intolerable. Although I valued the unguarded camaraderie and closeness I'd experienced with whites, it was ultimately not worth the risk that racist behavior might surface. I seem to have become more thin-skinned about this with age. But for years I'd wrestled with different ways of forestalling these unwanted discoveries. When I was

younger I was too flustered to say anything (which still sometimes happens when my guard is down), and would be left feeling compromised and cowardly for not standing up for myself. Or I'd express my objections in an abstract form, without making reference to my own racial identity, and watch the discussion degenerate into an academic squabble about the meaning of certain words, whether a certain epithet is really racist, the role of good intentions, whether to refer to someone as a "jungle bunny" might not be a back-handed compliment, and so forth. Or I'd express my objections in a personal form, using that most unfortunate moment to let the speaker know I was black, thus traumatizing myself and everyone else present and ruining the occasion. Finally I felt I had no choice but to do everything I could, either verbally or through trusted friends or through my work, to confront this matter head-on and issue advance warning to new white acquaintances, both actual and potential, that I identify myself as black; in effect, to "proclaim that fact from the house-top" (forgive me, Malcolm, for blowing my cover).

> "I tell Mr. Leroy," said Miss Delany, "that . . . he must put a label on himself, saying 'I am a colored man,' to prevent annoyance."
>
> —Harper, *Iola Leroy*, 245

Of course this method is not foolproof. Among the benefits is that it puts the burden of vigilance on the white person rather than on me—the same vigilance she exercises in the presence of a visibly black person (but even this doesn't always work: some whites simply can't take my avowed racial affiliation at face value, and react to what they see rather than what I say). And because my public avowal of my racial identity almost invariably elicits all the stereotypically racist behavior that visibly black people always confront, some blacks feel less of a need to administer the Suffering Test of blackness. Among the costs is that I've lost other white friends who are antagonized by what they see as my manipulating their liberal guilt or good will, or turning my racial identity into an exploitable profession, or advertising myself in an unseemly manner, or making a big to-do about nothing. They are among those who would prefer to leave the whole matter of race—and, by implication, the racism of their own behavior—shrouded in silence.

But I've learned that there is no "right" way of managing the issue of my racial identity, no way that will not offend or alienate someone, because my designated racial identity itself exposes the very concept of racial classification as the offensive and irrational instrument of racism it

is. We see this in the history of the classifying terms variously used to designate those brought as slaves to this country and their offspring: first "blacks," then "darkies," then "Negroes," then "colored people," then "blacks" again, then "Afro-Americans," then "people of color," now "African-Americans." Why is it that we can't seem to get it right, once and for all? The reason, I think, is that it doesn't really matter what term we use to designate those who have inferior and disadvantaged status, because whatever term is used will eventually turn into a term of derision and disparagement in virtue of its reference to those who are derided and disparaged, and so will need to be discarded for an unsullied one. My personal favorite is "colored" because of its syntactical simplicity and aesthetic connotations. But cooking up new ways to classify those whom we degrade ultimately changes nothing but the vocabulary of degradation.

What joins me to other blacks, then, and other blacks to one another, is not a set of shared physical characteristics, for there is none that all blacks share. Rather, it is the shared experience of being visually or cognitively *identified* as black by a white racist society, and the punitive and damaging effects of that identification. This is the shared experience the Suffering Test tries to, and often does, elicit.

But then, of course, I have white friends who fit the prevailing stereotype of a black person and have similar experiences, even though they insist they are "pure" white.

> It cannot be so embarrassing for a coloured man to be taken for white as for a white man to be taken for coloured; and I have heard of several cases of the latter kind.
>
> —Johnson, *The Autobiography of an Ex-Coloured Man,* 172–73

The fact is that the racial categories that purport to designate any of us are too rigid and oversimplified to fit anyone accurately. But then, accuracy was never their purpose. Since we are almost all in fact racial hybrids, the "one-drop" rule of black racial designation, if consistently applied, would either narrow the scope of ancestral legitimacy so far that it would exclude most of those so-called whites whose social power is most deeply entrenched, or widen it to include most of those who have been most severely disadvantaged by racism. Once we get clear about the subtleties of who in fact we are, we then may be better able to see just what our ancestral entitlements actually are, and whether or to what extent they may need to be supplemented with additional social and legal means for implementing a just distribution of rights and benefits for everyone. Not until that point, I think, when we have faced the full human and personal consequences of self-serving, historically entrenched

social and legal conventions that in fact undermine the privileged interests they were designed to protect, will we be in a position to decide whether the very idea of racial classification is a viable one in the first place.

> She really thought everyone would be like her some day, neither black nor white, but something in between. It might take decades or even centuries, but it would happen. And sooner than that, racism and the concept of race itself would become completely obsolete.
>
> —Perry, *Another Present Era*, 226

> Yet it was not that Lucas made capital of his white or even his McCaslin blood, but the contrary. It was as if he were not only impervious to that blood, he was indifferent to it. He didn't even need to strive with it. He didn't even have to bother to defy it. He resisted it simply by being the composite of the two races which made him, simply by possessing it. Instead of being at once the battleground and victim of the two strains, he was a vessel, durable, ancestryless, nonconductive, in which the toxin and its anti stalemated one another, seetheless, unrumored in the outside air.
>
> —Faulkner, *Go Down, Moses*, 104

These are frightening suggestions for those whose self-worth depends on their racial and social status within the white community. But no more frightening, really, than the thought of welcoming long-lost relatives back into the family fold, and making adjustments for their wellbeing accordingly. One always has a choice as to whether to regard oneself as having lost something—status, if one's long-lost relatives are disreputable, or economic resources, if they are greedy; or as having gained something—status, if one's long-lost relatives are wise and interesting, or economic resources, if they are able-bodied and eager to work. Only for those whose self-worth strictly requires the exclusion of others viewed as inferior will these psychologically and emotionally difficult choices be impossible. This, I think, is part of why some whites feel so uneasy in my presence: Condescension or disregard seems inappropriate in light of my demeanor, whereas a hearty invitation into the exclusive inner circle seems equally inappropriate in light of my designated race. Someone who has no further social resources for dealing with other people besides condescension or disregard on the one hand and clubbish familiarity on the other is bound to feel at a loss when race provides no excuse for the former because of demeanor, whereas demeanor provides no excuse for the latter because of race. So no matter what I do or do not do about my racial identity, someone is bound to feel uncomfortable. But I have resolved that it is no longer going to be me.

IN THE MISSIONARY POSITION
Recent Feminist Ecological Art

Suzaan Boettger

He hoped I'd understand. He had accepted my invitation to a dinner party—now two days away—a month ago, but had just learned of the post-opening banquet for the exhibition benefiting the Brazilian jungle. As an artist in the show, he had to go. Well, he wanted to go. He was sufficiently well known to be able to meet any other artist anytime, but he wanted to meet the organizer, Kenny Scharf, and mingle. He wanted to be part of the crowd not "bungling the jungle." It was 1989. Environmental consciousness had hit the star system. Madonna performed at the Brooklyn Academy of Music to save the planet and in SoHo the hard-edge artifice of Neo-Geo was swept aside by its pastoral "Other" landscape painting. At a marine transfer station for New York City's garbage, Mierle Laderman Ukeles' observation ramp and patchwork passageway, Flow City, recycled waste to challenge the definition of "garbage." And in Dallas's Leonhardt Lagoon, Patricia Johanson's environmental sculpture of bridges and plantings was revitalizing a marine food chain and downtown park.

In the past decade or so, a number of women artists have turned the evidently cross-cultural association of the "female" with "nature" upside down. Through recuperative projects for ecologically degraded environments, they have not only identified themselves with their timeless symbol, organic nature, but have simultaneously adopted the traditionally "masculine" position toward it—of "culture" boldly *man*ipulating "nature." Or rather, they have *adapted* it: combining sympathetic affinity and assertive acts, they not only create beneficial works of art but challenge gender stereotypes.

In contrast to the usual plurality of male artists identified with historical movements, the majority of current ecological artists are women. Their works not only are predominant in the genre, but also have been instrumental in making the genre prominent. Yet their recognition is not

an example of a new egalitarianism in the art world, since the appreciation of women's work does not extend to museum and gallery exhibitions of painting and sculpture, where they continue to be underrepresented. Thus the intriguing question: What especially draws *women* to work in natural environments and also allows them to receive a large share of public commissions and attention for it?

This new form of artistic practice has been fed by three currents: art, feminism, and ecology. The course of the stream can be summarized by noting a few outstanding texts. In the sixties: Allan Kaprow's *Assemblages, Environments, Happenings,* 1966; Betty Friedan's *Feminine Mystique,* 1963; and Rachel Carson's *Silent Spring,* 1962. In the seventies: Lucy Lippard's *From the Center, Feminist Essays on Women's Art,* 1976; Susan Griffin's *Woman and Nature,* 1978; and Barry Commoner's *The Closing Circle: Nature, Man and Technology,* 1971. In the eighties: John Beardsley's *Earthworks and Beyond,* 1984; historian Caroline Merchant's feminist interpretation of the scientific revolution as *The Death of Nature,* 1980; and environmental warnings regarding atomic warfare in Jonathan Schell's *Fate of the Earth,* 1982, and ecological crises in Bill McKibbon's *The End of Nature,* 1989. All were influential in articulating issues confronted in current ecological art.

The last three titles in this listing particularly resonate with anxiety; this, and the wide popularity of the final two, also evinces the broadening audience for these perspectives. Artists' increasing attention to the natural environment over the last decade parallels an intensifying apprehension for endangered species and ecologies on the part of the public at large. Membership in environmental philanthropies has grown. Between 1989 and 1992, during a period of economic recession, paid national membership in the watchdog of governmental policy and practice, the Environmental Defense Fund, doubled, to 200,000; that of the now century-old, more social and outings-oriented Sierra Club membership increased 30,000 to 574,000.[1] Public support for legislation protecting endangered wildlife and ecologies is strong, leading to the environment's escalating importance as a political issue counteracting the laissez-faire attitudes of recent United States presidents (when they were not actually showing a *preference* for economic consumption of natural environments).

In the art world, references to "nature" dramatically accelerated in the course of the 1980s. With the waning of interest in the gestural gushiness of Neo-Expressionism, in the mid-eighties attention shifted from emotive figuration to another form of romantic "primitivism":

identification with nature. The historic genre "landscape painting" was taken up by younger artists and gained increasing recognition, but without a curatorial consensus as to how to conceptualize the contemporary views: several of the same artists were included in *both* "Landscape in the Age of Anxiety" at Lehman College Art Gallery in 1986 and "The New Romantic Landscape" at the Whitney Museum of American Art, Fairfield County, Connecticut, 1987. (In these group exhibitions, respectively, five of nineteen artists and five of twenty-four were women.) Concurrently, a profusion of major museum exhibitions highlighted historic precedents, particularly nationalistic ones, and further stimulated the reception of current versions.[2]

By the end of the decade, the topicality of "nature" made exhibitions of landscape painting a staple of commercial galleries specializing in contemporary art. One could cynically view the prominence of this traditional subject (literally *conservative,* as in advocating conservation, e.g., Thoreau's statement "In wildness is the preservation of the world") as the apogee—since the late seventies return to art-as-commodifiable-painting—of the galleries' niche-marketing to conservative, newly affluent, urban professionals. Indeed, most painters of landscapes adopted historic styles of rendering (idealized realism, Luminism, Tonalism, Expressionism) to recapture a similar sense of awe of nature's beauty or forces (e.g., April Gornik, Mark Innerest, and John Beerman). Yet while some works were clearly inspired by nostalgia and served up regressive fantasies, stronger works, by Joan Nelson, David Deutsch, and Tracy Grayson, presented critical alterations of historic genres which evoked disrupted relations to the natural environment. The eighties had opened with much discussion of ideas of "postmodernism" and of recognizing images as mediated "representations." Thus informed, artists recognized that even landscape painting mourning the loss of "the natural" couldn't be sappy effusions recapitulating now-romanticized styles. Nelson's small "aged" panels reproducing details of foliage and sky from "Old Master" paintings—touchingly beautiful and deliberately conceptual—are particularly moving in their evocation of vulnerability, loss, and limits.

In recent years there has been an increasing activist involvement by artists using all media and subject matter, and of both genders and various sexual orientations, with censorship issues stemming from reactionary National Endowment for the Arts funding guidelines. Many have also gotten involved with political-social issues that affect them as members of the general citizenry, such as health care, AIDS research, and abortion rights. In New York, women artists have been particularly

engaged in these issues, making up a large component of the diverse membership of the burgeoning Women's Action Coalition (WAC), formed to hold political demonstrations, write position papers, and protest museums' and publications' exclusionary policies. Concomitant with the expanded number of female candidates in 1992 national elections and their broadly based enthusiastic supporters, and confirmed by female candidates' statements at the Democratic party convention, the courageous testimony of Anita Hill during the United States Senate confirmation hearings of Justice Clarence Thomas seems to have been a defining moment toward personal engagement with the political arena. Women artists' intensifying activism is another aspect of their increasingly direct engagement with the state of the natural world.

In the late 1960s, a (very) few of the male sculptors producing "Earthworks" who were also concerned with ecosystem destruction, notably Robert Smithson, conceived of works aimed at reclaiming natural environments such as strip-mined hills. The 1979 exhibition "Earthworks: Land Reclamation as Sculpture" was a pivotal encouragement of this approach, displaying eight proposals commissioned by the King and Kent Counties Art Commissions (Seattle, Washington, area) accompanied by a major symposium.[3] Significantly, this environmental program, which ultimately built two of the proposals, was sponsored by a region renowned in public art circles for its progressive municipal percent-for-art construction mandates and patronage of adventuresome approaches to public art. This exemplifies the stylistic sources of current artists' environmental approaches, which adopt aspects of rural, remote, very-large-scale "Earthworks" projects and merge them with another environmental art movement initiated in the mid-1960s: urban public sculpture programs. Generally funded by governmental agencies, museums, and (rarely) corporations, current environmental manipulations have profoundly "public," i.e., universal or broadly social, bases: the experience and preservation of nature.

In the past fifteen to twenty years, a small number of artists have dedicated their work to creating problem-solving works that address specific environmental situations; the most recognized of this genre are Newton and Helen Mayer Harrison's numerous plans and programs revitalizing waterways internationally. Betty Beaumont, Harriet Feigenbaum, Patricia Johanson and Mierle Laderman Ukeles have also been working on ecological projects for at least a decade. Yet only with the conjunction in recent years of broadening public concern for environmental issues and the involvement of increasing numbers of artists have

art periodicals and exhibitions begun to acknowledge artists' work in this area. "The Greening of the Art World," is how *ArtNews,* encapsulated "The Ecological Explosion" for their Summer 1991 issue, with typical newsmagazine hyperbole. Almost simultaneously, *Sculpture* magazine published "Breaking Ground: Art in the Environment." By summer 1992 the College Art Association's long-planned issue of its *Art Journal* devoted to "Art and Ecology" was out, and within a few months the major exhibition and accompanying comprehensive catalog "Fragile Ecologies: Contemporary Artists' Interpretations and Solutions" opened at the Queens Museum, Queens, New York, beginning a six-site United States tour through June 1994. A comprehensive catalog of the same name was published.[4]

Yet one of the most remarkable phenomena of this growing interest on the part of artists, critics, and curators is not the engagement with ecological crises—which is admirably, yet appropriately, responsive—but the unusual extent of women artists' participation in this unformalized movement, and its accurate reflection in the degree of women's inclusion in the publications and exhibitions. *ArtNews* discussed the work of four women and six men; *Sculpture,* three women and four men; *Art Journal,* ten women and seven men; and "Fragile Ecologies" exhibited the work of seven women and five men (and described work by several others in the catalog's background essays).[5]

Considered simplistically, women's involvement with ecological environments can appear "natural," consistent with the symbolic association across time and cultures of the gender "women" with organic "nature." Because of their procreative ability and the tradition of having primary parental responsibilities, women have been associated with macrocosmic nature. Signs of this connection are evident throughout historical art. The votive sculpture of the Minoan *Snake Goddess* (c. 1600 B.C.), her fully exposed breasts and her otherwise clothed hourglass figure emphasizing her nurturing capability, grips aloft gold snakes whose characteristic molting suggests her own menstrual cycle. This bold stance can be understood as control over either dangerous beasts or their visually similar male phallus. Christian iconography unites woman, serpent, and tree in depictions of a seductive Eve who as the devil's agent corrupted Adam, resulting in the Fall of Man. That power is restrained in the Gothic period by both secular women's and the Christian Madonna's depiction within an abundant *hortus conclusus,* the "enclosed garden" symbolizing her protected virginity. Women's association with flowers extends across civilizations and centuries, whether as a Renaissance de-

piction of the classical mythology of generative force as in Sandro Botticelli's *Primavera* (ca. 1478) or as part of Edouard Manet's confrontational realism, where a bouquet presented to *Olympia*'s imperious nudity suggests vegetation morphologically akin to the layered "petals" of her genitals (1863).

Traditional archetypes of "woman" associate her with "nature" conceived of as capricious and irrational (contrary to modern science's premise that nature is orderly) in contrast to the identification of masculine qualities with things "manmade": aspects of culture that are reasoned, or socially mediated. The latter have been valued more highly because they are constructed intentionally and are further removed from primal nature. Sherry B. Ortner's insightful essay, "Is Female to Male as Nature is to Culture?" (1974) argued the "universality of female subordination" as a culture's profound and pervasive conceptualization of women as "a lower order of existence than itself . . . 'nature' in the most generalized sense."[6] Women are seen as closer to nature because of their functioning in three nested spheres: (1) "woman's body and its functions are more involved with species life"; (2) "woman's body and its functions place her in social roles that in turn are considered to be at a lower order of the cultural process than man's"; (3) "women's traditional social roles, imposed because of her body and its functions, in turn give her a different psychic structure, which, like her physiological nature and her social roles, is seen as being closer to nature."[7] This analysis by an anthropologist elaborates upon Simone de Beauvoir's statements in her pioneering *Second Sex* (1949; first English edition, 1953) and has been substantiated in historical accounts such as Merchant's *The Death of Nature: Women, Ecology and the Scientific Revolution* (1980). Nonetheless, Ortner's essay remains the succinct theoretical articulation of the twin denigrations of the cultural identities of women and of nature.

When artists establish a strong relationship with nature in their work, they are connecting with society's Other. They are aligning themselves with processes of development and decay that are not made but grown, and that have traditionally been conceptualized as opposite the more sequential, linear process of rational thinking and will. In this schematic, dualistic thinking, nature and its personifications in animals, plants, terrain, and weather represent the irrational, instinctual, or primal, in comparison to humans' capabilities of cognition and self-reflexive consciousness. In art historical terms, this view of nature is akin to that of Romanticism and Expressionism, for instance, J. M. W. Turner's maelstroms in *Rain, Steam, and Speed* (1844) or the undulating torsos of

Franz Marc's *Blue Horses* (1911). In industrialized nations, artists as a group could be considered society's Other, since their work requires that they be both extremely self-aware and inner-directed instead of compliant with cultural conventions, which in turn demands that they continually challenge the (not just artistic) status quo to find their own voices and develop them. Yet female artists are already society's Other not only for their profession but, as seen from a male's perspective, in their gender identity. When women focus on nature in their work, there is a parallelism between their own historically secondary status and that of nature's. Thus it is significant that a number of women artists are now emphasizing just that connection in their work. As most of this work is rehabilitative, either of the viewer's relation to nature or of natural environments themselves, this suggests an identification with the distressed, which the work intends to ameliorate. These women are applying their traditional social role as care-givers to the recuperation of the earth.

The ideology for this position was first articulated in the same year as Ortner's essay, when Françoise d'Eaubonne, in her book *Le Feminisme ou la Mort,* coined the term *"ecofeminism."* Her polemical stance is evident in the blunt title, which can be translated as: *Feminism or Death.* In the linked social oppression of women and human dominance of nature, ecological feminists give predominance to changing consciousness regarding the latter. In contrast to social feminists, who investigate cultural history for sources of women's subjugation, nature feminists or ecofeminists emphasize civilizations' abuse of the natural world. As psychologist Joan L. Griscom noted, the ecofeminist replaces the concept of sexism in regard to women with *naturism* regarding the natural environment: the domination by one (gender or species) of another, facilitated by the emotional detachment produced by viewing the subject as an inferior Other.[8]

Ecofeminism seeks to break the mental structure that establishes difference and fosters dominance and to replace it with one that emphasizes affinity and promotes egalitarianism. This embrace extends to nonhuman species; as the introduction to *Rewearing the World: The Emergence of Ecofeminism,* the major anthology of ecofeminist positions, puts it, "Ecofeminism seeks to reweave new stories that acknowledge and value the biological and cultural diversity that sustains all life."[9] This philosophy of "holism"—that the world comprises an interconnected network of living beings having a nonhierarchical relationship to each other—is actually characteristic of progressive environmentalism as a whole, and is especially true of what is termed "deep ecology."[10] It is a worldview with deeply spiritual analogs, for the perception of cosmic

"oneness" is considered a universal aspect of mystical enlightenment, whether the Buddha's under the Bodhi tree; the itinerant St. Francis's, whose prayers in his *Little Flowers* praises the Lord, "for all thy creatures," including "Brother Sun and Sister Moon"; or Martin Buber's vision of the unity of the "I" and the "non-I," conceived of as "thou." Sigmund Freud called this sense of the dissolution of the boundaries between self and the world, akin to the fantasized prenatal harmony within the womb's amniotic sac, the "oceanic feeling."

Yet doctrinaire ecofeminists would feel uncomfortable with these examples, since they are all instances of experience by males.[11] Ecofeminists' advocacy of a holistic spirit is contradicted by their acceptance of an archaic dualism of "male" and "female" characteristics and their privileging of the latter. In contrast, for deep ecologists the concept of the "expanded Self" is "gender-neutral."[12] This distinction is clearly articulated by ecofeminist writer Marti Kheel:

> There is a significant distinction between ecofeminism and deep ecology, however, in their understanding of the root cause of our environmental malaise. For deep ecologists, it is the anthropocentric world view that is foremost to blame. The two norms of deep ecology—self-realization and biospherical egalitarianism—are thus designed to redress this self-centered world view. Ecofeminists, on the other hand, argue that it is the androcentric world view that deserves primary blame. For ecofeminists, it is not just "humans" but men and the masculinist world view that must be dismantled from their privileged place.[13]

Yet the emergence itself of ecofeminism, as well as of the several other radical environmentalist groups, indicates that this shift away from androcentrism is underway. Feminism has had an impact, and the expansion of gender identities from the strictly biological to the fluidly social has been accelerating over the past century. In this country and Western Europe, more women than ever currently hold professional positions of substantial responsibility and power, in which they draw upon their (much denigrated by schematizing feminists) faculties of reason, among other skills. More recently, men have increasingly been acknowledging their identification with what is traditionally considered the feminine: emotional vulnerability, domestic skills, appreciation for non-rational sources of knowledge. An antimale position is too reductive, continuing the vulgar dualism that social feminists describe as the source of the limitations circumscribing women's roles. In this dualistic view, "Mind and body, spirit and flesh, culture and nature, men and women, all are seen as opposites, rather than complements, and all contain a superior and an inferior half."[14] By its nature, ecofeminist activism im-

plies that women are cleaning up the environmental messes made by men, the historically dominant gender. Yet, to espouse an ideology that privileges the feminine over the masculine violates their own nonhierarchical precepts, which are of course modeled after those of nature itself. An inclusive ideal would be more truly "natural." As Griscom puts it, "In a true ecological vision, all participate equally, rocks as much as persons, males as much as females. All are part of the great community of being."[15]

This integration of two modes of consciousness traditionally called "feminine" and "masculine" is apparent in recent ecological art projects. It is evident in an observation by artist Harriet Feigenbaum that the underlying basis of her work was not literally "reclamation in an environmental or ecological sense but a form of development." A "development" implies growth through a regular progression, a linear, sequential formation such as a situation resulting from a specific event or the methodical construction of a structure or number of buildings. It also implies a bureaucratic aspect that indeed is a customary aspect of ecological works, whose sites and scale generally place them in the public domain even when on remote territory. After persistent searching through central Pennsylvania for a strip-mined site available for remedial landscaping, and after local networking with a city planner, a land owner, and the local director of the federal Rural Abandoned Mine Program, Feigenbaum was able to plant her *Valley of 8,000 Pines* in 1983 (Storrs Pit, Dickson City, Pennsylvania). The form was planned to be arcs of alternating five-row bands of white and Austrian pines that would diagonally cover two opposite slopes of a valley created by strip-mined land between them; the actual pattern of the seedlings themselves was a looser serpentine. The design was both visually striking and ecologically functional, intended, as Feigenbaum wrote, to "prevent soil erosion while at the same time creating an optical illusion of rolling terrain."[16] To complete a project of this scale the artist manifested aspects both of a nurturing sympathy for devastated nature and an aggressive persistence in finding site, funding, and means to obtain the seedlings and get them planted.

Another recent pragmatic ecological work is the *Papago Park/City Boundary* (1990–present) in Phoenix, Arizona, a project for which artist Jody Pinto collaborated with landscape architect Steve Martino to design an environment to restore a Phoenix park's ecosystem. The bursage cactus had been cleared from the park between the 1930s and 1950s, and another cactus whose seedlings it sheltered, the saguaro, was thus lost as well. Pinto and Martino aimed to revitalize the park's ecological balance by a strategy of water harvesting that promotes plant growth as well as

varied animal habitation; their plan uses stacked field stones that control the flow and dispersal of the water. The design of seven-branched steps suggests a "tree of life," an *arbor vitae,* which is an ancient symbol of growth and development both central to descriptions of the Judeo-Christian Garden of Eden and present in American Indians' creation imagery. The multiple elements of this work which was sponsored by the Phoenix Arts Commission and the Scottsdale Cultural Council, demanded that the artist become historian, botanist, hydrologist, visionary designer, and administrator.[17]

Lynne Hull's invention, isolated "wildlife habitat sculptures" sited along Interstate 80 in south central Wyoming in 1990, could appear to be an artist's solitary gift to birds. Hull's eccentric, tree-like forms made of recycled power poles, indigenous materials, and scrap metal provide hawks with safe perches as an alternative to utility poles carrying electrically charged wires. One form includes a nesting platform on which, she has recounted, "this summer a pair of ferruginous hawks raised two chicks to maturity on the nest they built. These large beautiful birds suffer from declining numbers in many areas and have been proposed for 'threatened species' listing by the Bureau of Land Management and other agencies."[18] To produce these works Hull coordinated assistance from biologists from the Wyoming Game and Fish Department's Wildlife Worth Watching program, two landscape architects, the local town government, and volunteers.

While women artists currently predominate in producing ecologically functional environmental art, this experimental mode is certainly not exclusive to them. One male artist whose work manifests similar ecosystem values, research procedures, and practical effects is Mel Chinn, who has received much recognition in recent years for his first ecological work, *Revival Field* (1990–present), which tested plants that absorb heavy metals from soil as a process of "green remediation" to remove toxic waste from a federal "Superfund" site near St. Paul, Minnesota. To enact his idea of utilizing these botanical "hyperaccumulators," Chinn worked with one of the few specialists in the subject, Rufus L. Chaney, senior research scientist at the United States Department of Agriculture. When the plants were harvested, Chaney "ashed" them to increase the concentration of metals; with refinements, this procedure could possibly not only purge toxic metals from soil but recycle it into commercial-grade ore. Yet beyond the pragmatic, Chinn's environment also displays expressive metaphors. Within a square plot of land, the planted field is in the shape of a circle. Both of these balanced, symmetrical shapes connote wholeness, while the circle's unbroken perimeter also suggests cyclical

continuity. It in turn is divided into four equal wedges by two paths that cross in the center. The union of curves and angles thus materialize the synthesis of forces and mentalities that came together to create this environment.

Some of the most complex ecological projects—conceptually and physically—are being created by artist Patricia Johanson. Leonhardt Lagoon in downtown Dallas was essentially "dead" when Johanson was brought in to design its revitalization, a project that resulted in the work *Leonhardt Lagoon* (1981–86). Rain washed lawn fertilizer into the murky water, causing algae bloom, and the shoreline was eroding. It was a five-block-long environmental "black hole" surrounded by museums. Johanson aimed to "bring people in contact with the real world" through an environment that was both "a viable aquatic community and a pleasing work of art."[19] Marine biologist Richard Fullington, head of collections and research at the adjacent Dallas Museum of Natural History, advised Johanson on compatible marine life that could be sustained in the lagoon. She selected two native Texas plants as emblems of the sculpture, used both as plants and as morphological models for the walkways over the water. The twisted root structure of the delta duck potato *(Sagittaria platyphylla)* helps to prevent water from eroding the shoreline, and its serpentine tendrils were echoed in the network of five-foot-broad paths criss-crossing that end of the pond. The forms at the other end were based on a species of Texas fern *(Pteris multifida)* for a network of short walkways, a bridge, and islands. Between all of these reddish paths one can observe fish, turtles, plants, and the birds those species attract.

This ecological project, like others, enacts a rejection of "transcendent dualism," a term used by theologian Rosemary Radford Ruether to describe "that view which regards consciousness as transcending visible nature and the bodily sphere as inferior."[20] The alternate has been described as "an epistemology which integrates reason and emotion, the intellect and the senses, an alternative metaphysics which integrates mind and body and rejects the dualism of the mechanistic position."[21] The works described here are all profoundly experiential, discovered through bodily movement throughout a site as well as visual perception and aesthetic cognition. Art historically, the source of this is interior, site-specific, minimalist installations, which moved outside in Earthworks. Yet in these works the experiential density of the work becomes another aspect of its holistic intentions to unite personal bodily and mental experience with each other and create an intimate relation to nature through art artistically and ecologically manipulated environment.

Johanson was asked to propose a work under San Francisco's per-

cent-for-art ordinance to be created as an adjunct to the planned municipal sewage treatment plant, but eventually her comprehensive approach led to her becoming codesigner of the entire project. After consulting with "all kinds of environmental specialists" (entomologists, sedimentologists, experts in shellfish restoration and endangered species) Johanson conceived of her *Endangered Garden* (1987–present). Instead of working with the environment surrounding the sewage plant, the building was buried, and on its roof was a path running along the shore of Candlestick Cove in the form of the endangered San Francisco garter snake. Other elements in the work provide habitats for endangered butterflies and nesting crevices for birds. Johanson's summary of this project is broadly applicable to all these approaches to utilitarian ecological art:

> *Endangered Garden* is art as activism. It fills in ecological gaps with food and habitat, actually making it possible for species that have been wiped out to come back. Combining art with public recreation and enjoyment, the site is also an educational opportunity. It presents visitors with a miniature world that integrates snake, bird, butterfly, worm, human, and intertidal life.[22]

Suzie Gablik, a zealous advocate of the practice of art that "will begin to redefine itself in terms of social relatedness and ecological healing"; reports in her book *The Reenchantment of Art* being blasted by a fellow participant at an artists' retreat who disputed that that way of working was "something 'new' . . . we've always had the missionary tradition of people who wish to engage the world's suffering and help bring about relief . . ."[23] True, but recent ecological art is distinctly different in the integrative procedures of its missionary position. Gablik attributes this to "the reemergence of certain neglected archetypal aspects of the human psyche, enabling more feminine ways of being to be reinstated in the general psychological patterns of society." Yet without specifying what "ways of being" are "feminine," what makes them so, and why they can be considered primal or "archetypal," Gablik frequently appears to espouse the traditional essentializing schema that characterizes women's fundamental identity as responsive earth mother. This frequently results in reductive polarizations such as "Science is based on the objective weighing of fact and detail, a mode of 'seeing without imagination,' whereas myth is not fully understood unless one enters into a nonlinear, non-Cartesian state."[24] This ludicrous characterization of the practice of science, where in reality one must creatively synthesize if one is to be more than a technician, leads her to also misunderstand the very art she promotes. The truly significant ecological art being done now

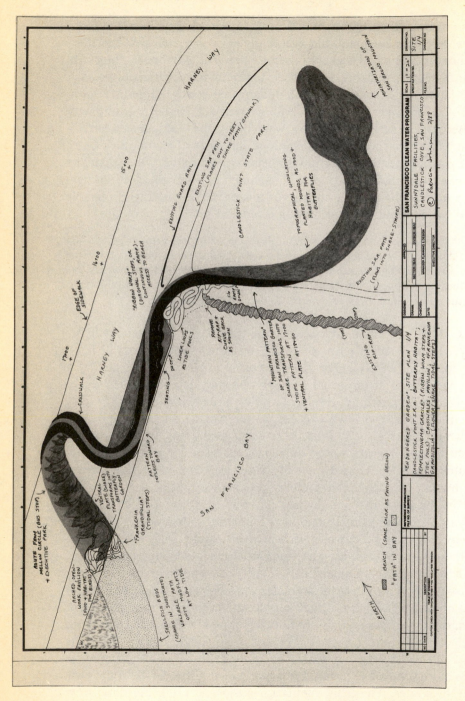

Patricia Johanson, *Endangered Garden, Site plan ¼,* 1988
Candlestick Cove, San Francisco
Acrylic and ink on vellum, 22″ × 34″

involves a union of sterotypically "feminine" and "masculine" modes of being—or, in Carl Jung's terms, of the anima with the animus. As missionaries both teach the "Word" and enact the "Spirit" (the fusion of *spiritus* and *logos*) visionary artists' work with "all kinds of environmental specialists" is the source of a new, utilitarian ecological art, as environmentally redemptive as it is visually stimulating. To paraphrase Percy Bysshe Shelley, These *artists* have become the unacknowledged *administrators* of the environment.

A hundred years ago, in 1892, the word "ecology" was used for the first time. It was derived from the Greek word *oikos,* meaning "house," by environmentalist Ellen Swallow.[25] If we consider our natural environment to be our true home, it's not surprising that those who have long been associated with the domestic sphere, women, are leading in the artistic care of our ecology. But these artists are not just cleaning house— say, ritually clearing litter from a riverbed—but are merging the traditional roles of nurturing mother and authoritative father. They enact an ideal aptly stated by Ynestra King:

> Ecofeminism suggests a third direction: a recognition that although the nature-culture dualism is a product of culture, we can nonetheless *consciously choose* not to sever the woman-nature connection by joining male culture. Rather, we can use it as a vantage point for creating a different kind of culture and politics that would integrate intuitive, spiritual, and rational forms of knowledge, embracing both science and magic insofar as they enable us to transform the nature-culture distinction and to envision and create a free, ecological society.[26]

Notes

1. Information supplied by the membership office of the Environmental Defense Fund, Manhattan, and the press information office of the Sierra Club, San Francisco, September 1992.
2. "American Light: The Luminist Movement 1850–1875" at the National Gallery of Art, 1980; "Views and Visions: American Landscape Before 1830" at the Corcoran Gallery of Art, Washington, D.C., and Wadsworth Atheneum, Hartford, Conn., in 1986–87; "The Expressionist Landscape," The Birmingham Museum of Art and four other American and Canadian venues fall 1987 through summer 1988; "American Paradise: The World of the Hudson River School," at the Metropolitan Museum of Art, late 1987 to early 1988; "Places of Delight: Pastoral Landscapes" at both the National Gallery of Art and at the Phillips Collection, Washington, D.C., late 1988 to early 1989; "Sounding the Depths: 150 Years of American Seascape," Milwaukee Art Museum and five other American venues, summer 1989 through spring 1991.
3. Two of the eight were women, Mary Miss and Beverly Pepper, and two proposals were constructed and remain extant, Herbert Bayer's and Robert Morris's. See *Earthworks: Land Reclamation as Sculpture* (Seattle: Seattle Art Museum, 1979).

4. Robin Cembalest, "The Ecological Explosion," *ArtNews* vol. 90, no. 6 (Summer 1991): 96–105.

 Jude Schwendenwien, "Breaking Ground: Art in the Environment," *Sculpture* vol. 10, no. 5 (September–October 1991): 41–45.

 Jackie Brookner, guest editor, "Art and Ecology" issue, *Art Journal* vol. 51, no. 2 (Summer, 1992).

 Barbara C. Matilsky, curator and author, *Fragile Ecologies: Contemporary Artists' Interpretations and Solutions* (New York: Rizzoli International Publications, 1992). This exhibition will travel to the Whatcom Museum of History and Art, Bellingham, Wash. (February–April 1993); San Jose Museum of Art, San Jose, Calif. (May–August 1993); Madison Art Center, Madison, Wis. (December 1993–January 1994); De Cordova Museum and Sculpture Park, Lincoln, Mass. (February–April 1994); and the Center for the Fine Arts, Miami, Fla. (May–June 1994).

5. All except the *Sculpture* article were written by women, yet this recognition of work by women cannot be attributed to gender bias on the part of authors, because I know of no additional male artists with a substantial commitment to this way of working who were omitted or slighted.

6. Sherry B. Ortner, "Is Female to Male as Nature is to Culture?" in Michele Zimbalist Rosaldo and Louis Lamphere, eds., *Women, Culture and Society* (Stanford: Stanford University Press, 1974), pp. 67, 71.

7. ibid, pp. 73–83.

8. "By *naturism,* I refer to humanity's domination of nature, which has resulted in the ecological crisis. It includes *speciesism,* the belief that humans are superior to other animals. There are other, subtler manifestations. For example since *mind* is associated with human superiority and since *body* is associated with *animal,* naturism includes the belief that mind is superior to body." Joan L. Griscom, "On Healing the Nature/History Split in Feminist Thought," *Heresies #13* ("Feminism and Ecology") vol. 4, no. 1 (1981): 4.

9. Irene Diamond and Gloria Feman Orenstein, eds., *Reweaving the World: The Emergence of Ecofeminism* (San Francisco: Sierra Club Books, 1990), p. xi.

10. Progressive environmentalism is described as a "loose aggregate of movements whose members are called 'new' ecologists: ecofeminism, deep ecology, Green politics, bioregionalism, creation-centered spirituality, animal rights, etc." Charlene Spretnak, "Ecofeminism: Our Roots and Flowering," in Diamond and Orenstein, *Reweaving the World,* p. 4.

11. In addition, two of American literature's most prominent nature poets are men: Henry Thoreau and Walt Whitman.

12. Marti Kheel, "Ecofeminism and Deep Ecology," in Diamond and Orenstein, *Reweaving the World,* p. 129.

13. Ibid.

14. Katherine Davies, "What is Ecofeminism?" *Women and Environments* vol. 10 (Spring 1988): 5.

15. Griscom, *On Healing,* p. 8.

16. All quotes from Harriet Feigenbaum, "Reclamation Art," *Heresies #22,* vol. 6, no. 2: 46–47.

17. Pinto's work is discussed more fully and illustrated in Jude Schwendenwien, note 4, pp. 42–44.

18. Letter to the author, September 11, 1992.

19. Stated during a panel discussion on collaboration between artists and scientists sponsored by the exhibition "Fragile Ecologies" (as in note 4), November 1992, Ronald Feldman Gallery, New York. My review of this panel appeared in *Maquette,* January 1993, p. 4.

20. Ruether's term is central to her book *New Women New Earth: Sexist Ideologies and Human Liberation* (New York: Seabury Press, 1978). It is explicated in Val Plumwood, "Ecofemi-

nism: An Overview and Discussion of Positions and Arguments," *Australasian Journal of Philosophy,* supplement to vol. 64 (June 1986): 121.
21. Plumwood, "Ecofeminism," p. 131.
22. Patricia Johanson, *Art and Survival: Creative Solutions to Environmental Problems* (North Vancouver, B.C.: Galerie Publications, 1992), p. 24.
23. Suzie Gablik, *The Reenchantment of Art* (London: Thames & Hudson, 1991), pp. 27, 116.
24. Ibid., pp. 124, 52.
25. "She envisioned ecology as a new science concerned with water and air quality, transportation and nutrition. She felt that anyone who used natural, life-sustaining elements selfishly was squandering the human inheritance." Katherine Davies, "Historical Associations: Women and the Natural World," *Women and Environments* vol. 9 (Spring 1987): 5.
26. Ynestra King, "The Ecology of Feminism and the Feminism of Ecology," in Judith Plant, ed., *Healing the Wounds: The Promise of Ecofeminism* (Philadelphia and Santa Cruz: New Society Publishers, 1989), p. 23.

VISIBLE DIFFERENCE
Women Artists and Aging

Joanna Frueh

I thank my mother, Florence Frueh, for her stories and her love.

I woke up crying in my parents' house. I was remembering a dream. I sat in an airplane with my mother and I said, "My mother is not a flight attendant." I rode in a cab, then a limo, leaving without my grandmother. But I was holding her anyway, my hand on her white head, my wrist sparkling with the diamond watch she often wore. I asked someone, "Will the airline pay for a bus ticket to Green Bay?"

At 6 A.M. I woke up again and birds were singing. I wondered, Is Green Bay death, or eternal life?

In May Stevens's *Alice in the Garden* (1989), the artist's mother, Alice, clothed in white, forearms and hands, knees, legs, and feet bare, sits in a field where stroke upon stroke of grassy colors seem to ripple, like a sea of immeasurable and horrifying depth. Though sunlight or supernatural radiance illuminates the garden, shadowy undercurrents negate any absolute connotation of Elysian fields. I see my dream's Green Bay, in which Alice, a radiant ghost with an androgynous face, wide hips, a broad lap, and thick knees and legs, is monumental, because of the painting's scale, 7' × 10', and because of her glowing presence and self-absorption.

On the right panel of Vera Klement's diptych *Red Spots/Green Field* (1988), layer upon layer of rich green marks form a thick meadow with

a distant horizon. At once rough with forceful brushstrokes, and inviting, an enormous nest, the meadow grows red splotches like flowers. The left panel depicts a nearly skeletal figure, grays and whites except for the large stomach full of blood or fire. The ashen, "burntout" body has sacrificed flesh, but not the lifeblood that smears the palms and spots the field.

You ask, is death always a martyrdom?

In Klement's *27 Tears* (1991) the big-bellied wraith returns, torso sanctified and impassioned with yellows and reds, ascending through a nightblue sky dotted with stars cum tears and into a white area that is at once window and tombstone.

Cry the stars right down your cheeks until the lies pour from your jaw

Stevens's and Klement's paintings do not treat aging as isolation or death as dreaded end. Their figures exist in the solitude that can be a welcome relief from the urgencies of younger years, a place of escape or release in which a human being renews vitality through recognizing her existence in a generative and sensuously mysterious expanse, the cosmos. Green Bay is passage, euphoria, and transformation.

The paintings image power from the perspective of old(er) women—Stevens and Klement are in their sixties—and provide relief from a society that fears aging and old age and whose ageism operates more virulently against women than toward men and functions to make old(er) women invisible, despite the reputation of women such as entertainer Lena Horne, feminist Gloria Steinem, and actress Jessica Tandy.

Elizabeth Arden manufactures a number of products, advertised in anti-aging language, called Visible Difference. The sheet included in Visible Difference packaging bills it as "the intensive moisturizing system that sets the standard for all others."[1] With Visible Difference Arden promises "smoother, softer, more resilient skin, fewer, less noticeable facial lines, a renewed radiance and youthful glow."[2] Visible Difference's "refining" creams and lotions will purify the aging woman's coarseness and turn the disability of aging into the visible fitness youth mask, an Invisible Difference, like the Emperor's New Clothes: for no one can stop gravity and destiny or pour bottled radiance into their soul-inseparable-from-the-body.[3] Interesting: Stevens and Klement paint radiance as simultaneously inner and otherworldly light, a glow whose source is neither youth nor age.

Visible Difference advertising copy, like that of other anti-aging products, frightens women into feeling that their faces and bodies won't

fit into the picture of femininity unless the women replenish their moisture supply. Arden's scare-and-sell tactic implies that old(er) women are dried up, and it typifies the beauty industry's demand that the sin of fallen female flesh be purified through cosmetic surgery and treatment applications.[4] Men's graying hair dignifies their wrinkles, which society reads as marks of character. When women's reproductive usefulness disappears in menopause, women become the sexually disappeared or the simultaneously celebrated and despised aging sexpot like Joan Collins and Zsa Zsa Gabor. The old male lecher receives admiration as well as ridicule for his hypervirility, but the aging female sex icon's hyperfemininity is society's target for fear of women gone wild, the body finally having a mind of its own when freed absolutely from sexual activity's reproductive consequences. In Western history, witches, most often pictured and tried as old(er) women, have been accused of sexual gluttony.[5] In the Hansel and Gretel fairy tale, the witch actually devours children, and we might today read her ravening as a representation of child abuse, inclusive of sexual molestation. The de-eroticized and neutered older woman has been much less likely than the older man to have a noticeably younger lover, and as she has become untouchable, her osteoporosis or heart attack have not received the degree of study or care that an aging man's health has.

The median age at which women in Western countries stop ovulating is fifty, a time that is a powerful marker of female aging. Age may command respect, but old(er) women do not assume the social or archetypal authority that aging men do. Elder stateswomen are still a rarity, and masters of art are men—the word remains sexually exclusive—whose patrilineage, despite the stature of Louise Nevelson, Georgia O'Keeffe, and Louise Bourgeois, remains in place. Aging is no lark for most art world players, but women artists suffer from art historians' and art critics' unwillingness to reference a contemporary and art-historical matrilineage or from their unconscious denial of it, from the art world's youth/beauty orientation, in which sex is a lubricant, and from a gendering of power that turns the interests of socially incorrect-looking old(er) women into trifles.[6] As multimedia artist Leila Daw says, "Many people in the art world don't consider [menopause, death, isolation, the aging and aged female body, or aged and aging women's sexuality] to be interesting—which is worse than considering them inappropriate. Inappropriate gets publicity. Uninteresting gets ignored."[7]

Moreover, "crone" and "witch," which some feminists use as words of power, are not popularly understood as respectful terms, Uncle Sam

is a far cry from Aunt Jemima, and neither the Cumaean Sibyl nor the Pythia has the fame of Father Time.

> *I see with sore eyes*
> *I say, Let pictures of a golden age develop*
> *green bays, time-spotted skin, hair dyed unmanageable colors and let go*
> *wild and white*

We called my mother's depressions black. She did not talk about her hysterectomy. I knew she had had an operation, and she stayed upstairs most of the summer after she came home. I felt like a terrible daughter because I thought I could have given comfort. Only five years ago did Mom and I start talking about her blood mysteries and misfortunes, and more recently my grandma's—her abortion, the bloody basin in her mother's bedroom when Mom came home from school, the doctor who had done the work, and Grandma in the living room telling her women friends she was all right. Mom's hot flashes were terrible, she said, for years, and she thinks her hysterectomy was unnecessary. A year ago, at age eighty, she said, "Every day is a surprise. I never know what my body is going to do."

No one knows what her body will do in its daily changes of identity.

I am not interested in prediction but in experience and in prophecies whose roots are sagas and shorter stories told by old(er) women. Originally saga meant female sage. The Pythia was an aging sage and seer whose words listeners had to interpret when they sought her wisdom and her healing at Delphi. *Give me my golden labrys, my silver tongue.* For she spoke in contradiction, oxymoron, poetry, paradox, gibberish, rhyme, and intellectual erotics on whose translation listeners believed their future depended.

I am interested in women artists over fifty, who deal with aging in their art and who act within the art world of galleries and museums, gossip, criticism, curators, and publicity, because they work from a position marked as old(er). I am interested in women's imaging of age and aging, in contrast to prevailing representations of old(er) women and as the manifestation of a new social reality, a visible difference.

Old(er) women's art-making is action and prophecy, the creation of a possible world: populated by hags, crones, and witches who do not fit into their popular conceptions as Halloween and fairytale horrors; in love with the aged and aging woman's voice. In my mid-twenties I read an article, unidentified as to author or date, titled "The Voice." The yellowing Xerox I've saved reads, "No word spoken is ever lost. It remains and

it vibrates.'' Once seen, images live in a similar way: they resonate, they hum or scream within a culture, make other images possible and prophesy the future.

Old(er) women artists' prophecies are not cause for celebration untouched by conflict, for celebrants would be naively sentimental journeyers. While Simone de Beauvoir's classic *The Coming of Age* may be too negative about old(er) women for many tastes, Judy Hall's *The Wise Woman: A Natural Approach to the Menopause* may suffer from spiritual romanticism. Ruth Raymond Thone's *Women and Aging: Celebrating Ourselves,* despite its title, deals with grief, loss, guilt, and discomfort with appearance as well as with having and taking time to honor one's own passage into a new life.[8] The subject of aging, women, and art is fraught with contradictions and untidy facts and perceptions: highly individualized bodily and psychic experiences of menopause, which may affect an artist's imagery and professional confidence; women's ageism against women; feminists who won't tell their age, not, they say, because they have an inordinate fear of aging, but rather because of how society perceives old(er) women; African-American women artists who, in greater percentage than their European-American counterparts, want to maintain anonymity regarding their words about the art and aging issue; the simultaneous respect and lack of respect or professional visibility and invisibility that many over-fifty women artists feel.

At forty-four I'm concerned that I'm too young for my project, because I think of Baba Copper saying in *Over the Hill: Reflections on Ageism Between Women,* when she was in her sixties, that old women can't count on women in their forties and fifties as allies. Midlife women, she says, can often pass as young enough, but they may release the anger, fear, and misunderstandings regarding their own future against its present manifestation, the visibly old woman.[9] Filmmaker Barbara Hammer says, "We 'old' lesbians are about sixty or so. A woman has to earn her oldness. At one time in my forties I attempted to join an older women's group and was told to 'take your daughter energy elsewhere.' " The daughters remove themselves from elder women and call themselves sisters. The sisterhood of the women's movement has excluded cross-generation sorority. Revolution and liberation are hollow if only for the young, but the daughters separate themselves from old women in a long-lived manifestation of patriarchal and filial control, the divide-and-conquer politics of female competitiveness: I am different from you becomes I am younger, prettier, better, so I will not identify with you.

Thus love is lost and women lose their way. While the current multicultural imperative demands more than lip service to action on behalf

of diverse races, classes, and ethnicities, the word "love" does not appear in the rhetoric. When artists and art thinkers write about crossing the borders of differences, love is not part of the basic vocabulary of change. Nor has postmodernist ironic distance permitted love a place in art.[10]

> *I will kiss the tears from your sad lips*
> *That have mouthed correctnesses and kissoffs*

Love, like the bodily fluids that keep human beings alive or that we must expel for health, remains an embarrassment. Love, however, is prophecy, for love unleashes the future from the rigidities of the present. Prophecy does not speak predictabilities but rather unknowns that ring true in the current holocaust of hearts. Love is a deep attraction to differences—the earth loves the sky, otherwise this planet would fly apart—and love allows the young(er) woman to identify with the old(er), her speech reshaped by a stroke, her unremitting backache that neither doctors nor acupuncturists nor naprapaths can name, and with the psycho-centers of continual bodily transformation. I say, To commit to love is to end the generational divorce that permits the feared and clichéd isolation of old age to exist.

I select pearls fresh from my grandma's grave and wind them around my throat. They are my wedding necklace, and I am married to her. We sit together on her bed after her first stroke and she tries to tie her shoelaces. In the impaired tongue of her injury she says, "I am worthless." I say, "No, you're not. I love you."

That beauty promotes love is an ancient philosophical idea and a contemporary underpinning of beauty-product advertising. The old(er) woman may submit to medical and cosmetic "fitness" experts, but she will fail as a love object because female aging remains in American society what writer Susan Sontag called it in 1972, "a process of becoming obscene. . . . That old women are repulsive is one of the most profound esthetic and erotic feelings in our culture."[11] In America today the media, cosmetic surgeons, and many women themselves see the aging woman's face as ugly and deformed and her sexuality as damaged. Despite the beauties or camouflage of fashionable or expensive clothing, people know veined, brown-spotted body flesh that answers to gravity, and they also know that the difference between wrinkled and surgically smoothed facial skin and between gray silver white or dyed hair is a difference in money, time, and self-confidence or -indulgence. The old(er) woman is doubly different, doubly degraded, and doubly injured by exterior identity: she

is visibly female, different from men, and visibly aging, even when cosmetically altered, different from the young.

Aging women's visible differences, and the changed psychic and physiological ground from which they manifest, disgust and frighten society to such a degree that in an effort to secure its members against ugliness and death, which society uses the old woman to symbolize, no socially active defined role exists for the postmenopausal woman and she fades into invisibility. The designation of grandmother continues in European-American culture to carry the burdens of sentimentality, though female elders in Native American communities embody authority and African-American grandmothers—who may be in their thirties—are often the bedrock of a family. In American culture at large the Grand Mother, a wisewoman, is a fiction awaiting incarnation.

The theme of invisibility runs throughout the literature on women and aging and recurs in the comments of women artists over fifty. The consensus in the literature is that at age fifty or so a woman becomes invisible.

> *Mirror mirror in my hand*
> *I the glamor lifting bans*
> *I the beastly breath of night*
> *I the Ministry of Sight*
> *I the Tongue That Strangles Wrongs*
> *I who sing Grandmothers' songs*

While feminist Germaine Greer believes that invisibility, though likely to be shocking initially, leads to freedom, for finally a woman need not submit to heterosexual compulsion—the looking and stalking of sexual/reproductive pursuit—or compulsory heterosexuality—acting out a model of femininity—invisibility in the art world may mean the unlikelihood of selling the art/artist package.[12] Because many dealers like to groom young artists and their preference runs to men, old(er) women are not prime competitors.

I think that I would have more serious gallery response if I were twenty-five and male.—Jessica Holt

When I finally made the rounds of New York galleries at the age of fifty-one, few showed interest once they met me. One factor was my "advanced age."—Ann Stewart Anderson

Is someone going to say, "I don't buy the work of a fat, frumpy old battle axe!"? At a recent gallery opening (I was one of the exhibiting artists, and the oldest by about fifteen years), everyone ignored me except

the gallery director who had invited me. I felt like I had a disease, or I was naked. It could have been the work—I have not chosen an art form that is readily accepted as "art," and this was a new gallery for me. The owner was twenty-three years old, and she never even said hello.—Mary Lee Fulkerson

Young people are curators and react to the "older woman." Perhaps they see a "mom."—Anonymous

I have been told by one dealer—a woman—that women artists over fifty or so do not change in their work or grow in their ideas. This was the reason for her rejection of my work.—Barbara Aubin

I feel there is so much discrimination toward women in the arts that I cannot separate that from the fact that I'm "older." I suspect the discrimination may double.—Judith Miller

Women artists speak the truth of experience and perception.
Truth does not speak in one voice.

The more years I'm around, the more I have to be reckoned with, even if it is to dismiss me.—Emma Amos

My sales increase and my prices go up each year.—Mary Lee Fulkerson

People take me more seriously because I have a graver presence than when I was young. They see in my face and in my images more visible struggle, an ability to be more authentic and empathic.—Eleanor Rubin

I believe that getting older gives me more credence. I am getting a new kind of appreciation and admiration. Good art is less threatening from an older woman.—Suzanne Benton

Looking enticing and seductive may have awakened interest, but not necessarily in the art, and did not in the long run help professionally. I believe the force of maturity, confidence, conviction, and a good track record of achievement are stronger benefits [than good looks].—Joyce Cutler Shaw

As I age I'm accepted more for my art not as before because I was an attractive woman. People take me more seriously not solely because age has made me wiser but now how I look doesn't interfere.—Anonymous

Had I not experienced firsthand the *reality* of being a woman aging in our culture, and felt the tremendous change in the reactions to me, I don't think my focus would be as keen as it is. It feels as if our culture wants me to feel marginal just because I am no longer young. The changes in my body and appearance have not affected me as they have the world.

I am beginning to feel a sense of respect for tackling the topic of aging women.—Ruth Hollis

At approximately the age of fifty I became a "pioneer," a "classic," a "mother" or a "grandmother" of avant-garde or lesbian film, depending on who was relating to me. I notice more deference in attitude, more respect, more acclaim from most everyone, younger women and men, as well as curators and collectors. It came as a surprise at first and really was what marked my age to myself. The other, so to speak, told me I was now old or nearly old.—Barbara Hammer

I have many more opportunities and invitations as I get older. I think it has to do with my energy and enthusiasm. Work is life.—Ruth Laxson

Old(er) women can become invisible due to lack of interest in them as the subject of art. Photographer Joanne Leonard relates, "Funding proposals I made at University of Michigan [where she teaches] were originally deemed too personal and not sufficiently objective. I did not describe in these proposals the concerns about body's and mind's decline in age that would come to be at the heart of recent work [about the women in her family and her mother's Alzheimer's disease]. Just mentioning the subject of my grandmother was enough to turn off the funding committee."[13]

Generational separation may also contribute to old(er) women's art world invisibility. Critics, for instance, may support art whose creator they identify with. Only in the past decade has a noticeable change occurred in critics' attention to artists whose race is different from the critics', but the notion that only younger artists are capable of creating significant work that advances cultural dialogue catches critics, young and old, in the trap of ageism. Conceptual artist Edith Altman is blunt: "Fifty is very different from sixty. I feel invisible. Younger critics don't know who I am."[14] Altman received a National Endowment for the Arts fellowship in 1990 and exhibits regularly in Chicago, where she lives, and in Europe, so her presence is distinctly visible. The exhibition for which she used her fellowship, a monumental installation concerning memory, healing, victimization, and the Holocaust, received one significant review. An older woman wrote it.[15]

> Take apart the taken for granted
> unwrap your wound
> blood undulates from infection into false soothsayers' mouths

Women elders in art, unlike aging men, endure Daughterism.[16] Whereas younger men artists can still play the honored Oedipal game of

son deposing father/master while simultaneously enjoying the benefits of patrilineage, the illegitimacy of matrilineage permits many younger women to play male heir and bad boy and to rebuff the "mothers" of feminist art who opened art world territory to women in the 1970s. Like the female child who rejects her mother in order to assume feminine, heterosexual "normalcy," some younger women artists continue to repeat the Elektra complex: They are attached to the male-dominant art world and hostile toward the mothers whom the father-critics, -curators, and -dealers never wholeheartedly accepted. (Fathers can be women just as daughters can be sons.)

Stevens says a woman artist on two occasions " 'othered' me, because I was older." She feels the attitude was, "You're a stranger, tell me about that strange place you're in and from," and she experienced "a lack of acknowledgement of our communality." Painter Joan Semmel, who has also felt "othered" by younger women despite the respect she receives from them, says, "When young feminists come out [in the art world], they dissociate from women of the seventies. They see you as not having a present. You're all in the past."[17]

The labels of "first-generation" and "second-generation" feminist, applied to artists, critics, and art historians, began to circulate in 1987 and have not died.[18] First-generation is equated with an essentialist and revisionist feminism of the 1970s and is considered obsolete, whereas second-generation feminism is praised for postfeminist, deconstructivist advances. The generational terminology plays into a stereotype of aged and aging women focused in an outmoded past.

Postfeminists of the 1980s and 1990s, involved in appropriationist and postconceptual genres, disconnect from feminists who originated and developed the women's art movement of the 1970s. The so-called crisis in representation invalidates painting and the positive use of the female body, live or imaged: Painting can no longer be authentic, and the positive is renamed romantic, essentialist, and naive. Painting also bears the burden of Western European tradition, its development as a high art practiced by white men. Many feminist artists over fifty paint, and some use or have used the female body, sometimes their own, as an empowering vehicle.[19]

Socially correct mothering assures daughters' successful assimilation into the worlds of work and culture where men's power holds sway. Because art mothers produced images and ideas that radically departed from the (male)dominant art world's notions of importance, the art mothers could do little but contribute to the unattractiveness of daughters who listened. And daughters have failed mothers. As artist Hannah

Wilke says about Cindy Sherman's 1992 exhibition at Metro Pictures in New York, which received numerous and positive reviews and which featured large color photos of prosthetic mannequins, one resembling a stereotypical witch in extreme sexual display and another suggesting a literal "old cunt," "Why does the art world like horror aging? It's like Star Wars." Wilke's self-portrait drawings and photographs of what she called her "beauty to beast" transformations as she underwent cancer therapies in her fifties contrast starkly with Sherman's counterfeit reality.[20]

Perhaps failure resides in the psychological primitiveness of equating old(er) women with the mother. Not only do "our earliest attempts to release the hold of maternal entity" result in "a violent, clumsy breaking away," according to theorist Julia Kristeva, but the incest taboo against the mother demands that the daughter, no matter what her adult sexual pleasures may be, repudiate erotic longings for the mother figure.[21] The daughter damns the maternal body and with it her own autoeroticism. The grown daughter must make a gentler separation so that desire for the old(er) woman, and in that, one's future, does not disintegrate in the trauma of one's own psychological history.

> *Grandma said We are here to suffer*
> *Take my words eat my words*
> *Blood mysteries and mishaps continue*
> *No will No way No do No get*
> *Shotgun war viral infections, menses childbirth menopause*
> *I look different from the young*
> *White hairs veined hands legs and feet*
> *I tell you myths I tell you true*
> *I give you my word*
> *Fatten your heart*
> *Under my eyes sleepless nights reign*
> *I Glamorpuss*
> *Who holds the wiseblood where it hurts*

Anne Noggle's black-and-white photographs of her own, her mother's, and her female friends' and acquaintances' aging and old faces fiercely break the spell of invisibility. In 1975, at age fifty-three, Noggle had a facelift. Before and after pictures show every pore, crease, dark shadow, and postoperative bruise. In *Face-lift No. 3* she delicately holds a flower to her chin and takes the stem between her teeth. Her puffy-lidded eyes scrutinize the viewer as the viewer assesses the healing process of a procedure whose aftermath calls battery to mind. *Self-Image in Cochiti Lake* (1978) shows Noggle floating and frontal, no Ophelia, ele-

gant in three strands of pearls and sensuous with her swell of breast and full, sunlit face: A vision of loveliness emerges from the culturally submerged beauty of maturity. Noggle's hair melts into watery shadow, her angel arms spread, like the crucified, and I think of women accused of being witches who had to prove their innocence by floating after being swum, thrown bound into water. Noggle rises face first.

Like Noggle, Claire Prussian has an abiding fascination in women's aging. She began a series in paintings and drawings of old(er) women's hands in 1975. In 1984, at age fifty-four, she completed the obsessive and labor-intensive *Sutured Self.* Prussian cut a lithographic self-portrait into ninety-nine squares, then handsewed the pieces back together. The grid they form is a sign of order, containment, and wholeness, but it is deceptive, a covering up of the inch-by-inch scrutiny that is an aging woman's visual and psychological self-torture. Surgery requires suturing, but Prussian's expression of near maniacal worry indicates that the attempt to take herself apart and put herself together, to (psycho)analyze herself bit by bit, has resulted in an incomplete picture: spaces between pieces, stitches, and the "loose ends" of thread at regular intervals.

The 1985 diptych *Woman on a Red Couch* continues Prussian's self-evaluation. In the left panel sumptuous colors and belongings—crimson couch, emerald-green dress, and purple pillow—embrace a seated woman who, despite the visibility of the lower half of her head, is faceless. Her arm extends into the right panel, where the scale shifts and a large hand with scarlet nails grips a vanity mirror whose entire face is Prussian's. The young and bewitching Venus of European painting has become the old and beseeching Everywoman. Pleasure and supposed conceit turn to pain and doubt, and in the painting Prussian seated cannot see Prussian reflected. The old(er) woman cannot see her self because her age is magnified by society into her only and monolithic identity, which defaces her.

Athena Tacha, born in 1936, has been recording her aging since she was thirty-two by keeping a diary of changes, published as artist's books in 1974 and 1987, and by photographing her face and body three times each year, not necessarily during the same session. The title of the 1987 book is *Reaching Fifty: The Process of Aging, II.* Reaching suggests accomplishment and pride, but along with such feelings Tacha describes "disfiguring" changes such as "deep grooves [that] have formed from nose to chin along the mouth," the sagged "flesh of the cheek on either side of my chin, creating two distinctly baggy areas that spoil the formerly smooth oval shape of my face," and the loss of her smile's "sweetness due to the increased wrinkles under and around the eyes."[22] Her clinical descriptions and explanations—getting too little sleep over a prolonged

period of time, deaths and illness of friends and family—outline the change from femininity as sexuality and beauty to femininity as wretched excess—too much flesh in the wrong places, what Noggle calls the "saga of the fallen flesh," and what I have discussed as "the fear of flesh that moves."[23]

Noggle writes,

> *are we granny or auntie or old lady down the street. I have*
> * lost my way*
> *and my face reminds me of that. Every stop and start, love and*
> * loss legible.*
> *A whole individual story and who will read it.*
> *Who will look at my face and find me there?*[24]

Everyone has lost their way, for we are burning in the holocaust of hearts, and everyone has lost their way if we believe in theorist Jacques Lacan's "mirror stage," which splits self from image: When an infant first sees herself in a mirror, she is here and there, un-unified. Incompleteness, lack of an absolute identity, allows stereotypes, which operate in the social psyche as original and absolute identity, to cling to old(er) women. Old lady, granny, witch, and hag are permutations of the larger stereotype that pictures postmenopausal women as ugly and obscene. Matron is a kinder word that encompasses the stereotype, which is a monotype. *Lear's,* a fashion magazine for old(er) women, also presents a monotype, the coercive model of beautiful youthfulness, which a woman can supposedly maintain indefinitely if she takes responsibility for her health and appearance.

"Old" derives from the German alt, whose Indo-European base is *al,* to grow, and from the Latin *alere,* to nourish.[25] Postmenopausal women need to grow away from the monotype, to nourish themselves by creating and loving a proliferation of polymorphous representations of old(er) women. Polymorphous representations are contra-dictions, voices speaking against cultural dictates that function as self-fulfilling prophecy. Women's embrace of polymorphous possibilities allows for greater personal comfort than an unwitting becoming of the monotype, which violates the multivoiced soul-inseparable-from-the-body and corrodes the conscience. Despite the ascendancy of critical theory that proclaimed the death of authorship (as women artists in the 1970s asserted their own artistic voices) and whose credence has not waned, the authorship of oneself as an old(er) woman is serious business.

Aspects of gender theory are helpful in construing postmenopausal polymorphousness and in understanding its aesthetic manifestations. If

the feminine is other, margin, and chaos, and therefore socially disruptive, then the old(er) woman, in her obscene and ugly wretched excess, is even more threatening. If woman plays absence to man's presence, then old(er) women can be polymorphously perverse by not fading away. If femininity, like masculinity, is an illusion, a cultural construction that marks female bodies into social submission, then gender is a repetition of performative acts that the old(er) woman, who is no longer identifiable as stereotypically feminine, the contemporary imitation of Venus, can outrageously parody. If the postmenopausal woman shares with the lesbian and gay man a nonreproductive eroticism, then she, like them, can defy and transgress gender restrictions, compulsory heterosexuality's demand that the female soul-inseparable-from-the-body be feminine. If menarche means taking on the veil of womanhood, then menopause means throwing off the veil and growing into the glamorously redundant "a-woman," to use theorist Teresa de Lauretis's term, who recognizes her (once-) gendered subjectivity as well as her acts and thoughts that do not conform to its authority.[26]

Greer believes that old(er) women, once they become invisible, must also become matrons, which, for her, means taking time for oneself, taking care of one's health, developing one's spirituality, pursuing creative and intellectual interests, tending one's garden, and enjoying the relief of being left alone by men. Such pleasures and necessities, she says, are the aims and outcomes of serenity and power.[27] Greer's advice is realistic and severely loving, but the matron, the essential old woman, as the one answer, does not permit polymorphous possibilities. These prophecies appear in old(er) women's art as gender and age parodies, testimonies to glamor, and fierce and fearsome archetypes.

Joan Collins and Zsa Zsa Gabor are parodies of femininity: They are imperiously inappropriate. Gender parody exaggerates the illusion of femininity, scandalizes and sacralizes—Mae West was a joke and an idol, a monstrous beauty. Hyperfemininity coupled with age emphasizes oldness, precisely because ageism defeminizes women; exposes the feminine act's absurdity; and aggressively asserts the mythic, the Sex Witch, erotic Grand Mother.[28] The outlandish Sex Witch is a shape shifter because she toys with femininity—and masculinity. Her experienced play provokes intolerance and pity and also stimulates love.

> *Love binds*
> *Catches you redhanded*
> *Love necessitates commitment*
> *Water commits to fish and coral*

Death commits to life
Whip commits to skin
Rose commits to sun
Virus commits to blood
And you who are committed
You are crazy
 for the beloved
 for the wisdom: all beloveds are the lover

Elise Mitchell Sanford photographs old(er) women costumed as famous women or men of their choice and assuming a celebrated pose of the renowned person. One woman is Marlon Brando in a T-shirt, another Betty Grable in a bathing suit, and we see a seductive Greta Garbo, a robed Thurgood Marshall, and a whimsical Albert Schweitzer. The mask of portraiture as a true picture of the subject collapses in absurdity, disjunction, and playfulness and reconstitutes in the affirmation of excessive or seemingly incongruous identities revealed through the subjects' fulfillment of fantasy and identification through admiration.

In a 1992 performance titled *Blue Velvet* Charle Varble wore a symphony of blues and purples: velvet dress from the 1960s that snugly fit her trim torso and revealed shapely legs, a veiled hat over short black hair, one evening glove, and makeup that was colorful and highly decorative. She looked like a painted woman and a fresh-faced fifty-six-year-old, and as she told a story that interwove past and present people in her life, including members of the audience, in a poetic, mystical, and humorous web, she at one point caressed young men in the audience with a long feather. Phallic and feminine, (grand)mother and seductress, Varble demonstrated her talent and skill at what she calls "confusing" people. That does not exemplify passing for young(er), which is an act rooted in fear, but rather demonstrates that age is a fluid reality and concept. Greer faults postmenopausal women who try to pass as younger for being "garish," "unesthetic," and "heartbreaking," but she makes no distinction between the fear of losing sexual visibility as one ages and the power of parody.[29]

Rachel Rosenthal says in her performance *Pangaean Dreams,* "I am a gay man in a woman's body. . . . Men don't want me because they sense something funny. Gay men don't want me because they see me as a woman. Women want me, but I don't want them because I want men, but not as a woman." Rosenthal's appearance, movements, words, and costumes both confound and concentrate age and gender specificity. Shaved head, wrinkled face, neck, and hands, tai chi–like groundedness and grace, Kabuki-wizard robes and camouflage jumpsuit, confessions, curses, incantations, chattiness, and giggles speak of an androgyny that

lives beyond, on one hand, simplistic models of pretty boys and sensitive men and, on the other hand, macho girls and leather Aphrodites. Rosenthal speaks of an autonomy and autoeroticism that connect the Crone, which Rosenthal calls herself, and the Virgin. The Crone is an archetype of sacred darknesses and cycles, such as Death and Passage, and she is female power at its most experienced. The Crone is the long-lived wise-woman.[30]

Fantasy and imagination redeploy the powers invested in gender and give human beings the ability to eroticize anything. The erotic is not only genital sexuality but, more expansively, a rich engagement in life, responsive and responsible living that are rooted in commitment. The erotic bears a relation to glamor, which Stevens calls "vitality, the life of the mind, always moving."[31] The erotic intellect seizes the degraded and the taboo and glamorizes them, bathes them in a magical light that warms their own radiance into visibility.

> *Transform the degraded into the beloved*
> *Bring visibility to the invisible*

Georgia O'Keeffe's monk- and nunlike "habits," which she had made for her, and Louise Nevelson's ethnic butch/femme drag are manifestations of the erotic intellect in action.

Ann Stewart Anderson and Leila Daw glamorize menopause. Anderson's painting and fabric construction *Fan Cover* (1985) shows a woman luxuriating in a hot flash. Semireclining in a flowered sundress, she raises her arms in a sexually available gesture.[32] Her skin is bright red, and she seems to be hot in more ways than one. Daw's *Red River* is a lament and a commemoration. In autumn 1991 she and helpers planted seeds in a spacious lawn on the Centenary College campus in Shreveport, Louisiana. The seeds have grown into a river of wildflowers indigenous to northwestern Louisiana. *Red River* is literally alive—germinating, blossoming, drying, and dying—and it is a lyrical equation of Mother Nature and the female body, which produces its own red river of menstrual blood that ceases flowing after menopause.

Theorist Mary Daly defines glamor as "the Attracting/Magnetizing Powers of Hags," and she defines a Hag as "a Witch, Fury, Harpy who haunts the Hedges/Boundaries of patriarchy, frightening fools and summoning Weird Wandering Women into the Wild."[33] The artist as Hag summons women into the wild of their own aging.

I, a perimenopausal woman who in her adulthood has rarely worn red, lately imagine myself in that color. As I envision the vanishing of visible blood, I must replace it with a color I can see.

Years ago I heard a story about an old woman who was shopping in a department store and looking for a red dress. A saleslady told her, "Old women don't like bright colors."

Today I see red on women politicians young and old.

> *I Glamorpuss the Pythia always wear red*
> *Lipstick when I'm naked*
> *And when I see my mother, her skin soft as suede, I love the scarlet on her lips. Mother's face, my father says, is heart-shaped. She says, I am an old lady, and I don't stop her.*
> *Word of Beauty: Lady.*
> *Our Lady of the Brilliant Mouth*
> *Our Lady of the Love-Formed Face*
> *Our Lady of Sorrows—back pain and Tylenol with codeine*
> *Our Lady of Bedtime Visions*
> > *I see millions of faces, she says, and I think I'm going to be joining them*
> *Our Lady of Many Years*
> *I Pythia knew Asclepius and he gave me the serpents from his own caduceus. I've loved them like I love my Python, who tells me stories from the underground. Python says, I see the snakes are rising on the backs of your hands, I see the spiders have been spinning webs all through your legs. Then Python curls around my calves and knees until, head in my lap, the hiss of Python's voice turns to a throaty whisper, and I hear the song I've sung to my mother many times: You didn't have to love me like you did but you did but you did and I thank you.*

In Western art and contemporary popular culture the eroticized woman is the nude, clothed only in conventional glamor. The contemporary icon of American beauty doctrine is "in shape," and she conforms to an ideal shapeliness that harks back to the classical Greek nude, a measure of order, rationality, and harmony. Art historian Kenneth Clark writes that "on the whole there are more women whose bodies look like a potato than like the *Knidian Aphrodite.*"[34] Apparently, real female bodies embody formlessness, which threatens society, itself built on ideas of form in contrast with bordering nonform. Aging women are excruciatingly aware of the visible changes in form that occur before their own and others' eyes, the "shapelessness" that makes them, even more than young women, unable to be the incarnation of perfection. If male ego is comforted by the toned and shapely woman who represents the phallus, then the aging woman whose flesh sags and wrinkles and whose body may even shrink due to calcium deficiency is surely a horror. Yet the nonphallic female nude must be seen in order to not be obscene. Like the black female nude, she has been all but invisible in Western art.[35] Love and

terror lie in the unknown, the flaunting of flesh that moves, the polymor-phous particularities of old(er), experienced female bodies. The experi-enced body is deeply erotic, for it wears the lusts and (ab)uses of living. The experienced female nude is unruly, for she contra-dicts the sex object status of most female nudes. Perhaps the aged and aging female body can become an object of love, for the old(er) woman herself to have and to hold.

I imagine a gallery filled with images freed of the fear of flesh that moves:

Alice Neel's *Self-Portrait* (1980), in which the eighty-year-old artist is the Grand Mother who defies the derogation little old lady;

Prussian's *Still Life* (1985), a lithograph whose opulently blossoming and diverse flowers indicate the level and complexity of life still flourish-ing in the reclining figure;

Noggle's *Stellar by Starlight* series, begun in 1986, in which she, accompanied by young men, frolics naked and tiara'd, like a Rococo Venus, in the vapor of Jacuzzi steam and a fogger;

Klement's "lumpish" self-portrait swimmers whose stretches are meditations and whose praying is athletic;[36]

Semmel's sauna and locker- and shower-room paintings (1989–92) that highlight old(er) women's unselfconscious relaxation and dressing;

Carol Mothner's *Mary, Age 80* (1989), a graphite drawing of the subject holding a teacup in veined hands, pubic hair white, posture bely-ing the work of gravity on her skin;

Bailey Doogan's *Mass* (1991), in which a screaming-in-prayer woman looks as though all her flesh is alive with an energy at once physical and spiritual.

As I look I hear Doogan saying, as she did when I interviewed her, "Freedom's just another word for nothing left to lose."[37]

In the holocaust of hearts the old(er) woman's body is malformed, a lost cause, and she is a monster. The word "monster" comes from the Latin *monstrum*, divine portent of misfortune. The old(er) female nude portends the undoing of perfect femininity and feminine perfection, and she is related to artistic assertions of fierce and fearsome archetypes. Like feminists in the 1970s who reclaimed the word "cunt" and lesbians and gay men now who reclaim the word "queer," aging women reclaim "crone," "hag," and "witch," archetypes of Medusan dreadfulness and glamor. Just as Medusa's "evil eye" turned men to stone, the experienced eye in the experienced body destroys grandmotherly niceness and takes the viewer on a subterranean journey, into the postmenopausal under-ground that conducts guerrilla warfare on the culture that makes women

afraid to walk alone at night and that simplifies old(er) women into caricatures of matronly invisibility.

In Stevens's *Fore River* (1983) two Alices sit in tumultuous darkness on either side of a columnar vortex that is a troubled white, like Alice's clothing. She gesticulates stiffly and passionately, and her hand gestures read as personalized blessings, arthritic mudras, sacred actions that part the darkness and say, Let there be light.

A seemingly stereotypical grandmother sits knitting in the middle of Ida Applebroog's *Rainbow Caverns* (1987) along with birds and ears of corn that compose an eerie landscape of light pinkish-purples and pale burnt browns, colors that fill in the old woman's outlined form. To her right a man and woman copulate in three positions, to her left a titaness female bodybuilder poses, and above, in eight frames, a story of apparent child sexual abuse unfolds. Grandma plays an implied role in the story, and she is hardly the calm center at the eye of a storm of sex and memories at once faded, bloody, and raw, like Applebroog's palette.

In performance Rosenthal the Crone is the spectacular beauty of flesh that moves, as if it is calling up the wind and called by the wind, and flesh that roars and shrieks in underground pitches and sings sanity in a lilt and a growl.

Ancient peoples believed that postmenopausal women retained their menstrual blood, called wiseblood. Wiseblood made wisewomen. While certain cultures treat menstrual blood as a defiling fluid and American slang refers to menstruation as the curse, menstrual bleeding also signifies being cleaned out, purified. American society treats old(er) women as if they suffer from the retention of blood that pollutes them: An old(er) woman is her own worst enemy. Blood is dirt, and as anthropologist Mary Douglas writes in her pollution behavior study, *Purity and Danger,* "Dirt is essentially disorder" and "A polluting person is always in the wrong." The aging woman is dangerous, as a polluter who is a manifestation of transitional states, which represent the undefinable. As the older woman passes from beautiful to ugly, as culturally defined, from moist to dry, in menopause and skin and vaginal changes, and from womb, associated with the generative earth, to tomb, associated with earth as burial ground, she is neither one condition nor the other. The transitional person is in danger and she endangers others, but contact with danger is contact with power. The old(er) woman is a power source, whose (non)identity/excess of identities identifies and energizes human being.[38]

> *You who go by the name old woman*
> *Your afterbirth is the knowledge of finitude and infinity*

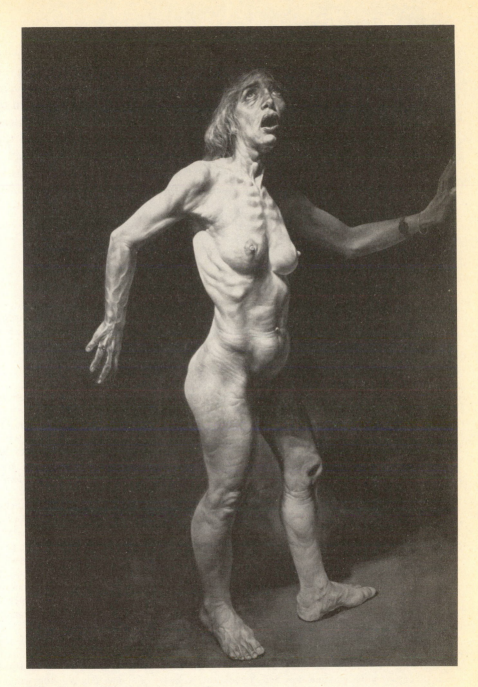

Bailey Doogan, *Mass* (right-hand panel)
Oil on linen, 72″ × 48″, 1991
Photograph by Andrew Harkins

I feel the energy in my mother's hand, which I hold now when we walk together. As in earlier years, our handholding signifies love, but the passage of years compounds the meanings of touch. She moves slowly, in the rhythm of old age, and she needs my support. I squeeze her hand to keep her from death, as we and my father tour the botanical gardens near their home, to keep her on my side of the divide between here and the Green Bay. The three of us admire the rose garden, and I read plaques that say things like: TO ED, YOUR LOVING BROTHER; WE REMEMBER MARY, A GARDENER OF THE SPIRIT—HER FRIENDS; FOR OUR PARENTS, IN MEMORIAM, THE SYLVAN SISTERS.

O Mother and O Father, I will bury your bones with roses.

Notes

Work on this paper was supported by a Junior Faculty Research Award from the University of Nevada, Reno. I especially appreciate the travel funds that allowed me to interview many artists across the United States. My thanks to the artists, for their time, honesty, and continuing interest in this project, are deep.

1. Visible Difference packaging sheet (Elizabeth Arden, Inc., 1989).
2. Visible Difference advertisement, *Vogue* (September 1987): 89.
3. The word "refining" appears in three Visible Difference product names: Refining Moisture Creme Complex, Refining Moisture Lotion, and Refining Toner.
4. In *The Beauty Myth: How Images of Beauty Are Used Against Women* (New York: Double-day/Anchor, 1991), Naomi Wolf dissects what she calls "beauty pornography," which is the fashion and beauty industries' images of feminine beauty, and she devotes a chapter to the religious metaphors and practices involved in the inculcation and practice of beauty pornography. See pp. 86–130 for "The Rites of Beauty," "Original Sin," "The Cycle of Purification," "The Cult of the Fear of Age," and more.
5. In one strain of the European tradition old(er) women are lustful, prurient, and sexually aggressive; bawds, procuresses, and minions of the devil. Lois W. Banner, in *In Full Flower: Aging Women, Power, and Sexuality: A History* (New York: Alfred A. Knopf, 1992), p. 189, writes, "From definitions of aging women as sexualized creatures and as go-betweens danger-ous to social harmony, it was only one step to accusing them of being witches, individuals who bound themselves diabolically to the devil through an infernal sexual pact. . . . Recent compilations of statistics for a number of regions during the massive witchcraft persecutions of the sixteenth and seventeenth centuries . . . show that the median age of suspected witches was between fifty-five and sixty-five years of age." See pp. 189–197 for more material regard-ing older women, sexuality, and witchcraft in Western Europe.
6. See Mira Schor's "Patrilineage" in this volume, for a keen analysis of the matrilineage issue.
7. Daw's statement is in response to a questionnaire I mailed to one hundred American women artists over fifty. Unless otherwise noted, all statements by artists in this article and the notes come from the questionnaires. Some respondents wished to be anonymous. As of this writing response to the questionnaires is over 80 percent, and I cannot thank the respondents enough for their time, honesty, and care in writing about their personal and professional experiences. My work, which will culminate in a book, would be impossible without the respondents'

words, which range from Patricia Morgan's "I cried when I answered your questions" (letter to the author, October 6, 1992), to Elise Mitchell Sanford's "The reaction to my work has been overwhelmingly positive. . . . Juries and curators seem glad to show work on aging, and I think it's because so little is out there" (letter to the author, August 24, 1992).

8. Simone de Beauvoir, *The Coming of Age,* trans. Patrick O'Brien (New York: G. P. Putnam's Sons, 1972); Judy Hall with Dr. Robert Jacobs, *The Wise Women: A Natural Approach to the Menopause* (Shaftesbury, Dorset, and Rockport, Mass.: Element, 1992); Ruth Raymond Thone, *Women and Aging: Celebrating Ourselves* (New York, London, and Norwood, Australia: Harrington Park Press, 1992).

9. The subject of intergenerational conflict runs throughout Baba Copper's *Over the Hill: Reflections on Ageism Between Women* (Freedom, Calif.: The Crossing Press, 1988). On p. 19 she writes, "Women in their forties and fifties, themselves victims of ageism, are often the most vicious in dealing with women older than themselves. Many old women become increasingly ageist and self-hating, decade by decade, from sixty to ninety."

10. Love is a rare and oblique subject in the writings of Guillermo Gómez-Peña, a key player in the theory and practice of border culture, reality, and living. Two paragraphs in his "From Art-Mageddon to Gringo-Stroika," *High Performance* 14, 3 (Fall 1991): 20–27, deal with "the humanization of our personal universe. . . . If we are not responsible and loving friends, sons and daughters, parents, lovers, neighbors and colleagues, how can we possibly be responsible citizens at large?" See also Gómez-Peña, "The Multicultural Paradigm: An Open Letter to the National Arts Community," *High Performance* 12, 3 (Fall 1989): 18–27, and "The New World (B)order," *High Performance* 15, 2–3 (Summer–Fall 1992): 58–65. Much of my own work focuses on love. Recent examples are performative lectures dealing with contemporary art practice and theory: "Faculties of Love," Rhode Island School of Design, Providence, Rhode Island, October 1992, Weber State University, Ogden, Utah, March 1992, and University of Illinois, Chicago, Illinois, November 1991; "Fuck Theory," Society for Photographic Education Conference, Washington, D.C., March 1992; "Silver Tongues Untie the (K)nots," International Association of Art Critics, USA Conference, Chicago, Illinois, February 1992; and "The Language of War and the Language of Miracles," Columbia College, Chicago, Illinois, November 1991, and Centenary College, Shreveport, Louisiana, October 1991.

11. Susan Sontag, "The Double Standard of Aging," *Saturday Review,* September 23, 1972, p. 37.

12. "It is quite impossible to explain to younger women that this new invisibility, like calm and indifference, is a desirable condition," writes Germaine Greer in *The Change: Women, Aging and the Menopause* (New York: Alfred A. Knopf, 1992), p. 378.

13. Leonard submitted a revised research proposal and received funding. One reviewer's lengthy comments about the first proposal centered on the reviewer's requirement that Leonard "would have to view her own grandmother . . . critically," as would a historian, and that Leonard's proposal did not evidence her ability to do so.

14. Interview with Edith Altman, July 8, 1992.

15. Claire Wolf Krantz, "Questions as Model," *New Art Examiner* 19, 10/11 (June–Summer 1992): 30–33, 60.

16. Throughout *Over the Hill* Copper discusses "the subjugation of the old mother by her daughter," p. 41. On p. 23 she says, "Sometimes I feel as if ageism is misnamed; that the problem should be called Daughterism."

17. Interviews with May Stevens, June 13, 1992, and Joan Semmel, June 17, 1992.

18. The first-generation/second-generation distinction originated in Thalia Gouma-Peterson and Patricia Matthews, "The Feminist Critique of Art History," *Art Bulletin* 69, 3 (September 1987): 326–357. Liz Kotz repeats the formulation in an article on Lutz Bacher, "Sex with Strangers," *Artforum* 31, 1 (September 1992): 84: "This work seems to go beyond a kind of

'first stage' feminism predicated on identification with 'feminine' roles and the critique of 'masculine' ones, investigating the kinds of instability and ambivalence elicited when female artists invite female viewers to inhabit traditionally masculine subject positions."

19. Since the late 1980s some of the art that has gained the most currency concerning the human body does not image it. In a review of "The Body," a Spring 1991 exhibition at the Renaissance Society of Chicago, Kathryn Hixson writes that "late '80s [installation work] privileges the body's visceral physicality over its rational capacity for language or its potential for emotional expressiveness. In a shift away from the problematic representation of the body as image, a strategy of sociopolitical critique popularized in the appropriationist work of the early and mid-'80s, artists are making sculptural and temporal allusions to the anatomical materiality of the body, its chemical composition, and its capacity for brute action." See Hixson, ". . . And the Object Is the Body," *New Art Examiner* 19, 2 (October 1991): 20–24.

20. Telephone interviews with Hannah Wilke, early June and November 9, 1992. Wilke's *So Help Me Hannah Series: Portrait of the Artist with Her Mother, Selma Butter* (1978–81) is another tremendous contrast with Sherman's work. Wilke's Cibachrome double portrait shows the differences between actual women's bodies: Wilke's young, "beautiful," and apparently healthy; Butter's old, "ugly," and marked by mastectomy and radiation therapy.

21. Julia Kristeva, *Powers of Horror: An Essay on Abjection,* trans. Leon S. Roudiez (New York: Columbia University Press, 1982), p. 13.

22. The text of *Reaching Fifty: The Process of Aging, II* appears in *Aging: The Process, the Perception* (Jamestown, N.Y.: The FORUM Gallery, 1990), pp. 55–58.

23. Anne Noggle referred to the "saga of the fallen flesh" in an interview on July 1, 1992, and Janice Zita Grover titles her essay on Noggle in *Silver Lining: Photographs by Anne Noggle* (Albuquerque: University of New Mexico Press, 1983) "Anne Noggle's Saga of the Fallen Flesh." On p. 15 of the essay Grover quotes Noggle: "I photograph the saga of the fallen flesh." In Joanna Frueh, "The Fear of Flesh That Moves," *High Performance* 14, 3 (Fall 1991): 70–71, I write, "Flesh that doesn't move is an aestheticized and impossible integrity," and "Thinking about the body as never being in a fixed state is necessary to begin to name where all bodies exist and to unshame them."

24. In Grover, *Silver Lining,* p. 32.

25. The word "old" is problematic. People do not like to call themselves old. Baba Copper and Barbara MacDonald, both of whom have written essays on women's aging and women's ageism against women from their over-sixty perspectives, say that "old" is a word women use to define other women. Old age has become a fluid idea in the United States today, and sixty-five, retirement age, is an unsatisfactory marker of old age. For pointed discussions of the aging of the United States's population and the blurring of age-appropriate roles and behaviors, see Alan Pifer and Lydia Bronte, "Introduction: Squaring the Pyramid" and Bernice L. Neugarten and Dail A. Neugarten, "Changing Meanings of Age in the Aging Society," in Alan Pifer and Lydia Bronte, eds., *Our Aging Society: Paradox and Promise* (New York and London: W. W. Norton, 1986), pp. 3–13, 33–51. Only one questionnaire respondent answered the question Are you old? with an unequivocal yes. Copper, p. 75, writes, "I am an *old* woman. I am sixty-eight. Part of the reason I self-identify as *old* is a need to escape the prissy category of older. . . . Like other words which feminists are reclaiming by proud usage, I take to myself the word everyone seems to fear." Artist Miriam Schapiro says, "It isn't language that's the problem—it's image and denial of image." I have used "old," "older," "old(er)," "elder," and "aging" as I write. When definitions are blurry and confusing, various choices are necessary. Throughout *Over the Hill* Copper explicates why old is maligned, but see, in particular, pp. 64, 75, 77. In MacDonald with Cynthia Rich, *Look Me in the Eye: Old Women, Aging, and Ageism* (San Francisco: Spinsters, Ink., 1981)

MacDonald, like Copper, tells harsh truths about being unmistakably old, and Rich, pp. 55–56, writes about how old women preserve their personhood by denying they are old.

26. Judith Butler's *Gender Trouble: Feminism and the Subversion of Identity* (New York and London: Routledge, 1990) and Louise J. Kaplan's *Female Perversions: The Temptations of Emma Bovary* (New York: Doubleday/Anchor, 1991) were especially helpful to me in thinking about ways that old(er) women can activate their own power and challenge society's power over their self-authorship. Butler led me to rethink the usefulness of parody, a strategy discussed, only partially convincingly, by Lisa Tickner, "The Body Politic: Female Sexuality and Women Artists Since 1970," first published in *Art History* 1, 2 (June 1978), reprinted in Rosemary Betterton, ed., *Looking On: Images of Femininity in the Visual Arts and Media* (London and New York: Pandora, 1987), pp. 235–253. In Betterton, p. 247, Tickner views parody in regard to "subject/object contradictions which face women working with the female body." On p. 508 Kaplan writes, "It is often said that persons who are unable to identify the genitals as the principal sexual organs and coitus as the principal goal of erotic excitement are polymorphous *perverse*," but her discussion at that point centers on human beings' polymorphous sexuality, which "is, on the one hand, a protection against gender stereotyping." Teresa de Lauretis develops the a-woman in "Strategies of Coherence: Narrative Cinema, Feminist Poetics, and Yvonne Rainer," *Technologies of Gender: Essays on Theory, Film, and Fiction* (Bloomington and Indianapolis: Indiana University Press, 1987), pp. 123–124.

27. Greer's final chapter in *The Change*, titled "Serenity and Power," pp. 363–387, contains her most tender and inspiring words about the matron.

28. Hyperfemininity is not necessarily a correlate of today's fitness/beauty mania. Hyperfemininity is an extreme, not an ideal. Obsession with the fit ideal promotes a version of Victorian America's "split[ting] old age into sin, decay, and dependence on the one hand, and virtue, self-reliance, and health on the other." See Thomas R. Cole, *The Journey of Life: A Cultural History of Aging in America* (Cambridge: Cambridge University Press, 1992), p. 232. Hyperfemininity may belong to what Jeffrey Deitch calls the post human. In *Post Human* (Pully/Lausanne: FAE Musée d'Art Contemporain, 1992), p. 19, Deitch writes, "The matter-of-fact acceptance of one's 'natural' looks and one's 'natural' personality is being replaced by a growing sense that it is normal to reinvent oneself." The hyperfeminine and the post human are two ideas I will continue to develop as avenues for old(er) women's self-authorship.

29. Greer, *The Change*, p. 378, and quoted in Sarah Boxer, "You Might as Well Act Dreadful," *The New York Times Book Review*, October 11, 1992, p. 33.

30. Jane Caputi, "Our Planet, Ourselves," *Camerawork* 19, 2 (Fall 1992): 21, believes that "we need to reconstellate one extremely potent metaphor capable . . . of ameliorating both gynocide and genocide—the Crone or Grandmother." Banner, *In Full Flower*, p. 248, gives a historical look at the word "crone," which, "initially associated with the wisdom of aging women, was subsequently reversed to imply inappropriateness. By the nineteenth century it was transmogrified into 'crony,' a word referring to an aging man's close companions."

31. Interview, June 13, 1992.

32. Some women describe devastatingly embarrassing and disturbing hot flashes, while others, many fewer, describe a sensuous quality. For numerous and wonderfully diverse personal accounts of menopause, see Dena Taylor and Amber Coverdale Sumrall, eds., *Women of the 14th Moon: Writings on Menopause* (Freedom, Calif.: The Crossing Press, 1991).

33. Mary Daly in Cahoots with Jane Caputi, *Webster's First New Intergalactic Wickedary of the English Language* (Boston: Beacon Press, 1987), pp. 128, 137.

34. Kenneth Clark, *The Nude: A Study in Ideal Form* (New York: Pantheon, 1956), p. 93.

35. Lorraine O'Grady, "Olympia's Maid: Reclaiming Black Female Subjectivity," in this vol-

ume, speaks eloquently for "the reclamation of the body as a site of black female subjectivity."

36. Interview with Vera Klement, July 9, 1992. Klement's "An Artist's Notes on Aging and Death," unpublished as of this writing, enriched my thinking.

37. Interview with Bailey Doogan, June 21, 1992. Her words are from Kris Kristofferson's song *Me and Bobby McGee,* whose most famous version was sung by Janis Joplin.

38. My thinking about pollution, danger, and transition owes much to Mary Douglas, *Purity and Danger: An Analysis of Concepts of Pollution and Taboo* (New York and Washington: Frederick A. Praeger, 1966), pp. 96–98, 121. Quoted statements are on pp. 2 and 113. Regarding the postmenopausal woman as polluted, I find Lois Banner's statement interesting: "The ending of the menstrual cycle was viewed as negative [before the mid-nineteenth century], as a process whereby evil humors remained present in the body, capable of adding to that complex of female wickedness which could turn aging women into witches." Banner, *In Full Flower,* p. 192.

THE HAIR OF THE DOG THAT BIT US
Theory in Recent Feminist Art

Christine Tamblyn

July 6, 1992

have decided to use a diary format to structure this essay. Although such a format may be unconventional as a vehicle for critical writing, I believe that an essential aspect of the feminist project entails altering the forms as well as the content of social discourse. The rational violence of the Law of the Father is inscribed in the rhetorical devices of argumentation. If a feminist alternative to academic criticism is to be found, the goals and methods it employs must be redefined. If criticism did not function as patriarchal evaluation or combat, reinforcing the legitimacy of the roles of the judge and the general, what would it be like? Rather than describing a new model for feminist critical practice, I would prefer to manifest one in the process of writing this essay.

Why have I chosen the diary format for this experiment? I want to address my readers as intimates, eschewing the formal, estranged tone employed by the authors of most academic articles. I also want my writing to reflect the vicissitudes of my daily life. The discipline of keeping a diary is closely connected to the rhythms of the everyday; it bridges the personal, the political and the professional in a way that follows established feminist precedents. It's important to me to demystify critical practices by demonstrating where ideas come from and how they interface with experience.

As I undertake this project, I do have a focus that is more specific

than merely keeping a record of my days. I want to write about recent feminist art that uses theory as a genre to parody or subvert theory itself. The goal of such subversion is often to critique the elitist institutions that academicize art. For example, Andrea Fraser analyzes the museumization of art and the obfuscation of art discourse in her simulated curatorial projects. Joan Braderman performs her analysis of "Dynasty," pushing the conventions of film deconstruction to hilarious excesses in *Joan Does Dynasty,* a Paper Tiger–produced videotape.

Although some of the artists I want to discuss use humor or playfulness to deflate patriarchal authority and pretension, others are very serious about the political implications of their work. Millie Wilson's *Living in Someone Else's Paradise* makes an important point about the exclusion of lesbian art from the mainstream canon. Yvonne Rainer's recent film, *The Man Who Envied Women,* conveys her ambivalence about theory by lampooning its obtuseness even as she uses it to lambast racism and sexism.

I also want to examine "theory art" that furthers feminist debates about the body. For example, Judith Barry's simulation of erupting bodily fluids in *Imagine, Dead, Imagine* (a multimonitor video installation) neither exalts nor denigrates the body, but reflects changes technological media have wrought on it. Likewise, in a recent videotape, Marjorie Franklin uses digital editing to transform her own image into a facsimile of the cyborg Donna Haraway alluded to in her "A Cyborg Manifesto: Science, Technology and Socialist Feminism in the Late Twentieth Century."[1] Interrogating their own theoretically driven fascination with horror films and female serial killers, the group Theory Girls employs suggestive fragments of found images and texts in its performances and installations.

The examples I have mentioned are purposefully varied because I hope to demonstrate that many different kinds of artists are blurring the distinction between theory and practice in ways that are neither elitist nor intimidating. Instead of behaving deferentially and worrying about correct applications of theory, these artists bring an overtly feminist perspective to their work. This perspective permits them to prescribe theory as a preventive medicine against itself.

July 8, 1992

Today I looked at Yvonne Rainer's 1985 film, *The Man Who Envied Women.* I noted how many ways she expresses her ambivalence toward theory in this film. The film's protagonist, Jack Deller, uses theory to

reinforce his patriarchal privilege in several key scenes. He is shown giving a tedious, obfuscating lecture about the French sociologist Michel Foucault's ideas to a group of students. During a party, he employs his erudition to seduce Jackie, a woman clad in a shimmering gold gown who is as fluent in theoretical discourse as he is. Throughout the film, Jack continually relies on theory to justify his execrable behavior and attitudes. For example, he blames his marital infidelities on the contradictions to which individuals are subject under capitalism.

Rainer also employs montage techniques to counterpose images that emphasize theory's etherealness with clips of debates about pragmatic political issues. As Jack's cinema studies lecture drones on, the voice of his estranged wife, Trisha, interrupts on the soundtrack with a passage about class struggles in El Salvador and the United States. Evidence of class struggle also appears in several interspersed speeches about affordable housing culled from a hearing in which artists' interests were pitted against those of community residents and in artist-critic Martha Rosler's analysis of a group of photographs pinned on a bulletin board. The juxtaposition of these clippings from newspapers and magazines neatly encapsulates the themes of the entire film. A gruesome shot of decapitated El Salvadoreans shares the space with a photograph of a self-satisfied male executive and an advertisement from a medical journal depicting a tense menopausal woman who supposedly needs estrogen therapy.

How are these ostensibly diverse phenomena related? The quotations from Foucault and other writers Rainer has included in her script constitute a critique of the mechanisms of patriarchal domination, whether it is exercised to quell revolutions in the Third World or to control women's bodies. Foucault has demonstrated how power is woven into all aspects of social and personal life, including schools, hospitals and prisons. He exposes the links between power, truth and knowledge, describing the ways liberal-humanist values support such technologies of domination as surveillance and the internalized pressure to conform to standardized norms. Whether Deller is looking at a *Playboy* magazine or scrutinizing a film as part of his academic research, he is exercising his male prerogative of voyeurism and the controlling knowledge associated with it. At one point he even claims, "I knew so little about women then. I know almost too much now. And yet I have for a moment failed to realize that they face hazards in life which a man does not face, and therefore should be given special tenderness and consideration. . . ."

Underneath his veneer of sensitivity, Jack patronizes and manipulates women, as this quotation indicates. His confessional monologues, addressed directly to the camera as though the film's viewers were his

psychotherapist, consist of intricate rationalizations and self-deceptions. Rainer adeptly turns the academic theories he has learned to use as weapons in his arsenal of evasions back on him, deploying them like boomerangs. By enclosing his pontifications within other frames of reference rather than trying to argue against them, she effectively deflates his pretensions. His bombastic abstractions sound especially hollow when they overlap with the perceptive insights articulated in Trisha's voice-overs.

Personal and political contingencies are inextricably imbricated in the memorable speech Trisha intones as the film begins:

"It was a hard week. I split up with my husband and moved into my studio. The hot-water heater broke and flooded the textile merchant downstairs; I bloodied up my white linen pants; the Senate voted for nerve gas; and my gynecologist went down in Korean Airlines Flight 007. The worst of it was the gynecologist. He was a nice man. He used to put booties on the stirrups and his speculum was always warm."

Trisha's concerns are grounded in her body and immediate circumstances. She serves as the mouthpiece for Rainer's social conscience, articulating some of the ways in which artists are complicit in the oppression of the poor, both in their own neighborhoods and in Central America. But it is important to remember that just as all the figures who appear in dreams are aspects of the dreamer, Jack also stands in for Rainer's subjectivity. However villainous and alien he seems to be, the patriarchal arrogance he embodies can be a facet of either men's or women's identities. The Foucaultian theories alluded to during the film remind viewers that we all inhabit a broad range of social positions. Thus, we need to be aware of the conflicting constraints involved in living out class, race, ethnic, regional, generational, sexual and gender positions.

The same sort of psychic mechanisms of denial and self-pity Jack uses to rationalize his sexist treatment of women are often employed by artists of both genders to disavow their complicity in and responsibility for larger social inequities. The role theory plays in this scenario is complex. Although it can operate as another distraction or evasion from an activist response to issues like gentrification or abortion rights, it can also provide the strategic acumen needed to circumvent political impasses. Sometimes it is necessary to grasp the underlying causes of social problems before they can be effectively redressed.

July 9, 1992

After looking through the documentation of Millie Wilson's work, I've been thinking about the debates around "identity" in feminist and lesbian politics. The negative connotation of "identity" is associated with a repressive process of social normalization that reduces difference to uniformity. The positive connotation, on the other hand, focuses on the consolidation of a political identity based on one's historical and cultural background and one's racial, class and gender status.

Wilson's *Museum of Lesbian Dreams,* portions of which have been presented in various exhibitions between 1989 and 1991, celebrates the pleasures and codifies the dilemmas of lesbian identity politics with particular reference to the art arena. Wilson's ongoing project critiques the lack of a consideration of lesbian "Otherness" in postmodern art theory, an absence that is rendered particularly notable by postmodernism's emphasis on how the Other has been excluded from dominant culture. "Other" often designates women, people of color and gay men in postmodern thought, but rarely refers to lesbians.

In *Fauve Semblant: Peter (A Young English Girl),* Wilson depicts the work of a fictive early modernist lesbian artist. She recreates art history in her own image and likeness, satirically invoking stereotypical notions about lesbian identity both to debunk them and to reinvest them with subversive power. For example, the wall texts in *Museum of Lesbian Dreams: Objects and Tableaux* quote from 1950s pop psychiatry books that feature reductive Freudian analyses of lesbian dreams. The intention behind these analytical procedures was always to pathologize lesbian desire. By reframing these texts, Wilson exposes the mechanisms they employ; she also adds another twist by giving material form to the already heavy-handed symbols that figure in the work of the dream analysis. For example, a dream about a woman's ambivalence as to whether she prefers turnips to potatoes is manifested in the formal presentation of bronze casts of both vegetables under a vitrine.

By focusing on how lesbian sexuality has been regulated historically within the medical arena, Wilson exemplifies Foucault's ideas about how sexuality is constructed. Rather than regarding sexual desire as a primal force that precedes and seeks to escape socialization, Foucault asserts in *The History of Sexuality* that it is social control that produces and shapes desire.[2] Sexuality is saturated with power and finds expression in the particular images and narratives the culture provides. Countering the exclusion of lesbians from mainstream art contexts, Wilson has under-

taken the ambitious project of revising art history, her retrospective inventions intertwining the real and the imaginary.

Wilson's version of conceptual artist Marcel Duchamp's *Self-Portrait in Profile* uses his preferred technique of appropriation to alter his work. She replaces Duchamp's male profile with a female one that is turned in the opposite direction. This manipulation is an "inversion"— a Duchampian pun on one of the appellations for homosexual that also refers to Duchamp's female alter ego, Rrose Selavy. Similarly, Wilson adds a black lace curtain to a replica of Duchamp's *Fresh Widow,* concealing his window/widow in seductive fabric. The phrase "lace widow" has the further significance of being a lesbian euphemism for "femme." By transforming all the cultural allusions in her parodic museum into lesbian-identified codes, Wilson demonstrates how pervasive the markers of compulsory heterosexuality have been in mainstream art.

July 11, 1992

I interviewed Andrea Fraser, a member of the V Girls, in conjunction with *Aren't they lovely?,* her solo show at the University Art Museum in Berkeley. Fraser articulated an idea that I had been contemplating, not only in reference to her work, but also regarding Rainer's film and Wilson's installation. She explained that she was engaged in a critique of the fetishization of theory. Her intention is to refute the ubiquitous application of theory to create prestige in academic contexts, thereby rendering it more efficacious and relating it to real practices. In *The Man Who Envied Women,* Rainer also lampoons the fashionableness of theory. Jack Deller's lecture is given in a sleekly decorated Soho loft. His elevated language and the names he drops operate like the labels on designer jeans; they are the signifiers of class and property. In a parallel vein, Millie Wilson appropriates the tasteful look of minimalist art objects and the adroit packaging of museum displays in constructing her installations. She reduces art movements and strategies to simple formulas, and then applies these formulas to create art pieces that self-deconstruct by conveying alternate messages. Form belies function, rather than fitting it, in an apt economy of lesbian desire.

Like Wilson, Fraser engages with the politics and ideology of museum display. When she was invited to curate an exhibition drawn from the permanent collection of the University Art Museum, she decided to focus on a particular bequest. Her installation incorporates forty-five objects selected from the collection of photographer Thérèse Bonney. The objects, including portraits of the donor by Dufy and Rouault, coins,

medals, eyeglasses and a life preserver, are arranged in a recreation of Bonney's Paris salon. Accompanying wall texts frame quotations from the museum archives concerning the circumstances surrounding the bequest.

Fraser's installation interrogates the criteria for selecting and appraising collections assembled by individuals or institutions, examining how these criteria impact the power museums have to define culture. She analyzes the process whereby museums take the private, domestic culture of the wealthy, abstract it from its original social location and turn it into public culture. One of the tools commonly used to effect this transformation is art-historical discourse. The abstractness of this specialized language makes it possible to conceptually reinforce the physical removal of art objects from their original settings and functions. By returning Bonney's possessions to a reproduction of their original domestic environment, Fraser reverses this process.

The astutely chosen texts on the wall labels for *Aren't they lovely?* convey an unsavory narrative. Thérèse Bonney was living alone in Paris in the years preceding her death at age eighty-three in 1978. She was ill and her only financial assets were the paintings and furniture in her apartment. The University Art Museum made a substantial effort to convince her to bequeath her collection to them. They wrote numerous flattering letters to her, pretending they were interested in her accomplishments as a documentary photographer and implying they would accede to her request to keep the collection together. Bonney envisioned the creation of a "salon-gallery" on campus where she could live and give seminars about "French civilization, international culture relations, etc."

Although the university had no intention of acceding to Bonney's demands, they continued to negotiate with her until she capitulated, unconditionally willing her estate to them. The disparate rhetorical styles employed in the various quoted documents that convey this information make the gap between her perspective and the museum's apparent. Bonney discusses her possessions in the intimate, autobiographical tone appropriate to an appreciation of the mementos of a full life. She mentions still having the dress she posed in for one of the portraits, or buying stiff cellophane to protect her Art Deco rugs from her cats. For the museum, the same objects have no sensual resonance or anecdotal significance; they are merely tokens of prestige or economic value. Thus, the museum appraised the Dufy paintings Bonney cherished as minor works and plans to deaccession them.

However, the final irony involved in the settlement of Bonney's estate is that Fraser has fulfilled her desires by reassembling the fixtures

of her salon. Fraser's motives for this intervention are her own; rather than taking a sentimental interest in the details of Bonney's story, Fraser is concerned with its sociological implications. In the exhibition brochure, she writes, "What museums institutionalize in a public sphere is what could be called symbolic struggles for legitimacy. These are struggles that are always taking place one way or another in the field of culture between different classes and class 'fractions'—class being defined in sociological as well as in strict economic terms, by education, geographical location, and other determinants."

July 16, 1992

Symbolic struggles for legitimacy waged between different classes figure prominently in "Dynasty," the television soap opera Joan Braderman playfully deconstructs in her 1985 videotape, *Joan Does Dynasty*. Braderman's image is electronically overlaid over images from an episode of the show as she engages in an entertaining monologue in counterpoint to the actions of the fictional characters. Criticism usually occupies different spatio-temporal parameters than its objects, but here the object and the analysis coincide. Braderman uses the gaps between dialogue to interject her comments, or she alters the temporal flow by repeating key shots in a hiccuping editing rhythm. For example, a kiss becomes endlessly deferred as the actor bends toward the actress again and again without ever reaching her.

Braderman literalizes the premises of reception theory by interjecting herself on screen like an animated footnote to the text of the program. Functioning as an exemplary spectator, she breaks through the imaginary fourth wall that seals the actors into their own hermetic bubble and aggressively invades their space. Reception theory has emphasized the importance of the contributions readers or viewers make to a work of art. Theorists like Roland Barthes do not believe that works of art are self-contained, autonomous entities.[3] Instead, the spectator plays a collaborative role, fleshing out suggestions the artist makes in the work with his or her own subjective interpretations. Spectators use artworks as raw material to be actively transformed, not passively consumed.

Articulating her reactions to the plot developments in the soap opera, Braderman uses her spectatorial presence to interrupt the seamless flow of television. Her zany monologue shifts from arcane snippets of poststructuralist theory to slang expressions and snatches of song and dance. She begins the tape by introducing herself, stating, "I am your local beatnik professor (as opposed to anchor clone), an unabashed (well

a bit bashed) sixties type doing stand-up theory as TV infiltrator, media counterspy and image cop. These campy creatures have been interceding in my key personal relations for several years now." The "campy creatures" she is referring to here are the characters Alexis and Dexter, who share a bubble bath while Braderman peers at them through slits superimposed over the image. Her insights into the impact they have had on her everyday life are derived from cultural studies that trace the close linkage between media representations and identity.[4] In postmodern society, people tend to base their self-images and behavior on the television and advertising images that saturate the electronic landscape.

Braderman's slapstick discussion of the cultural significance of "Dynasty" makes the reciprocity between viewing the show and other forms of compulsive consumption evident. After mentioning the line of products Bloomingdale's department store marketed as spinoffs of the characters' possessions on the show she states, "You can't even tell the advertisements from the stories in prime time America. Here it is: the place the yuppies are going to go. They're going to crawl right into their little television sets. They're going to feel whole. Their food will match their nail polish. In terms of anything like values—I mean real values in the eighties—we're in a black hole and I'm here to say without something as oral-aggressive as Joan Collins's mouth, you can't even tell you're alive." The scene that accompanies this comment features Joan Collins and her paramour of the moment clad in kimonos lounging in a living room decorated in a Japanese motif that corresponds to the Japanese food they are eating.

Throughout *Joan Does Dynasty,* Braderman employs theory in a pragmatic manner, utilizing it as a tool to decipher how cultural icons are manipulated by the consciousness industry. In the passage I noted above, she elucidates the complex psychoanalytic mechanisms of desire predicated on identification and lack: the identification viewers make with Joan Collins to temporarily assuage their "black hole" of lack. But the flippant, informal tone of Braderman's speech demystifies theory and makes it accessible to viewers. Fulfilling the feminist agenda to challenge the unconditional authority of patriarchal discourse, Braderman inverts the power relations embedded in the practices of both academic research and television viewing.

The posture adopted by most academic practitioners is one of controlling detachment: aloof from the object of their research, they observe it from a distance and make predictive generalizations about it with the intention of more efficiently manipulating it. Braderman's conclusions, on the other hand, are provisional and speculative. She emphasizes their

improvisational quality by engaging in an unrehearsed stream of consciousness patter. Her pleasure in watching *Dynasty* is not concealed. At one point she wonders, "Is deconstructing it merely the invention of a new way to love it?" However smitten she may be with the program, her theoretical methods nevertheless allow her to make a critical intervention by unraveling the seams in the construction of the spectacle. From a feminist standpoint, it also seems significant that she not only brings her mental faculties to this task, but also literally inserts her entire body into the television scenes. Assuming different postures, she fills the electronic vacuum, interjecting her presence as an intermediary between the real world and its fictive representations.

July 18, 1992

What implications do new electronic technologies have for feminist theory and practice? One of the most provocative articles devoted to this topic is Donna Haraway's "A Cyborg Manifesto: Science, Technology, and Socialist-Feminism in the Late Twentieth Century."[5] In this essay, Haraway advocates the designation of the cyborg (cybernetic intelligence) as a feminist icon that might replace the goddess with her atavistic connotations of nostalgia for a prehistoric past. What appeals to Haraway about the cyborg is its hybrid nature; it straddles the boundaries between genders and combines aspects of humans and machines. Delineating the cyborg condition, Haraway writes, "Cyborg politics is the struggle for language and the struggle against perfect communication, against the one code that translates all meaning perfectly, the central dogma of phallogocentrism. That is why cyborg politics insist on noise and advocate pollution, rejoicing in the illegitimate fusions of animal and machine."[6]

Haraway is interested in the potentials the cyborg offers for escaping the master narratives that have shaped Western civilization. Because it has no parents, the cyborg escapes the Oedipal conflict that Freudian psychoanalysis has posited as crucial to the formation of the self. The cyborg also does not participate in the Judaeo-Christian creation myth with its emphasis on original sin and apocalyptic restitution. Moreover, the figure of the cyborg suggests options for a productive interface between humans and our technologies that would produce a mutual evolution. It seems particularly important for women to overcome their technophobia by imagining a more symbiotic relationship to machines.

Computer artist Marjorie Franklin has embarked upon such a project, partially as a consequence of her exposure to Haraway's writings. In

Marjorie Franklin, . . . *HER* . . . *SIGNAL* . . .

a recent videotape, . . . HER SIGNAL . . . (1991), Franklin uses computer digitizing techniques to transform her own image into a cyborg facsimile. She mixes electronic noise patterns into the outlines of her hair and automates the rhythm of her blinking. Her voice is also electronically synthesized and split into two channels. The voice on one channel still closely resembles a human voice, although it is speeded up. But the voice on the other channel sounds completely mechanical; it provides continuous commentary in response to the assertions made by the first voice. For the sake of convenience, I will call the first voice "Marjorie" and the second voice "the computer."

"Marjorie's" monologue begins with a definition of cyborg: "a hypothetical human being modified for life in a hostile or alien environment by the substitution of artificial organs and other bodily parts." "Marjorie" then goes on to speculate about what it would be like to have various organs replaced by prosthetic devices. She muses, "If I had wheels instead of feet, would I still feel the same way? Would I still get an ingrown toenail? Maybe I'd feel better." "Marjorie's" viewpoint serves as an unusual alternative to dystopian science fiction–inspired fears of machines taking over; she rhapsodizes over a litany of electronic tools: "I love charge-coupled devices. I love diskettes but I love hard drives even more. I lover laser printers. I love the binary number system," etc.

While "Marjorie" is speaking, "the computer" articulates its reactions, querying, "Who is she? What is she saying?" "The computer" initially seems to construct an antagonistic relationship to "Marjorie," criticizing her for spending all of her money on equipment. But as the tape proceeds, the two identities seem to merge, bound together by mutual self-interest. When "Marjorie" lists the numerous technological devices she wants, "the computer" agrees, "I want equipment too so I can complete myself." Similarly seeking wholeness, "Marjorie" finally declares, "I want perfect stainless steel body parts. I want plastic skin. I don't want to rely on my immune system." As "Marjorie's" image becomes an increasingly abstract digital flicker, "the computer" proclaims, "I am she. But she is not me—yet."

Franklin's manifestation of Haraway's theories in . . . HER SIGNAL . . . does more than illustrate them; the tape extends Haraway's ideas through their realization in the concrete realm of practices. Franklin's digital transformation of her own visage epitomizes the ways that human-machine interfaces radically decenter the body, altering the once sacrosanct repository of the essential self. According to Haraway's posthumanist perspective, the self is ineluctably split; accepting this hybridization is therefore more productive than longing for a lost unity.

If nature and culture are reconfigured, one need no longer serve as the resource for the appropriation of the other. Although ... HER SIGNAL ... concludes with the consolidation of the two voices, they never fuse; rather, they retain their difference. Thus, the tape configures a model for the complementary interdependence of humans and machines that does not entail a struggle for totalitarian dominance.

July 19, 1992

I want to examine another pivotal work that constructs a relationship between feminism, theory and the mass media. Judith Barry's *Imagine, Dead, Imagine* cogently exemplifies French sociologist Jean Baudrillard's theories about the significance of simulations in contemporary culture. Baudrillard[7] defines "simulation" as the *substitution* of a sign (word or image) for whatever it originally indicated. With the progressive extinction of the natural world, we increasingly inhabit a "forest of signs." Digital technologies like those Franklin employed in ... HER SIGNAL ... serve as the most effective means for engineering simulations. Barry used digital-image processing in the production of her multimedia installation, exhibited at the Nicole Klagsburn Gallery in New York city in 1991. The installation consists of a 10-foot cube; each side contains a video screen displaying a huge close-up of the front, back and sides of a human head. Two models, one male and one female, were used to create the piece. Their features were digitally fused to form a composite face.

Simulation does not merely figure to facilitate an androgynous fusion of disparate identities in *Imagine, Dead, Imagine.* The monumental face is periodically drenched with streams of liquids that resemble bodily fluids: vomit, blood, urine, and pus. It is also covered with crickets and meal worms in an uncanny evocation of the putrefaction that follows death. Although the insects and worms are real, the liquids are simulated equivalents for real effluvia; beet juice, egg yolks, dried skin and other substances substitute for human secretions. Within the context of recent art world practices, this substitution process posits multiple ironies. Several artists (most notably Andres Serrano) have used bodily fluids to signify authenticity in their work. Taking a stand against censorship and in favor of the immanent presence of works of art, these artists have desublimated the usual media of paint, clay, wood, etc. by referring to their scatological precedents.

Barry interrogates the validity of such postures of authenticity by subjecting them to electronic mediation in her installation. Instead of glorifying the body as many feminist artists have done, she confronts the

fear and loathing that physical existence sometimes educes. Because they cross the boundaries separating self from other, bodily fluids have been subject to taboos in many cultures.[8] When they leave the body, these substances cease being part of the self, negotiating the barrier that divides life from death to become inanimate matter. But in *Imagine, Dead, Imagine* even the demarcations between life and death seem fluid or provisional. After each wave of effluvia deluges the head, a video wipe passes over the image, replacing it with a shot of a cleansed visage. The cyclical recurrence of this process creates the impression that the debasing baptism never really happened. Counterfeit wastes have been poured over a fabricated face that the viewer encounters through the additional filter of the video screen.

Because the material Barry has chosen to work with is so inherently horrific, her attempts to distance herself from her sources through the application of layers of mediation only evoke clearer perceptions of the abjection of the human condition. Confronting her installation, the viewer oscillates between an uneasy identification with its beleaguered subject and a relieved detachment from him/her: *If I am witnessing the death of another, then I must still be alive.* Perspicaciously, Barry introduces a postmodern twist into this scenario: If the death I am witnessing is merely simulated, then what does that imply about my own existential status? Baudrillard's theories have been criticized because of their equivocation about death, the "bottom line" guarantor of the real. In *Imagine, Dead, Imagine,* Barry carries this equivocation to an extreme that induces a recognition of the paradoxical interface between the blank surface of the video image and the void it conceals within.

July 21, 1992

The power of *Imagine, Dead, Imagine* may be attributed to its conjuration of the fear of and longing for death. Feminist theorist Julia Kristeva associates this ambivalence with the desire for a return to the undifferentiated union with the mother in *Powers of Horror.*[9] Elucidating the psychoanalytic basis of the sensations of aversion and dread, Kristeva posits that psychic separation from the mother is only tenuously achieved by the infantile ego. Thus, the figure of the "monstrous-feminine" is the mythic expression of the cannibalistic mother who threatens to devour the child by reabsorbing it into herself.

Is the icon of the "monstrous-feminine" related to the images of aggressive women that have been so prevalent in the mass media recently? The gun-toting protagonists of the Hollywood film *Thelma and Louise*

seemed to capture the popular imagination in a particularly compelling way; they were even featured on the cover of *Time* magazine. Numerous critics debated whether female aggression was empowering.[10] Were women abdicating the higher moral ground they had traditionally held as the gentler sex by adopting male-identified patterns of behavior? Or could women's heretofore unexplored capacity for violence symbolically counteract the media backlash that attempted to discredit feminism during the 1980s?

Theory Girls, a San Francisco–based artists' group, has addressed these questions in a series of installations and performances. Styling themselves as cultural critics, Laura Brun and Jennie Currie explore the nature of female subjectivity in relation to Hollywood cinema, trends affecting the social and economic status of women, the institutional colonization of women's bodies and female rage. Their first performances contested male-centered interpretations of horror films by recontextualizing images appropriated from medical documentaries and slasher movies. Effectively interweaving biological facts with folk theories about the female body and reproduction, and counterposing news stories with nightmares, *Blood Dreams* (1988–90) exposed different aspects of the female experience of the horrific. Found text and images presented in slide form or read aloud by the performers were augmented by the startling appearance of a nude woman with a meticulously detailed rendering of the human circulatory system drawn on her skin.

Like pornography, horror films are frequently targets of censorship by right-wing critics who are offended by their salacious violation of taboos. Horror films traffic in images of the "monstrous-feminine," a voracious black hole of dread that menaces the boundaries of the self. Kristeva's ideas about the significance of taboos that separate the abject "monstrous-feminine" from what is socially acceptable explain the mingled disapproval and fascination horror films elicit. The toothed vagina/womb of *Jaws* or the amorphous form of the extraterrestial in *Alien* are phantasmagoric figures of the "monstrous-feminine." Horror films also commonly feature other taboo signs of the abject, such as sexual perversion, physical decay, human sacrifice, murder and bodily wastes.

Theory Girls audaciously celebrate the pleasure they find in horror films, although they also subject these films to a social critique. As feminists, Brun and Currie reclaim the visceral response to terror, twisting it into adrenaline-fueled counteraggressive strategies. In *Scream* (1992), they excerpted images and sound from horror films to subvert the myth of female submissiveness. *Scream* was a site-specific installation presented outdoors in an area of San Francisco where prostitutes ply their trade.

Slides of women being attacked scavenged from news sources and horror movies were projected on the side of a building. The accompanying soundtrack juxtaposed screams from these films with statistics about rape and domestic violence. Rather than presenting women as victims, the piece focused on examples of women fighting back. The story of Aileen Wournos was featured prominently on the audiotape; Wournos is the prostitute who was convicted of murdering several of her johns after they allegedly battered her.

As one of the few women serial killers, Wournos challenges stereotypes about female behavior. Although they do not heroicize her murderous deeds, Theory Girls utilize her story to exemplify new potentials for female strength, implying that it may be necessary for women to discard the most basic habits of identity in order to survive in a male-dominated world. Feminist theorist Judith Butler adduces some controversial arguments about this topic in *Gender Trouble: Feminism and the Subversion of Identity*.[11] Like Donna Haraway, Judith Butler represents the "cutting edge" of feminist thought by daring to envision a state of being that would transcend binaristic gender categories.

Butler suggests that being female may consist of putting on a cultural performance rather than in having a biological sex. Gender can thus be described as a persistent impersonation that passes for the real. Identity categories are not natural in Butler's view; rather, they are the effects of institutions and discourses. Because identity is predicated on a foundation of instability, parodic acts can disrupt the categories of the body, sex, gender and sexuality, redefining them in nonbinary terms. The injunction that men or women identify exclusively with members of their respective genders may be seen as an oppressive by-product of compulsory heterosexuality.

Butler's provocative thesis seems relevant to the theme of this article. I would not dispute that theory has been intrinsically patriarchally determined and identified. But it may be efficacious for women's struggle to turn the weapons of the "enemy" against him, whether these weapons are guns or theories. Because women have historically been excluded from the theoretical arena, we often tend to internalize this exclusion by experiencing theory as an alien and forbidding discourse. However, there is no reason why women should eschew the potential theoretical discourses offer for the clarification and inspiration of artistic practices.

Dr. Samuel Hahnemann, the nineteenth-century founder of homeopathy, believed that remedies which, in large doses, caused a particular set of symptoms, could relieve those symptoms when taken in small doses. Employing analogous strategies, the artists I have discussed in this

article utilize theory as "the hair of the dog that bit them." By poaching on ideas derived from phallogocentric premises, they inoculate themselves against the controlling and inhibitory aspects of these insights. When women appropriate academic discourse into art practices, they alter the institutional parameters of both art and the academy.

My own methods in writing this essay parallel the modes of subversion adopted by the artists I have mentioned. Although my vocabulary and concepts stem from postmodern theory, I have utilized them in unconventional ways. My thought patterns tend to be associative and synthetic rather than linear and analytic. I have tried to preserve the traces of my conceptual processes in the structure of my writing. Instead of presenting tightly constructed logical arguments, I have used an open-ended diary format to introduce contingent connections into my article. My intention is to stimulate the reader's conjectures and to induce her to draw her own conclusions. The work of the artists I have considered and the ideas that inspired them interface in ways that are too multifarious to elaborate exhaustively.

Notes

1. Donna J. Haraway, *Simians, Cyborgs and Women: The Reinvention of Nature* (New York: Routledge, 1991), pp. 149–181.
2. Michel Foucault, *The History of Sexuality* (New York: Vintage Books, 1980).
3. Roland Barthes, "The Death of the Author" in *Image-Music-Text,* trans. Stephen Heath (New York: Hill and Wang, 1977).
4. For a useful introduction to cultural studies, see Lawrence Grossberg, Cary Nelson, Paula Treichler, eds., *Cultural Studies* (New York: Routledge, 1992).
5. Haraway, pp. 149–181.
6. Haraway, p. 176.
7. Jean Baudrillard, *Simulations* (New York: Semiotext(e), 1983).
8. See Julia Kristeva, *Powers of Horror: An Essay on Abjection* (New York: Columbia University Press, 1982).
9. Ibid., p. 13.
10. For a summary of these debates, see J. Hoberman, "On Girls with Guns," *Artforum* 30, no. 1 (September 1991): 26–27.
11. Judith Butler, *Gender Trouble: Feminism and the Subversion of Identity* (New York: Routledge, 1990).

TRANSGRESSING
LE DROIT DU SEIGNEUR [1]
The Lesbian Feminist
Defining Herself in Art History

Cassandra L. Langer

In this paper I want to look at three points: art history, constructing a lesbian gaze, and feminism from the vantage point of a feminist and art critic who came out in the late 1960s, chose to live a lesbian life-style in the 1970s, and during the 1980s came to understand the fluidity of human sexuality. In order to do this I will have to look at representations in the history of art that have been written as though women who love each other simply don't exist or exist only as heterosexual constructions. As a consequence I am going to examine the neglected question of women's experience within lesbian/gay theory—that is, how self-defined gay women's experience may have a different meaning from that of gay men within their differing cultural and legal positions.[2]

For the purposes of this discussion I am going to define a lesbian vision based on Mary Daly's term Gyn-affection, which she delineates as "woman-to-woman attraction, influence, and movement . . . female friendship . . . a loving relationship between two or more women . . . a freely chosen bond which, when chosen, involves certain reciprocal assurances based on honor, loyalty, and affection."[3] One of my reasons for doing this is to resist the conventional identification of gay with male, in a political context in which lesbians are demonstrably less visible, and gay subjects are already routinely assumed to be male.[4]

Other premises upon which this essay rests may be found in the

writings of Jill Johnston *(Lesbian Nation),* "situationist" analysis, the Milan Women's Bookstore Collective *(Sexual Difference: A Theory of Social-Symbolic Practice),* and my own experiences as a woman in a male-dominated society.[5]

I

As a woman, feminist, and art critic.[6] My understanding of a lesbian is culled from a series of conversations with other feminists that reflect a "process-oriented" continuous dialogue. I want to make it clear from the onset that this is a definition in progress. I am not arguing for a homogeneous lesbian point of view because I think lesbians, however they may define themselves, and there is a great heterogeneity among such women, are far too complex to be labeled merely by their affectional, sexual, or political preferences.[7]

In an interview with psychotherapist Irene Javors, she defined the lesbian within a phenomenological context—meaning as a subjective experience fluid within a wider context of sexuality.[8] A lesbian then is someone who in a particular moment feels completely authentic and whole only in a relationship that is sexual and emotional with another woman. This is not to exclude that she may find self-expression in relationship with men both sexual and emotional, but that only with another woman does she feel completely at one with herself. Within the context of patriarchy, it appears to be very difficult for women to be totally themselves in relationship to men.

Perhaps, within a nonpatriarchal society, many women who define themselves as lesbian might define their sexual self in different terms. They might see their behavior within a larger continuum of sexual expression that is less reductionistic and more fluid. In sum, the focus would be not on what you are but on how you express yourself at a given moment.

To begin with I will look at how several male artists, since the nineteenth century, have presented images of women (some of them with lesbian subtexts) and theorize how a sophisticated woman-to-woman gaze might transform how human beings, particularly those society constructs as "lesbians," look at the history of art.[9] "Culture," explains Naomi Wolf, "stereotypes women to fit the myth by flattening the feminine into beauty-without-intelligence or intelligence-without-beauty; women are allowed a mind or a body but not both," so those defined as lesbians are seen as having to be less attractive than heterosexual women, especially if they aren't brain-dead.[10] Second, by examining a select num-

ber of art-historical and feminist interpretations, and contrasting them with statements by several self-defined lesbian feminists and artists who have been instrumental in attempting to find a visual counterpart for Monique Wittig's statement:

> J/e—a symbol of the lived, rending experience which is m/y writing, of this cutting in two which throughout literature is the exercise of a language which does not constitute m/e as subject. J/e poses the ideological and historical question of feminine subjects.[11]

I hope to ascertain ways in which such women defined themselves and their lesbian resistance during the 1970s and into the 1980s. Then I would like to posit a case in point of such historical practices by looking at Romaine Brooks's self-portrait and examining how a recent well-meaning feminist art-historical reading has continued to uphold the discourse of femininity, beauty, and sexuality as heterosexist power. Finally, I will suggest some methodological guidelines for future practices in both art-historical and gay and lesbian studies.

Over the last two decades the accomplishments of the women's movement, which are undeniable, have allowed women to gain confidence, fill in the gaps, and to speak for themselves on a variety of problematic issues in the history of art. A second aspiration that has been partially realized is to give women artists permission to express something of their own experience in their art and criticism. Among contemporary self-identified lesbian artists such as Harmony Hammond, Tee Corinne, Betsy Damon, Jody Pinto, Fran Winant, Deborah Kass, Christina Schlesinger, and Nancy Fried the female presence has been depicted as organic and spiritual.[12]

To date, the discipline of art history, with its sexist and misogynistic standards of evaluation, has been challenged and modified by the special concerns of a generation of feminist and feminist bisexual and lesbian writers. To varying degrees, authors including Linda Nochlin, Harmony Hammond, Arlene Raven, and Lucy Lippard have alerted us to the need to deal with sexuality openly in order to assess the work and lives of artists without the prejudices, distortions, and myths surrounding the homosexual presence in visual art.[13]

A persistent problem has been that lesbians, even in readings by gay men, have been deprived of a political existence through inclusion as female versions of male homosexuality. In this manmade world, there has always been an active homosexual eroticism, which manifests itself in a variety of visual forms, for instance, the Golden Age of the Greeks. Gay men have not been constructed as the "other" in the art-historical canon;

in fact, the homosexual aesthetic is held up as "perfection" itself, for example, Michelangelo and Leonardo. Generally speaking, women have been brainwashed or manipulated into accepting male constructions of nature, beauty, politics, and art, including the concept of what constitutes an audience.

As Adrienne Rich points out, "Sensuality between women, including erotic mutuality and respect, is 'queer.' . . ."[14] But "queer" politics have changed a lot since Rich wrote that statement. At the time she was writing, traditional psychoanalytic theories, for instance, maintained that women who sought same-sex relationships suffered from arrested sexual development. Their experience was seen, and still is seen in some camps, as abnormal and inferior to the dominant heterosexist model.

Those who accept the tag "lesbian" were transgressive, whether or not they defined themselves as such. They challenged compulsory heterosexuality and threw into disarray the dominant discourses involving beauty and gender. Society defines the lesbian in language as a "female homosexual" *(American Heritage Dictionary)*. In fact, when she tried to define herself her voice is heard as an attack on the feudal (futile) male right of access to women *(le droit du Seigneur)*. Concerning this, one gay male critic instructed me that "there are many lesbian lifestyles, . . . and some of them include men."[15] His example of a "lesbian" who "includes" men was Zoe Leonard, a young woman in her twenties, who apparently has a romantic relationship with a man with AIDS and thinks condoms on penises are sexy.[16] I can't help asking myself, is his choice of a self-defined political lesbian model who identifies with gay males connected to his decision to privilege gay males over lesbian subjects—is it an attempt to foster a theory of lesbian sexuality apart from feminist theory?[17] Or is this merely a function of age and stage? Why is my experience any less valid than Zoe Leonard's? My point is that women have a variety of diverse experiences. We need to value them all because they enrich our possibilities of seeing a larger, not a narrower, picture.

Jungian analyst Karen Lofthus Carrington argues that relationships between women are "particularly threatening as an archetypal image to man and the patriarchy" because men feel rejected by such intimacy between women. This would appear to be true of even some gay men, if my critic's letter is any measure of the threat that gyn-affectional relationships pose. Carrington concludes, "If women are gazing into mirrors and into one another's eyes as a way of remembering their wholeness, who then will mirror to men *their* souls."[18] This is perhaps particularly true in an era of AIDS when women generally end up being the primary caretakers. Woman's desire for feminine energy thus becomes above all an act of

resistance. So how we choose to identify ourselves, however we find ourselves labeled, is what I believe frees the mind, spirit, and sexuality of women.

For the purposes of this paper I want to address the question of the "gaze" from a lesbian feminist perspective. I want to examine the differences among various gazes: male heterosexual, gay male, lesbian feminist, feminist heterosexual, etc. Up to this point, there has been only one gaze—"male."[19]

In the context of feminist art-historical discourse the Dutch painter Christiaen Van Cowenburgh's *The Rape of the Negress* (1632), most feminists would agree, is a vicious, sadistic, racist white male fantasy in which three young men are shown taking pleasure in violating a screaming black woman as she helplessly protests their actions. If we accept the theoretical generality that the gaze is male, what can any feminist say about men who voyeuristically take pleasure in so demeaning another human being simply because she is black and female.

For one who reads from a gyn-affectional position, the whole question of rape is much more complex.[20] For the female-identified and -centered woman, the nagging notion that a phallocentric culture proposes through media and other channels—namely, that the victim, for example, Anita Hill, did something to invite her violation—should not come into play.[21] Possibly because a woman whose sexual choice is another woman has no doubts regarding any complicity when it comes to asking herself, "Did I do something to invite it?" She knows she did not.[22] She knows that violation is about domination.[23] Perhaps for this reason, she is able to have complete empathy with the rape victim, without any of the plaguing uncertainty that some might entertain because of patriarchal brainwashing, viz. having "done something" or doing something to attract harmful male attention.[24]

In a similar vein, Allan Jones's "pneumatic, streamlined and lacquered lovelies, . . ." such as *Girl Table* (1969) are not lovely for me.[25] The sexual fires that may burn for him as a white male at the sight of a corseted white female with naked breasts, shod in a pair of high-heeled black boots and arm-length black gloves, crouching on her knees as she balances a glass table on her back while gazing into a mirror, are the cold ashes of humiliation for any female who has her self-esteem intact after looking at his depiction.[26]

Rene Magritte's reductive *The Rape* (1934), which presents a female head as specifically sexual parts of a woman's body—the eyes are breasts, the mouth a vulva—is not amusing. Here woman is literally depicted by man's depersonalized use of her. She is a thing and has no other meaning

for him. To me and many other feminists, regardless of sexual predilection, this is a demeaning misogynist expression. But a gyn-affectional feminist would be furious at seeing Magritte's conception and might wonder what it would be like for a lesbian artist to make an equally man-hating work. The question arises, would it be an act of empowerment or merely a hateful expression of a binary model in reverse? Would such an image change anything for a lesbian, since it would mean total annihilation of the man as a person? What possible political purpose could objectifying the male, as women has always been "thinged" by patriarchy, serve? None, since it would simply reinforce the present inhuman condition of power relations. The only thing it would prove is that lesbians could be as abusive as patriarchal men have always been.

I want to make it clear from the onset that I am not arguing for the development of a feminine sensibility, or to define a feminist art in this article, but instead, to explore the subject of several gay women's responses to the female nude in the history of art. The question I want to explore is, If a female subject is watching images defined as lesbian what can this mean to her?

As one lesbian woman explained, "Gay women are women-identified. They choose to center their energies and their love and everything around and for women only. Their love relationships are with women . . . as far as they're concerned, men don't enter the realm of a lesbian lifestyle at all."[27]

"Emotional and sexual love between women has been consistently feared and pathologized," explains Karin Lofthus Carrington.[28] She asserts that "to name and describe the embodied love between women poses a threat to the consensual reality of our culture as well as to the women who dare to speak the truth of their experience in love with another woman."[29]

What is a lesbian anyway? Clearly, any woman who is a feminist has to deal with her sexuality when she meets a lesbian. It is not simply a matter of politics, but of sexuality. It is only when we begin to discover the erotic in female terms and, as Audre Lorde described it, "the sharing of joy, whether physical, emotional, psychic . . ." that we will really discover what the relationship between sexuality and gender might be.[30] Carrington asks, "What, really, is this love between women?" She then explores archetypal patterns of lesbian love and individuation, discovering four patterns: a participation mystique, which involves a deep identity with the loved one; a reunion with the sister; a "twinning" of the self; and a re-echoing of the first pattern, in which a woman reunites with the "mother at the center of the earth."[31]

For that matter, erotic objects, including breasts, buttocks, shoes, corsets, garter belts, and stiletto heels, while created about women by men (or women), may in some cases hold enjoyment for the female as well.[32] Given these diverse ideas concerning women, sex, love, and objects, I think it is time for those women who define themselves as lesbians and who are in the life to come out of the closet and express their own feelings regarding a female gaze, and the diverse meanings of female nudity.

Lesbian artist Monica Sjoo tackles this problem directly, stating, "A real women's culture can only be developed by women together, women who have withdrawn their sexual, creative and emotional power from men. Women who ultimately seek male approval because they are sexually dependent on men, will never ultimately be able to draw any real consequences of their own actions, feelings, and thoughts. They will always be somehow looking sideways."[33] In "Class Notes," lesbian feminist artist Harmony Hammond challenges us to examine the assumptions of class and heterosexuality in art.[34] She also cautions us to examine the preexisting presentation of lesbians in butch-femme roles as sick, masochistic, and sadistic, as though sexuality was the only thing in their lives.[35] This is a point to which I will return in the second part of this essay.

Such heterosexual representations as butch etc. I would argue are demanded by a patriarchal order whose objective is to reinforce their own sense of gender, power, and possession. Margaret Small and Hammond claim that the primary role lesbians have to play in the development of revolutionary consciousness is ideological because they are outside of both heterosexual and homosexual reality.[36] They don't view other females as a castration threat. In fact, as Hammond recently explained, "I realize there is a whole different problem for us in that the gaze for even the lesbian has always been the man, so I catch myself not waiting to even show vaginas or women doing it—we are too vulnerable."[37] So the pleasures of looking and being looked at have to be reexamined from the actively looking perspective of a lesbian-feminist theoretical view and re-presented in that context—a context that has yet to become fully visible because we are all socialized as heterosexuals in a male-dominated system and many postfeminist lesbians don't identify with feminism.

Considering how much of Western art deals with themes that are overtly or covertly erotic, it is not surprising that a good deal of attention has been paid to these implications by scholars and critics. What is surprising is how little attention has been focused on the psychosexual development of the artist or the spectator, or the commodities aspect of such themes in a capitalist society. Sadie Plant, in her book *The Most Radical Gesture,* reiterates:

The commodity fetishism of Capitalism is a renewed consideration of the phenomenon in which relations between people assume the form of relations between things. In the absence of any real world of unalienated social experience, commodity relations become mysterious and fantastic; labour is turned against the worker and appears as an autonomous power, and because the totality of these relations is presented as a natural order, the worker loses all reason to challenge or understand the experience of alienation.[38]

Very few heterosexual and gay or lesbian artists have successfully challenged this apparatus. As Linda Nochlin so perceptively pointed out, "The very term erotic art is understood to imply the specification erotic for men."[39]

So we begin with a textual comparison of the theme of Orientalism as sexual colonization. A white male interprets the French nineteenth-century painter Ingres' *Le Bain Turc,* saying:

This picture is a hymn to the glory of the female body—there are nudes everywhere we look; they fill the whole picture-space as if the artist suffered from horror vacui. The eroticism of the paintings is of a particularly complex kind, as it is possible to discover a number of contributory elements. In the first place, there is the fact that this is a variant of the "harem" or "slave-market" theme. These women are animals, herded together and preparing themselves for the pleasure of the male (whom in this case they cannot refuse to satisfy). Secondly, the implications are strongly voyeuristic: we are looking in at a scene normally forbidden to the male gaze. Thirdly there is more than a hint of homosexual affection in some of the poses—note, in the principal group, the way in which the second figure from the right is clasping her companion's breast. And lastly, we can also read the composition as something kinetic. Instead of being a crowd of women, this is one woman displaying herself before us in every conceivable variety of pose.[40]

On the other hand, feminist critic Lisa Tickner regards the theme of Orientalism as

. . . a primarily national subject by reference to its exotic (and subsequently colonial) "Other." It articulates a difference of race in which sexuality is also critical. The odalisque or harem painting is structured by a scenario of desire centered on a spectator positioned like the artist as a European male. The viewer is invited sexually to identify with, yet morally to distance himself from, his oriental counterparts depicted within the objectively inviting yet racially distancing space of the painting. His female counterpart is compromised by the promise, intrinsic to Orientalism, that culture may be penetrated and mastered through the (literal and figurative) possession of its women. She is offered an oscillating identification with the "imagined communities" of her sex or her nationality: ethnically she sides with the men, sexually with the women.[41]

In both these readings no consideration is given to how a gay male audience might gaze at this image, and in the second no consideration of a lesbian and bisexual audience is entertained, since women are assumed to be heterosexual and feminine and their "imagined" community is only comprehended as an object of male desire. To Tickner's credit, her representation does, at least, allow that women can take pleasure in images of other women that are both disturbing and fascinating, but she never explains why.[42] And she neglects to deal with the possibility of the masculine en-genderment of their gaze, much less the images that Carrington suggests in her four archetypal images.[43] Ironically, the odalisque of European painting, who is, as Linda Nochlin discloses, a depersonalized woman denuded and immobilized beneath the male gaze and held in her place by the complicity of other females, is transformed by the gyn-affectional gaze into a revolutionary sexual adventuress who may embody the erotically compelling lover/mother referred to by Carrington and poet Adrienne Rich.[44]

This raises the question, "What if the woman's attitude toward women—toward the central image of the nude woman in art history—is conditioned by her own experience and sexuality as a lesbian?" For the gyn-affectionally identified woman the concept of gender being fixed by representation begins to fall apart when she examines her own sexuality and compares it with the existing gendered male and female / masculine and feminine models. And if she is an artist, perhaps she does merge with her muse in what Carrington would characterize as a "coniunctio—a reunion with the lost sister self," rather than penetrating her with a willful brush. Because as Betsy Damon explains, "The muse and I are inextricably entwined and she is a woman."[45] Damon is female, and she is clearly not ambivalent about her sexuality, or her desire for the feminine which is gyn-affectional. The demands of heterosexual culture/male-dominated culture insist that her desire define her as masculine. A demand she rejects.[46]

By Ticknor's reasoning, since Damon is white and American she should identify with white American males, but she does not. In Damon's case she sides with the female and is fiercely supportive of the claims of African-American, Native American, Asian, Latina, working-class, and poor women in art, and in life. So the presented concept of representation breaks down, and the gyn-affectionally identified woman rejects it as reductive and untrue.

Consider putting yourself in this woman's place as she looks at Courbet's *Sleep,* which was painted for the former Turkish ambassador to France, Khalil Bey, who, Nochlin says, "no doubt felt . . . invigorated

by the spectacle of two voluptuous female nudes locked in each other's arms."[47] Psychologically we know that lesbian themes have always been an invigorating spectacle for heterosexual men and are the second most popular fantasy listed in Masters and Johnson for both sexes. But, apparently, not so for gay males. *New York Queer* editor Avril McDonald comments, "Any lofty notions of queer solidarity that I entertained before I started working for *NYQ* were rudely shattered when I discovered that every time we put a lesbian on the cover, sales plummeted."[48] But the question remains, "What possible erotic meaning—what affect—might these images have for a gay woman?"

Rather than bringing about an impoverishment of the eye, looking might instead provide a particularly feminine relation to the fluid, tactile, melting diffuseness of two female bodies locked securely in each other's arms.[49] Clearly, two naked women sleeping in each other's arms are seen as lesbian by most gazes and, as lesbian feminist poet Adrienne Rich notes, have more than their sleep to protect. The lesbian, explains poet Olga Broumas, is

> a woman committed to
> a politics
> of transliteration

The delicate eroticism with which Courbet has suffused the theme of his sleeping women may infuse the scene with a delicious sense of power and possession for the male gazer, but what does it symbolize to a lesbian or bisexual female? Perhaps she sees the naked brunette who lies on her back with head thrown back, a mass of dark, thick hair flowing from her brow onto the white pillow—her translucent flesh a rare concert of light, one leg effortlessly thrown over the other woman's hip—as a potential lover. Conceivably a woman might imagine herself turning in the curve of her brunette lover's arm—imagine her own long blond hair cascading over her shoulder like rivulets of sparkling water and her fingers tenderly caressing her partner's calf. Desire, as Carrington proposes, eases the mind along the intimate slopes of these intertwined bodies. The scene is further enhanced by the shining tangle of the sheets, which helps any memory once engraved on the twin passions of one's own experience to decode the significance of these women's twin satisfaction. So a lesbian vision shifts the meaning of Courbet's sex fantasy to a woman's own erotic horizon. She traces the consistent vowels of same-sex passion in the broken scatter of glistening pearls, the unbounded, wildly disheveled hair, and discarded comb—evidences of these two women's mutually untamed,

erotic appetites. What we women are relishing is the pleasures of claiming the female nude for women's pleasure.

Take another example, the hugely successful sculpture the *Greek Slave* by Hiram Powers, which depicts a submissive, passive, and available white female. The subject is a young, nude, Christian girl offered for sale in a Turkish slave market, sheltering her modesty as best she can with chained hands. Her body marks the site of male possession and has a sadistic component. In it, Powers attempts to consciously embody the white woman's virtue in the face of her humiliation, while at the same time perhaps relishing that degradation.[50] Resistance to her salability as a commodity and sexual possession are bound into his sculpture.

How might a gyn-affectional woman look at this nude? How does she see it? Does Powers's slave tantalize her with its youthful beauty, powerlessness, and vulnerability? Does she, like the male viewer, too wish to possess this captive and delight in the woman's humiliation? Or does she identify with what she has been—her own powerlessness and vulnerability—or possibly what her experience has taught her about gazing at the female and empowerment, or does this engage an erotic lesbian s/m fantasy?

When the lesbian feminist looks at Paula Modersohn-Becker's *Self-portrait Nude,* does she identify with the joys of her body as a garden of earthly delights, does she associate the image with Eve, or is she looking at herself through traditional patriarchal eyes as breeder stock—a docile cow? Why wouldn't such a Sapphist suppose that this lushly voluptuous creature is offering herself to her? What would prevent her from feeling free to reclaim such images for herself? Reflecting on her own gaze, this woman also sees the odalisque as offering herself to a same-sex gaze and imagines herself to be actively looking and touching back? I would argue that for such women the slave's nudity may become part of a colorful wardrobe of lesbian eroticism with multiple references. This property of the gaze in the field of visual art and in life itself seems to have escaped traditional heterosexist interpretations and feminist readings, as Carrington's innovative work so vividly illustrates. From the vantage point of sexual politics, a lesbian-feminist vision is free to pick and choose at will. In the works of contemporary lesbian-feminist artists such as Tee Corinne and Marcia Salo, women are not passive or totally submissive to either men or women. They dive, plunge, suck, enter, pirouette, and pleasure, engaging in a transformative remembering of their own power, depth, and beauty. Because the meaning depends on who is doing the looking and how that viewer chooses to see it, the image remains a

question of who determines the connotations of woman as body, as sexual, as intellect, as beautiful, as nature.

In summary I would argue that for a gyn-affectional woman, visual pleasure begins with the female. So one of the most prickly problems in a male supremist culture is that femininity is not an alternative to masculinity, but rather a negative. These are culturally determined positions simply because in male-defined theory the phallus remains the sign of power in androcentric societies. To reject it marks the frontier of an awakening that challenges the whole structure of patriarchy and its dominance over other value systems. For a gyn-affectionally identified feminist, the otherness of woman is herself and she thus engages in the radical work of reconstructing woman as a sign of independence, strength, and transformation. It is her intervention that determines her gaze. What she sees when she looks at the history of art is necessarily very different from what the heterosexual male and female, gay male and male-identified lesbian, sees.

II

Simone de Beauvoir's *The Second Sex* (1949) was a ground-breaking work, not only for feminists but, most particularly, for gyn-affectional women. She has been hailed as the first nonlesbian in Western philosophy to claim that lesbianism is a mode of resistance to male domination. So her work supports the radical argument that lesbians are a feminist vanguard whose choice of a sexual love object is a quintessential act of resistance against patriarchal domination.[51] In the feminist movement in art and art history this fact has received little acknowledgment. When faced with an out lesbian presence, in either life or art, many heterosexuals and gay people feel themselves threatened and resort to behavior that colludes with socially approved stereotyping. They uphold gender convention rather than challenging the status quo.[52]

Given these circumstances, I am now going to present several criticisms about art history, feminism, and the lesbian-using Romaine Brooks and her work to illustrate certain points about a lesbian identity and Brooks's defiance. Here, I am going to approach the life and work of Brooks from a lesbian-feminist perspective, which I maintain differs from a feminist position.[53] Feminist art historians, not just traditional art historians, I will argue have an uneasy relationship to the lesbian, and many women in this field are still afraid of calling themselves feminists because they fear being labeled as lesbians by the larger rank and file.

In my reading of several women's interpretations of Romaine Brooks's work, I detect that many of them become so disturbed by Brooks's sexuality that they do not know what to do with her. Take for example Whitney Chadwick's recent misleading statements regarding Brooks in *Women, Art, and Society*.[54] Chadwick explains, "Brooks' portrait of Barney, *The Amazon* (1920), is the only one of her female portraits which does not involve cross-dressing." This is factually wrong, since Brooks painted portraits of several straight and bisexual women and also painted men. Chadwick goes on to psychoanalyze the artist, telling us that "Brooks' other female portraits, with their tuxedos, pinched faces, and morning coats, expose the self-divisions, the pain the male costume produces on and in the female figure."[55]

In my article published in *Art Criticism* entitled "Fashion, Character and Sexual Politics in Some Romaine Brooks' Lesbian Portraits," I argue that to dismiss lesbian portraits as portraying women in "male attire" perpetuates a shallow and misleading reading of the lesbian code as embodied in Romaine Brooks's work—work that represents one of the few out examples of a direct lesbian iconography that exists in the history of art.[56] Hers is an "articulation" that establishes a "unity among different elements within a culture under certain conditions"—one that allows for various levels of reading and interpretation.[57]

For women, fashion and dress are commodities that encode matters of power and control. In the case of Romaine Brooks, she designs her own clothing in order to assert self-definition free from the corseted constraints of gender. In fact, she breaks out of the feminine identity; in so doing she shows the connection between sexual politics and fashion, but this does not necessarily make her a butch. Chadwick claims that Brooks's Whistlerian palette of black, gray, and white renders female images "tense and secretive," for example, the *Self-Portrait* of 1923.[58] In my opinion it is far from being "tense and secretive." As Brooks's lover, Natalie Barney, explains, this palette was an expression of her exceptional style and taste.[59] Although Chadwick is a feminist, she misses, like many heterosexist art historians, the lesbian code embodied in Brooks's self-portrait and other works.

At forty-nine Brooks saw herself as a desirable woman. In her self-portrait she depicts herself in one of her exquisitely tailored suits.[60] This is a portrait of "a small, dark, arrogant and mocking cynic" who retains beneath an elegantly tailored facade traces of both poet and child. Her eyes are direct, but guarded. The shadow cast by the brim of her foppish hat further intensifies the impression that this is an artist looking out at the world from some private retreat. Her black suit is severely simple and

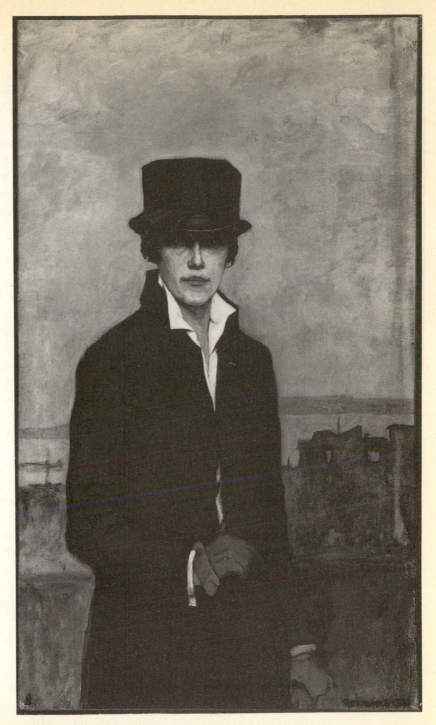

Romaine Brooks, *Self-Portrait*
Oil on canvas, 1923, 46¼″ × 26⅞″
Photo courtesy of National Museum of American Art,
Smithsonian Institution, Washington, DC; gift of the artist

conservative. She is meticulously turned out, a figure of imposing author-
ity. Her neck and face are exposed, and glowing like a tiny red ember in
her lapel she wears the medal of the Legion of Honor, which the French
government awarded her in 1920. A slightly flattened cityscape suggests
an abstracted urban twilight, perhaps an inner consciousness, which
nonetheless Romaine Brooks dominates in majestic isolation.[61] This is
not "a soul locked in its own despair," as Brooks's straight biographer
Meryle Secrest has suggested, but instead, a strong-willed, independent,
and defiant personality, consciously aware of her assessed strengths and
weaknesses; boldly revealing all to the sensitive and knowledgeable fe-
male viewer. And she is more than a little on the make.[62]

I disagree with Chadwick's analysis of Brooks's works. Her language
reflects an internalized homophobia. She unknowingly upholds the social
construction of otherness—the other being the lesbian. She makes Ro-
maine Brooks up to mirror socially acceptable interpretations of who and
what a lesbian is. Her explanations for cross-dressing leave much to be
desired.[63]

Several feminist critics provide an alternative basis. According to
Carroll Smith-Rosenberg, "Feminist modernists turned to dress and to
body imagery to repudiate gender and to assert a new order."[64] Judith
Butler pays careful attention to psychoanalysis, commenting that "by
grounding the meta-narratives in a myth of the origin, the psychoanalytic
description of gender identity confers a false sense of legitimacy and
universality to a culturally specific and in some contexts, culturally op-
pressive version of gender identity."[65] Chadwick has little or no awareness
of the existence of anyone but the stereotypical heterosexist construction
of the lesbian, who is always seen as trying to be a man. She is unable to
grasp the idea of not categorizing human beings as other-than-herself.

All this demonstrates Brooks's womanish resistance to being defined
by others and provides a foundation for our discussion of a humanistic
approach to lesbian studies in art history and criticism. Brooks is a
dangerous woman who refuses to be silenced, and who most articulately
defines a lesbian gaze by showing her disdain for the heterosexual oppres-
sion of the "other." Her assertiveness of self offers lesbians a validation
model for self-empowerment, i.e., I define myself, you don't define me!

We have established that Romaine Brooks's experience as a Sapphist
shaped her concept of self. Her contributions to gay and lesbian studies,
feminism, and the history of art are unique and original. We have yet to
deal with the internal contradictions that shaped her and her work. What
she demonstrates is the impossibility of universal interpretations and

solutions as offered by the traditional art-historical canon or a conservative feminist art history.[66]

III

I shall conclude my inquiry by continuing to ask, "How can I practice art history and criticism in a way that minimizes its service to prevailing sexist attitudes?"[67] I would argue that the socially constructed sex/gender system practiced by art historians, revisionists, and even well-meaning feminists, as well as some gay and lesbian scholars, can only reproduce a set of arrangements that supports the patriarchal status quo in an academic environment. As we look back historically, it becomes obvious that there has been and continues to be a lack of appreciation of the qualities of democratic values and norms. This has given rise to elitist attitudes such as those that many of us have experienced within academe.

As a theorist and activist who identifies with situationist criticism, I know there is a need to confront the inequities present in our discipline, and in culture in general.[68] Art history is therefore a discipline that has given only token acknowledgment to a lesbian presence, despite the many closeted brothers and sisters who populate the field. Currently those gyn-affectional feminists, such as myself, who have had the courage to be "out-selves" find ourselves *out* in a world that continues to find us alien and unwelcome. As one lesbian put it, "The boys promised us equality in the queer nation."[69] But when we put ourselves on the line and looked around for them they were not there.[70]

For many heterosexual men, gay males, and feminists, Brooks remains an enigmalike sphinx when she poses the question that they cannot answer, Who or what is a lesbian? Yet instead of going to a lesbian feminist for a clue, they make up their own questions and answers, and say that this is what Brooks is really all about. They are talking to themselves. Essentially, what we are left with are "fairy tales" that tell us more about the authors than the person/art being analyzed. My concern is how can I use Brooks's experience to illuminate my work as a critic and activist.

In writing this essay I am trying to point out how frightening it is to even raise these questions—in fact, to question is a threat. In such an atmosphere we cannot even begin to ascertain how this affects the work that we do, i.e., coding our language, passing for straight, and hiding our identities even in the "queer nation." Also I would suggest that lesbians have played an enormous role in both the feminist and multicultural

communities, marching for civil rights, abortion rights, demonstrating with Act Up, volunteering for the Gay Men's Health Crisis, etc., yet are still being treated by these groups as second-class citizens.[71] As Avril McDonald asserts, "The sad reality is that queer nation is an illusion, unless it's a nation of masters and slaves. It's a microcosm of the wider world, where lesbians are women first, collectively shafted by men."[72] So my question remains, "What is the feminist community doing about it?" Judging from what's happened thus far, not much. Particularly disturbing is a new coalition of heterosexual women and gay men who have ultimately abandoned any attempt to insert the diversity of lesbian experience into male culture, to ask, "How do you define yourself? What are you really relating to?"

Lesbians have been invisible for too long. We need our lives to be seen, stories to be heard, and our own theories constructed and put into practice. In this postmodern period that claims to celebrate diversity, we need to remember Hannah Arendt's words, "Only where things can be seen by [people] in a variety of aspects without changing their identity, so those who gather around them know they see sameness in utter diversity, can worldly reality truly and reliably appear."[73]

In regard to how to accomplish this I am of two minds. On the one hand, I am arguing for a consciousness distinct from dependency on previous models that limit our ability to see clearly. What I am searching for is an active theory and practice that is not rooted in methodologies and practices that have proved inadequate for the complexities of our times. How to free ourselves from a negative dependency on patriarchal models of reality, which often demands a kind of self-censorship of our desire for authenticity, remains one of the primary goals of feminist activism and lesbian studies.

On the other hand, I have to conclude by posing the question, Does the fact that we are still on the margins—are considered absurd by the powers that be—indicate that we are dealing with real problems in the most dissenting and constructive way, despite our exploitation?

Notes

My sincerest thanks go first to the many, many people who contributed to the successful completion of this book. I am particularly indebted to my partner, Irene Javors, who has been a source of inspiration, shared her writing and research with me, and read everything as I worked on the final stages of my paper. Linda Nochlin supplied a wonderful critique on the first draft of my essay in this collection, which was enormously helpful. I am also indebted to my coauthors and colleagues, particularly Lee Ann Miller, elsewhere in the country for their kind assistance

and support when I read the Romaine Brooks portions at the meeting of the College Art Association. I wish to thank the Lesbian Study Group, especially Flavia Rando and Marsha Salo, for our many informative readings and discussions, which helped to sharpen my thinking and were of great importance to me. Adrienne Rich's thinking on so many issues influenced my own, as did the work other lesbians, including Bettina Aptheker, Lillian Faderman, Susan Sherman, Tee Corrine, and Harmony Hammond.

1. I am indebted to Irene Javors, who is an expert on feudal/futile marriage rituals, for this reference.
2. See Lisa Duggan, "Making It Perfectly Queer," *Socialist Review,* vol. 22, no. 1 (January–March 1992): 11–31.
3. Mary Daly in cahoots with Jane Caputi, *Webster's First New Intergalactic Wickedary of the English Language* (Boston: Beacon Press, 1987), 77.
4. See Elaine Marks, "Lesbian Intertextuality," in *Homosexualities and French Literature,* ed. George Stambolian and Elaine Marks (Ithaca and London: Cornell University Press, 1979), 353–377.
5. See Sadie Plant, *The Most Radical Gesture: The Situationist International in a Postmodern Age* (London and New York: Routledge, 1992).
6. See Cassandra L. Langer, "Against the Grain: A Working Gynergenic Art Criticism," in *Feminist Art Criticism: An Anthology,* ed. Arlene Raven, Cassandra L. Langer, and Joanna Frueh (Ann Arbor and London: UMI Research Press, 1988, 111–131; reprint, New York: HarperCollins, IconEditions, 1991).
7. In all fairness it should be noted that there is a vast difference between those women who make a political decision to call themselves "lesbians" and those who are actually "in the life." To be in the life means to survive on the edges and all the consequences that go with being single and lesbian in a patriarchal society. Younger women who define themselves as political lesbians are engaging in a radical gesture, but there are significant distinctions between saying you are a lesbian and living as one. For an admirable overview of the generational experience, see Arlene Stein, "Sisters and Queers: The Decentering of Lesbian Feminism," *Socialist Review,* vol. 22, no. 1 (January–March 1992): 33–55.
8. Interview with the author in New York City, June 16, 1991.
9. See Naomi Wolf, *The Beauty Myth: How Images of Beauty Are Used Against Women* (New York: William Morrow, 1991): 58–85.
10. Ibid., 59.
11. Ibid., 217. Currently the question of sexuality and notions of sexual difference are hotly debated issues among feminists and are constantly under reconsideration. Wittig's "The Straight Mind," *Feminist Issues* 1 (Summer 1980) remains essential to any discussion regarding the discourses of heterosexuality that oppress us and prevent us from speaking for ourselves in all our diversity.
12. Please note that if "All But the Obvious," the second major group exhibition of lesbian art exhibited in Los Angeles at LACE this year (1991) is any measure, younger lesbian art appears to challenge the aesthetic advanced by lesbian artists of the 1970s. But it is not my purpose here to discuss the new generation but instead to posit how members of the older generation tried to deal with the obligatory social relation between "man" and "woman" by constructing their own theories and images.
13. For an in-depth discussion, see Harmony Hammond, "A Sense of Touch," *Wrappings* (New York: TLS Press, 1984).
14. Adrienne Rich, "Compulsory Heterosexuality," in *Powers of Desire,* ed. Ann Snitow, Christine Stansell, and Sharon Thompson (New York: Monthly Review Press, 1983), 185.
15. Letter to the author March 22, 1991, from an anonymous reviewer who identifies himself as

a gay male in the commentary for *Genders* with his suggestion that the article I submitted be published with his revisions.

16. Zoe Leonard, "Safe Sex Is Real Sex," in *Women, AIDS and Activism,* ed. the Act Up/New York Women and AIDS Book Group (Boston: South End Press, 1990), 28.

17. Ibid.

18. Karin Lofthus Carrington, "The Alchemy of Women Loving Women," *Psychological Perspectives,* "Gender," issue 23, no. 6 (1991): 73.

19. See Laura Mulvey, "Visual Pleasure and Narrative Cinema," *Screen,* vol. 16, no. 3 (Autumn 1975). Mulvey describes this power: "In a world ordered by sexual imbalance, pleasure in looking has been split between active male and passive female. The determining gaze projects its fantasy onto the female figure, which is styled accordingly."

20. See Arlene Raven, *Crossing Over: Feminism and Art of Social Concern* (Ann Arbor: UMI Research Press), 157–169. Also see Wolf.

21. When it comes to women's victimization in a male-dominated society and under male law, what happened to Anita Hill constitutes socialized rape.

22. See Wolf, 38.

23. As Wolf notes (p. 40), "Studies repeatedly show that at least one woman in six has been raped, and up to 44 percent have suffered attempted rape. The popularity, among women, of the films *A League of Their Own, Fried Green Tomatoes, Strangers in Good Company,* and *Thelma and Louise* confirms women's identification with both their victimization and their desire to resist it and defend themselves."

24. I thank Arlene Raven for calling my attention to this fact by way of her experience, not only as a rape victim but because of her interaction with other rape victims through groups and in the context of the show, "Rape" she wrote the essay for (Ohio State University Gallery of Fine Art, 1985). Those who say women invite their own rape are influenced by the same misogyny and gynophobia that leads them to the conclusion that incest is the victim's fault. Most lesbians attempt to re-present femininity and masculinity in their own terms.

25. Rudolf M. Bisanz, "The Nude and Erotic Art: The Pick of the Crop Reviewed," *Art Criticism,* vol. 5, no. 1 (1988): 68.

26. This is not meant as a criticism of lesbians who are involved in s/m fantasies wherein each person in the scene comes to it from a position of choice. This is a comment upon the erotization of misogyny in the form of sexual subjugation of women during lovemaking.

27. Kathleen Brandt, "It Could Happen to You," *Maenad,* vol. 2, no. 2 (Winter 1982): 46. My question remains, In master discourses does one automatically inform the other? Do lesbians exist without their naming by master narratives? And do all lesbians think in the same ways? I think not if an active lesbian s/m practice reveals the complexity of lesbian sexuality. See Tania Modleski's *Feminism Without Women,* particularly her chapter "Lethal Bodies" (London and New York: Routledge, 1991), 135–163.

28. Carrington, 64.

29. Ibid.

30. Ibid., 193.

31. Ibid., 64–82.

32. Eileen O'Neill, "The Re-Imaging of Eros: Women Construct Their Own Sexuality," *Ikon,* second series, #7 (Spring–Summer 1987): 118–126. Discusses women's eroticism and the visual arts from the point of view of redefinition of pornography and noxious pornography. But she never really comes to grips with s/m fantasy and patriarchy. Carrington's article also discusses the sexual meaning of butch and femme. The whole area needs a serious examination in terms of the question, "Is there a feminist pornography?" For more on this issue, see Alice Echols, "The New Feminism of Yin and Yang," and Ellen Willis, "Feminism, Moralism, and Pornography," in *Powers of Desire,* ed. Ann Snitow, Christine Stansell, and Sharon

Thompson (New York: Monthly Review Press, 1983). *Drawing the Line* (Vancouver: Press Gang Publishers, 1991) by Kiss and Tell is another example of lesbian sexual politics.

33. Monica Sjoo, "Lesbian Artists," *Heresies,* "Lesbian Art and Artists" (Fall 1977): 45.

34. Ibid., 34. Hammond also suggests examining lesbian art as a potential catalyst for social change.

35. What happens when the "other" speaks as a subject, as in *The Well of Loneliness* viz. masculine and feminine gender. Who is he/she speaking to and about who/what and to whom. This is a question posed by an exhibition of lesbian art, "All but the Obvious," curated by Pam Gregg and Catherine Lord, Phranc, Cheri Gaulke, Liz Kotz, and Adriene Jenik at LACE (1989–90).

36. Ibid., 35.

37. Letter to the author, May 14, 1991.

38. Plant, *The Most Radical Gesture,* 11.

39. Linda Nochlin, "Eroticism and Female Imagery in Nineteenth-Century Art," in Thomas B. Hess and Linda Nochlin, eds., "Woman as Sex Object," *Art News Annual* (1972): 9.

40. Edward Lucie-Smith, "Venus Observed," in *Eroticism in Western Art* (New York and Washington, D.C.: Frederick A. Praeger, 1972): 180.

41. Lisa Tickner, "Feminism, Art History, and Sexual Difference," *Genders,* no. 3 (Fall 1988): 105.

42. For possible insights see Christine Holmlund, "When Is a Lesbian Not a Lesbian? The Lesbian Continuum and the Mainstream Femme Film," 145–179, and Danae Clark, "Commodity Lesbianism," 180–201, both in *Camera Obscura,* no. 25–26 (January–May 1991).

43. I am using this term in a political sense of the Euro-centric gaze which puts them in the male power position viz. their colonization other. These women may not side with their sex at all.

44. See Adrienne Rich, *Poems: Selected and New, 1950–1974* (New York: W. W. Norton, 1974).

45. Ibid., 2.

46. Damon, the mother of two, self-identified as a lesbian at the time that the statements quoted in this article were made and has recently decided to re-explore her heterosexuality.

47. Nochlin, 9. It is interesting to note that the picture was inspired by Baudelaire's poem "Les Femmes Damnées." The painting shows two lesbian lovers asleep in each other's arms. One of the models was Joanna Heffeman, Whistler's beautiful Irish mistress. The painting was first known as *Paresse et Luxure* and later renamed *Le Sommeil.*

48. Avril McDonald, "From the Editors," *New York Queer,* April 26, 1992.

49. I am not using the term "feminine" in the traditional heterosexist way, but, rather, in a more current revision that sees the feminine as outside patriarchal law, as undomesticated, and as a central figure in a new feminist mythology. This is a view supported by the work of Colette, Violette Leduc, and Monique Wittig.

50. The racist overtones suggested by the stories generated by Powers's work require another essay.

51. See Ann Ferguson, "Lesbian Identity: Beauvoir and History," in *Hypatia Reborn,* ed., Azizah Y. al-Habri and Margaret A. Simons (Bloomington and Indiana: Indiana University Press, 1990): 280–289.

52. Having come to these conclusions on my own, it was nice to have them validated in an intelligent article by Claudia Card, "Lesbian Attitudes and *The Second Sex,*" in *Hypatia Reborn,* al-Habri and Simons, 290–299.

53. Wittig argues for the elimination of gender categories. Natalie Barney, whom Elaine Marks calls "a crossroads of lesbian associations," defined herself as a Sapphist and favored a politics of androgyny.

54. Whitney Chadwick, *Women, Art, and Society* (London: Thames and Hudson, 1990): 262–263. Chadwick prefaces her misinterpretation of Brooks's work with what appears to be a sensitive appreciation of homophobia. "The appearance around 1900 of a cross-gender

figure whose behavior and/or dress manifested elements commonly identified as 'masculine' corresponded to an early twentieth-century medical model which constructed lesbianism around notions of perversion, illness, inversion, and paranoia. The ideology of the 'third sex,' the soul of a man trapped in a woman's body, advanced by pioneering sexologists like Havelock Ellis and Kraft-Ebbing, was rooted in destructive and homophobic attitudes."

55. Actually, that is arguable, since there were many models, for instance, the Sappho, which these women may have relied on within the larger corpus of lesbian intertextuality.

56. Cassandra L. Langer, "Fashion, Character and Sexual Politics in Some Romaine Brooks' Lesbian Portraits," *Art Criticism,* vol. 1, no. 3 (1981).

57. See Stuart Hall, "Race, Articulation and Societies Structured in Dominance," in *Sociological Theories: Race and Colonialism* (Paris: UNESCO, 1980), 305–345.

58. Chadwick, 262.

59. See Langer, "Fashion, Character and Sexual Politics," 30. This tailored form may also suggest Brooks's own identification with modernism viz. the architecture of dress.

60. This may have also been a statement about her own brand of modernism, since the Austrian architect Adolf Loos had praised English tailoring as the epitome of modern style. See Bridget Elliott and Jo-Ann Wallace, "Fleur Du Mal or Second Hand Roses? Natalie Barney, Romaine Brooks, and the 'Originality of the Avant-Garde,' " *Feminist Review,* no. 40 (Spring 1992): 6–30.

61. On the other hand, perhaps the burned out city represents patriarchal society in front of which Brooks stands. She represents herself as the sole survivor whose intense energy dominates the ruined landscape offering life.

62. Ibid. This is a paraphrase of my 1981 description.

63. See Esther Newton, "The Mythic Mannish Lesbian: Radclyffe Hall and the New Woman," in *Hidden from History: Reclaiming the Gay and Lesbian Past,* ed. Martin B. Duberman, Martha Vicinus and George Chauncey, Jr. (New York: New American Library, 1990): 281–293. Please note, I think Newton does the same thing from a lesbian point of view.

64. Carroll Smith-Rosenberg, "Discourses of Sexuality and Subjectivity: The New Woman, 1870–1936," in Duberman et al., 275.

65. Judith Butler, "Gender Trouble, Feminist Theory and Psychoanalytic Discourse," in Duberman et al., 330.

66. This will be the subject of a forthcoming book that I am writing.

67. See Langer, "Against the Grain," 112. Edited by Arlene Raven, Cassandra L. Langer, Joanna Freuh (Ann Arbor/London: UMI Research Press, 1988): 112. [Reprint: HarperCollins, IconEditions, New York 1991.]

68. See Plant, *The Most Radical Gesture.*

69. See Natasha Gray, "Bored with the Boys," *New York Queer,* April 26, 1992, 27.

70. In my own case, in a head-to-head confrontation over a paper I had presented at the College Art Association of America which was to be published in a journal, I was informed by a straight editor that I wasn't lesbian enough. My gay academic brothers, with whom I had worked for over two years, informed me that taking a stance on this "wouldn't be good for their careers." No concern over my career was shown when I was asked to risk my future by being out as a lesbian in order to obtain parity in a newly formed gay and lesbian task force.

71. What comes to mind is the enormous outcry from a number of gay men when women began to demand that they reciprocate the amount of energy women had put out concerning AIDS in relation to breast cancer and abortion. Tom Duane, the HIV-infected city councilman from New York's District 7, and Tim Sweeny of Gay Men's Health Crisis are among the few gay males who have put their bodies on the line for women's rights.

72. McDonald.

73. Hannah Arendt, *The Human Condition* (Chicago: University of Chicago Press, 1958), 57.

NOTES ON CONTRIBUTORS

Arlene Raven is an art historian writing criticism for the *Village Voice* and a variety of art magazines and academic journals. She is the East Coast editor of *High Performance* magazine and a member of the editorial board of *Genders*. Raven's selected essays were published as *Crossing Over: Feminism and Art of Social Concern* (1988). She was an editor and contributor to *Feminist Art Criticism: An Anthology* (1988) as well as editor and contributor to *Art in the Public Interest* (1989). *Exposures: Women and Their Art* was published by NewSage Press in 1989, and the monograph *Nancy Grossman* by the Hillwood Art Museum in 1991. Raven is a founder of the Women's Caucus for Art, the Los Angeles Woman's Building and its Feminist Studio Workshop, and *Chrysalis* magazine. She has lectured and taught at the Corcoran School of Art, the California Institute of the Arts, the Maryland Institute, Otis Art Institute, the Parsons School of Design and The New School for Social Research. Raven has curated ten exhibitions, including major surveys for the Baltimore Museum of Art, the Long Beach Museum of Art, Artemisia Gallery, and the Hillwood Art Museum. She studied at Hood College, George Washington University, and Johns Hopkins University, and holds an MFA in painting and M.A. and Ph.D. degrees in art history. She has received two National Endowment for the Arts Art Critic's Fellowships, and was honored by Hood College in 1979 with a Doctor of Humanities degree.

Amelia Jones is an assistant professor of contemporary art and theory and the history of photography at the University of California, Riverside. She writes art criticism for *Artforum* and *Art Issues* and has published articles on contemporary art, feminism, and film. Her book *Postmodernism and the En-Gendering of Marcel Duchamp* is forthcoming from Cambridge University Press.

Mira Schor is a painter and co-editor of *M/E/A/N/I/N/G*, a journal of contemporary art issues. She writes and lectures frequently on theories of painting and on gender issues in visual art, including essays on Ida Applebroog and the Guerrilla Girls, in *Artforum;* also essays in *Tema Celeste, Art Journal, Heresies,* and *M/E/A/N/I/N/G.* Currently she teaches at Parsons School of Design. Mira Schor is the recipient of a 1992 Guggenheim Fellowship in Painting and a Marie Walsh Sharpe "Space Program" grant. She is represented by Horoduer Romley Gallery, New York, where she had a one-person show in October 1993.

Phyllis Rosser is an art critic, sculptor, and educational researcher who was a contributing editor to *Ms.* magazine for fifteen years. Her feminist art criticism appears regularly in *New Directions for Women* and she published numerous articles on arts in education and testing reform in *Ms.* and other magazines. She is currently director of her own consulting firm, the Equality in Testing Project, in New Jersey. She has focused national attention on sex bias in the Scholastic Aptitude Test through her landmark study, *The SAT Gender Gap: Identifying the Causes,* funded by the Women's Educational Equity Act of the Federal Department of Education. Her extended foreword for *The Young Women's Guide to Better SAT Scores* is published by Bantam.

Andrea Liss is a contemporary art historian and critic specializing in photographic issues, feminist theory and practice and historical representation. She is visiting faculty member at California Institute of the Arts, Valencia, and is a Ph.D. candidate in the Department of Art History at the University of California, Los Angeles, where she is writing her dissertation on "Trespassing Through Shadows: History, Mourning and Photography in Contemporary Representations of Holocaust Memory." She regularly publishes essays on feminist artists and the interchanges between feminist philosophies and new ways of thinking about photographic and cultural practice. Liss collaborated with artist Karen Atkinson in the recent publication of the guidebook *Remapping Tales of Desire: Writing Across the Abyss.*

Harmony Hammond is an internationally known painter and sculptor who lives and works in New Mexico. Her work is included in the permanent collections of many museums. She is the recipient of two National Endowment for the Arts Fellowships and a Guggenheim Fellowship. Her writings have been published in many feminist and art journals, and her book *Wrappings: Essays on Feminism, Art and the Martial Arts* (TSL Press, 1984; out of print) is considered a classic on feminist art of the 1970s. She worked on the editorial collective for the "Lesbian Art and Artists" issue of *Heresies* magazine and curated "A Lesbian Show" at the 112 Greene Street Workshop in New York City. Currently she is a Professor of Art at the University of Arizona, Tucson.

Laura Cottingham is a writer and art critic who lives in New York City. She is a contributing editor to *Frieze,* London; *Blocnotes art contemporain,* Paris; *ACME Journal,* New York, and *The Journal of Contemporary Art,* New York. In 1992 she was a critic in residence at the Foundation Cartier pour l'art contemporain, Jouy-en-

Josas, France. She currently teaches at the Cooper Union for the Advancement of Science and Art in New York City.

Lorraine O'Grady began making art in 1980 as a performance artist at the Just Above Midtown Gallery, New York, and has since received NEA, CAPS and, currently, Sharpe Foundation fellowships. Her photomontages were in a one-person show at INTAR Gallery, New York (1991), with a catalogue by Judith Wilson, and have been included in numerous group exhibits at such venues as Bronx Museum/PaineWebber Gallery (1992) and the Southeastern Center for Contemporary Art (1993). She teaches courses in Symbolist and Surrealist literature at the School of Visual Arts, New York, and writes regularly for *Artforum.*

Margo Machida is a New York-based painter, independent curator and writer specializing in contemporary Asian American visual art. Her recent articles include: "(en)-Gendered Visions: Race, Gender, and Sexuality in Asian American Art" for the Guadalupe Cultural Arts Center (Texas, 1992); and "Seeing Yellow: Asians and the American Mirror," catalogue essay for *The Decade Show* (New York, 1990). Ms. Machida has curated a number of exhibitions including *Street of Gold* at the Jamaica Arts Center (1990); *Crossed Cultures: Three Japanese Sculptors* at the Rotunda Gallery (1989); and *Invented Selves: Images of Asian American Identity* at the Asian American Arts Centre (1988). She is currently organizing an exhibition for the Asia Society, *Out of Asia: Issues of Identity in Asian American Art,* scheduled to open in February 1994. Among her recent awards are: a Rockefeller Foundation Fellowship in the Humanities (1989–90) and a New York Foundation for the Arts Fellowship in Painting (1991–92). She is a founding member of Godzilla: Asian American Art Network, and a board member of the College Art Association of America.

Charleen Touchette is an artist, arts activist, writer, lecturer and curator. Her paintings, inspired by her dreams, memories, visions and multicultural heritage, are exhibited nationally. Touchette is a networker and activist working for multicultural diversity in the arts and is chair of the Honor Awards committee for the Women's Caucus for Art (WCA). She has taught with the Minnesota Arts Experience program, and was a visiting artist at the Minneapolis College of Art and Design. Touchette has developed a slide curriculum for the Minnesota Center for the Arts entitled "Native American Art Is World Art."

Adrian Piper is Professor of Philosophy at Wellesley College and a conceptual artist whose work, in a variety of media, has focused on racism, racial stereotyping, and xenophobia for over two decades. Represented by the John Weber and Paula Cooper Galleries in New York, she is the recipient of Guggenheim, AVA and numerous National Endowment for the Arts fellowships. She has recently exhibited at the Whitney Museum, the Museum of Modern Art, the Hirshhorn Museum, Kettle's Yard/Cambridge University and the Munich Kunstverein. A symposium on her work in art and in philosophy was held at New York University in October 1992. Her contribution to this volume first appeared in *Transition 58* (1992).

Suzaan Boettger is an art historian and critic. In the 1980s she curated exhibitions of conceptualized landscape painting in New York and Los Angeles; she is presently writing a history of contemporary Earthworks. At the 1993 College Art Association conference she chaired a session entitled "Decorating the Augean Stables. Use of Reclamation Procedures for Public Art: Precedents, Practices, Proposals." Boettger teaches graduate seminars on modern art and theory at City College of New York.

Joanna Frueh is an art critic and art historian and a performance artist. She has written extensively on contemporary art and women artists and her articles, reviews and performance texts have appeared in *Art in America, Art Journal, Afterimage, High Performance* and *New Art Examiner,* among others. Her publications include *Hannah Wilke: A Retrospective* (University of Missouri Press, 1989) and *Feminist Art Criticism: An Anthology* (2nd printing, HarperCollins, 1991), which she co-edited and which won the Susan Koppelman Award. Currently she teaches art history and criticism and performance art at the University of Nevada in Reno and lectures widely in her areas of expertise. Frueh received her Ph.D. in History of Culture from the University of Chicago.

Christine Tamblyn is a conceptual artist and theorist who teaches at San Francisco State University. She has published over one hundred articles in art magazines, catalogues, text books and anthologies. Her performances and videotapes have been shown widely at artists' spaces, museums and academic conferences.

Cassandra L. Langer is an independent art historian/critic, appraiser, and co-founder of the Psych-Art Society. She works in New York City, lectures widely, has authored many catalogues and published in *Arts Magazine, Art Journal, Art Criticism, American Artist, Ms.* magazine, *Women Artists News* and the *International Journal of Women's Studies.* She is currently a critic-at-large for *Woman's Art Journal.* Langer's most recent books are *Feminist Art Criticism: An Annotated Anthology* (G.K. Hall), *Mother and Child in Art* (Random House) and *Feminist Art Criticism: An Anthology* (HarperCollins). She is currently working on a biography of the American landscape painter John F. Kensett. She has taught art history and criticism at the School of Visual Arts, Hunter and Queens colleges, and at the University of South Carolina (Columbia), where she was a tenured associate professor. A recipient of a Smithsonian postdoctoral fellowship from the National Museum of American Art, Langer earned her MA in Art History from the University of Miami and her Ph.D. in Art History/Criticism from New York University.

INDEX

Page references in italics refer to illustrations.